Cosmos Screen

Perry Kelly

authorHOUSE®

AuthorHouse™
1663 Liberty Drive
Bloomington, IN 47403
www.authorhouse.com
Phone: 1-800-839-8640

Published by AuthorHouse 4/30/2013

ISBN: 978-1-4817-4642-7 (sc)
ISBN: 978-1-4817-4641-0 (hc)
ISBN: 978-1-4817-4640-3 (e)

Library of Congress Control Number: 2013907582

Cosmos Screen is the story of the son of a Southern sharecropper coming of age during the Great Depression and World War II and his subsequent life as he seeks education, artistic expression, economic security, religious and sexual identity, and love. It is a story of one who rises from the 1930's poverty to achieve his doctorate degree and retirement as professor emeritus. Moreover, it is the story of his lifelong struggle to assuage conflicts of personal versus family values in his large conservative family and the society in which he lives.

Cosmos is a Flower.

The tall feathery Cosmos plants, bearing multicolored flowers, serve as a screen from which the author records his first memories as well as a screen to his historical family that he will come to know; thus, the *Cosmos Screen*. PK

Dedicated to
John & Linda Mahony
As well as Jay Mahony, Kelly Mahony and Dru Mahony,
My closest friends for about thirty years.

Isaac Perry Kelly 2010

TABLE OF CONTENTS

TRAVEL

INTRODUCTION

I have chosen the cosmos flowers growing in the edge of a yard as metaphor for a curtain or screen: The Cosmos Screen. I remember this screen of cosmos flowers, as well as experiences that followed, from the age of five years. This screen separates the life prior to that fifth year from those subsequent experiences that I remember. Any events relative to my life before that age of five years are historical. In much the same way, the Cosmos Screen separates my immediate family from the extended family that I had yet to discover. The Cosmos Screen also separates my immediate geographic space from later empirical geographic space. This story is completed in my eighty-seventh year, and I hope the perspective is not distorted! I have attempted to explore seven themes that seem to have been major factors to my development. Those themes are (1) family, (2) people who aided me, (3) security, (4) education, (5) companionships and sexual orientation, (6) the international perspective, and (7) religion. I hope the reader will recognize these themes.

As you open and read this book, share my journey remembering this quote from *The Prophet* by Kahlil Gibran (Fitzgerald, pg.7):

"These things he said in words.
But much in his heart remained unsaid.
For he himself could not speak his deeper secret."

And, as you go on this journey I would ask that you keep in mind

a quote from *Shadow of the Silk Road* by Colin Thubron (pg 2), when he ponders the "Why?" of his journey.

"Sometimes a journey arises out of hope and instinct,
the heady conviction, as your finger travels along the map:
Yes, here and here ... and here. These are the nerve ends of the world ...
A hundred reasons clamour for your going.
You go to touch on human identities, to people an empty map.
You have a notion that this is the world's heart.
You go to encounter the protean shapes of faith.
You go because you are still young and crave
excitement, the crunch of your boots in the dust;
You go because you are old and need to
understand something before it's too late.
You go to see what will happen."

CHAPTER ONE
THE ALABAMA EXPERIENCE

The year of the "cosmos screen" was 1930, the time of my earliest memories, before which all was prehistory and after which, for me, came new realities. Cool shades of pastel cosmos blossoms swayed in a breeze high above my head. The space around the house, called the yards, were white sand swept clean with brooms of dried branches. Rural Barbour County, Alabama, a stretch of sandy farm country, like the rest of America was entering the horrors of "the great Depression." At the time, my father was a very poor "sharecropper" tending land owned by Mama's uncle. A "sharecropper" is one who rents land with the promise of sharing the farm products, usually fifty percent, with the landowner. Unfortunately, the sharecropper usually had to borrow money for seeds and fertilizer so that he more often than not had nothing left after the crops were gathered!

The house in which my family lived sat only a few yards from the cosmos flowers in the middle of this white oasis. It was a simple, unpainted frame structure facing east and the unpaved sandy road. The house had a front porch, a main room, a second room to the rear, and a "dog-trot" across which one entered the kitchen-dining room. The main room had a fireplace and two double beds. The second room had only two double beds and a closet for clothes. We had carefully wallpapered each room with newspapers and magazines for insulation. The kitchen had a wood-fired cook-stove around which we gathered for meals, for wintertime family conversation, and beside

which we often bathed in a metal washtub. It seemed that this last room always served as my retreat to Mama and the smells of country cooking. The center piece in this room was a long hand-hewn table with benches on either side which served as dining table, as study table for my older brothers, and as the family center. There was also a tin-front "safe" that held dishes but more importantly it contained cooked food and pies! It was called the "pie safe." The stove was warm and comforting in winter, hot in summer, but always ready for another family meal. The "warmer" above the stove nearly always concealed warm baked potatoes or fresh cornbread.

Several kittens, a couple of dogs, and sometimes a few chickens dozed under the house or huddled there in winter weather. Occasionally it was also the retreat for a wandering pig or hog that would enter the space amid ensuing noisy opposition.

The "smoke house" was located just to the rear of the kitchen at the edge of the white sand yard. It housed the smoked or salted winterkill of meat, a few gallons of sorghum syrup, and often a little golden corn whiskey "for Daddy's cough" or for wintertime sore throats. We stacked firewood under the eve of the smokehouse for use in cooking and heating the house. Of course, there was no electricity in rural areas at that time. The garden and the small barn with its single cow stall, a place for our one mule, and the adjoining pig pen sat just to the rear west of the smokehouse. We kept the cow that provided all of our milk and butter, and the few hogs that would come to the table in their own time, in this small enclosure throughout the summer. In the fall they were free to forage over the farm during the day, and we would round them up each night. It was customary for neighbors to help each other to keep up with these unmarked animals as they roamed the open fields. Then only a few feet from the barn, at the edge of the corn field, one could find the "outhouse," privy or toilet. We had no plumbing.

Still farther west through the field and down a steep incline into the woods, the cool clear water of a spring gurgled from beneath the bank at the foot of a large tree. The stream was a delightful place for us to play while Mama did the family wash beside the spring. She

boiled the clothes in the big iron pot above a wood fire. Afterwards she would beat them with an oak paddle on a nearby wood block. She used the soap that she had made from pork fat and lye. It was from that spring that all of our water came, for use in the house as well as for the animals, bucket by bucket up the well-worn path.

Except for the garden to the rear of the house, in every direction from the house were fields of cotton, corn or peanuts. The dirt road ran through the farm past our house. To the north it crossed a cool stream in the shade of spreading oak trees. To the south the road passed the church with its graveyard, or cemetery, and continued past the home of my aunt and then on to the school; only grades one through eight. That road was a symbolic path from the cosmos screen to what was to become my world. That tall stand of cosmos became the screen that separated what I was from that which I was to become.

For a boy of five this was a sensuous place filled with new experiences and simple pleasures! I loved the cosmos. I loved having my bare feet in sand warmed by the sun or cooled by the shade. I delighted wading in the cool stream. I enjoyed the closeness of family, the beauty of tall corn, and the rough tongue of the cow as she licked my hand. We had a great tom turkey that I liked to see strut and gobble around the yard. I also liked to frighten him so that he would gobble noisily! However, one day I jumped from the porch to scare him, only to fall too close to the turkey. The darn bird jumped on top of me and terrified me with the terrible flurry of those huge wings! Daddy rescued me, and I respected that turkey's space thereafter.

At that age, it seemed to me that everyone was either in my family or "kin" to me. Everyone outside my immediate family had the title of uncle, aunt, or cousin. We learned to use those titles when referring to, or addressing people. It was always Uncle Victor or Aunt Callie or Cousin Mary! By the age of five, my world had expanded from the cosmos screen. I then knew the way along the road past the church and graveyard, past the house of Uncle Lijah and Aunt Callie, all the way to Uncle Victor's house. All of this was a distance of about four miles. Close to the edge of our farm, in the shade of tall oak

trees, stood the white frame building where everyone I knew went to "church" when the preacher came one weekend each month. Often Grandpa would come from Georgia in his big, black, high-top Buick to preach and then to visit us. Man Pitts was Grandpa's driver, and he was the first black person that I remember seeing. Grandpa lived about sixty miles away, which was somewhere beyond what I could grasp; but I really liked that big car! It was the largest car at church, and I was not allowed to play in it as we kids often did in the smaller model T Fords in the area. It was during one of those visits and in Grandpa's service that I first saw the men washing each other's feet, while the women sitting on the other side of the room, were doing the same. During this act, the congregation continued singing, and often many of them began crying. On one particular day at church, a terribly frightening thing happened. After the regular service, everyone got into the cars, wagons and buggies and drove north of our house to a wide place in the creek. There Grandpa, accompanied by Daddy and Mama dressed in their Sunday clothes, waded over waist-deep into the water. Then, with singing and some words from Grandpa, he pushed Daddy and Mama, one at the time, under the water! The other church members stood on the bank and continued to sing. Then we all went home to Sunday dinner. For me that was a frightening event. I later learned that this activity was part of their joining the church ritual called "baptizing." To this day, I still do not like the idea of someone putting me under water for any reason.

The church benches were hard and too high for my feet to touch the floor. I often became restive during the service which could easily last two hours afterwards. My sister Louise and I were then allowed to go outside to play with other children. We would often climb into different wagons, buggies and even some of the cars. Sometimes my oldest brother, Marvin, would just sit in one car with a girl, and he would not like it when we came to that car. Jay enjoyed shooting marbles in the sand, where he would win a lot of marbles. Once each year Grandpa and Grandma came to the church for the Communion. The members brought food that they would set out on a long table made of wire fencing stretched beneath the oak trees. I remember

that I liked the fried chicken and especially the chocolate cakes. I also knew who made the best of each! I later learned that these were special days for "communion" that included the foot washing ritual. I do remember that Grandpa gave very long sermons.

The school that my two older brothers, Marvin and Jay, attended was about one mile from our house along the same road and east of the church. Often they would let me go with them. The trek was long for me, but there was always time to play along the road, to explore bird nests, or to just shuffle my toes in the dry sand. In winter, the ice spewed up along the road, especially in the clay banks, and it was fun to crush it with my bare feet. Next year 1931, I will be six years old. Then, I will go to this school daily.

The wood-frame schoolhouse had three rooms. There were two rather large classrooms, each containing desks, the teacher's desk, a chalkboard, and a wood-burning stove. Two students would share each of the double-seated desks, and as in church, my feet would not touch the floor. A third room contained firewood along with our coats, and brooms for sweeping both the floors and the yard. It was in this room that we also kept our lunches that we brought in tin buckets. It was also in this room that the teacher kept the ever-threatening switch that I witnessed the teacher use on Jay one day while I was there. It scared me, and I ran all the way home. It was always a standing rule at our home that if one of us got into "trouble" at school we would be in trouble with Daddy when we got home. Of course, Daddy, as promised, used a switch on Jay when he returned home!

Older students were taught in one room while the younger ones were in the other. Students in this school could go as far as the eighth grade and then transfer to the bigger school in the town of Clayton, unless they had to work on the farms. For me the idea of going anywhere beyond the immediate area of home was a strange idea. Since I was so close to the cosmos screen, I only knew that this road went to the church with its cemetery, to the school, past Uncle Lijah's and to Uncle Victor's house.

From the school I could look north and see the house across the fields where Uncle Artis and Aunt Alice Benefield lived. Aunt Alice

was Mama's aunt. They had several children. One of them, Cousin Faye, was about my age. She often came to play with my sister Louise and me. Faye's mother never grew cosmos or other flowers as did Mama and I would get very angry when Faye picked flowers in our yard. Mama told me that everyone should grow flowers just as we grew vegetables.

Aunt Callie, who lived near the church, often had headaches and took many aspirins every day. She was a big person who made biscuits larger than any I have ever seen. That was the way Uncle Lijah wanted them for his syrup or gravy. More importantly, she baked big sweet potatoes that oozed sweet candy from each end. She would give me a few anytime I would go the short distance to her house for them. She seemed to get them ready much too near the dark of night, and I passed the graveyard hurriedly. It seemed never to be fast enough. Sometimes I would tremble and turn cold as I ran past the graveyard at dusk. Mama always assured me that nothing would bother me there, but Jay would laugh and tell me that "nothing but a ghost" would get me. Anyway, the sweet potatoes were good, especially if I could get them home before dark. It was customary to bring such foods, or even candy, home to be shared.

In the summer of 1930 the corn beside the cosmos patch and back of the barn was very high and dark green. The shadows were cool as the long blades swayed above my head much as did the cosmos blossoms. One day, a female cousin of my age and I came here to play and, as it often does, play became exploration and learning! Anyway, we were exploring our anatomical parts just as my brother, Jay, came around the corner of the barn and saw us. He immediately made it seem that what we were doing was very bad and he sent my cousin home. He said that it was so bad that Daddy would "skin me alive" if he learned about it. However, he promised that Daddy would not know about it if I would never do it again, and if I did what he told me to do. Even though I did not understand, I did not dare refuse his offer, a threat that he held over me for a long time. I later had nightmares about this incident that, strangely, included me being in my wedding to an objectionable person.

In the house north of us, beyond a strip of woods and a creek, there lived a rather large family. I really did not know them because, like us, they had just moved there, and they were not kin to us. Daddy said that they were good folks, and we sometimes did play beneath their peach and pear trees. Early one morning in the fall when the weather turned cold enough for a fire in the fireplace, one of the boys in that house used what he thought was kerosene to start the fire, only it was gasoline! The explosion was awful, and the boy died. The house burned, and the family moved away. That was my first knowledge of death. The loss made me very sad.

That September, Mama was sick, and Aunt Callie came to help her. Grandma also came from Georgia. It was then that my brother Clifton was born. Even to this five-year-old the new baby looked so very small. Daddy said that I also was once that little. Now our family consisted of Daddy, Mama, Marvin, Jay, me, Louise, and Clifton. Daddy said that we needed a larger house.

The Christmas of 1930 was a big event in our house. Aunt Callie sent a big pan of those sweet potatoes, Grandma made a bowl of ambrosia, and Mama made some eggnog. Marvin added extra coconut to the ambrosia, and everyone laughed when Grandma added some rum to the eggnog while Grandpa was outside! Santa Clause left apples, oranges and long striped sticks of peppermint candy through which I learned to suck juice from the oranges.

Jay had developed a habit of sleepwalking, and he would sometimes wet the bed. Mama stopped scolding him. Instead, at night she would put a sheet around his waist, knotted in the back, so that he would not sleep on his back and thus not wet the bed. No one seemed to know what to do about his sleepwalking. Once in his sleepwalking Jay placed some large rocks on the front porch but he could not lift them by himself the following morning. Marvin had to help him remove them. There were later episodes of sleepwalking for Jay. Some years later he dreamed that he was swimming and dove from the foot of the bed into the floor!

Daddy did find a slightly larger house and a farm that he rented as a sharecropper located only about three miles south beyond the

7

farm of Uncle Victor and Aunt Ollie Baxley. It was winter of 1931 and time to prepare for the new crops that Daddy said would grow better there because the soil was less sandy. Relatives came to help us to load our things onto the wagons and to move us. Thus I left behind the cosmos flowers, the cosmos screen, after which life would be forever an expanding experience with perpetual references back to that screen.

A New House: A New World

Our new house, about three miles south of our former home, was not a new one at all, and it was very similar to the one we had just outgrown. It was the same aged gray wood. It really did seem larger, and the kitchen was in the house rather than being set apart as the other one was. The house faced west, overlooking the same winding road of white sand that crossed a creek just a short distance south of the house. A porch extended across the front of the house, beyond which there was a large room with a fireplace as in the older house. This served as both the front room and a bedroom with two double beds in it. Back of that room were two other bedrooms, then the kitchen and dining area that opened onto the back porch. The roof was made of metal and I loved to hear the rain falling on that roof.

Mama and Daddy said that, because the former occupants were not clean housekeepers, we would have to take everything out of the house and clean for bedbugs! They assigned tasks to each member of the family, and we scrubbed everything with water brought from the spring a short distance from the rear of the house. We scrubbed the walls with lye made from oak ashes, and we scrubbed the floors with lye, soap and sand. Even the yellowed newspapers, which had been pasted on the walls to keep out the cold, were taken down and replaced. The house was cleaned, and it smelled very fresh. The wide boards of the floor were beautiful. They were almost white with deep wood grain. The surface of the wood, due to age and use, was a little fuzzy and soft to the touch. I enjoyed the feel of the floor to my hands

and bare feet. Sometimes I would just lie on the floor with my cheek on the cool smooth surface and smell the clean! Of course, we were all nervous about the bedbugs until Mama assured us that we had killed all of them.

Again the smokehouse was located just back of the house at the edge of the yard. This is where we would hang the pork and sausage to cure in salt and smoke. It was customary to do the butchering after the first winter frost when the hogs were fat from eating all the corn and peanuts left in the fields. We built a fire and then smothered it so that for several days there was a lot of smoke rising to the meat. It smelled good, and the whole smokehouse smelled good after years of curing meats there. Salt from earlier curing littered the earthen floor inside the smokehouse. Daddy explained that we were lucky because there was not any salt available for us to buy even if we had the money to do so. So we carefully scraped the salt from the floor and stored it in the kitchen. We saved the ashes from the smokehouse fire as well as those from the fireplace to be used in making lye. The lye was combined with pork fat to make soap. The lye was also used in cooking the hominy corn. Mama and Daddy rendered the pork fat, made the lye soap and cooked the hominy in the big black wash pot, the same pot that was also used to boil our clothes.

Mama repeatedly told us that soap was very necessary because "no matter how poor we are, nor how ragged our clothes might be, there was no excuse for being dirty!" We were also afraid that, if we did not keep clean, the bedbugs and lice might come back! So, all of us would help with the washing by bringing water from the spring, stirring the boiling clothes, keeping the fire going or batting the clothes on the stump. We would wash our face, hands, and often feet, in a pan on the back porch. However, we would bathe in the creek or, during cold weather, in a tub before the fire in the fireplace. I found that I liked to bathe in the kitchen near the cook stove where the heat seemed to fill the room better than the fireplace did. Of course, the seven of us would have to take turns bathing, and sometimes we would argue over who got to go first! The family attitude toward cleanliness would follow me the rest of my life!

The toilet was an outhouse back of the smokehouse. It was different from the one at the other house in that it had two seats with lids and it was deep and dark below the seats. I observed that the sunshine made an interesting spot on the wall as it came through the moon-shaped hole in the door facing south. My brothers would sometimes scare me when I was in there by banging on the door unexpectedly. All of us knew that no one was supposed to disturb anyone in there, but often when Daddy was not near, Jay would do it anyway! We were also taught that when the toilet was in use, it was more appropriate for men to go to the cornfield or the horse stable instead of going to the toilet. The outhouse was usually stocked with old magazines, newspapers or Sears catalogues while clean soft corncobs were used in the stable in lieu of toilet tissue.

We carried our water in buckets from a spring located at the head of the creek just south of the house. It was near the spring that Mama also washed the clothes and paddled them on a stump near the boiling pot. I helped to carry water, but I remember spilling a lot of it. When I struggled with a full bucket, the water almost seemed to jump out of the pail. Jay would laugh at me and then flex his muscles and assure me that someday I would be able to lift that bucket and more. At the time, that seemed unlikely to me, but Mama made me feel good about the little water that I finally did get to the house!

The barn with its adjacent pig pen and cow pen was just across the road in front of the house. I learned not to go to the barn because the mule might kick me or I may see a rat! Often I would stand by the fence to watch Mama, Marvin or Jay milk the cow. Of course, standing by that fence made me a perfect target for a squirt of fresh warm milk. I remember that it was fun to see the cow grasp the long corn leaves with her tongue, and I could pet her as she ate. However, I felt differently about the hogs. When we brought food scraps from our table to the hogs, they made such noises that I was afraid to go near them.

During this time, Daddy seemed to worry a great deal about not having any money and, even at the age of six, I was aware of that problem. He worked very hard as a sharecropper farmer and often

worked for other farmers. One morning he went with Mama to milk the cow, and they were talking very loudly to each other. When they returned to the kitchen Daddy became very angry and threw a plate against the wall toward Mama. I am not sure that it was thrown at her. Each of us knew that when Daddy was angry it was best for all of us to go outside, or at least away from him, unless, of course, he was talking to one of us! I had never heard my parents talk so angrily at each other, nor did I ever hear it again after that. By the end of the day, it seemed to have been settled. Daddy called us together to explain that sometimes adults also get angry at one another, but still love each other just as he does us. Mama then explained that she was weak from her recent birth of Clifton. She was also tired after all of the work involved in moving. She did not tell us that Daddy was having trouble with alcohol. I later, much later, learned that they had argued because he had been drunk and had taken a shotgun after Uncle Victor! I do know that he never drank alcohol or allowed us to do so after that incident.

Aunt Ollie and Uncle Victor Baxley lived on the farm adjoining ours with their house about one mile north on the same sandy road. Between the two houses there was a swimming hole where they had dammed up the creek. We would often take off our clothes and play in the water there. The older boys could dive into the water from the bank or swing from a vine. I was much too afraid to do that. I do remember being told that Uncle Victor had a still down the creek from the swimming hole, deep in the woods where we were not permitted. From that still came the golden colored moonshine whiskey that Daddy would sometimes drink. Uncle Walt kept some of it in his smokehouse, where he drank a little each morning before breakfast, so we were told. I remember that conversations about the still, the whiskey and its consumption were always in whispered tones, as if it was all a big secret. I suppose everyone knew this secret except perhaps the sheriff!

However, we often played at the edge of the woods near "that place," where there were some deep gullies. We would slide down the banks or play with the wild melons that grew there. It was here

that I learned to carve the melons with a knife so that I could make faces or animals out of them. My favorite activity there was stamping the damp reddish sand with my bare feet and feeling the cool water as it rose to the surface as if by magic. When I moved off the sand the water would just as magically disappear! It was along the banks of these gullies that I learned to climb a sapling tree and ride it as it bent under my weight. The tree would arch over the gully where I could then drop off into the sand. It took only one fall for me to learn that a hickory or gum tree was more flexible than the brittle pine that would break and drop me before I was ready.

At the time it seemed to me that Uncle Victor must have the biggest house in the world, certainly in my world anyway. It was painted white with green trim, and it was surrounded by a white picket fence. The yard bloomed with pretty roses, other flowers and green bushes. The wide porch stretched all across the front and along the east side of the house. The porch had ladder back rocking chairs and a green swing in which two or three of us could swing at once. Entering the house into a big hall that went through to the back porch, I found the fascinating water pump. A person could pump water from the ground right there on the porch! The largest front room was Aunt Ollie's parlor, with its beautiful furniture, which was usually closed unless she had company. We did not have a rocking chair. I took great delight in rocking on the front porch and found it interesting that I could rock without being able to touch the floor!

It was much later that I learned that Aunt Ollie was really my great aunt since she was sister to my maternal grandmother, whom I did not know. We often played with her children. My favorite playmate at the time was Hubert, whom I perceived to be gentle and kind. I thought his brother Huey was a bit of a rascal, and I admired him for many of his daring acts.

Uncle Victor was a deacon and lead singer in the nearby Antioch Church. As far as I knew that was the only church, and everyone I knew went there every third Saturday and Sunday. I remember there was some talk about Uncle Victor operating his still in the woods at the same time he was playing a big role as Deacon in the church.

There was talk among some of the members that he should not be a member at all if he was operating the still. However, that was hushed talk and he continued both activities. I would hear this discussion repeated for years, while nothing changed!

The home and farm of Aunt Alice and Uncle Walt Benefield was only a couple of miles farther toward the church. Aunt Alice was another of my maternal grandmother's sisters. Their house was not as large as that of Uncle Victor, nor was it painted. It was comfortable and looked very good in its broom-swept white sand yard. They had fifteen children, fourteen of whom had red hair. The youngest, a daughter, had black hair. All of my life I would hear jokes directed at Uncle Walt which questioned the parentage of this last child. I, and all of our family, had white hair that turned black in our mid teens. We inherited that trait from the Cliftons, a Welsh family of my paternal grandmother. Therefore I remember thinking the red hair of these cousins to be rather peculiar, and I never related to any of them as close friends. Uncle Walt, who was also very active in the church, was known to have his early morning drink in the smokehouse because Aunt Alice would not allow it in the house.

The family of Uncle Albert Benefield lived on a farm just south of Uncle Walt. His white house was built very much like that of Uncle Victor with a center hall having rooms on each side. The kitchen in each house was across a porch to the rear of the house. One of the sons had a crippling disease, probably muscular dystrophy, which confined him to a bed in the largest front room. From about the age of fifteen, he remained in this room and bed, where he was cared for by his parents, until their death and then by a sister until he died some forty-five years later. His younger brother, at the age of fourteen, began to develop the same affliction, and the last time I saw him, before his death at an early age, he was already on crutches. Grandpa always made special efforts to visit this family when he came anywhere in the area. He would always have a long talk with the son and offer prayer with him. Years later I accompanied Grandpa on these visits, where I learned the value of compassion, tolerance and dedication. Even though the son could move nothing more than

his eyes, his emotions were clearly perceptible. The joy of those visits was evident in his eyes. Each time we left the house neither of us would, nor could, speak much for what seemed like an eternity as we drove toward home. I have always admired the dedicated care which his parents, and later his sister and brother-in-law, gave to that invalid son. For the rest of my life those images and impressions have rendered me speechless when they invade my thoughts. From that early age I have continued to wonder about the reasons for his affliction and indeed about the reasons for his life. Until, that is, I assess the impact and value that his life has had for me. Then I am so very grateful for the experience and the meaning that his life had. If others learned, as I did, from knowing that person, then surely that is reason enough for his life as well as that of his brother.

Anyway, it was late afternoon on June 2, 1931. Mama and Daddy had just come in from the field where they had been planting potatoes. Mama called all of us together, took me in her lap and explained that it was a very special day; my sixth birthday! She explained that just six years ago in Orlando, Florida, I had come to the family, just as Clifton had done last year. For the occasion of my birthday she had prepared fried chicken and baked sweet potatoes for dinner! Then she reminded me that in September I would be able to accompany Marvin and Jay to school every day. My infrequent visits to the school last year made me eager to go with them.

That summer went without other memorable incidents until the cotton started turning white in the fields, and everyone had to be involved in picking cotton. Marvin could pick cotton rather rapidly because he would just grab cotton, burrs and leaves! I liked the feel of each lock of cotton, and I did not want any trash in mine. Therefore, I was never able to pick much nor did anyone expect me to do so. Clifton was very much afraid of the cotton and would scream each time it was brought near him because the individual staples looked like fuzzy worms. Louise and I enjoyed playing in the fluffy white cotton. When the wagon had been filled with cotton high above its body sides, Daddy had to drive it to the gin in Clayton. It was an exciting day for me when the first load was ready because Marvin,

Jay and I accompanied Daddy to the gin. The gin made a lot of noise, and when I saw the large pipe sucking the cotton from the wagons ahead of us, I became afraid of the machinery and the noise. Of course, Jay told me that the gin had enough force to pull me right into it just as it did the cotton! So I stood my distance and watched with fascination as the cotton was unloaded from the wagon as if by magic. Then Daddy took me through the gin with assurances that it was safe even for little boys. There I saw our cotton going through machines that removed the seeds and trash such as Marvin had put in and later packed it into bales to be shipped. I really thought the large bales were so very neat and beautifully packaged. However, I never liked the noise of machinery.

Daddy was paid for the cotton after it had gone through the gin into the bales and had been weighed. We then went to the store where Daddy bought, among other things, salt cured fish in a large barrel. The barrel had excess salt from the fish that had already been sold. We needed that salt badly. He also bought some candy that he handed to me with the admonition that I must wait and share it with everyone at home. For a six-year old boy, that was a difficult task. The fish, besides having a very good flavor, provided us with iodine, thus preventing gout, swelling of the throat. The salt was used in cooking or in curing meat in the smokehouse. Salt was a very rare commodity during the Depression and often not available at any of the stores. As I sat in the empty wagon on the way home with the candy in my hand, I was sure that the distance home was much longer than it was going into Clayton! When we finally arrived home, we all ate it happily. Generally candy was available only at Christmas, so this candy was really a treat. I would remember both the candy and the lesson of sharing as it was later reinforced in many ways.

Just as Mama had promised, after the cotton had been picked and the peanuts were dug and stacked on the haystacks, we were able to go back to school. Even though we had moved, we went to the same school that Marvin and Jay attended the year before. We were then about two miles from the school. Each day we would walk to the school accompanied by cousins who lived along the way. We

had a lot of fun along that walk. Sometimes some of the older boys would get into fights, but no one seemed to get hurt. Often we would try to guess the names of trees or plants along the road. Each day I would look forward to lunch because after breakfast each morning Mama would put buttered grits into a saucer, and then top that with a fried egg and a jelly-filled biscuit. This was then placed in my lunch bucket, a shining new half-gallon syrup can. Occasionally she would surprise me with a baked sweet potato or some bacon. I liked the cold grits with the yellow of the egg in them. We would often swap some of our lunch with other kids.

After the crops were gathered that fall, Daddy paid Uncle Victor, the landowner, his share of the income from the crop. He then paid what he borrowed to make the crop, and there was little left except a few hogs, potatoes and our one mule. Even the ownership of the mule was in dispute! One afternoon Daddy was told that the sheriff was coming to take the mule to its owner. As I reflect on this incident, I am certain that I could not have understood all of this, but the tension in the family was apparent. I do remember it being quiet clear that we could not work the farm or even prepare the land for farming without the mule.

During the afternoon before the sheriff came, Daddy hid the mule in the woods. During the night he rode the mule sixty-five miles into Georgia to Grandpa's plantation. When the sheriff came late in the evening, the fear of his coming had been conveyed to all of us. Mama told him that she did not know exactly where Daddy was. Later she explained to us that she had not lied because she really did not know "exactly" where Daddy was at that time of the night, and the sheriff did not ask about Georgia! Daddy came back the following day in Grandpa's big high top Buick car to move all of us to Georgia. He came back along the south road to avoid the sheriff, and we left the same way, quickly. On the way, Daddy explained how things would be much better for all of us in Georgia, in a larger house and on a larger farm owned by Grandpa. This hasty trip closed the chapter on Alabama, moved me farther from the cosmos screen, and opened new horizons for this six-year old barefoot kid!

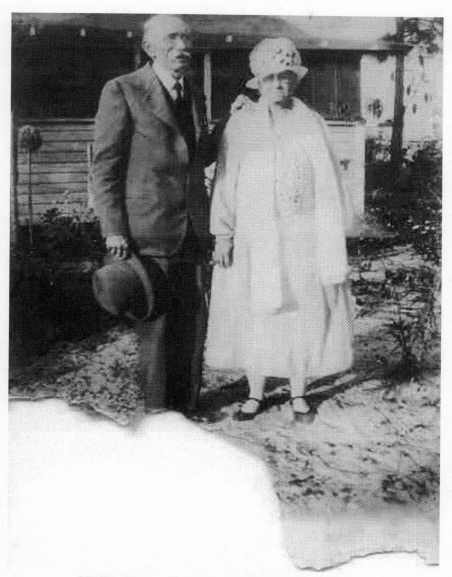

Willie Isaac & Clara Addie (Clifton) Kelly

CHAPTER TWO
A TIME BEFORE THE COSMOS SCREEN

The beautiful cosmos patch became the screen beyond which lay my amorphous prehistory and from which I was to extend the conscious experience of living. What happened before the cosmos screen was history. I yet had to learn about it as I would have to experience the future. This is the continuum in which my story unfolds.

Sometime in the early nineteenth century the family that I will come to know began in Ireland. My paternal great-great grandfather, by the name of O'Kelly, and his wife from Scotland, immigrated to America to escape the famine in Ireland. Either that family or immediate ancestors then migrated south along the Atlantic coast. His son, Isaac O'Kelly, my great grandfather, omitted the "O" from his name and began the traditional family name of "Kelly". The O'Kellys brought with them a strong anti-Catholic bias and a conservative Protestant faith. This industrious family sold horses and handmade lace along the Atlantic seaboard. Isaac Kelly also fought for the South during the American Civil War. He died (10-22-1864) during that war, leaving a wife and one son, my grandfather William Isaac Kelly, known as Willie or W.I. Kelly (Oct. 18, 1864-1963). My great-grandfather died in battle only four days after his son William Isaac was born. Therefore they never knew each other. My great-grandmother, Martha, then married John Walker, who soon died, and then Walter Skates, who evidently was a tyrant of

a stepfather. At the age of twelve my grandfather, William Isaac Kelly, left home to live with his mother's sister, Harriet, and James Welch in Barbour County, Alabama. He did attend school to about the fourth grade or at least until he learned, as he later told me, "to spell scissors" in the standard blue-back speller."! He spent his early years clearing forests and farming in southeast Alabama, where he met and married Clara Addie Clifton (1862-1931), whose family was of Welsh descent. In 1906, at the age of forty-two, he was ordained a minister or Elder in the Primitive Baptist faith in which he served for more than fifty years. He and Clara Addie Clifton Kelly were parents to seven children: Eva Pearl Kelly (1886- ?), Beaulah Alma Kelly (1888-1980), Arrabella Kelly (died as an infant 1890), Junious Orbie Kelly (1894-1957), William Carlos Kelly (1897-1953), Dora Olive Kelly (1898-1990), and Albert Roy Kelly (1903-1974).

Trading horses, making lace, scrambling for a meager living as sharecropper farmers, and frequently moving in pursuit of promises became a way of life. One such promise was the development and economic growth in Florida after World War I. The roaring twenties boom in Florida attracted wealthy northern investors and vacationers from the north as well as the less fortunate from neighboring southern states. The apparent success of my great uncle and aunt (Will and Roxie Long, Grandmother Kelly's sister), who migrated to Orlando, Florida, sometime before 1920, was incentive for Willie Isaac to move his family to Orlando in the early twenties. Uncle Will and Roxie Long had successfully acquired and cultivated an orange grove near Orlando. With their help and encouragement, Willie Isaac Kelly brought his wife and five of his children from Alabama to Orlando just at the end of World War I. My father, Junious Orbie Kelly, also made the move to Orlando. He brought his wife, Flossie Bay Davis Kelly (1896-1934), and two sons, John Marvin Kelly (1915-1967) and Junious Willie (J.W. or Jay) Kelly (1918-1950) to Orlando.

Grandpa (Willie Isaac Kelly, most often called Elder W.I. Kelly) opened a general store in Orlando on the corner of Church Street and Orange Blossom Trail, where he and the family lived upstairs. He accepted the "call" or invitation to serve the Orange Primitive Baptist

Church in Orlando as well as other churches in the general area on a monthly weekend rotation. He would drive a horse and buggy each weekend to a different church. These churches usually had a small number of members and the remuneration was certainly meager. It was customary for these churches to have services only one weekend per month, but these services often included Saturday and Sunday meetings, sings and services. The churches would hold Communion services once each year, extended over the full weekend. This service included the ritual of sacraments, washing of the feet, and hours of singing and preaching as well as the community dinner on the ground or dinner brought to the church grounds.

Daddy (Junious Orbie Kelly) found work in orange groves, in ice delivery and as a mechanic. At one time he helped lay a brick paved road from Orlando to Daytona. At another time he worked with a crew building the overseas railway from Miami to Key West. William Carlos worked in the groves and later went into moving and transfer work that became his lifelong employment. Albert Roy, the youngest of the family, had bit parts in various movies being made in Orlando during this boom period in the early twenties. Beaulah married Colin Scott (1880-1948), from Alabama with whom she had three daughters: Florene, Myrtle and Mildred. Dora married Edward C. Moseley with whom she had two children: Edward Jr. (Buck) and Theresa. Dora divorced Edward soon after the birth of their second child after she found Edward in a parked car with another woman. When Edward returned home from the rendezvous where Dora had secretly observed him, she had his suitcase packed ready for his departure. Grandpa took her and the two children to his home and he forbad Dora to see Edward again.

Under Grandpa's guidance the family developed a deep sense of unity with very strong patriarchal governance. The family expected allegiance, respect to, elders and being "brother's keeper." Everyone was expected to contribute to the family welfare, reputation and good name at all times. Being "one of the Kelly boys" became a phrase of pride that I would hear all of my life. The Protestant ethic, a patriarchal family, morality, and the bond of one's word and promise

were as familiar to me as were the familiar hugs and kisses among kinfolks and friends of either gender. Thus, in this family, a son might become a non-entity or non-family member, as did my great uncle, who was jailed in Atlanta as a result of an illegal horse trade. Thus, too, a daughter might receive absolute rejection by the family, as did aunt Pearl, by premarital pregnancy or other grave misconduct. I never heard any of the family mention or acknowledge the name of my great uncle or aunt Pearl. She either left home or Grandpa drove her from home as a teenager for reasons that vary with the later telling among relatives. It was into this setting that I was born and in which I would spend my formative years.

Mama (Flossie Bay Davis Kelly, 1896-1934) was born in southwest Georgia where her father, Charles Davis, abandoned the family and went to Texas when Flossie was only two years old. In desperation, Grandmother Davis placed the three-year-old girl alone on a train en route to Clayton, Alabama, a distance of about sixty miles. In Clayton, the stationmaster took her from the train and delivered her to her aunt in the nearby countryside, where she lived until she married my father. When Mama was near death at the age of thirty-eight, her mother came to see her for the first and only time in her life. About the same time, her father wrote from Texas that he was almost blind. Understandably, she received her mother graciously, but certainly not warmly, and she never answered the three letters from her father. My maternal aunts, uncles and cousins do play an important role in my early life. Maternal grandparents were never a part of my life. This, of course, contributed to or reinforced the patriarchal orientation.

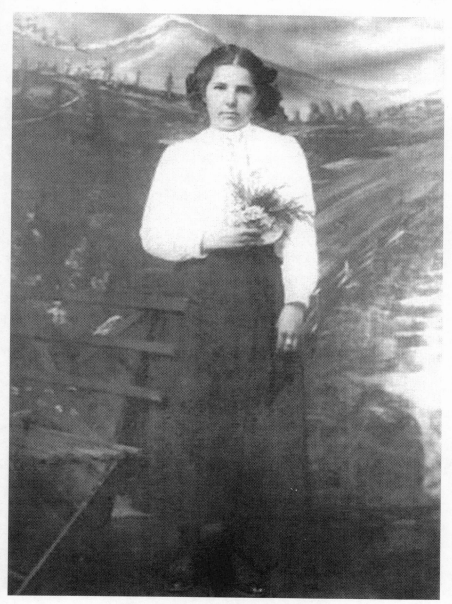

Flossie Bay (Davis) Kelly 1920

In 1928, at the end of the Florida boom and the beginning of the Depression, Grandpa bought a rather large farm and home near Edison, Georgia, in the southwest section of Georgia known as one of the poorest areas in the country. He moved his family there where he farmed and served as minister to various churches in that area of Georgia and Alabama. This proved to be a fortunate move for all of us as the South struggled through the depression years. The following year (1929), Daddy moved his family of four children (Marvin, Jay, me and Louise) back to a farm owned by my mother's uncle in Barbour County, Alabama, that he tended as a "sharecropper." Farm soil in that section of Alabama is sandy, easily leached and low in production. It was here, among Mama's relatives that my younger brother, Willie Clifton Kelly, was born, and it was here that the cosmos bloomed. What follows thereafter is the story of one great-great grandson of a poor Irish emigrant. I was born during the promising Florida boom but experienced the great depression during my formative years as son of a sharecropper in Alabama and Georgia. It is also the story of three distinctive forces that shaped, nurtured and threatened this life. Those forces were family relationships, professional relationships, and my very private personal life, forces that have more often been in conflict than in harmony with each other.

CHAPTER THREE
THE GEORGIA EXPERIENCE

The distance from Clayton, Alabama, to Edison, Georgia, is about sixty-five miles. It seemed much longer that morning when we were fleeing the situation in Alabama. The mule was safely across the state line, where the Alabama sheriff had no jurisdiction, and we were a family of seven with all of our possessions packed like sardines into that tall, flat-topped Buick bumping over dirt roads. However, the anxiety and excitement of going to Grandpa's overshadowed the discomforts.

It was late fall of 1931 when we arrived at Grandpa's farm, which would be our home for the next several years. Cows and hogs roamed the bleak red fields in search of corn and peanuts left after the harvest, much as they did in Alabama. The hogs also foraged on nuts in the nearby woods. The house into which we moved was a new, spatial experience because I had never seen such a big house. It was even larger than Uncle Victor's. However, the two were of a similar common design. Grandpa's was a white frame house with floors of wide, planed boards that showed years of wear and scrubbing. The walls and ceilings were also made of wide unpainted boards. The shingled roof and the wood ceiling did not resonate with the familiar sounds of rain on the tin roof that I so enjoyed in Alabama. The house sat rather high off the ground with several wide, wood steps leading up to the screened front porch. That porch included a small room, called a "shed room," on each end. There was one large window on

Perry Kelly

each side of the big, double, front-hall door that opened into a wide hall leading between two large rooms to the screened rear porch. On the other side of this porch were the dining room and kitchen. Each room off either side of the hall had a fireplace and enough room for two double beds as well as room for all of us to gather in front of the fire. The west room also contained Mama's foot-peddled sewing machine and her quilting frame, which she lowered from the ceiling for quilting. A door beside the fireplace opened to the outside. A third door in Mama's room opened into the shed room on the back porch. The east room was similar, but it had only one door, a window on each side of the fireplace and a window opening onto the front and rear porches. Two shed rooms flanked the back porch as they did the front porch. Across the screened porch, the spacious dining room contained the dining table, chairs, a buffet, a china cabinet and rocking chairs around the fireplace. The adjacent kitchen had the familiar wood-burning stove with its warming oven above and baking oven below. There was also the familiar sight of a countertop supporting dishpans, cooking utensils and water buckets. A rear door opened to the back yard, the smokehouse, the outhouse or toilet, and a storage house. Furniture on the screened porch consisted of a few chairs, the wash-basins beside the water buckets, a common drinking dipper, towels, and a wash tub for bathing. The screen door from this porch opened to the well with its hand crank, rope, pulley and bucket, and to the side yard. All of this would play a role in my life over the next several years. In summers to come, some of us would enjoy sleeping on quilts on this porch, and friends would gather to enjoy evenings of singing and guitar music. The dining room with its fireplace and adjacent kitchen served as a multipurpose room where we ate and did school homework. In the evenings, the family gathered or entertained friends there. In winter we also bathed in a washtub before the fire in that room. Mama and Daddy occupied the west room, while Clifton, Louise and I shared the east room. Jay had the west front shed room and Marvin had the east front shed room. Later, I would share the room with Jay until Marvin moved away and Jay moved into that room. For me, that was a wonderful house, on

a wonderful farm. It was an exciting adventure. There was not any electricity, but Grandpa did have gas lights in his house.

The soil in Georgia, unlike the sand that I knew in Alabama, was dark red clay. The road that ran in front of the house, between the house and the barn with its horse stables, was also red clay. Our yard around the house was white sand to red clay that we swept with brooms made of small branches. The front yard was shaded by two large cedars and two larger magnolia trees. The cedars smelled refreshing, and the wind whispered through their lacy leaves, whereas the magnolia blossoms smelled sweet and wind rustled through their broad, waxy leaves.

Marvin showed me how to use a stick to draw on the white petal of the magnolia blossoms after which, as if by magic, the drawn lines would turn a nice dark brown. Marvin also used milk to draw on white paper. When we heated it, the milk would turn brown. Marvin could draw well, and I admired him for that talent.

A rather large lawn covered the yard on the east side of the house, which in spring became submerged in yellow jonquils almost as tall as Clifton's head! Often we would play in them, breathe in their perfume, and feel the long, cool leaves against the skin. A pecan tree at the north end of that field of jonquils bore strange worm-like blossoms and big pecans. Sometimes we would slip the fuzzy pecan blossoms down Louise's collar and she would scream!

A tall uncut privet hedge bordered the south end of the jonquils. The privet bore tiny sweet smelling blossoms that would almost stifle us when they were in full bloom. Beyond the privet hedge was another large pecan tree under which sat the black wash pot and the bench used for washing clothes. That was also the place for butchering and cleaning the hogs in early winter. It was also the place where Jay and his friend would slip away to smoke a cigarette. I knew he was doing it but I dared not tell because he still held our secret over my head.

The smokehouse was located directly back of the house as was the outhouse, a cotton storage house and the largest fig tree I have ever seen. The fig tree had grown into two main branches that leaned

in opposition to each other so that we could easily climb far up into the upper branches. Once "Junior," a black boy of my age with whom I often played, ran a race with me to see which of us could more quickly climb to the upper branches. When he was about half way up the tree trunk he slipped and slid down straddle of the trunk. He landed at the bottom of the tree and began to cry. I found that on the way down he had snagged his penis. One time when I had cut my foot, Daddy poured kerosene on it. So, I ran for the kerosene and poured some on his penis! The following day, it had swollen so much that we had to tell Daddy and his mother. Daddy took him to the doctor, and he soon healed.

After we picked cotton in the fall, we stored it in the cotton barn until we took it to the gin. Clifton was still afraid of cotton. When we tried to get him near it, he would scream, especially if we chased after him with a small staple of it. He would never play on the cotton as the rest of us did. I particularly enjoyed jumping into the cotton from the rafters of the barn or just lying there in silence with my classmate Vernon Roberts.

Three rose bushes that stood about six feet high grew only a few yards west of the house. One bush bore red blossoms, another pink and another white. They were tea roses, with a very alluring aroma and long stems, which we cut each spring for the school graduation exercises. They grew so well because Mama placed cow manure around them every winter. Beyond and to the west of the rose bushes was a garden of about one-half acre in which all of us worked to raise vegetables. I remember vividly the tall okra with blossoms much like that of the cotton plant. I remember even more vividly the fuzz on the okra that made me itch when I attempted to gather it. However, I have always liked okra, fried or boiled, but especially when it is cooked in field peas served with tomatoes and corn. One day when Mama was picking beans from the vines on the garden fence, a green snake wrapped itself around her arm! The sight of that snake frightened me so badly that I could hardly run to the house. As far as I recollect that was my first experience with snakes. I have had a lifelong fear of snakes.

West of the garden in the red clay field, we kids found many Indian arrowheads that were smooth with sharp edges. Marvin explained to us that the Indians found the hard flint rock here and spent many hours chipping out arrowheads for hunting. A creek made its way around the roots of tall trees in the woods at the foot of this red clay hill and provided us with a heavenly place to play. Once, as Jay preceded me on a walk along this creek, his bare foot touched the side of a rather large snake. He not only jumped into the air, he also knocked me several feet out of the way! I still get chills at the thought of that snake. One day when Jay and I were in these woods, we came upon a large hog and her pigs. Jay had a stick that he planned to use to frighten the hog away. Instead the sow took after us and in my haste I ran directly into a tree. I had no time to think about the pain, but only to run to the fence where Jay helped me over just in time to escape that protective sow! She was so angry at our intruding upon her pigs that she continued for some time to run back and forth along the fence. We observed this action from some safe distance. Daddy later explained that she was only protecting her young and that we should not go near any hog with pigs. That, I thought, was a ridiculously late admonition! On another occasion in these woods, Jay was teaching me to shoot with a slingshot. I finally shot a bird, wounded it, and saw it flutter to its death in a thicket. The plight of that dying bird devastated me. I gathered the dead bird up, carried it to the house where I placed it in a box, and gave it a burial. To this day I have never shot another living thing.

The garage, the barn and corncrib, and the stockade for the mules and the cow were across the road in front of the house. One of my fascinating experiences was to climb up onto the edge of the feed trough and watch the mules eat corn off the cob. I remember being amazed at the size of their teeth and how noisily they ate. Often a chicken would be brave enough to get into the trough and eat corn right along with the mules. One day as I was climbing on the fence and Clifton was standing in front of the gate, which Jay had opened, one of the mules jumped completely over Clifton but did not hurt him.

However, Daddy was furious with Jay for not being more protective of us!

Daddy, Marvin or one of the adult farm workers would go into the stables to bridle the mules. The bridle had a metal piece called the bit that fit into the mouth of the mule. The bit made it easier to make the mule behave and obey the driver. One mule named Pete had a bad habit that even this mouthpiece could not overcome. When Pete worked in the fields, he seemed to know exactly when it was noon or sundown, and he would stop wherever he was, turn, and head for the barn. No one seemed able to make him stay in the field, and sometimes he would drag the plow across the crops. Some of us thought he was mean, but Daddy said that he was very smart and worked well in the fields. He knew when it was time for lunch because he could hear the dinner bell. He then knew that it was feeding time! Of course he knew that it was time to stop at sundown! Marvin declared that he just hated that one mule.

Anyway, it seemed to me that since we moved to Georgia from Alabama my world certainly had expanded. I now knew more relatives and more people who were unrelated to my family. For the first time I also knew black people, and I knew to which farm they each "belonged." Though these workers were not slaves, they certainly were indentured. If any one of them wanted to move to another farm, they first would have to secure money to pay off the land owner. They were known as "Orbie's" or "Mr. Kelly's workers" or "hands."

Grandma Clara Addie Kelly had died in 1931. Grandpa later married Argie Fain Ward, a widow from the adjacent farm, and he moved to her house. That is why we had moved into Grandpa's house. "Miss Argie," as we called her, had three daughters: Mary Ruth, Golden and Lucile, who were older than I. Miss Argie was a very talkative person, and I loved going to her house, especially in the morning, when she brought freshly made biscuits to the table already buttered. There seemed always to be plenty of honey, cane syrup or jelly for those biscuits. Her biscuits were always tiny compared to the huge ones Aunt Callie prepared in Alabama. I also enjoyed sitting

in the parlor with Grandpa and his friends as they talked for hours before an open fire. I was sitting beside Grandpa during one such evening when I dozed off and fell out of my chair into the floor. The fall as well as the laughter embarrassed me. Grandpa just lifted me up and gently suggested that I go to bed. When Grandpa "suggested" that we do something, we understood that we were to do it!

None of us had electricity. Ms Argie's house had gas light, but we used kerosene lamps. The newest and brightest light in our house, which I thought was beautiful, had a very sheer, and fragile, mantle that glowed and made a bright light. It was by this light that we did most of our reading and studying.

A family to whom we were unrelated, lived on a nearby farm: Staff Williams and his wife Lottie. Through the years they remained very good friends and were kind to us on many occasions. Mr. Williams was also a barber for the community, and he would always complain as he cut my hair because it was so thick and wavy.

The black people on our farms played an important role in my daily life and in shaping some of my attitudes. I really liked every one of them. Man Pits was lighter in color than the others. He drove Grandpa to the various churches, to make home visits and to shopping. "Uncle Henry," as I knew him, was the same age as Grandpa. He lived very close to Grandpa's house, and he was a really great friend to all of us. He and his grown daughters, Anna, Arethabell and Pretty Mama, treated us children much as they would their own children by being kind to us and being firm when necessary. Arethabell was a large, robust woman with a loud and infectious laugh. She was always able to make me feel happy, or she could easily move me to tears. Uncle Henry's son, "Junior," the one injured in the fig tree, and I were the same age, and we often played together around the farm or in the woods. I was aware that his hair was curlier and of coarser texture than mine, that his skin was smooth and very black, and that his nose was flat, broad and soft compared to mine. We both found it rather funny to explore such comparative features. "Uncle George" who was the oldest individual on the farm, lived alone in a small house, very near our house, which had only two rooms with

a porch and a fireplace. The house had some cracks that he stuffed with papers in winter, and he covered the walls with newspapers to keep out the cold. Often I would visit with him because he roasted nuts, corn or potatoes in the fireplace for us to munch on while he told stories. I cannot remember the stories, only the smell and flavor of the eats! How could we have known that these relationships would change so greatly over the next few years? Even in my first year of school, it was difficult for me to understand why Junior could not go to school with me.

Even though I did have my first year of school in Alabama, I had to repeat the first grade upon entering Bluffton School (Bluffton, GA). It was 1932, and I was seven years old. As a consequence, I went through school one grade level behind my age group and one year older than my classmates. I cannot remember that being an issue until the last two years of high school, when it was only then a small social problem. It may have been instrumental in shaping later attitudes toward preferences for younger or older associates, and I feel rather confident that it did affect my later relationships with my peers. It seems that all of my best friends have been either older or younger than I.

Bluffton High School, located about five miles from my home, comprised grades one through eleven. The circuitous route of the school bus, however, made the trip miles longer to and from school. On rainy days, the slippery mud roads lengthened the time of the trip, especially if we happened to slip into a ditch as we sometimes did, much to the delight of the children. The school was a simple single-level brick building with classrooms along a single long hallway, an auditorium, and an entrance with white columns. The lunchroom and the industrial arts shop were in a separate wooden building. Each morning, we lined up by grade levels in front of the school, where we recited the pledge of allegiance before going "in line" to our rooms. Once each week we went to the auditorium for a program. The school had electricity.

Marvin and Jay entered the same school in grades ahead of me while my younger brothers and sisters would in turn enter the same

school. Grandpa's stepdaughters and my several cousins attended the same school. From the first day at school, I had a good feeling about the teachers, and that attitude continued throughout my time there. Well, except for the one who tried to teach us to sing and the one in the sixth grade who paddled me on my bare legs when she caught me reading a comic book inside my geography book from which I was to read aloud. It is ironic that I would later teach world geography. I remember that the music teacher had a terribly high-pitched voice that blocked forever my attempts to sing. Visits to our home by these teachers, when any of us had trouble or received some special recognition, made them seem much a part of the family.

Daddy set rather firm rules relating to school. He taught us never to "tattle" on anyone, never to lie about what was happening to us at school, and never to be disrespectful of our teachers. He had attended school through the seventh grade while Mama went through the eighth grade; both in Alabama. They were both good at arithmetic and emphasized the need for us to get a good education. While Jay did not share our enthusiasm for going to school, Marvin was a good student who drew well and encouraged me to draw. We did not have art instruction in the school.

I very early developed a close friendship with my classmate Vernon Roberts, whose mother had recently died. He lived nearby with his uncle and aunt, Duncan and Ruby Fain. When my mother died, it was Vernon who gave me solace because he alone, it seemed, knew what it meant to lose a mother. It seemed that Vernon was always near. We were often together at school and after school at his home or mine. We were both protective of each other and would quickly enter a fight against anyone who picked on either of us. Often we would spend time together in the very large hayloft at his house, where there were many pigeons, or on the cotton at my house, where we sometimes enjoyed silence. Interestingly, I have always treasured being near a close friend with whom I could share times of silence, where words are not necessary. Once, as Vernon and I ran barefoot through the hayloft, I caught my big toe between two boards and split the toenail. That minor injury shaped that toenail for the rest of my

life! In 1935, when I was ten years old, Vernon moved away, and I never saw him again. His leaving left an emptiness that I still feel. Many years later I learned that he became a dentist. When I later heard of his death, I felt deeply hurt for not having made the effort to contact him and for the loneliness that I then felt.

Mama's Death

Mama became very sick in November 1934, when I was only nine years old and in the third grade. The doctor often came the five miles from Edison to treat her. I was told that she had pneumonia and, only fifty years later, I learned that she really had cancer. Daddy, relatives and neighbors stayed with her around the clock. I recall seeing them giving her lots of medicines and rubbing her with some very aromatic ointments. I observed that, during her sleep, sweat would collect in the hollow space just above her breasts.

One day, during the time Mama was sick, Jay smoked tobacco rolled into a roughly shaped cigarette. We were playing with some friends, and I tried a few drags on the cigarette, coughing repeatedly much to Jay's amusement. Upon our arrival at home we went in to kiss Mama, and of course she smelled the cigarette. She gave us a talk that seemed interminable and then hugged us again to reassure us of her love.

Mama was very ill on the morning of November 10, 1934, the doctor was there, and Daddy told us to play only in the back yard close to the house. Daddy soon came to the back steps, where he sat down with his head in his hands. Marvin called us over, and Daddy told us that Mama had died and would be leaving us now. Then he took each of us to see Mama lying in her bed covered all over with a white sheet. Daddy lifted me up, slowly pulled the sheet back so that I could see her and then let me kiss her good-bye. Afterwards, Daddy took all of us into another room to wait.

Many relatives and neighbors came that afternoon to see Mama and to console us. The next time I saw Mama, she was in a casket in

the big room where Clifton, Louise and I usually slept. There were flowers with her, the shades blocked out the sunshine, and lamps shed soft light in the room. Mama was pretty and seemed to be sleeping, just as I had so often seen her.

A fire burned in the dining room fireplace while people came and went throughout the night, gathering around the big dining room table which was laden with food. The visitors often paused to sing and to join Grandpa in prayer. Vernon's aunt and uncle came, but he did not. I wanted him there so badly because I knew that he would know how I felt, as indeed he did, which I discovered when I later returned to school with him.

The next morning we bathed and dressed in our Sunday clothes. We traveled about four miles in a long s procession to the Mars Hill Primitive Baptist Church to participate in a lengthy funeral service. We were brought to see Mama once more before she was transported to the cemetery, then we waited in the car until the return trip home.

After Mama's death, Daddy had to face many grave decisions that would affect all of us forever. His brothers and sisters wanted to take the five of us children into their separate families, but Daddy would not even discuss that. He was determined to keep us together with him. Marvin was old enough and capable of doing a lot of the cooking. Each of us made our own bed and performed regular chores. Anna and Pretty Mama came often to do laundry and house cleaning, and to see that we had our baths. Pretty Mama sometimes bathed Louise and Clifton, and she enjoyed helping Louise to arrange her hair. Understandably, there was almost nothing for any of us that Christmas except the fruit and candy that our aunts brought from Orlando. It was the last Christmas that all of us would share together.

The Family Continues

Again in the spring of 1935, as always, the jonquils grew as tall as ever and bloomed with their customary fragrance. But, for this ten-year-old they seemed much shorter! It became obvious to Daddy that

Marvin was struggling to do our cooking, to keep up his grades in school, and to do what he could in the fields. Also, it was necessary for Anna and Pretty Mama to work in the fields. So Daddy hired a white lady, Miss Gracie Singleton, to live with us and to take care of the house and cooking. She was a tall, stout person with nice white hair, who had to sleep diagonally across the beds so that her feet would stay under the covers! We soon came to love Miss Gracie, but sometimes she would get angry with Daddy and then take it out on us! She was good to us, and we would laugh at her when we often caught her talking to herself. She was most prone to do this when she was angry with Daddy. One night after I had taken my bath she claimed that my ears were not clean and proceeded to wash them. This made me very angry and Daddy came to my rescue, but he made me wash again to show that I was indeed clean.

When school let out that spring all of us had to work on the farm as well as to continue with our regular chores. We had to make the beds each morning, wash and iron the clothes, feed the animals, milk the cows, and churn the butter. Each of us had assigned chores among these and other tasks.

Jay went to plant corn in a very large back field across the creek one Saturday when Jay had other things that he would rather be doing. After all, it was Saturday, when customarily young people would find any excuse to go to town. He dumped most of the seed corn into the creek and then told Daddy that he had planted all of it. Indeed he had! He was then allowed to go into town. Jay could walk that five miles into town without difficulty, but I could not do that. However, not long thereafter, Daddy was crossing the creek one day when, to his surprise, he spied a large amount of fresh green corn growing along the creek side. Of course, Jay had to face the truth and the consequences of a switching from Daddy, who explained that he did not mind the loss of the corn as much as he disliked the lie.

As the crops became ready for harvest in the fall, all of us had to help, and school did not start until most of the crops were gathered. Marvin could pick cotton very fast, often as much as three hundred pounds in one day. Some of the most experienced hands could pick

five hundred pounds. I remember one couple that could pick a bale of 1500 pounds in two days. I worked hard, yet never picked more than ninety-nine pounds a day except when Marvin would slip a little cotton into my cotton sack. Daddy said that I was too fastidious because I did not want dark burrs or leaves in my cotton. Obviously, my small amount of cotton certainly was the whitest. I learned, of course, that the gin would have taken care of all the trash when the seeds were extracted. At that time, those of us who picked cotton were paid five cents per pound.

We had to follow the plow, as peanuts were plowed out of the ground, to shake the dirt from the peanuts and stack the peanut plants around a pole with the nuts inside toward pole. Later we hauled these hay stacks across the field to the peanut picker and the hay baler. It was back-breaking work, and I was never able to keep my two rows gathered up fast enough to keep up with everyone else. So, I took one row to do each time.

When the weather turned cold, it was time for the exciting business of butchering the hogs. We were up early and started a big fire under the steel barrels filled with water from the nearby well. I did not watch the hogs being killed, but I did help with scraping the steaming hair from the skin of the hogs after they were dipped into the boiling hot water. I thought that the hogs were beautiful after we had removed all of the hair and they were hanged head-down by the tendons of their rear heels. The white skin stretched in stark contrast to the red of the meat and the bloody insides tumbling to the tub below. We wasted very little of the hog as we made it into food or rendered it into soap. Some parts of the hogs, such as kidneys, testicles, ears and feet, that we would not eat, were given to local black people, who would. I enjoyed helping to make the sausage because the spices were an olfactory treat, and the new sausages hanging in the smoke were visual delights.

Caring for and milking the cows were chores that we all shared when we were old enough or big enough to safely lead a cow, or to handle the milking task. As we spent time with the cows it became obvious that each cow and calf had a unique personality and they

seemed to take on family-member status. I enjoyed milking except on cold winter mornings when the cows resisted my cold hands! On these occasions, we took warm water to wash the tits and utter, and to warm the hands. One cow named Hanna was a large Holstein with a big utter, long tits, and lots of milk. One needed large hands and all the fingers and thumbs to milk her. I remember her as being a favorite. Often, while milking Hanna, I would squirt the warm milk into the mouth of a waiting cat, and as often into my own mouth. I liked the warm milk fresh from the cow. Hanna gave birth to a calf that died shortly after it was born and she seemed to miss the calf very much because, as we petted her, she would make low, mournful sounds. I interpreted this as crying sounds, and that touched me deeply. Another smaller cow, whose name I remember as Daisy, was a tan colored Jersey with a small utter and very short tits. We had to milk her with the thumb and two fingers only. Her milk contained more cream, thus more butter, than did the milk from Hanna.

As a child in this large family there were certain rituals that marked one's advance to new circles of maturity. Caring for and milking the cows was one such ritual. Another was the breeding and birth ritual among our animals. I can now see this as prelude to understanding similar activities of humans. I was perhaps ten years old, and had not yet reached puberty, when I first observed the breeding of the Jersey cow by a neighbor's large bull. Later, I also observed the birth of the calf. I found the birth to be fascinating, but I thought that the sight of the placenta was repulsive. On another occasion, I observed the breeding of one of our sows that we took to a neighbor's very large male hog. Amid the squeals and agitated noises, I was sure they would kill each other before they quieted down and performed as we expected them to. In this process I noted that, unlike the bull, the male boar's penis had the form of a cork screw that actually screwed its entry. When the pigs from this union were born, I received the runt of the litter to care for because it needed special care and feeding. As the runt grew up he would follow me about the farm. He would sleep under the front steps of our house as he waited for me to come out again, and he learned to help me round

up the cows from the pastures! I could not bear to think of butchering that hog, so Daddy sold it. Interestingly, I would remember that pig fondly the rest of my life.

Eventually, Miss Gracie became dissatisfied with her work with us, and she grumbled increasingly. Daddy talked to us about it and told us that we should help her to change to another home. We had come to love Ms Gracie, and we did miss her after she left. Little did we know that her departure and events immediately afterwards would change our family forever, at least as much as had the recent death of our mother?

The Stepmother and Stepsister

Mr. and Mrs. Long, an elderly couple who lived on a farm about two miles away, customarily served as foster parents. Two of these foster children were Ms Mary Ruth Best and her baby daughter, Mary Trease Best, who would come to play major roles in our family. After the departure of Miss Gracie, relatives again encouraged Daddy to let the children be separated to live with relatives. It was at this time that Daddy met Mary Ruth Best. One day in November Daddy called all of us together around the dining table to tell us of his plans to marry Mary Ruth whom we had come to know as "Miss Ruth." She would bear this title for the rest of her life. He expressed his love for her and assured us that she would never be able to replace our mother. However, he was certain that we would come to love her and that she would be good to us. It seemed that all of our relatives opposed this marriage. Their attitudes convinced Marvin and Jay that it would not be acceptable. Daddy went through with the wedding in November 1935. Marvin was twenty years old, Jay was seventeen, I was ten, Louise was eight, Clifton was five and Mary Trease was four.

After the wedding, Grandpa and his wife, Miss Argie, refused to accept or even speak to Miss Ruth and Mary Trease for several years. Our uncles and aunts also refused to visit us anymore. Marvin had finished high school and went to Orlando, where he would stay

for a while with Aunt Beaulah. He was then drafted into the army and subsequently served in the Pacific Theater. Jay left home also but, because of his age, Daddy was able to bring him back home. Obviously, all of this was very difficult for Daddy and even more difficult for Miss Ruth. I was old enough to understand the pain and, more importantly, I was able to see the hypocrisy of Grandpa's actions. My love for him and my faith in him as a religious person until then had certainly been the most absolute and secure thing in my life. I had been taught by him and all of my relatives to see events through the eyes of others and love even those who do wrong. Yet here was an event in which I could not see any wrong except for the way they were reacting to it. I was at the right age to be deeply affected by these tensions. It was not until many years later that I would come to know why all our relatives had reacted so emotionally and emphatically.

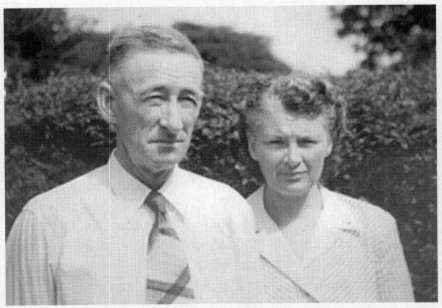

Junious Orbie & Mary Ruth (Best) Kelly c1940

It was obvious to me that Daddy was indeed a very strong and determined person, and he must have loved us and Miss Ruth very

much to go through all of that grief. He had married an equally strong individual who had great love to share with us. I felt that it would work out well, but Jay continued his protest, and encouraged Louise and me to be resentful and uncooperative. Aunt Beaulah continued to encourage Daddy to let Louise come live with her in Orlando. It was a very difficult time for the family.

Mary Trease, whom my father adopted, was only four years old, and undeservingly came to be the recipient of much of the family tension and our relatives' rejection. It is understandable that she would feel insecure and occasionally resort to negative behavior such as tantrums and lies. Once when Daddy and Miss Ruth were leaving the house to visit someone Mary Trease, because she wanted to go, began to scream, and threw herself onto the floor. Daddy came back into the house with a long slender switch from the peach tree. With only a couple of stinging blows with it on her legs she ended the screaming and never had another tantrum. She at one time fibbed to Daddy that Jay had hit her while we were playing. All of us verified that she was lying and Daddy again switched her, thus ending her lying. Through such incidents, we came to realize that Daddy really meant to treat all of us equally. He really loved all of us equally, and he expected all of us to live as brothers and sisters.

It would be many years before I would come to know the truth behind the family's objections about this marriage. Miss Ruth was in her eighties when she shared some of the details with me. She hesitatingly, and in broken sentences, told me that she had completed high school and was living with her parents in Dothan, Alabama. She became pregnant out of wedlock and was thrown out of the house with only her clothes in a box. She did not make it clear, but I assumed that much of the action was vented by her mother. She told me, some time later, that her mother tried to beat her with a yard broom and that she believes that her mother would have killed her had her father not intervened. She said that her mother then attacked her father! In her senility, she remembered vividly, and with fear, the events of that pregnancy. Mrs. Long, a family friend in Bluffton,

Georgia, offered Miss Ruth a home. It was the social stigma of this unwed motherhood that caused the furor. It must have been deeply rooted in the consciousness of those who knew the story of my Aunt Pearl of whom no one ever spoke! Only now can I understand the memories, guilt and pain that this event must have brought back to Grandpa. In a few years, Miss Ruth won the family over through her devotion and her love. She would finally raise us, along with her daughter, and subsequently her six children with Daddy, to become the recipient of love from all of us.

When Daddy and Miss Ruth married, for some reason Mary Trease stayed a few days with Mrs. Long. Many years later she told me that she had felt abandoned! After a few days she packed her few things into a box. She waited in the yard for Flozell, one of the farm hands, to come by in a wagon, then she climbed aboard for the ride to our house. While this seems like a minor incident, it was probably the basis for her tantrums and lies as well as a lifetime of alienation. It psychologically undermined her feeling of security and belonging in a way that would last throughout her life. Only some forty-five years later was she able to discuss with me this alienation and estrangement. Even then it was an emotional event for her. She is aware that, for other reasons, I also developed a strong sense of alienation from my family. Sharing this commonality with her strengthened our mutual bonds. In later years, we grew closer than I was with any of my other siblings.

My sister Louise, who was little more than one year younger than I, was always "Daddy's little girl," and we kids felt that she often got preferential treatment. We accepted this as normal, since she was the only girl in the family until Mary Trease came to live with us. She had a very cute way of sitting on Daddy's lap and persuading him to give in to what she wanted. On one occasion, several of us were sitting before an open fire in the fireplace. I had my feet stretched toward the fire when Louise crossed them and tripped away from the fire. Daddy immediately slapped me backwards out of my chair before I knew what had happened or

what I had done! It was the only time that I was ever slapped, and undeservedly at that!

Clifton was at that time the baby and often got special treatment from Daddy. I remember very well once when Clifton pushed me into a shallow ditch and hurt my back. I got up and likewise pushed him into the same ditch just as Daddy appeared on the scene and observed my actions. Daddy would not listen to any discussion, but immediately grabbed a rope and gave me several very hard licks with it. This, and the event with Louise mentioned above, were the only times when I ever felt that Daddy had mistreated me, and I still think it was irrational.

Extending the Family

Miss Ruth gave birth on December 4, 1937, to Ross, my first half brother. He was born at home with the aid of the doctor. I was twelve years of age, and I had by then understood breeding and births of the farm animals, including the manner in which cows disposed of the placenta. I had never really related that to human acts. When Daddy brought the placenta out to bury it, I am sure that he did not mean for me to see it, but I did. It made me so sick that I vomited. I have carried that vivid memory with me since. Miss Ruth gave birth to the second child (Willie Edd) in 1939 in the hospital.

When I reached puberty. Jay was quite aware of it. Indeed at times I thought the whole world must know! It was he who explained what was happening to me. He and I would discuss sexual feelings, and he induced me to participate with a couple of his friends in the ritualistic "circle jerk," in which the boys would masturbate to see who would reach climax first. At times, the game was to see who could ejaculate the greater distance. The real object of the game was for the older boys to participate only to the point that, by prior agreement, the newcomer to the circle would finish alone. This brought much laughter and teasing! Of course, at one time I was that

newcomer! It was embarrassing, but it was also the ritual through which I joined the older boys!

Jay was seven years my senior and my idol. He was very active and muscular in build, even though he had a rheumatic heart condition. He enjoyed showing off his strength, especially by beating up on me or tossing me about. This only strengthened our relationship. It seemed that he was into some mischief all the time, but he was always exciting to be with. Once, he encouraged me to share a cigar, which I did, and from which I became very sick. He gave me my first taste of moonshine that burned my throat, and once he challenged me to suck a raw egg as he seemingly demonstrated. I did it, and, of course, I vomited for what seemed like an eternity!

Once Jay became very ill, and the doctor came to treat him at home. Daddy would not let us go into his room. I assumed that he had some illness of which we could not even speak to others. I soon learned that he had a venereal disease as a result of having had sex with Pretty Mama, one of the black women on the farm. At that time, these situations were shameful guilt trips for any southern white family. It was a long time before we could discuss either the sex act or the disease. I have never heard of it being discussed with anyone except a couple of my brothers.

On another occasion Jay had a cat that, for some reason, he was going to drown in the creek. He threw the cat into the water and it swam out. He then took it by the hind legs and beat its head against a tree before throwing it back into the water to drown! The very next morning Jay became ill with a fever and was bed-ridden for one year. The cruelty of the act horrified me, as it did him. I believed that his illness was related to that act. Neither of us ever harmed another cat.

There was yet another incident in which Jay was involved in the shooting death of a black man on another farm. He had driven the mules and wagon to the other farm and in some way became involved in a confrontation with the black man who was shot. The sheriff came to the house for some long, hushed talks with Daddy and with Jay. I have never learned the facts of this incident, but I do know that Jay was never charged in the case.

The Albany Incident

After we gathered the crops in 1938, it became obvious that as sharecroppers we really were not getting ahead financially. Each winter, Daddy had to borrow money from Grandpa and from the bank to make the crops. Each year, he ended the year just as broke as the year before. Uncle Roy, who lived on another of Grandpa's farms, was having the same difficulty. So Daddy and Uncle Roy decided to move about forty-five miles away to Albany, Georgia, where they would open a grocery store. Our family lived in the rear of the store while Uncle Roy's family lived nearby. We were being introduced to urban living in one of the most undesirable urban settings in the state.. We enrolled in a nearby school to which we could easily walk. However, we had to walk past a casket warehouse and a funeral home. I recall that we would walk on the opposite side of the street each time. I do not recall anything about the school.

I had been playing with my cousins one Friday evening, when one of the younger boys (Earl Mack) became ill, he died of diphtheria the following Tuesday. We had to fumigate their house, burn his clothes and bedding, and get shots that hurt worse than any I have ever taken. The trauma and the expense caused Uncle Roy to move his family back to the same farm from which they had come.

During the summer of 1939, while we lived in Albany, I went to spend a summer with Grandpa and Miss Argie and to work in the fields on his farm. Uncle Henry, the oldest black man, and I had the task of hoeing peanuts in a very large sandy field about a mile from the house. The peanuts were planted between rows of corn that then stood well above my head. The peanuts could hardly be found in the overgrown grass and weeds, and the July heat was unbearable. I am certain that those peanuts never produced much except some hog feed and a little government payment for improving the soil. Each morning as Uncle Henry and I went to the field, we would take a couple of ripe watermelons and place them in the nearby creek to cool, and during our mid-morning and mid-afternoon breaks we would enjoy those cool melons. One afternoon, I stood leaning against my hoe with my

attention focused on the act of splitting corn leaves meticulously into tiny ribbons, as they do so beautifully, when Grandpa walked nearby, where he observed me. Without letting me know he was there. he returned to the house and called Daddy to come for me. He felt that my behavior indicated some mental problem for which I needed help. Otherwise, why would anyone enjoy stripping corn leaves and thus be so distracted from the task that I supposedly was doing? Anyway, that ended my summer at Grandpa's farm.

The store that we operated in Albany, and in which we lived, was located in a neighborhood that required we have some protection. For that purpose, Daddy had placed a shotgun on a rack just beneath the counter, near the cash register. Daddy kept it in the breached or open position at all times because it was loaded and ready for action. One day, as Jay was cleaning near the gun and Daddy was standing in conversation near the end of the counter, Jay accidentally pressed the gun closed. It discharged into Daddy's left thigh and blew his hand out of his pocket. Daddy had to spend a lot of time in the hospital and finally lost the forefinger of the left hand. With his inability to work and the mounting hospital costs, we had no choice but to return to Grandpa's farm. However, other tenant farmers had rented our farm and our former house. There was a small unoccupied house nearby, and we moved into it under crowded conditions only slightly better than we had in Albany. The house was very much like the one we had occupied in Alabama and certainly no better. We all went to work to make it as attractive and clean as we could. It was the end of summer, and we were broke. Grandpa and other neighbors gave us clothing and food. We received raisins, cheese, spam and oatmeal from the government surplus. It would be many years later before I could again eat raisins! Those were indeed two very difficult years for all of us, but I think it must have demonstrated the importance of friends and neighbors. It certainly forged a life-long friendship with Staff and Lottie Williams, our neighbors, who were so kind to us. The experience surely taught me a life-long fear of poverty. Being a sharecropper was better than being so dependent.

I can now look back on these incidents and make some assessment

of the impact they must have had on shaping my personality. Experiencing the family tensions of the marriage, the traumatic experience attendant to the birth of Ross, the move from a large house, and the subsequent dependent life in a shack at a very vulnerable and formative age had a lasting influence on me. I really can recognize the sources of some of my later behavioral patterns and attitudes.

We lived in that shack from January to September of 1939. We were then able to move to a one-horse farm of some thirty-seven acres, given to us by Grandpa. Daddy later purchased adjacent farms. This became the home that Daddy and Miss Ruth would never leave. It became the place that all of us still refer as "home."

The Place Called Home

Uncle Roy, the youngest of Daddy's family, had until recently lived in the large house on the farm to which we were moving. A few years earlier the house had burned, and Grandpa built a much smaller one to replace it. I remember watching the fire from a distance of two miles, and it was a frightening sight. Uncle Roy had married his fourth wife (Mildred Blackshear), and they had five sons and one daughter. He was an alcoholic and certainly not a good farmer. He moved his family to the small county-seat town of Fort Gaines, Georgia, and Grandpa gave the farm to Daddy. Later, Uncle Roy overcame alcoholism and became a minister in the Primitive Baptist Church. It took even longer for Roy and his siblings to forgive Grandpa for giving that farm to Daddy and Miss Ruth!

The farmhouse into which we moved was small and much the same design as the other small farmhouses in which we had lived. However, we would soon add additional rooms to the house. The pride of having our own farm was well worth the inconveniences. Finally, in 1940 through the American Rural Electrification Administration, for the first time in my life, we got electricity. That made it possible for us to install running water and a bathroom. It also gave us electric lights, primarily one bare bulb hanging in the middle of each room.

The house stood in the corner of a pasture, so the yard was covered with bermuda grass and bitter weeds. When the bitter weeds bloomed, the yard was a mass of yellow, button-like flowers that would pull off between my toes as I ran barefoot through them. When the cows would sometimes eat these bitter weeds, their milk would become very bitter, so we tried to keep them away from the weed. There was not a tree or shrub in the yard, and during the first winter months we began to plant whatever we could get from the neighbors. Daddy, with our help, brought a water oak tree, about eight feet tall, from the woods and planted it in the front yard. We put fast growing mulberry trees in the back. Grandpa felt certain that the oak would either die or grow so slowly that we would never benefit from its shade! Today that tree is larger than the house, and we have enjoyed its shade for years. I enjoyed this experience with planting and successfully growing plants. It established a life-long interest in plants as well as an ability to manage them well.

Our nearest neighbor was Rooster Dixon, a black man with a large family, who was able to buy the farm through one of the government loan plans. We saw him as a very courageous and hardworking individual, and we established a good relationship with the whole family. I admired Rooster because he was the first black farm owner that we had known. However, even for Rooster and his family, it was customary for them to always enter our house through the back door, even though we could easily enter either door of his house. We never mentioned this, but all of us understood it as a matter of social practice of racial separation. At the time it was confusing because I was not certain if this practice was a result of race or socio-economic status. If the latter, then should I observe the same practice when I entered homes of other more affluent whites? Like all black people there at the time, the children rode a different bus to a separate school in the nearby town of Bluffton.

Vernon's uncle and aunt (Duncan and Ruby Fain or "Mr. Duncan and Miss Ruby") now lived less than a mile from our house but, Vernon was not there. These new neighbors were very supportive of Daddy and kind to all of us. Their son and daughter were our friends.

Daddy was able to borrow money from Mr. Fain on several occasions to buy seeds and fertilizer and to purchase adjacent land. He was Daddy's confidant, advisor and good friend who operated a general store, a hatchery, and laying hens. To us, he seemed very rich, which of course he was not. At that time in southwest Georgia, anyone who was making a good living would appear to be rich.

Grandpa was minister or pastor to four Primitive Baptist churches in Georgia and Alabama, where he rotated his services to each church one weekend each month. After my sixteenth birthday in 1941, I was able to drive him to these churches as a weekend job and my first paying job. His former driver, Man Pits, had moved to Albany. Grandpa had served most of these churches for years, and each weekend was much like going back to visit family. We would often stay over the weekend in some family home when we were in Alabama. I usually had my private room in these homes, but on at least one occasion I had to sleep with Grandpa. While we had a large double bed, I still tried to sleep on the very edge of the bed so as not to disturb him. Obviously, I got little sleep that night. The food was always good and the annual "dinner on the ground" (annual communion) saw a fantastic spread of food. The services on these weekends were very long. Miss Argie was always trying to pair me off with the most desirable girls in each location. She was a jovial, exceedingly vocal, and flirtatious person who knew my timid nature and enjoyed seeing me blush.

Grandpa was often called to conduct funerals, and I had to sit through each one. The funerals were very difficult for me because I would identify with the family and their loss. I had to learn to concentrate on the flowers, often counting specific flowers within a wreath, and ignoring the funeral, or I would often study the architecture of the building. I learned to talk to myself about the body as repository for the life, the nature of death, and how funerals and graves serve the living. It was here that I learned to separate the living person from the material body. a process that promoted introspection and psychic detachment for me.

When we returned from these trips, I would drive the car into

49

the garage, where it was likely to remain until the next weekend trip. I would walk the two miles to my home unless the weather was bad and Grandpa allowed me to drive the car to my home. Then I had to return it to the garage the following day. Usually, after I had put the car in the garage, I was ready to hurry home but Grandpa would talk for a seemingly interminable length of time before paying me. During the talks, he would slowly, very slowly, bring his billfold out of his pocket. Then he would slowly count every dollar in it, as if my pay depended upon the amount of money in the billfold. He would finally hand the payment to me. I was very fond of Grandpa, and I enjoyed hearing his viewpoints, concerns and advice. However, I was afraid of the dark and dreaded every minute of this talk as light faded around us. I knew I had to walk two miles across three creek areas. When dark did overtake me, I would run most of the way, beat on a tin can to frighten off whatever was in the dark, or sing as loudly as I could. The distance, which in daylight seemed only a good walk, in dark became a real obstacle. I have always been afraid of the dark.

My brother Jay married Thera Evelo Strickland in 1939 and moved to a house nearby while he still worked on the farm with Daddy. Evelo was a lovely person, and our family loved her. Jay arranged a date for me with a friend of theirs by the name of Virginia Ellen Majors, and the four of us went to a movie. Evelo died with the birth and death of their first child, and the following year Jay married Virginia Ellen Majors, whom I had dated. Thereafter, he forbade me to talk with Virginia, or to be alone with her, although he still had a terrible habit of leaving home; just as earlier he would occasionally run away. More than once he left his wife and his two children for weeks. Jay knew that they would be cared for, and it then became Daddy's burden to look after them. Jay would subsequently return with no explanation or apologies. I remember one time he hitchhiked to North Carolina, then all the way to Miami, before returning home with holes worn in the soles of his shoes. His rheumatic heart was bothering him, and he smoked and drank heavily. In retrospect, I believe that Mama's death, Daddy's remarriage, and the attitude of relatives toward Miss Ruth must have hit Jay at a most vulnerable age. It was very difficult for

50

him to acknowledge how dedicated and caring Miss Ruth had been to all of us. He was torn between accepting her love and sharing the resentment created by Grandpa and our uncles and aunts. In time, he began to settle down and to overcome his resentment. He finally came to love Miss Ruth and told her so, just before his death in 1950 at the early age of forty-two. Fortunately, I had returned home after a year of study in Hawaii, and I was with him in his last days. He was carrying a tremendous load of guilt and psychic pain, and he could not accept the full responsibility of being a husband or father. I still loved him very much, and he made positive contributions to my life. Subsequently, Virginia and the two children, Shylone and Judy, moved to Atlanta to be near her family.

Marvin moved to Orlando after he completed high school. Thus I was then the oldest child at home with more responsibilities for me to undertake. I had more work to do with the farm, the animals and chores. On occasions, when our parents would visit elsewhere, it was my responsibility to look after the younger children. During one such evening, a very dark night, we heard frightening noises outside including the sound of horses. I herded the children into a bedroom and blocked the door. I did not want to go outside to see what was happening. When Daddy came home, he found that the horses had broken the gate and were in the cornfield having a feast. Of course, I was then afraid that he was going to take his anger out on me. He was very patient and accepted my explanation that I could not leave the children to go out there. I am sure that he must have found that an amusing excuse.

Once, a neighbor, whose name I shall omit, who was one of the leaders in the Mars Hill Primitive Baptist Church, came to talk With Daddy about some farm problem. I sat with them during the discussion about how one "Nigger" was insolent and they would "have to show him his place." He related to Daddy how they had taken him into the woods, tied him to a tree and beat him. Daddy, to my surprise, seemingly sanctioned this action. On another occasion, I saw Daddy hit Flozell, one of the black hands on our farm, with a peanut slat for not "behaving." It seemed that Flozell had responded

to Daddy in what Daddy considered a disrespectful manner. These two events were very disturbing to me on two levels. First of all, I felt that Flozell was a friend and it was he who brought Mary Trease to live with us. I could not understand how Daddy could hit anyone with such an instrument. On the second level, I did not understand the hypocrisy that permitted professed Christians to be involved in such acts as these. That new insight into the nature of my father and members of that church made me question religion generally and that church specifically.

I enjoyed high school. The facts that Miss Ruth and Marvin had completed high school inspired me to study. I decided that anything less than a high school diploma would be a failure. Marvin received a scholarship offer to study education at the University of Georgia, which he refused. Instead, encouraged by Aunt Beaulah, he decided to go to Orlando to work. I also had at least two teachers whom I admired and who motivated me to set even higher standards for myself. As far as I could see at the time, there was no hope for me to pursue post high school study, and I had nothing to suggest that it would be necessary. However, Miss Ruth and my teachers made it apparent to me that learning was a worthy lifetime pursuit.

The two teachers to whom I refer were personable guys who visited our home and knew our problems. I found those visits to be very important in cultivating our interest in school. Mr. Sam Clinkscale was my science and physical education teacher. He was a handsome athletic man with black hair, olive-toned skin, and big brown eyes. I believed him to be the most handsome man I had ever seen. His manner of teaching made me feel that he was indeed a friend. At the start of school one fall, I was unable to attend the first few days until we had gathered the crops. Mr. Clinkscale had the other boys already conditioned when in my eagerness to achieve his goals, I overdid the runs, bends and especially the duck walk! The next morning I was physically unable to go to school and Daddy upset me when he expressed his anger at Mr. Clinkscale. Miss Ruth massaged my legs and back, and I remained in bed until the following day. Interestingly, upon my graduation, Mr. Clinkscale married

Jean Davis, a girl I had dated in high school and with whom I had maintained a close friendship since the seventh grade. They still lived in Blakely, Georgia, in the area of our farm, but I did not see either of them until fifty years later, when they attended a local exhibition of my photographs. There I was able to tell him how important he had been in my life and joke with him about taking my girlfriend!

Unbelievably, we had teachers named Mr. Corn and Mr. Bean the same year. Mr. Corn was a tall attractive person who taught shop and agriculture and advised the Future Farmers of America (FFA), a club to which I belonged. In the shop course, we gathered up various parts of wagons and buggies from the community, repaired them and sold them to raise money for the club. My experiences in shop and agriculture courses have proved to be invaluable. One summer, Daddy and I constructed chicken brooders in which we raised small chicks to frying sized chickens. We sold many of these, and I shared in the proceeds. After Mr. Corn convinced Daddy of the importance of me having my own agriculture projects, Daddy gave me an acre of corn, an acre of peanuts and a sow that soon gave birth to several pigs. One year later, this project would prove to be the impetus for my leaving home!

Mrs. Edna Smith was my math teacher, and I always had difficulty with math. I remember that Daddy could easily solve math problems in his mind while I was struggling with pencil and paper. Mrs. Smith was so patient and thorough that she motivated me to do better, but I remember one of her traits that greatly distracted me! She was an attractive redhead with rather large breasts. When she came to a student's desk to assist with a problem, she would lean around back of the student to write on the desktop. In so doing with me, her breast was always pressing against my left ear! Of course, the other boys would watch and kid me about it. There is little wonder that I could not learn math. Many years later, to her amusement, I had the opportunity to relate this story to her.

After school was out in spring of 1942, I went to Orlando to visit my brother Marvin. By then he had moved away from Aunt Beaulah's home into his own apartment that he shared with Carl Isbell. Carl

was a member of a very large family from Georgia who operated the Georgian Hotel or boarding house that had a large public dining hall with family style service. Carl was an attractive and congenial young man, and his family treated me as a member of the family. Marvin, Carl and the family took me to the major tourist sites and made that one of the most memorable summer vacations of my life. That vacation also laid the groundwork for my later return to Orlando. One incident raised questions in my mind that would only become clear more than a year later. I had taken a photograph of Mr. Clinkscale with me, and Marvin insisted that I not keep it, that I destroy it! Over a year later I learned that my very innocent affections for Mr. Clinkscale disturbed Marvin because of his own sexual orientation.

While I did date a couple of other girls in high school, Jean Davis remained my close female friend throughout high school, and Bruce Talbot was my close male friend and confidant. The summer following our graduation, Jean married Sam Clinkscale and Bruce died of a heart attack in a war materials production plant in Albany. His parents were grief stricken and began to share their grief with me. I did not know how to handle their attention. It was with the wise advice of Miss Ruth that I was able to work this to an amicable solution by making myself less available. A classmate, Marilyn Jones, who I thought was a very beautiful girl, was my date for the senior prom. Her father was very strict about the time for her return home. On the way from the prom my car overheated, and we had to stop at a farmhouse pump for water. We both went, in our formal attire, to the pump, slipped on the damp grass and fell in the red mud! I was afraid to take her home and, of course, no one wanted to believe the story. Fortunately, we were only a few minutes late for curfew, and it was only I who was overly concerned about it.

After graduation, I had a few dates with a classmate named Agnes Brooks, of whom I was rather fond, and we sometimes double dated with my sister, Louise. I remember how afterwards Louise and I would compare notes from male and female viewpoints on events of the evening. Daddy was fond of Agnes and encouraged me to marry her because her father was a highly respected deacon in their Church.

Besides, she was the only child in a family that owned a lot of land. Marriage, however, was the least of my concerns at that time. After graduation, I moved to Orlando, and I wrote a letter of some thirteen pages to Agnes in which I explained that we could not continue our relationship.

The United States entered World War II in 1941. The government quickly paved the highway that ran north-and-south in front of the school to expedite troop movements. Marvin entered the army and saw duty in the Pacific area. Carl joined the army also and served in the European area. For the duration of their military service, they would correspond with each other through letters to me, a practice that I did not understand at the time.

My Departure

I graduated from high school in June 1943 and turned my attention to the crops and hogs that were my high school projects in the Future Farmers of America club. I tended these projects with anticipation of the money I would derive from the sales that fall. When we gathered the crops, and butchered the hogs, Daddy bought me a new suit from the proceeds. That was all I got from the project! He explained that the crop and the hogs were mine for the FFA project only and that the proceeds would have to be shared with the family. That ended my optimism for farming. It awakened me to the hopelessness of the life of the sharecropper that I would become if I continued in this situation. I knew then that I would have to do something for myself. I was naive and so timid that I would not even ask Daddy for use of the car until Miss Ruth had ascertained that he would probably give me a positive answer. It was then that Jay and Marvin came to my rescue.

Marvin told me the year before, and had written to me from the South Pacific, that he would welcome me to Orlando if I wanted to return there. Carl had returned home from the European area early in 1943. I knew that Daddy had a strong sense of family unity and

55

would not want me to leave home just as he had forcefully kept Jay at home. So, in November, on a Sunday evening while Daddy and Miss Ruth were visiting Grandpa, I secretly left home. Jay helped me to pack a small suitcase, made me feel that I could do it, and instructed me in what I must do. He did not dare transport me or even accompany me away from the house because Daddy would be angry with him and likely would beat him. I took my suitcase, walked in the dark through the woods along a stream to an abandoned house on the main road leading to the town of Edison. The wait in that abandoned house seemed forever. I was so afraid of the dark, and I was perhaps more afraid that Jay might change his mind or that Daddy might return home before Jay could complete the mission. Jay did arrive and quickly drove me to Edison and returned home ahead of Daddy. I spent the sleepless night in a rooming house dreadfully afraid that I might miss the bus to Orlando. The following morning I hurriedly boarded the bus and slouched into the seat in fear that Daddy would find me, and I arrived in Orlando where Carl met me. I then wrote Daddy to let him know where I was, to let him know that I was well. I told him that if he decided to come for me it would be futile for I would move to somewhere else. He never came nor answered my letter. I learned later that when Daddy returned home to find that I had gone, he did blame Jay, went into a rage of anger, and drove around for hours looking for me. Soon after Christmas I returned home for a few days, and Daddy could not have been more loving and accepting. Thus a door had opened, and I had stepped through, leaving the cosmos screen farther behind me. I had returned to Orlando, Florida, the place of my birth. I would never return to live in Georgia or Alabama.

CHAPTER FOUR
THE FLORIDA EXPERIENCE

November 1943. It was difficult for me to believe that at the age of eighteen I had the temerity to run away from home. It was difficult for me to believe that I had braved the dark route to make my way to Orlando. I arrived with my one high school graduation suit purchased with money from the sale of my hogs, a few other clothes and little else. Carl met me at the bus station because Marvin had not yet returned from the Pacific. After Marvin returned, the two of them would play a major role in my development for the next thirty years. By then, my whole family was familiar and comfortable with the term "Marvin and Carl," and we accepted Carl into the family much as one would another brother. The two of them shared an apartment in the center of Orlando, where I stayed for a few weeks until I moved to the Georgian Hotel that was owned by Carl's mother and father. "Mom and Pop Isbell" gave me a room as well as a job in the dining room of the hotel.

Mom and Pop Isbell were from Georgia, and the hotel they operated was a three-storied brick building near the railroad tracks in the center of Orlando. The hotel catered to railroad engineers, conductors, retirees, etc. It also served as an inexpensive stop for any number of salespeople. The meals, which then cost fifty cents for all one could eat, were served family style in the dining room on one very long table. The food was southern basic, seasoned well, plentiful, and served in large bowls or platters. The Sunday ritual was

fried chicken at noon. Mom and Pop had raised six children there and more-or-less adopted me as the youngest. Mom was a large, forceful person who worked very hard in the hotel and encouraged others to follow her lead. She was up early every morning to see that the vast breakfast spread was readied. Later she helped prepare the vegetables for lunch. She would then cashier through lunch, retiring to her room for an after-lunch rest before undertaking preparations for dinner. She was everyone's mom. Pop was a huge person, much overweight, and a little less energetic than Mom, who could hold the attention of everyone in the entire dining room with his warm greetings and tall tales. He was a very honest and trusting person who loved to embellish the truth for the sake of a good story. There was little doubt that he ran the hotel, until he ran counter to the wishes of Mom. It was traditional for the children and grandchildren of the family to have Sunday lunch with Mom and Pop. It was through these contacts that I came to feel very much like one of them. There were many incidents with this family and that hotel that made my stay there exciting. For my nineteenth birthday, Carl's brother, Billy, gave me a small knife that I kept until I was sixty-five years old, when I gave it to a godson as a sixteenth birthday gift. Carl's sister, Lucile, had a fantastic aptitude for making money. She liked to buy property, and it seemed that everything she tried to do made money for her. She also habitually acquired younger men or took in younger men, worked them extensively on her projects and then dismissed them. I related to Carl's oldest brother, Jimmy, as a very trusted older brother or even father figure for me. I kept his home on Lake Sue for a few weeks while he and his wife were on vacation, and I remember letting the used dishes stack in the sink until the day before they were to arrive home. Then a friend and I, in bathing suits, loaded them into a wheelbarrow, rolled them to the lake and washed them there. Afterwards, we rolled them back to the kitchen, where we wiped them dry and stored them. Later, I worked in the grocery store owned by Jimmy, and I told him about the dishes. A few incidents with hotel guests were also memorable. Once, an elderly resident male made sexual advances that I considered repugnant. While he did not threaten me or force

the issue, I learned a little more about how to handle such events. Another guest, a young and very handsome salesman for Proctor Gamble Company, very obviously enjoyed any physical contact with me, but his affections never became sexual. I did learn later that he was gay and that our relationship was his gratification. On one occasion at lunch, a giant of a man made obscene remarks to Carl's sister Sarah. I was so incensed that I grabbed a chair and hit him over the head with it. I was so small that it did not seem to hurt him, but I immediately fainted onto the floor. When I regained consciousness some time later I was in the bed to which someone had taken me, and I was certain that he had killed me. That taught me that I could fight, but that I probably would get the worst of it. I was never in a physical fight after that, ever. Finally, my twenty-year-old roommate, who also worked at the hotel, habitually went out every evening "to the movies." Upon returning from one such outing he brought me a chocolate milkshake that he knew I liked. It was late, so I sat up in bed prepared to enjoy the drink. With the first swallow I began to vomit. I ran to the bathroom where I discharged the remainder and discarded the cup. He expressed surprise, but I am sure that it was poisoned. Later that night he stole everything from my billfold and left with all of his clothes. Mom and Pop notified the police who soon caught him in Tallahassee with some small amount of the money left. I had to testify against him, and I remember well how nervous I was in that courtroom. During his two-year term in prison, I maintained correspondence with him and even took him some toiletries. I made one trip to Tampa to see him after he was released. There he told me how jealous he was of my relationship to the Isbell family and of his inability to establish a physical relationship with me. I had no idea that he was gay or jealous. In fact, I was so naive that I did not even know the term nor did I relate any of these subtle overtures to sexuality. However, these events certainly taught me to be more observant of people.

Upon his return from military service, my brother Marvin became a butcher at the grocery store owned by Jimmy and Sue Isbell. In December, they gave me a job as stock and delivery boy.

Most deliveries were in the lovely lakeside neighborhood, and I enjoyed this much more than I did the work at the hotel. Many of the homes into which I made deliveries were large and beautiful, and the customers were always so very nice to me. I remember one blind lady, who lived alone, had ordered a dozen eggs and grape juice among other items. I delivered them, returned to the store and was summoned back to retrieve the eggs and the grape juice. The eggs had been stored upside down and the grape juice, which she had not opened, had turned dark! I could understand the egg positions but it was harder for me understand how she knew the juice was not fresh. She pointed out that by shaking the juice she could tell that the consistency was not that of good grape juice! She wrote letters to me for years after I left Orlando, and she nurtured my compassion for handicapped persons.

During the time I was in Orlando, Marvin and Carl bought a home on South Delaney Street in Orlando and invited me to live there with them. The small two-bedroom house was surrounded by orange groves, making it a very pleasant, private place. Carl opened a small grocery store and filling station on the corner of Delaney and Michigan streets very near the house. Marvin left the butcher's job and began working with an auto-parts store next door to the Georgian Hotel. I moved to another grocery store within a few blocks from the one where I was working.

The grocery to which I moved was owned by Ethel and Walter Bass, who became very influential in my life. Ethel was an attractive, kind and forceful person who dressed in simple but beautiful cotton dresses. She also happened to be the first Jew I had met. Walter was a jovial, rotund, Irish Protestant.

One morning I reached to put a cereal box on the highest shelf and in so doing I pulled a hernia in my left groin and could not lower my arm. Ethel rescued me and took me to the hospital, where I was examined and scheduled for an operation. I went to the hospital on Sunday evening and was prepared for the operation on Monday morning. The preparation included having a large black man shave my pubic hair. I was embarrassed! When no one came for me by

noon on Monday I called a nurse and was told that the doctor had an infection on his arm and could not operate. So, I went home with the operation scheduled again in two weeks! Shaved pubic hair, during its growth, itched unbearably. When I returned to the hospital the same person prepared me. However, on Monday morning a female nurse came in to see if he had done it well and proceeded to shave my pubic hair a third time! I remember that I would not look at her and kept my mind on controlling my impulses! The operation went well.

Another incident in which Ethel Bass came to my rescue was perhaps more embarrassing. The representative from Gerber Food Company was a young blond fellow who came regularly to the store to take orders. One morning he came to the checkout counter, where I was standing in conversation with Ethel, and he asked to see the ring I was wearing. He then quickly took my hand before I could remove the ring and held it in a manner that sent chills all over me. I immediately got the message, as did Ethel. I rushed to the storeroom to compose myself, and the man left with his order. Ethel came back and observed aloud that I did not look well and that I should go home for the day. About a month later the guy returned to restock the Gerber products. Ethel stopped him at the door with instructions for him to remove all Gerber products from the store and to never return. I was shocked at her language and tone of voice and found some work to do outside until he left. It was obvious that she knew more about what was happening than I did.

First Art Experiences

About a year later, in 1945, Ethel observed me arranging produce in the front window of the store and commented that I had an artistic touch that made the produce more attractive. She stated that I should be studying art or working in art. Of course, no one had ever made such comments to me, and I had no idea what it meant to study art. She later sat down to discuss this with me, pointing out various jobs that might be available in which I could use my talents. One such

suggestion was display man in the department stores downtown. Within two weeks she arranged an interview for me at Dickson & Ives Department Store that was primarily a women's fashion center, where my cousin Myrtle operated the beauty salon and cosmetics center. I got the job and moved into work that would forever change my employment. I have always been very grateful to Ethel for her kindness and directions.

My immediate supervisor at Dickson & Ives was a wonderful woman whose red hair was like steel wool. She tied it back with a ribbon, but when the ribbon was removed the hair would spring out in all directions in tiny coils. Another person with whom I worked, Joy Turner, was the daughter of a syndicated comic strip artist. The head of the department at the time, a competent artist, was an alcoholic. He kept a bottle of gin behind each set of windows where he would fortify himself during working hours. He lost his job, and Joy moved up to the position. Later she left to do some writing and the job of "department head" was given to me. It was unbelievable that in such a short time I could adapt to this kind of work. I was grateful for the opportunity to administer that department. However, one aspect of it frightened me greatly, and I maneuvered to avoid it. That was the prospect of going to New York to the merchandise market to order display props for the coming year. I could not face going to New York. The prospects of the trip frightened me. Luckily, I avoided that trip by joining the Air Force!

During this time I met many new friends and established a very close relationship with my cousin Myrtle. She would later become my closest friend and confidant. At Dickson & Ives, I met Rosalind, a vivacious young lady about my age, whose husband was in military service in Europe. We dated and became close companions. At that time I was still a virgin and I remember how gentle and how natural Rosalind made our relationship develop. Sex was easy, without great passion and without romantic attachment. When her husband later returned home, we did not see each other for a couple of weeks, but the three of us then became good friends. Our prior relationship was never mentioned or resumed. I was no longer a virgin!

About this same time, I met Maury Rothenberg, a Jewish youth of my age with whom I formed a very close relationship. He often accompanied me with Marvin and Carl as we toured different sites in the state of Florida. Maury and I were about the same size; both of us had black curly hair, and were often mistaken for Jewish brothers. Maury was not gay and he amazed me with his mathematical skills.

Introduction to the Gay Community

One evening I was working late to complete the changes in a window display. It was about one o'clock in morning, when I opened the blinds to a completely upside-down window display! I remember the theme was "Sanity and Simplicity in A Topsy Turvy World" featuring simple cotton dresses. This upside-down display astonished servicemen walking to and from the local bar.

On another occasion I was completing a display late one afternoon. When I opened the blinds, a young man outside turned in surprise and smiled. For some reason he, or his smile, made me extremely nervous and faint. I went upstairs to compose myself and to rationalize my reaction. I had to leave for the day. That evening I related this to Marvin, who understood my reactions far better than I did. Interestingly, we had never discussed sexual issues or the relationship between Marvin and Carl! That same weekend at a party I was introduced to Jimmy, the young man who smiled from outside that window. He expressed similar surprise and emotional feelings upon seeing me in that window. We became friends and traveled together occasionally over the next few months while enjoying complete, gentle, sexual passion; my first same-sex experience. This sex was as natural as it had been with Rosalind and lacked romantic attachment. I soon learned that Jimmy and I had far too little in common to continue the relationship or even the friendship.

Early in 1946, through friends at the office, I met an Air Force Captain with whom I became a friend, close companion and lover.

It was he who introduced me to my first openly gay relationship. He made it seem the most natural relationship of my life. Our relationship paved the way for me to discuss my emotions and sex with Marvin and Carl who, by then I knew, were also gay. This brought me closer to my brother Marvin than we had ever been. The Captain gave me an expensive watch for my birthday. I still have it. He also was influential in my decision to enlist in the Air Force. These two gay encounters now established a psychological conflict with which I would struggle during the next thirty years. I was not ready to accept that I might be gay!

The Floor Manager security person at Dickson-Ives where I now worked was a very charming, well-groomed, daily flower-in-the-lapel, married man. However, I had to continually dodge him in private sections of the building, especially in the work space behind the large windows where he would attempt to be affectionate. Not only did I dislike the idea, I was also suspicious that he may be trying to find out if I was gay, information that he very possibly could and would use as he so needed. I was able to keep our relationship on a cordial, courteous basis.

I met the president of one of the largest banks in Orlando who happened to be gay. He invited me to a party in Tampa, where I met some very wealthy gays and lesbians and the most sophisticated group with whom I had contact. The party was in a private home in the country surrounded by trees and palmetto plants. In the late hours of the evening, someone noticed that one young man was missing from the group. I went out to call to him and located him quite some distance from the house walking in the woods! He told me that he was twenty-one years old, had lived in near poverty with his mother and two sisters all of his life having never met his father. Only that day he had learned that his father not only lived in Tampa but that he owned a very large laundry and dry cleaning business and lived a rather wealthy lifestyle with his second wife and daughter. This problem and the evening social events were just too much for him to handle. I attempted to console and council him and soon we

returned to the house. My empathy for him was really sincere and I have thought often of his plight.

Sydney, a gay son of one of the owners of the store where I worked, came by the store late one evening. He asked me to walk with him a distance of about five blocks to the home of the former head of the display department. We had to walk a short distance through the corner of Eola Park where we were accosted. Two men came up behind us and demanded that we walk without looking back at them. They directed us to walk into a dark area, where they took the little money from my wallet and returned the wallet. While they were focused on me, Sidney ran like hell! They then asked me how well I knew Sidney. I explained that I worked for his father, after which I was slapped. Then they wanted to know if I knew that he was queer. I did not. They slapped me again and asked how quickly I could get back downtown, some two blocks away. With that I ran as fast as I could. In retrospect, it is obvious that this was an attempt at gay bashing. I was shaken and afraid to report the incident to police. I went to the nearest bar for a drink and to find a friend. From there, a friend took me to his home outside of Orlando, where I spent a sleepless night. The following morning when I arrived home, Marvin had notified the police that I was missing. Sidney and I got together and went to the police. Nothing more came of this except that later the public did demand that Eola Park be made safer. I was one frightened guy during that incident, and it left me afraid of parks, where I may be vulnerable. I was never again in the company of Sidney.

I was working at Dickson & Ives when President Franklin Roosevelt died. We immediately curtained all windows in black and set a large vase of white lilies in each. The store was closed, and I remember everyone being in tears. I felt, as many of us did, as if my father had died. He was the only president that I had known, and I could not imagine someone else taking his place. His death also stirred in me greater feelings of patriotism that raised questions in my mind about my military duty.

The death of Franklin Roosevelt and the robbery were sobering events. I began to take stock of my life. In 1943, when I became

eighteen and registered for the draft, I was deferred for two reasons. I had a hernia that was still not severe enough for an operation, and I was farming. After my hernia operation in Orlando, I had never notified my draft board and continued to be deferred. I now felt that my work was going well, but I could not see much future in display work. My personal life seemed to involve a lot of weekend trips to see the sights all over Florida, no close female relationships, and a parade of friends who came and went. Indeed, I was restless, ambivalent about my emotions, slowly becoming alienated from my relatives, and the Captain, my closest friend, was facing transfer that would leave me alone again. All of these factors contributed to my decision to join the Air Force. However, I weighed only one hundred and twenty pounds at the time. I gorged myself all summer to get my weight up to one hundred and thirty pounds so that I would qualify for enlistment.

Marvin and Carl continued to be a stabilizing support for me, but having recently returned from army wartime duty, they hated to see me go into any service. However, my decision to join the Air Force gave completely new directions to my life and personality. It was, without a doubt, the best decision that I ever made. I left my job near the end of September and went home to Georgia before enlisting. I thus closed another chapter and stepped into new opportunities; a new life.

CHAPTER FIVE
THE MILITARY EXPERIENCE

I joined a group of enlistees, October 1, 1946, for the trip from Orlando to the Boca Raton (Florida) Air Force Base. It was an emotional and in many ways exciting event. I shall never forget the experience of having to use the latrine of some fifty toilets lined up without partitions and urinals some yards in length. For some reason, the urinal did not intimidate me as much as the toilet did. I simply could not force myself to sit on one of the toilets during the three days at Boca Raton. Little did I know how naive I was and how much I had to learn. By then, for unknown reasons, we were given leave for three days, during which I found relief and reconsidered the relevancy of privacy. At that time I had not yet been sworn in, and I seriously considered not returning to the base. Ironically, I was ultimately sworn in only six days before the draft ended.

I did return to Boca Raton and shipped out to Fort Bragg in Fayetteville, North Carolina, where I received clothing. I weighed only 130 pounds after I had fattened myself in order to make the minimum required weight for enlistment, and I was never very strong. So when we came to the end of the clothing line, the duffel bag was more than I could lift. However, with one yell from the noncom I did manage to get it to my shoulder and struggle with it to the barracks. I am certain that the scene would have made a comical film. Fayetteville, what a hole that was. I received a weekend pass,

boarded a bus into Fayetteville, where I saw the serviceman's strip, had dinner and caught the next bus to the base.

Very soon afterwards I transferred to Lackland Air Force Base at San Antonio, Texas. I found the base there had better facilities, private toilets, and better food than did Fort Bragg. There I went through the usual basic training. I will never know how I did the sit ups, pull ups, and runs as required, but I did it without any problems. I was beginning to know that I could physically do far more than I had ever dreamed possible. There were a few incidents that I remember from San Antonio. I remember that it was cold, and each night a guy from Indiana would come across the barracks and sleep with me with no sexual involvement. I remember that he was terribly warm and that it was a joke among all of us. Later, upon his request, I wrote a letter to his girl friend in Indiana on his behalf because their relationship seemed to be deteriorating. It worked! They were married during his first leave home. Another young Latino man from Jacksonville Florida came to my bunk one afternoon, engaged me in conversation and wanted to show me a picture of his lover. I tried to avoid any expression of surprise when he showed me a picture of a sailor. He expressed his strong desire to go back home to him, and I advised him that a talk with the Chaplain would certainly get his wishes. The following day he took such action and received his discharge. Once he arrived home, he wrote to thank me for the advice. I remember a third man from Tampa, Florida, for his belligerent attitude. One day after preparations for general barracks inspections, while we waited outside the barracks for inspection officers, he dropped several cigarettes on the ground and scrubbed them in with his shoe. I made a disparaging remark about what his home must have been like, and he came at me. I stood against the wall with my arms folded, waiting to be blasted. I called his bluff orally, and he withdrew to pick up the cigarettes whereupon others and I turned to help. Of course that made him furious. Later, when I was on duty at night, the same guy refused to turn out the lights as I instructed him to do. So I put him on report, and he had to serve kitchen practice (KP) duty for one

week, Some months later in Spokane, Washington, we would become friends and go skiing together.

By far the most memorable experience I had during my stay in San Antonio was with William Grannell, a man from Brooklyn, New York. The San Antonio Symphony, on Tuesday night, was having as guest violinist the famed Jascha Heifetz. About a week before the concert, we asked permission to go to hear him. Every authority refused us permission until we came to the Base Commander, who readily agreed that we should go. He gave us a pass that we had to present to each authority all the way down the chain of command. What a glorious event it was to hear that man play! It was the first time I had been to a symphony concert, and certainly the first time I had heard the violinist. It was an experience of a lifetime. Of course, Bill and I had to go through some hassle when we arrived back on the base at about one o'clock that morning, but it was worth it.

Marvin had told me of his basic army training in Louisiana and his experiences in the Pacific during the World War II. His basic training, and especially his maneuvers, had been very difficult. For that reason, I had dreaded the thought of going on maneuvers. It was a cold winter in San Antonio when we got orders to prepare for maneuvers. Most of us packed for inspection, then, after inspection, carefully lifted items out of our packs to make room for foods, that we had lifted from the mess hall supply. We assembled on the field and loaded onto busses for the trip out to the maneuver area. There we found our tents, including bunks, already made and ready for us to occupy. To our surprise, a Post Exchange (PX) van loaded with supplies followed us. Maneuvers were not difficult. I spent one whole day hiding in a tree in the hills waiting to be "captured" by "enemy forces"! Two of our men who were hiding went all the way back into San Antonio and slipped back to the tent that night undetected. We did go on a dreaded ten-mile hike at night. At about five miles, when I was dodging a gas explosion, I ran into a rock. I hurt my shin and was delivered back to my tent. When I later described this experience to Marvin, his only remark was "Air Force softies"! The rest of my basic training went smoothly, and upon finishing the

training I processed for transfer to Spokane, Washington, to a school for medical technicians. The processing included medical checks, a sinus drainage operation and extensive questions about my ability to take the weather in Spokane. Since I had never seen snow, it seemed they were directing these questions to the wrong person.

The trip from San Antonio to Spokane was by troop train with upper and lower sleeping bunks. I vividly remember that when I prepared to sleep in my lower bunk the young man above quietly moved down into the bunk with me. There we slept warmly until we were awakened at a stop in Denver, Colorado, by the cold snow blowing into our half-opened window. As all of us tumbled out of our bunks, no one commented about the two of us coming from the same bunk. This was the first time either of us had seen snow, and we had time to leave the train for a little play in the snow. As we made our way toward Spokane the snow became deeper, and I recall seeing the small plumes of steam where elk and moose had come to drink. Of course, seeing these huge animals, stretches of snow, and the mountains for the first time was an exhilarating treat.

I learned, upon arrival at the Geiger Air Force base in Spokane, that the medical school had closed two months earlier. So I waited a couple of weeks while the staff considered a new assignment for me. During the wait, I had to do minor details and guard prisoners who were American boys confined due to infraction of various military rules. I had to accompany one guy on an ambulance ride to a nearby hospital for some minor treatment. When we returned to the stockade at the end of the day, he asked me to take a knife that he had picked up at the hospital and that he knew would cause him trouble as he entered the stockade. This request was a little frightening because I then realized that we had been very casual about our relationship that day. The next day, three prisoners did attack a friend of mine who was guarding them as they delivered garbage to a nearby dump. The prisoners bound him with rope and left him in the snow behind a rock from which he managed to escape and walk to a farmhouse, where he called for help. On the following day, it was my duty to escort three boys on a garbage detail. When we stopped at the mess hall

for garbage, all three of them disappeared into the mess hall. After a short time, I went into the mess hall only to find them having coffee with the cooks. I rounded them up, ordered them back onto the truck and directed the driver to deliver us back to the stockade. I returned them to a surprised officer, went across the road to the stockade officer, a captain, to whom I handed my weapon and asked for a different duty assignment. When I told him that I would never shoot one of those boys who may be escaping, he accepted my weapon and sent me to my barrack. Of course, I was afraid that this would get me into trouble, and I worried about it until I received assignment to the supply room the following day. After some heated conversation from my commanding officer, I was given work space and supplies to make signs and posters. Someone had finally learned that I had some art training, but I was still waiting for assignment to some school. It seemed that no one could figure out what to do with one who was a "display man of ladies fashions" in civilian life.

Another week went by before I received notice to report to the school assignment office. The non-commissioned airman to whom I first talked was courteous and rather respectfully suggested that they had found a school for me in heavy equipment operation. Now, I had seen people operating heavy equipment, such as a bulldozer, in the snow. I did not want to get into that kind of work. So, I refused the school assignment, thanked him and nervously returned to my barrack. A couple of days later I was again summoned to the same office. I was very much afraid to return. Upon my arrival I was told, "if we ignore scores on your aptitude tests taken in San Antonio, we can assign you to training in sheet metal work!" I replied that I was an artist and had no intention of cutting my hands on sheet metal, although I actually had very little idea of what one does in sheet metal work. At this refusal an officer came out and began to tell me that I had no choice but to take the assignment. I calmly replied that I did have a choice and that I would definitely flunk out of such a school immediately. He spoke a few more harsh words and dismissed me. I waited and worried through another week before being summoned before the same officer who offered me an

71

assignment to refrigeration mechanic's school. Again, I nervously refused to accept that assignment. I stood at attention through some tough language and again the captain dismissed me. A few days later my commanding officer called me to his office. I trembled all the way to his office, and I stood at attention through his harangue while he walked around and around me and popping questions at me as fast as I could answer. I began to visualize myself being shipped off to war in the Pacific or being punished then and there. After what seemed like an eternity, he asked "what did you do as a civilian?" After my explanation he asked if I was then an artist, to which I replied in the affirmative. His attitude changed immediately as he asked "why in the hell do they not assign you to the school for drafting?" I explained that I had asked for that school each time they interviewed me. He turned to the telephone, shouted orders into it, and dismissed me with instructions to report to the school assignment office the following morning. Thus they assigned me to study drafting, which I thoroughly enjoyed. I can only look back on these experiences with awe at my being unpunished for refusing to guard and for refusing repeatedly to accept the assignments. How I got by with all of that is yet a puzzle. I suppose that I had some generous officers there,

One of the assignments in the drafting classes was to draw a landing strip from the side view and mathematically project the lowest altitude. In other words, to draw the landing strip's side view indicating a sunken mid section but allowing adequate length for planes to safely land. Well, as I have said before, I am weak in math. So, I quietly took my French curve, drew the line, and then projected the vertical lines as if I had done it mathematically. I got an "A" on the assignment! The exercise gave me greater understanding of the structure of airports, and I think of it each time I see or use an airport.

At the end of the six weeks in the drafting course I returned to the processing center for assignment orders. I had informal (grape vine) information that my next assignment would be in Hawaii. With little effort, I was able to confirm that information. However, I again received a call to report to my commanding officer. Of course, I was afraid that I was in trouble. Instead, of being in trouble, he greeted me

informally and told me that he wanted to keep me on duty in his office as his "morning clerk." I thanked him and stated that the central office had already received my orders for duty in Hawaii. At that, he stiffened and wanted to know "how the hell do you know that?" My reply was "General rumors, Sir." That evening a friend told me that he had seen my orders already printed and that I should get them the next day. The following day, after my commanding officer had confirmed that central office had processed my orders, he summoned me to his office again. He kept me at attention as he walked around me. He then cited a list of desirable qualities that he had observed that would make me a good morning clerk for his office. Of course, I was as nervous as I could be, but I stated that my orders were for an assignment in Hawaii and that I did want to go there. Again, he wanted to know how I knew about my orders because they had classified them as confidential until I received them. He did not press me for an answer. After many more persuasive and complimentary remarks, I agreed that if he could get my orders changed, which I was certain that he could not do, then I would be glad to take the assignment. Thereupon he stood me at ease, went to the telephone immediately and called headquarters to change my orders. He was told that the change would not be possible. He then complimented me much like an old friend, wished me well in my new assignment and dismissed me. The following day my orders arrived and I left for home on a one-month leave before reporting to San Francisco for transfer to Hawaii. I was feeling like the luckiest person alive.

The leave time spent in Orlando and with my family in Georgia, as I remember it, was uneventful. I do recall that I was very proud of my uniform and enjoyed the attention and the affection of friends and family. I did not spend time with any of my former friends in Orlando because the Captain had shipped out and I wanted to discontinue other relationships there. Everyone seemed to be envious of my pending trip to Hawaii.

When I reported to the Army base north of San Francisco, I observed that the base accommodations were not as nice as the Air Force bases to which I had become accustomed. None of that

mattered much because a friend had come from Orlando to San Francisco, where we rented an apartment for our short stay there. During the three weeks that I was stationed there I spent much of the time either in the apartment or seeing the city with him. When I shipped out to Hawaii, he returned to Orlando, and I soon lost contact with him. San Francisco was absolutely delightful.

As I went through the processing for transportation to Hawaii and to other locations in the Pacific, they stamped my papers "SO-PAC" instead of "HAW-AREA." I held up the entire line as I protested first to the enlisted person that had stamped the papers, then to a non-commissioned officer. He defended the stamp by stating that there was no difference in the two designations. I continued to hold up the processing line until a captain came from his office to see what was happening. He listened to the issue and then stated "there is indeed a difference." Much to my delight he ordered that they stamp my papers "HAW-AREA." The following morning I boarded a troop ship to Hawaii. I later learned that the SO-PAC designation would have landed me in the Pacific combat area far beyond Hawaii. I must have been one gutsy little Irishman!

The troops were crowded aboard the ship, of course, but it was not an unpleasant trip. To this day I remember well the "short arm inspection" that we underwent as we neared Hawaii. None of us had bathed or showered because the water was cold, the odor was unbearable, and the medical officer who did the inspection raised hell with us.

Arriving in Hawaii was indeed a romantic dream come true. We passed along Waikiki Beach, Honolulu, Hickam Air Base, and into Pearl Harbor. It was truly a beautiful sight. We disembarked in Pearl Harbor and those of us in the Army Air Corps (later in 1948 renamed U. S. Air Force, 7th Command) transferred to Hickam Air Base. There I received an assignment to the headquarters command of the Seventh Army Air Corp. Two of us from the eight trained draftsmen were assigned to Hickam while the other six were transferred on to the South Pacific. My assignment was to the office of the Army Corps of Engineers. My insignia at that time was a mix of Seventh Air Command and Army Engineers. In 1948, the Air Force became

a separate entity, and my insignia was changed to that of the Seventh Air Force Command. I was happy, and took pride in finally losing all of the army and engineer insignia. I took greater pride in being in the Air Force.

Those of us who worked in the headquarters offices lived in one of the seven wings of the very large dormitory. This two-story concrete residential complex still showed damage from the 1941 attack by the Japanese. Our quarters there were spacious and comfortable. About forty of us from Headquarters occupied single bunks on the second floor. While the entire building was well screened, and to my surprise, there were no glass panes in the windows because they were unnecessary in the Hawaiian climate. The adjacent wing of the building, which formed an "L" shape, was occupied by African American service men. The toilets and showers in the two wings were separate but adjacent. We faced integration in 1948 with anxiety and a lot of emotional expressions of ignorance. The troops generally dreaded and feared the integrated use of these facilities. As I remember it, the walls came down and there were no incidents, even though a few whites arranged to use the facilities in the absence of blacks. However, I do remember the first time that I showered along with black service men. It was a new but uneventful experience, probably for all of us.

My work assignment was in the planning section drafting room of the headquarters building. My immediate supervisor was a Korean-American civilian by the name of Isao Yabusocki. He was a very pleasant person who later invited me to his wedding, an event that I shall always remember fondly. At first my work involved the boring task of tracing numerous details of drafted plans for air landing strip designs. Within a short time I was cleared to handle top-level secret materials, and I began to travel to other bases to collect materials for our planning staff. In this capacity, I had access to any of the Air, Navy, Army or Marine bases to which I, a Corporal, always traveled in an official staff car with an armed driver. On my initial visit to Pearl Harbor, the Marine guard saluted the staff car as a courtesy and motioned for us to pass. However, on the exit, after he saluted, he

stopped the car to ask, "Is not this an official staff car?" To which I replied, "Of course it is." With that, he saluted and passed us through without comment. I was never questioned or stopped at any other location.

Isaac Perry Kelly 1948

One location, to which I went for maps and other information, greatly intrigued me. It was a huge tunnel facility on the north end of the island of Oahu. We traveled by jeep to the facility along dirt roads through expansive pineapple fields, into the hills and down into a gorge to the entrance of the tunnel. I learned later that a small wooden hut that I had observed in a section of the pineapple field served as vent for the facility. The entry was a well-guarded steel door large enough to admit trucks or airplanes. There was also a small entry for pedestrians. Once inside the tunnel we drove directly onto a very large elevator to some of the five levels where I collected maps, drawings and information. I guess that I was simply awed by the size of this tunnel in which planes were repaired during the war and by my first experience of being in a tunnel. The armed driver really made me nervous because he drove the jeep far too rapidly for those winding roads, but I held on and kept quiet.

Soon after I started work at Hickam Air Base, I met a colonel who was assigned to the intelligence service. We met off base at the YMCA in Honolulu, where we both were having some alterations done to uniforms. He invited me to dinner at the home of a civilian friend and we became close friends. Since I was an enlisted noncommissioned airman, our association was strictly against rules of conduct. We both knew that and even discussed it. For that reason, we would go separately into Honolulu and check into separate hotels, or we would both go separately to a beach or to the home of friends. Because we both had many civilian friends on the island, we were able to spend a lot of time together and, yes, we were lovers. He gave me an expensive Leica camera for my birthday. Whenever we met on the base, we saluted and exchange smiles only, we both realized the consequences of this relationship could be hazardous, to say the least. Had we been exposed, I am sure that I would have gone immediately to the brig and to a dishonorable discharge. He would certainly have been arrested and permitted to resign with no further benefits. It was dangerous, it was frightening, and it was exhilarating. A short time later, he was transferred elsewhere, and we lost contact.

Air Force Pals: Milne, Vulick, Kelly 1948

A fellow airman named Pennock, from the state of New York, soon filled the void and we maintained a social friendship until I was transferred to Pearl Harbor. Pennock was a tall, handsome man who

could easily have been a model, but he was probably the most camera shy person that I have known. I did take a few photographs of him as we were sightseeing and at various beaches. Pennock, along with airmen Vulich from Iowa, Milne from Connecticut, and I bought an old surplus command car that we drove around the island almost every weekend. We would eat off the land, sleep in the car and enjoy the native quality of life in Hawaii at that time. Neither Vulich nor Milne was aware of, or cared about, the special relationship that Pennock and I shared. On one such trip, we were carrying a big birthday cake for Milne. Vulich was driving rapidly when he missed a curve and almost threw us out of the vehicle. The cake went flying through the air, after which the rear tire landed right in the middle of it. We could barely think about the loss of the cake as we all sat on the grass and nibbled on its remains.

Hawaii was not a state when I first arrived there. In fact, it was considered "overseas duty," and we were expected to take a two-week leave each six months. Where could one go for rest and recuperation (R&R) from Hawaii? Many servicemen came to Hawaii from the South Pacific for R&R. Indeed, it was among these service men that I met a sailor named Tommy, whose ship was in harbor. We both had been invited to a civilian party. When I arrived, Tommy was resting in the living room on a very thick white rug. His black hair and tanned body certainly made a beautiful sight. Our affection for each other developed in that one evening, and he came to play a major role in my life in Hawaii.

A civilian friend in Honolulu by the name of Ian owned floral and gift shops in Honolulu and Hilo. He offered me the use of his cottage in Hilo. A mutual friend of ours, Roman owned beauty shops in the same cities and maintained a car in Hilo. . So, I spent my R&R on the island of Hawaii. It was there that I met Jack, who owned the only oil company on the island and drove a very large Cadillac even though there were few roads. In fact, there was only one road over the volcanoes to Kona. Jack lived in a large house very near the edge of Kilauea crater, maintained by a gardener, a maid, and a cook. The

drive to the house was lined with a hedge of lavender orchids. I spent a few weekends there.

On one of my visits to Hilo with Tommy, we used Roman's Ford car to drive to the Kilauea volcano edge and to visit a hotel, which sat right on the crater's edge, that used thermal heat from the volcano. En route back down to Hilo along a clay road winding through cane fields, the brakes failed. Of course, it frightened us, but our first concern was for the car. Luckily' we were able to move to the red mud and a shallow ditch, stopping against the bank without injury to us or the Ford. We drove the car in low gear to Hilo, using the hand brake. We spent the evening together on the tin-roofed porch of Roman's cottage. Thus I came to take my R&R on the island of Hawaii.

METAL ROOF
Perry Kelly

Rain caresses
The metal roof above my bed.
Water splashes gently
To the rocks below,
And I sleep.

Rain beats loudly
On the metal roof above my bed
While water rushes noisily
To the rocks below,
And I awake.

Thunder and wind
Ripple across the metal roof.
He quietly enters the room
And I feel secure,
In the embrace.

Rain caresses
The metal foof above our bed.
Water splashes gently
To the rocks below,
And we sleep.

In 1948, my civilian boss advised me to apply for a job opening for which I was qualified, on the staff of the Commander-in-Chief's office at Pearl Harbor for a draftsman and typist. I was later told that a bulletin had gone out throughout the Pacific Command and that I was the only draftsman in the Command who could also type. I was assigned to the office of the Joint Chiefs of Staff in the headquarters of the Commander-in-Chief of the Pacific Command, located on a hillside overlooking Pearl Harbor. At that time, the commander-in-chief was an Admiral in charge of all armed forces in the Pacific. The office of the Joint Chiefs of Staff was made up of one each Army, Air Force, Navy and Marine officers of colonel or commander rank. I served with other enlisted personnel from each of those branches. I remember fondly my association with Colonel Rothrock (Air Force) and Colonel Swable (Marines) because they took such personal interest in my welfare. I remember Colonel Swable also because he later faced court-martial on charges dealing with some command decisions he made. I believed him to be totally innocent.

My major duty at Pearl Harbor was preparation of briefing charts for use in the Admiral's briefings. I was also assigned the task of delivering those charts, with my armed driver, to the lecture rooms on various bases where the Admiral would brief the staff. There, I would post the charts that I had made, exit the room and wait for the briefing to end. Then I returned the charts to the safe at Pearl Harbor. This was rather nice duty, and my evenings and weekends were always free. Most were spent in Honolulu.

I was housed in barracks at the submarine base in Pearl Harbor. I well remember the timidity with which I, in my khaki Air Force uniform, would accompany the seemingly vast number of white

uniformed sailors at mealtime or at movies. Sailors would openly whistle or make remarks about the cute "Airedale." I soon learned that I could avoid this if I accompanied a Marine on these occasions. It was thus that I became friends of several marines with whom I spent a lot of time away from the base as well. Two of these marines were discretely gay.

The Purge

My work at Pearl Harbor was enjoyable, and my time spent off base in Hawaii was extremely enjoyable and rewarding. Perhaps the most depressing event that I experienced was the purge of homosexuals that was carried out throughout the Pacific Command. The "purge" began when three sailors, stationed at three different bases, became involved in a triangle love affair. One of the sailors was stationed at Ford Island in Pearl Harbor. It seems that he felt rejected in this triangle affair and committed suicide in a major downtown hotel. The subsequent investigation revealed the other two parties of the triangle as well as names of their friends. I knew, but was not close to, the Ford Island sailor and his suicide upset me greatly. Fortunately, we had never exchanged telephone numbers or addresses, therefore, had no known contact. The other two sailors were arrested by marine guards, who treated them as the lowest of criminals. Their heads were shaven and they were ridiculed. They were made to do the most menial of tasks. They were threatened into revealing names of everyone they knew, gay and non-gay alike. Each of these in turn was investigated and interrogated. I received this information as factual from my Marine friends.

It was well known that there were many gay officers and enlisted personnel in all branches of the service at that time, and, as one should expect, there was a large concentration of gays in each of the headquarters. When this investigation began to reveal the names of so many gays, one could sense the fear permeating every office. Suspicion ran rampant among the troops. Friends became afraid to

leave the base together or even to talk to each other on buses. I well remember that our daily ride by bus to and from our offices had been times of chatter and friendly banter. This typically was about events or experiences the previous evening or weekend. These rides became silent journeys after these investigations began. Each of us read something or tried to ignore each other. Tension was clearly apparent in the offices. The inquisitions and discharges were debilitating and demoralizing generally and particularly traumatic for those who were personally involved. These purged discharges and resignations were at a terrible cost to the government. We lost well-trained personnel, knowledgeable in their fields, and serving their country well. Their training, of course, came at a high price for the government, and the disruptions and replacements likely cost as much.

During this time, Tommy and I had been dating two female professors at the University of Hawaii and had acquired many friends on the islands of Oahu and Hawaii. During the purge, we had to sit apart on the bus or take separate buses and meet at private homes. Even in the private homes, we had to be cautious about invited guests who might divulge our names. Tommy and I continued to be close friends and lovers during my entire time in Hawaii as a serviceman and as a student. Unfortunately, in 1949, our affair ended when he finished his enlistment and he returned to Texas, and I to the University of Florida. We continued a regular correspondence for about twenty years. We finally lost contact with each other when I began my doctoral studies in 1960, and he moved after the death of both parents. I had planned to complete my doctorate and resume our relationship. I have to admit that the loss, that disconnect, has haunted me ever since.

My barber in Pearl Harbor, a sailor who I knew was not gay, was in town one evening and took a cab back to the base with a Marine, who happened to be in need of a cab to the same place. This was a common practice. However, the following morning when he came to the barbershop, he was arrested by two Marine guards and underwent extensive questioning. There was absolutely no indication that either of these persons was gay, and they were cleared. That experience was

indeed traumatic for both of them. It certainly increased the tension and anxiety among all of us.

At the same time, the head of our personnel office at CINC-PAC headquarters was an openly gay person who daily wore sandals with his uniform. He was never even investigated. Presumably this was because he knew too many of the highest ranking officers who were also gay. He could have exposed several of them. One need only imagine how everyone distanced themselves from him during this time. During these purges, officers most often were given the chance to resign while enlisted men were summarily discharged with "less than honorable" or "Section Eight" classifications, leaving them without educational and veterans' benefits. Over three thousand officers and men in the Pacific Command were humiliated and sent home for no reason other than sexual orientation. This was clearly a demonstration of homophobia at its worst. It was a very costly and futile exercise. It was futile because many of the replacements themselves were gay. Unfortunately, it was an experience that still frightens me today and that I would later see repeated in civilian life.

During this purge, when Tommy and I were guests in a private home, we met a civilian named Ed. He was from Chicago where he had a former wife and a daughter. He was a well-dressed courteous man, old enough to be my father, and deeply interested in the arts. When Tommy was at sea, Ed and I often had dinner together or attended concerts as friends, much like a father and son. Later Ed would, as a friend, come to play an important role in my life. He invited me to return to Hawaii and to live with him at any time, an offer that did not appeal to me at that time.

I enjoyed the camaraderie that I found in the military. I liked being taken as I was instead of for whom I had been or to whom I was related. While I was very discrete in my personal relationships, no one ever questioned my sexuality, probably because it was not of interest or perhaps no one cared. I loved being in the Air Force. I loved the uniform, and I was proud of what I had accomplished. It

was with regret that I would be leaving so many great friends. I would not reenlist because I had my heart set on going to college. Without a doubt, the military and experiences in Hawaii changed me. They gave me a new orientation and self confidence that would positively affect the remainder of my life. I often say that those experiences gave my life a complete turn. I completed my tour of duty in mid 1949 and returned to Orlando.

There is a custom in Hawaii of giving flower leis to departing friends. Friends gave me a party before I left aboard a military ship. I received many leis, as though I would be departing in a civilian ship. Of course, because of military policy, I had to leave them with Ed rather than taking them aboard the ship to be thrown overboard, as was the custom, to assure my return. I left Hawaii with the one lei given to each of us at the pier by flower vendors. Leaving the Air Force, leaving Hawaii and friends, and leaving my companion Tommy, was traumatic. I was so deeply afraid that I would not see Tommy again. But we were together a few more times while I attended the University of Hawaii at Monoa.

As we sailed to San Francisco, I stood along the rail beside a man whom I had known at Hickham Air Force Base. We were engaged in conversation when I asked, "What do you intend to do upon arrival home?" His reply much to my surprise was, "I will return to the University of Hawaii." I then asked, "What will you major in?" He surprised me even more when he replied, "I will study Philosophy." What a great idea! It then occurred to me, if he thought he could make a living at Philosophy then I certainly could make a living at art! Then we agreed that the major was unimportant and that the obsession with career objectives was equally unimportant. Living a good life in pursuit of learning and personal objectives was important. That is when I decided that indeed I would study art.

When we arrived in San Francisco, he and I decided to share a hotel room overnight before our departure the following day. We had dinner and, as we took a taxi back to the hotel, he spoke to the driver and engaged the service of a prostitute. What in the hell am I to do now? Luckily, we had a two-room suite. We had hardly entered the

room before she arrived. I quickly left them in the bedroom while I watched TV in the other. In less than ten minutes it was all over and she left. Then he wanted me to get one. No way! Because of my fear of disease and my bias against prostitution, I could not consider a prostitute no matter what the gender might be. The next morning we departed on separate trains. I went to Orlando.

CHAPTER SIX
THE UNIVERSITY EXPERIENCE

Before leaving the military service I had applied to and had been accepted in the University of Florida and the University of Hawaii. Luckily, the GI Bill would pay for my tuition and costs for university study. The University of Florida required that all freshmen live on campus, but the University of Hawaii had no such rules nor did they have any dormitories at that time. After my return to Orlando, I spent a few day at home in Georgia and then went to the University of Florida to enroll. After some processing, I located my assigned quarters in a World War II Quonset hut. I did not like the Quonset hut. I recall that the smell in that dorm was much as I had experienced in some military quarters; the distinctive smell of men. It seemed to me that I should not have to endure that any longer. So, I returned to Orlando, called Ed, and flew to Hawaii the following day. There I enrolled in the University of Hawaii to study art and began my year sharing a nice apartment with Ed.

The University of Hawaii

My freshman year at the University of Hawaii was absolutely fantastic. I remember the English class because I had to do a research paper on the derivation of a word. I had never known or thought of words having a history. I also remember a paper in which I had marked through a correct phrase and changed it to an incorrect phrase.

The professor returned it with the remark "trust your intuition". I certainly thought the teacher would have simply marked the second item as incorrect. An aged geology professor, with very white hair, taught the general science class of two hundred students. He was a dynamic lecturer who required us to do research on the geologic development of the Hawaiian Islands. As a final exam, he required us to write a paper explaining the cyclic vegetation growth on a newly formed island. That one concept has helped me to look at natural growth from that viewpoint ever since. My world history class of four hundred students met in an auditorium where the professor entered the room lecturing and continued so until the end of the class period. He taught me to view history as cultural development instead of military accomplishments and dates to be memorized. He made history relevant for me. To this date, I have kept those history text books: World Civilizations, Past and Present.

It became obvious very early in the year that in art classes my strength was in design. However, I remember the drawing professor because she introduced me to the nude figure. She moved a fellow student away from me when she observed him making inhibiting remarks to me about my drawing. He and I were friends, and I did not realize that he was inhibiting my work by his snide remarks. My drawing did improve afterwards. While he could draw well, I achieved better results in design classes. In the drawing class the model would enter wearing a cape and pose in a bathing suit, sun glasses and often other props. But one day, much to our surprise, when she removed the cape she was nude. The entire class immediately focused on the drawing pads. We were then instructed to do contour drawing which requires one to keep the eyes focused on the lines of the body. We were all very timid and the drawings were comical. Subsequent sessions with the nude model developed my objectivity and observations skills.

Jean Charlot was an art professor at the University of Hawaii and Clarence Tibadeau, a friend and neighbor of mine, was his assistant. Charlot had studied with Orozco and had done work at Black Mountain College in North Carolina. Of course, I was not aware of either name,

but I certainly admired the murals painted by Charlot. It was with great admiration and respect that I observed Charlot painting his first large fresco in the university administration building. He was painting an Hawaiian scene, and it was slow, meticulous work. The results were beautiful. I recall the rich deep blue in the sky and waters contrasted with the tans of natives. The colors were far more vibrant, deeper, richer colors than any frescoes we had studied in art history. I loved that fresco mural, and I learned a lot about the construction and painting of fresco.

My English class met at 10:00 A.M. on Tuesday, Thursday and Saturday. On Saturday, I would dress with a bathing suit under my khaki trousers along with my aloha shirt and sandals. From the classroom windows we could see Waikiki beach to which we rushed after the Saturday class. During the fall semester, a classmate by the name of Fred, a tall blond who had skated professionally with Sonja Henie, and I enrolled in Saturday hula classes at Waikiki Beach. Fred, one Hawaiian man named Dayton, and I were the only male dancers among ninety-six females. The three of us studied the ancient male dances under the direction of Emma K. Bishop, a large motherly Hawaiian. For public exhibitions, we wore sailor pants with aloha shirts and no shoes. Fred gave up the classes because he could not do the knee bends required in the dances. Dayton and I continued and "graduated," along with a large number of the ladies, during an elaborate luau on the windward side of the island. I then got a role dancing in the 1950 Kamehameha Day Parade, thus becoming the first Caucasian to dance in that parade. I was twenty-five years old.

Edward and I had a most enjoyable year together. He seldom talked about his wife and daughter who lived in Ohio. He was supportive of me in every way. We especially enjoyed concerts and dining in some of the best restaurants in Hawaii, as well as many quiet evenings at home. We had many male and female friends and enjoyed weekly parties with them. Tommy, my long time Navy buddy, was still in the Navy and would arrive in Honolulu from time to time. While he was ashore, we had great times together including compatible, mutual love making. Robert, an Army friend with

whom I was still in contact until his death in 1995, was stationed at the north end of Oahu. He often made our apartment his home on weekend visits to Waikiki. During the spring semester, my evening forays, especially those with Tommy, became a problem between Ed and me. Ed became increasingly demanding of my companionship and wanted detailed accounts of my evenings or nights away. I remember that he often asked where I was going. I would tell him that we would be at this or that location. Then, when he learned that we also went other places, he would accuse me of lying. My retort was that I never lied; I only told him some of the truth. I was quite unaware of how his interest in me was growing into an untenable sexual interest. Both of us knew very well that my stay in Hawaii would be terminated in June, and the nearer we came to that date the more difficult our relationship became. However, we ended the year as best of friends.

There was one very distressing event during the school year in Hawaii: a twenty-year-old friend and frequent member of our social evenings committed suicide. Dixon was indeed a charming, small, blond young man who was loved by everyone. His parents, upon hearing that he was gay, would have nothing else to do with him and demanded that he leave home. The rejection was more than he could handle. This tragedy disturbed me greatly and shocked all of our mutual friends. It is painful, even now, for me to recall this tragedy.

I remained in Hawaii at the end of the spring semester in 1950 for about two months, during which time I daily spent long hours on the beaches. It seemed that the last week of my stay was one of endless parties with Ed and friends. I had acquired several close female friends who often gave legitimacy to my social evenings with Ed. My departure aboard the ship Lurline was the occasion for one final champagne party, where I received fifty-two flower leis. As the ship pulled out to sea it seemed as though my heart would break because I loved living in Hawaii, and I had never enjoyed so many close friends anywhere. As the ship moved out to sea I dropped my leis overboard

one by one, each accompanied by tears, in the hope that they would indeed facilitate my return.

Ed did not want me to leave and later went into seclusion for a long period of time. I wrote to him constantly to reassure him and to make him see that I had to go on with developing my life. Other friends wrote of their concern for Ed and that his depression was a dangerous turn. Ed knew from the start that I would have only one year in the University of Hawaii before returning to Florida. Some years later we would again enjoy a few visits together in Hawaii, but Ed never overcame the void of my leaving. I have always regretted that, even until his death years later, he would continue to be lonely.

I sailed back to San Francisco in July 1950, where a friend met me and took me to my hotel. That evening his mother gave a nice party to which I received an invitation. However, I was totally on edge and could not enjoy the people. His mother took me aside, gave me a sedative and advised her son to take me to my hotel. She will never know how much I admired her for understanding. I was simply too nervous and perplexed with events to enjoy the frivolity. The following morning I took the train to Florida. My luggage included a trunk full of books, art equipment, art work, and memorabilia from Hawaii. I had a private room aboard the train and spent most of my time in that room meditating on what I was leaving and to what I was going. This trip took me through Los Angeles, Texas and into Florida. I remember that when we arrived in Dallas, Texas, I stepped off the train into the insufferable heat and immediately returned to the air conditioned train. My next stop was Orlando.

While I was in Hawaii, I acquired many friends, primarily through the circle of friends of Ed and Tommy, who was aggressively social. I enjoyed a social life, such as I had never known, among a very diverse ethnic group, diverse of age, singles and couples, and diverse in economic status. I was leaving this social life and Tommy for a very conservative university setting.

Isaac Perry Kelly in Hawaii 1950

Returning Home

When I arrived in Orlando, I again went to live with Marvin and Carl who had moved to Nottingham Street between Orlando and Winter Park. The house was quite spacious, much larger than the one in which we had lived on Delaney Street, but we now lacked the seclusion afforded by the orange grove. Nottingham Street was new, the houses were new and the neighborhood was one of families. I never felt as comfortable there as I had been on Delaney Street. However, we did have more room in the new house, and the neighbors were very pleasant.

I then went to Gainesville, enrolled in the University of Florida, and secured an apartment that I shared with Chuck, a former Navy friend from Michigan, who planned to enroll in the University of Florida. I then took the bus to "home" in Georgia, where I had to get better acquainted with my half brothers and sisters.

The visit with the family was amicable, but everyone expressed surprise at seeing me so tan. They found my speech to be amusing since, to my surprise, I had acquired an accent while living in Hawaii because I had become accustomed to using the accepted pigeon English. One of my closest friends in Hawaii was a Japanese American lady with whom, for several months, I spoke pigeon English until I learned that she had a master's degree in English. She was far too polite to correct me after we had begun that mode of communication. I was first made aware of my speech when my grandfather failed to pursue conversations with me. I asked Daddy why this was so, and he explained that Grandpa "could not understand my talking." I was excited about being back home and wanted to share with the family so much about college life in Hawaii. In my excitement I forgot the much slower phrasing and pronunciation customarily used in Georgia. I became aware of changes in my speech and in my viewpoints about many things during that visit.

One of those changes related to my views of religion. Since leaving home I had purposely visited various churches and had attempted to find something in one of them that had some relevance

for me. Once, during a service in a large Baptist church in San Antonio, the preacher came to my side and asked me to "come down and be saved!" I replied, "My Rabbi would kill me!" He quickly left me. During my military service in Hawaii, I lived a few months during off duty time with Gilbert and his Chinese American family who were Buddhist. Otherwise, all of my experiences at that time had been in the Catholic and Protestant Christian context. While I was at home, I went to church with the family, where I again heard my grandfather deliver his sermon. I was always amazed that this person with so little education could quote the Bible so extensively. I loved him so very much. I admired him for his sincere dedication to his religion and his respected status among his followers. I believed him to be the most honest person I knew. However, I now listened to his sermon with greater attention, analysis and skepticism. This renewed my interest in finding out what it was in religion that others seemed to enjoy so much and that seemed to escape me. This piqued my curiosity and played a role later in developing my current views of religion. Of course, I did not express any such concerns with my family nor did I elaborate on my social life in Hawaii.

Another factor in the Georgia environment contributed to my philosophical development. I became acutely aware of the persistent racial attitudes. I listened with pain as Daddy and one of the church officials discussed the recent beating of a black man. My observations of the religious and racial bias and bigotry, along with the earlier expressions of homophobia, further contributed to my general alienation from the family. It was indeed difficult for me to face that reality. I increasingly came to accept that alienation; my secret life was coming between us, and I was becoming more aware of it. It was equally difficult for me to keep these feelings and ideas to myself. It now seems that in reality I had only begun the life of protective silence. Protective, that is, of myself and the feelings of my family. To this day, I have not shared my religious beliefs or my sexual orientation with the family for fear of rejection and of bringing pain, especially to my parents. In this inaction I have added to the isolation

and alienation which I bear. Only now, since both my parents are deceased, I can face the issues openly.

During this visit home, I found Jay to be in declining health. He had always had a rheumatic heart, and now his arteries would constrict and send unbearable hot pain throughout his chest and his upper arms. Often, while he was sitting and talking, the pain would hit him. He would jump from his chair and begin walking rapidly while almost screaming from the pain. During these attacks, I would walk with him or hold him tightly while vigorously massaging simultaneously his chest and back. I left him on Saturday and he died the following Tuesday. His death brought so many questions to my mind about the reality of life, especially about the reality of his life and its value. It pained me deeply that he had attained so little in happiness or material wealth during this short life. I rationalized that he had indeed contributed to my life immeasurably, that he had produced two lovely children, and that he now rested in peace. I took great solace in having him resolve his rejection of our step-mother and that he finally told her how much he had grown to love her. His death left a great void in my own life because I loved him dearly.

Daddy asked me, on one occasion during my visit with the family, to go for a ride with him. This was unusual because he would normally ask me to go with him to some specific place rather than "for a ride." After a short distance, he asked me if my brother Marvin was "queer." Of course I thought, "Oh my God, what now?" I hesitated a few minutes to rush this through my mind for some rational answer and to consider how to handle this issue. Then I simply said "Yes" and asked how this question came about. It seems that my cousins Myrtle and Florene in Orlando had divulged this information to their mother, who in turn whispered it to Daddy. Now, one must remember that this topic had never been discussed with anyone in my family or with my relatives. We simply took "Marvin and Carl" as innocently as we had "Jay and Virginia." I could see that the answer that I had given was not about to satisfy or end the conversation, and I began to explain their relationship in other than sexual terms because I knew very well that Daddy would not understand the physical. Soon

Daddy ended that conversation by saying simply "Well, I will never understand that but I guess I will have to accept it." However, Marvin never visited the home or Daddy again. I do believe that he attended Daddy's funeral without Carl.

I was certain that the next question would be about me. However, the conversation quickly turned to something else and left me wondering if I should or should not discuss my own orientation with him. I could not do this because I was so aware of the pain the revelation was causing him at that moment, and I was already aware of the alienation that Marvin was experiencing. I did not want to have that alienation from my family because my own insecurity made me dependent on the psychological support of the family. I now missed the military and Hawaiian friends, and I was heading into new situations at the University of Florida. I had left all of my friends in Hawaii, and had very few in Orlando. The family was my only support group at that time. The pain of maintaining a gay identity or struggling with philosophical questions in that conservative Baptist family was more unbearable than I anticipated. I was certain that it would come between us if I divulged these secrets. Believe me, the pain is real. It is suffocating.

The University of Florida

I returned to the University of Florida where Chuck, a former Navy friend, joined me. We rented an apartment, redecorated it and enrolled in school. After only two weeks Chuck decided that he would be happier in California and departed. I was able to find another student to share the apartment with me, but he turned out to be a smoker and rather crude motorcyclist. I left him after only a few days to live in a rooming house near the campus. My roommate there was a Methodist minister who did not like my art or my "hedonist views." I accepted his ministerial views because he was quite a decent fellow, but I did contribute to our psychic distance by hanging a large mobile in the middle of the room. The moving shadows drove him nuts. The finale

came when one morning I told him that I had gone out at four o'clock to see a train come through town. He decided to seek another room. To his surprise, I joined a social group and moved into the Georgia Seagle Hall, a residential house supported by the Methodist church, where I served as social director. In this social setting I found the kind of camaraderie that I had known in the Air Force, and I had many close friends there. The minister of the local Methodist church which sponsored the living residence became a good friend and for many years sent copies of his weekly sermons to me. I would read them and reply with my own observations on the topic.

The Department of Art at the University of Florida was located in the School of Architecture and Design. There seems to have been an eternal grumbling about funding always favoring the Architecture facilities and programs. The Art Department occupied space in World War II frame buildings, and it had limited crowded studio space. However, the professors and their instruction were memorable. As I went through the various courses in drawing, painting, design, and history, my interests and capabilities began to direct me into advertising and commercial art. I had difficulty in painting classes because the professors, all trained in Bauhaus concepts, wanted me to paint in very loose expressionist and abstract techniques. These techniques emphasized quality paint and color at the expense of content. My personality directed me in the more concise, object or form enclosure techniques. As one professor explained it, "you are too tense and up tight; let go, let loose." He suggested that I get a pipe and smoke it. When classes were over that day I bought a neat, trim, little pipe and tobacco and went to my room, where I tried to smoke it while I observed my reactions. It was repulsive! The following day when I took the pipe to class the professor laughed and remarked, "Why in the hell did you not get a big, burly, rough pipe? That pipe is just as up tight as you are!" I just threw it away and realized that he was trying in no subtle way to change my personality. Those qualities to which he objected better suited work in my design problems. I, therefore began to lose interest in painting.

The Art History professors taught through slide lectures that were

97

usually quite dull. The emphasis was always on learning to identify artists and memorizing dates. Not one professor seemed to put art in a context so that I could see the broader scope or development of art. The more I had to memorize, the more I came to dislike art history. I do recall fondly one professor, Dr. Didier Graffe, in the School of Humanities, an eccentric and dynamic guy from Belgium who taught an art history class in the department of art. His lectures started with reference to an object, perhaps a sarcophagus, and would proceed in a circuitous route. He would then encompass the cultural setting of the object. Finally, as class was about over, he would wrap the whole lecture back to the original reference. I also remember that he walked only a few steps back and forth continually during his lectures! Once, when I met him in the hall and asked, "How are you this morning?" his reply was, "Do you mean generally or specifically?" I replied, "Specifically." To this he gave me several minutes of discourse on his aches and pains! He was an intelligent man of delightful eccentric.

I have always been weak in mathematics and dreaded taking the general math class. However, the professor spent the semester in a study of logic. This was my introduction to logic, and I believe it has been more beneficial to me than the math would have been. I found it interesting but very difficult. It would take years for me to come to realize how extensive would be the impact of that course in helping me make rational decisions. I am grateful for his having taken some liberties with that math course. I am also grateful to have passed that course.

I applied for and got employment as a student assistant in the School of Humanities. As such, I had to prepare teaching materials for the professors and assist with teaching materials and equipment in their lectures. I recall the Dean escorting me down the hall where he introduced me to the Professor for whom I would be working. I found him to be physically unattractive and crude in his mannerisms. Only minutes after the Dean left us the professor made it very clear to me that he was gay and that he "expected to have me"! I was on the spot. I needed the job badly but I felt trapped, cheap, and victimized. I explained that I expected us to be friends and that as such we could

not do that. He accepted that idea and our respect for each other grew into a lasting friendship. Once, when he was about to give a lecture to about two hundred students, he had to rush to urinate. I had prepared to project slides for him. He rushed to the toilet but was some ten minutes late coming to the lectern. When he came into the room he whispered that he could not zip his fly. He requested that if I saw his fly opening I should wave my hand so that he would remember to stand erect! We have often laughed about that event. It turned out that he was a highly respected professor who had a wonderful rapport with his students. He was timid about having never obtained his doctorate, but his ability to make humanities subjects lively and interesting made him a popular professor. I really learned a great deal from this person with whom I had such an objectionable beginning. He was yet to play a major role in my life.

In my senior year, I assisted him in organizing a student tour to New York. We took eighty-five students on the train overnight to New York, where we had a week of museums, operas, plays and concerts. It was indeed a delightful and rewarding experience for me, and I well remember that first opera. Thanks to him, I have liked opera ever since. En route back to Florida, he decided that we no longer needed the records of the trip and threw the whole file out the window somewhere in Georgia. I was aghast! A few days after we returned to the University the Dean asked us to send invitations to all of those students to attend a reception at his home. We had to spend hours remembering names and calling various students to name others on the trip. Unbelievably, we came very close to completing the whole list, and the reception went off without a hitch. Jim, as I had come to address him, had traveled extensively throughout Europe and loved visiting Italy. In years to come, I would join him in tours to Europe. I would continue learning from him.

Among all of my student friends in the art program, I became especially close to Henry Buck and his wife Joan, so close that they named their first child "Kelly." I have never understood how we formed such a lasting friendship because we were absolute opposites. They never knew of the problems I was still having with

my sexual identity. Henry grew up in Memphis and the Mississippi delta country. He and Joan were ultraconservative Catholics, proud of his father being a Southern Colonel. Henry was also deeply involved in the military reserves. He was an opinionated racist to the point that when he later found employment in an advertising agency in Chicago, under a boss who was African American, he resigned that well-paying job. Upon one brief visit with his family in Memphis, where we briefly discussed religion, his father was certain that I was a lost soul. He gave me a book on comparative religions as a means to convince me that Catholicism was "the religion." I read it and wrote him that he had instead convinced me that other religions were valid for other people and that all religions serve similar basic needs. Henry remained my friend throughout his life.

One art professor, Dale Summers, taught me lettering, and as a friend he gave me invaluable advice. He had a most interesting humanistic approach to design in which he related forms and space to human emotive qualities. All of my other professors were Bauhaus design oriented. Dale's humanistic approach to design offered a welcome difference, which appealed to me. He was refreshingly honest and forthright in his viewpoints and advice. He spoke, incidentally, disparagingly of Henry's biases. Later, in my graduate work, Dale and his family would come to my aid as devoted friends.

In my senior year, I was concentrating in advertising and commercial art, including courses in journalism and marketing. I was very involved in the Alpha Delta Sigma advertising fraternity in which Henry was serving as President. We had an assignment to invent, organize and execute an extensive advertising campaign. In a brainstorming session with Dale, we decided to host a group from Eastern Airlines and their New York advertising agency during which they would present information on agency and client relationships. The fraternity elected me to Chair the event and, as such, I was responsible for invitations and arrangements for the event. I believed that the ideas for this project had grown far more encompassing than I was confident to handle, but Dale calmly assured me that I could carry out the project. After we planned the project, I contacted

Eastern Airlines and their advertising agency. Their response surprised me. They were very enthusiastic about participating in the project. Since we did not have funds to carry out this project, I went to the marketing professor for advice. I remember that he listened to me, leaned back in his chair and laughed. This surprised me until he explained, "You have two thirds of your project done and all you need now is the money. So let's go for it." He then took four of us to lunch with the Jacksonville (Florida) Advertising Club. After our presentation, the club president asked for donations to help us. The professor halted that and stated that what we wanted was for the club to underwrite costs of the whole project. To our surprise, the club then voted to do just that! We floated back to the University, knowing that we had just had a lesson in salesmanship. Students from other universities as well as personnel from advertising agencies attended the program. We learned that those of us at the University of Florida were products of a humanistic orientation having far less aggressive attitudes than those held by students at Miami University. The program went well and several of us made contacts that helped us later to obtain employment.

From the time I entered the University of Florida in 1950, I spent only brief visits in Orlando or at home in Georgia. I was in school full-time, even during the summer of 1951 and 1952. I was deeply involved in my studies and in the social life of Georgia Seagle Hall. I felt that I had less and less interest in family visits. As I see it now, I had little time for dates or social life of any kind. I had no gay attachments among the many gay students and professors.

I graduated in 1953 with a Bachelor of Design degree or BD degree as is usually associated with the Bachelor of Divinity degree. Interestingly, I have had to clarify this ever since. I sent graduation invitations, but not one member of my family could come to the graduation. Henry Buck and his family included me in their celebrations, but I did feel so lonely and neglected at not having any of my family in attendance. Marvin certainly could have attended. I had to rationalize their absence by remembering that the cost would have been prohibitive for them and that the social setting would have

been quite alien. However, this event still added to my alienation from the family.

At the University of Florida I had three years of near celibacy as I engrossed myself in my studies and work and spent free time with Henry and Joan. I was absolutely attracted to my friend Harry, even though I knew very well that he was straight. My feelings for him led to many enjoyable but very frustrating times with him. Interestingly, Harry came to play a major role in my career decisions the following year. I came to know a lot of gay students and professors but failed to get involved. Unbelievably, I left with only three student friends, none of whom were gay! I did leave behind two professors with whom I had become friends. After life in Hawaii, life in Florida was really dull, but I was too occupied to notice.

Saint Augustine

As I neared the end of my senior year of college, like my fellow students, I sent out resumes and waited for the world to call. Few calls came, but I did get an invitation for an interview with an advertising agency with headquarters in St. Augustine, Florida. I arrived early for the interview, and I was waiting in the lobby when Ken, a classmate, came out of his interview for the same job. After my interview I got the job and Ken never spoke to me again.

After graduation, I took my meager belongings, including my art work, to Marvin's home in Orlando. Marvin did not relate to my art, especially to my paintings, but he was kind enough to store them while I went to St. Augustine to locate an apartment. I bought my first car, a small blue 1950 Ford, which I drove to St. Augustine as if it was the finest car in the world. I did not return to Orlando until Christmas, when I discovered that Marvin had stored my paintings in the rafters of the garage. The heat had damaged many of them, but I was not in a position to be angry or to say anything to him about it. After all, he had no way of knowing their value to me or that the heat might damage them.

Although my education had been in commercial art, I never did any art work in my job. Instead, I had the title of Production and Traffic Manager. In that capacity, I had to keep a schedule of every item handled by the agency. From the time a client placed an order for an ad or brochure or article, it was my responsibility to log its circulation. I sent it to the copy desk, the artist, the client, production and placement on time, and without error. If anyone detected an error, it was my responsibility to know where the error was made and by whom. Obviously, we operated my office at a hectic pace. The pressure was tremendous. My two secretaries and I worked very hard. The artists hated me when I had to pull them off one job to expedite another. One of my secretaries regularly purchased a bottle of wine every afternoon after work. The staff artist would grab a beer and head off to fish. I regularly went for a drink at my favorite bar and then for a swim before I went to participate in the community theater productions, where I could escape the tension of my job. This pressure, along with the hypocrisy of the advertising world, was simply too difficult for me.

Madaleen

My social life improved in St. Augustine. I became involved in the St. Augustine Little Theater, where I met a great group of people. It was through this group, in the spring of 1954, that I met Madaleen whose sister was very active in the Little Theater. Madeleen was a vivacious woman about my own age. She was married to a violinist, employed in New York, with whom she had two children. Our mutual attraction was immediate and powerful. She had come to St. Augustine on vacation alone to visit her sister. On the evening of her birthday, her sister asked me to invite Madaleen to dinner and to keep her away from the house until the party was ready for her about ten o'clock. We had a light dinner and drove along the beach. During these few hours the tension grew unbearable. At nine-thirty I told her that I had to get her home. She did not want to go home. She wanted to know

why I was afraid. She even asked if I was gay My excuses ran out. I had to tell her about the birthday party, and I promised to date her the following night. The party went well. We dated the following night and each night afterwards during her vacation. Madeleen was the most passionate woman I had ever dated. Nights with her and the theater, along with full days of work, were ruining my health. Friday, her final night in St. Augustine, was one night I shall always remember. We corresponded through friendly letters for about two months. In one of those earliest letters she told me that she was pregnant and that her husband assumed that it was his child. We left it there, and I have not seen or heard from her since. The idea that the child may have been mine has always disturbed me. I don't even know the gender of the child. Of course, I would like to know if the child is mine, but I could not think of causing her family the almost inevitable disruption that such truth would surely prompt. Even today I have a haunting desire to know that person who most likely is my child. I have to assume that I shall never know.

The theater group and the servicemen in St. Augustine presented many opportunities for gay relationships. However, St. Augustine still had a small town atmosphere; everyone seemed to know everyone except the tourists and visiting service personnel. Becoming too involved in the gay community, and certainly being known to have a mate, would most certainly have jeopardized my social relations as well as my job. Furthermore, I was trying to convince myself that I did not need gay sex; that I could overcome my desires. I discovered that my closest friend in the theater group, who had a wife and three children, was bi-sexual. He was my only gay involvement in St. Augustine. The year passed rapidly because I was so deeply involved in work, theater and social events. I think it was a good period in my life with many maturing episodes.

However, at the end of my first year I realized that the pace of advertising work and the low pay was not the life I wanted. Pressure in the advertising business is tremendous. I left the agency with no job in mind and no direction except to go home for a rest. I packed everything into that blue Ford and drove to Georgia. En route, I

decided that I would go back to Hawaii. After a short visit at home, I bade the family good-bye and drove to the University of Florida to say good-bye to my friend Harry. I was very fond of Harry and could not think of going off to Hawaii without a farewell visit. However, within five hours Harry had persuaded me to stay at the University of Florida, to share an apartment with him, and to pursue my master's degree in art education. Thus, ended my escape to Hawaii.

I went to see professor Dale Summers who congratulated me on my decision and advised me to enroll. Dale clearly understood that my personality was not suited to the pace of advertising. He did think that it was most important for me to learn that for myself. To my absolute surprise, the following day I enrolled in the graduate program to become a teacher. Ironically, upon graduation from high school, my brother Marvin and I both had refused scholarships to the University of Georgia's School of Education because neither of us wanted to be a teacher. Psychologically and emotionally, I closed the door on St. Augustine and opened the one to a new life-long career.

This chapter may read as though I am confused or disoriented during this time in my life. Indeed, I was confused, ambivalent and insecure. Leaving my first job seemed like a defeat, and I was depressed. Only Harry and Dale gave me direction and optimism.

Return to the University of Florida

Harry and I rented an apartment very near the University that we shared with two other students. Harry was a small young man from Jacksonville, Florida, with smooth light skin, blond hair and a gentle personality. He was a beautiful person, a straight guy. He was a Presbyterian, and our two suite mates were Jews, one orthodox and the other liberal, which led to many interesting discussions about religion. During the year, Harry and I occasionally double-dated with women. However, we enjoyed many evenings together sitting on the pier at the lake enjoying a few beers. We often watched the sun set or the stars fill the dark Florida skies. We simply enjoyed being

together. Harry never knew the struggle I had with my emotions. The psychological conflict within me was, at times, almost unbearable. I discussed this only with Professor Jim with whom I resumed the work I did with him in undergraduate school. In the spring semester, I went to do my internship in Orlando. Harry graduated in May, and we lost contact until 2012. That had been one year of celibacy with a great friend. Fifty-seven years later we renewed our contact and friendship. I thanked him for what he had done for me.

My courses in education proved to be much more suitable to my personality than was commercial art. Dale continued to be my mentor and guided me through some tough times. He and his wife, Irma, took me into their home for the last two weeks of the semester, when I returned from my internship. Dale introduced me to Marion Davis, who taught art at the laboratory school. She practically adopted me and offered me extensive encouragement. I remember her sage advice that, "If you want to be a big fish swim in a small pond"! That idea has given me solace many times since.

I did my internship at Memorial Junior High School in Orlando during the spring semester. Glen Bischof, an art education classmate, also did his internship in Orlando at Cherokee Junior High School. Marvin and Carl invited the two of us to live with them for that short time, and we accepted the invitation. My supervising teacher was Julie Powell and I admired her greatly because she was a very good art teacher as a well as pleasant and generous person.

I loved teaching students in the Jr. High School age group. I was simply amazed at their creativity. I did have one unpleasant experience there. My university supervisor was a music educator without experience in practices of creating art. During one visit, he observed that "some students were not on task." Three ninth grade discipline problems were the culprits, out of an otherwise on-task class, to be exact. Then he suggested, or directed, me to "consult each student at the beginning of class to ask what objectives the student had for the class period." He instructed me to again "consult with each student to help the student evaluate the progress made during the class." One will have to realize here that the class period was only

fifty-five minutes for a class of 32 students. My supervising teacher and I knew that his was an unreasonable request and that it would preclude my teaching anything. So, the following day, I explained to my students what instruction I had received. They laughed as if it was a joke until I explained that I was a student-teacher and needed their cooperation. Each student, every student, got busy, and cooperated with me. The process did indeed take up the entire fifty minutes. I then wrote a letter to my supervisor in which I described what I had done and what resulted. I also pointed out that it was an unreasonable request from someone who had no practice in the dynamics of art learning, which is quite different from music class functions. That letter brought a response from my major education professor which stated, "Who are you, an intern, to pass judgment on the qualifications of your supervisor or to question his instructions?" That really burned me up, so to speak. Nothing was said about this when I returned to campus and faced my committee. I did not have to face that jerk. Glen had a successful practice teaching experience and returned to campus with me.

I graduated and received my Master's degree in Education (M.Ed.), in August, 1955. Again, I sent invitations to my family. None of them attended the graduation. However, my cousin Myrtle did bring both Aunt Beulah and Aunt Dora to visit me just before the graduation. I really appreciated that visit. The graduation ritual was, just as it had been for the baccalaureate graduation, en masse as hundreds of us stood to be recognized and awarded the degree. Only doctoral candidates went across the stage to receive personal recognition. I felt that while the education had been a valuable experience, it was now ending in a medieval farce, in a ritual that had little meaning. I was ending a year of what I thought was a great achievement but with so little psychological reward. Am I bitter or resentful about these experiences? No, indeed, I understand the family economic situation and the family social temerity. I also understand the relevance of the graduation ritual as a tool to garner support for the university.

In August, 1955, I returned to Orlando and to my first teaching job in Memorial Junior High School, where I had interned. My classmate

and friend, Glen Bischoff, obtained a job in the Cherokee Junior High School where he interned. It was an exciting time for me. I thought that I had ended my association with the University of Florida, and I really thought that I was through attending college. How could I possibly know that in only a year I would be taking other classes or that I would later return for further graduate work?

CHAPTER SEVEN
THE ORLANDO EXPERIENCE

Memorial Junior High School was the oldest school in Orlando, but it was in good condition. It was a brick building on Lake Eola in the heart of Orlando. It had three floors and a basement. The art room was formerly the Home Economics facility, and it was a spacious, well- equipped space. The Principal, Charles Terry, and the assistant principal, Bill Frangus, were two of the most effective administrators I have known. Since I did my student teaching internship in this school, I was familiar with the facilities, students and faculty. I was at ease in the school and with the students. My former supervising teacher, Julie Powell, had moved to a new school. My first teaching job was off to a good start. In the second semester, I accepted my first student teacher from the University of Florida, and I had a new student teacher each semester I taught thereafter. This earned free tuition for me at the University of Florida.

Glen and I rented a lakeside house that had been unoccupied all summer. We had packed all of our possessions into two small cars and arrived on a hot Saturday afternoon in August. Both of us wore khaki trousers, and, as we walked through the house, fleas covered our pant legs. We hurried out, called an exterminator, and went to spend a few days with Marvin and Carl until we could go back to the house. Glen and I had a most enjoyable year in that house on the lake because we both liked the quiet environment away from school, as well as swimming and fishing.

The Junior High School Experience

When I reported to the school, the principal told me that I would be teaching art and world geography. I asked, "Why am I assigned to teach geography?" H replied, "You had a course in World Geography at the University of Florida." Glen found that he was to teach art and mathematics. It pleased me that I was spared the task of teaching math. I had one geography textbook that I read quickly and prepared lessons accordingly. However, that was a difficult course for me and probably a boring course for those students.

One day, a rather unattractive boy, whom I had judged to be somewhat dull, arrived in class with something bulky under his field jacket. Once in his seat, he removed it and placed a six inch alarm clock on his desk. I took that as a clue to change tactics in that class. I also reappraised the intellect of that kid.

Another boy in that class, who had great difficulty speaking, reporting, or reading aloud in class, came to see me in my classroom after school. He had a very-high pitched voice and would become extremely nervous when he had to speak in class. He told me the story of conflict between his mother and an aunt who was trying to dominate his life. I learned that the mother was a Christian Protestant while his aunt was Catholic. There was an ongoing tug of war over which religious practice this boy should follow. It was practically destroying the boy's self esteem and motivation. He was intelligent enough to know that but unsure just how to handle it, since he loved both persons. During three such visits I encouraged him to discuss his views of the two religious orientations and his relationship with his mother and his aunt. I asked him to realize that neither of these relatives could live his life and that each of them had a life that they had chosen. I told him that he would have to do the same. Furthermore, I encouraged him to see a medical doctor and then a speech therapist to get his voice under control. Much to my surprise, he went home and told his aunt that she would have to lay off trying to influence his religious preference. He then persuaded his mother, to take him to a doctor who gave him hormone treatments. Happily,

during that school year his voice changed, and he no longer had problems with class participation.

I soon realized that teaching geography by "the" textbook was contrary to my method of teaching and that the varied capabilities of my students made any single textbook unsuitable. This was in direct conflict with my teaching practices in art. The Principal told me that I would be teaching the same subjects the following year. So, I went back to the University of Florida the following summer to study geography. I also got the principal to promise that I would have at least four textbooks for that class.

The following year, I changed my teaching practice to a thematic research approach in understanding human geography. The teaching and learning improved. At the beginning of the year, the students and I discussed the content of the course in world geography. Together we set themes that we would research during the year. One such theme was world religions and their major locations. The class contained three Jews, two Catholics, several Baptists, a few Methodists, members of The Holiness Church and several Seventh Day Adventists in the class. It was not permissible for me to ask students about their personal religious practices. However, they volunteered to discuss their religion before they researched other religions. They also asked if we might visit churches and synagogues within walking distance of the school. It turned out that the three Jewish students were of different sects, but gave a general description of what they saw as Judaism with emphasis on the one God. In discussing Christianity, the topic of the Trinity came up in a general discussion. Later, when we approached Buddhism, a Protestant girl asked aloud, "How could there be so many gods?" To which one Jewish boy retorted, "Why not? You have three!" One can well imagine how quickly I diverted that discussion. When we had finished the unit, I requested that three nearby churches and synagogues permit us to visit. Each welcomed us. I then discussed this with the Principal who supported me in doing so. However, the following morning I had a telephone call from the Superintendent. He asked me, "Please do not take students on that field trip because my telephone will ring off the hook with parents

calling." I relayed this message to the students. They then entered into a discussion about religious tolerance, inter-faith relationships and territorial claims.

Jeff was an eighth grade boy, somewhat larger than I, who cursed repeatedly in class. So, one Saturday I invited him to go fishing with me. When we were on the lake, far from the shore, he lost a fish that he had hooked and he sounded off with a long line of expletives. I asked him to sit quietly, to assess the distance to shore and his ability to swim there. He said that he could not swim that far. I then asked him to look directly into my eyes as I explained that his cursing would result in his having to swim to shore. I explained that only he and I were available to hear his curse words and that his ability to use such phrases did not impress me. I assured him that I would be far more impressed by his better command of English. We became good friends, and I never heard him curse in class again. These are only a few of the many stories of students whose personal and family problems directly affected their learning and my teaching. Any good teacher could cite them endlessly.

Teaching boys and girls in their early teens is a challenge in any subject, and I soon decided that the content of the course was not what counted. It was the student that mattered, and the student at that age had many things that were more urgent than learning from the text book. I felt that I was more successful in teaching art than any "academic" subject because my emphasis was on nurturing a child through art experiences and human relationships. I learned that I could teach other subjects much the same way, that is, by making the learning relevant to the child's interests, allowing for flexibility, and meeting the needs of the child at his or her individual level of understanding.

The school had very limited art supplies, so the students and I scavenged materials for some very creative projects. For instance, we used palm fronds for weaving experience and made some intriguing art forms with them. A student found a place where a plastics company was discarding scraps of plastic. We gathered up a lot of it and learned to heat it for bending, cut it and glue it so that we made sculptures and

architectural forms. Thus having to gather materials, we were forced to be inventive, the very core of creativity. I never again had such an exciting, open-ended and creative teaching experience.

Cathy

During an art demonstration to a group of seventh graders, one boy named Johnny asked me "why aren't you married?" I replied, "I have never met anyone who wanted me." Immediately Johnny spoke up to say that his mother would. I offhandedly replied that I would have to meet her sometime. To my surprise, he was being honest, and the following day he invited me to dinner at his home on Friday evening. I called his mother to make certain that she had invited me. I then did some research through which I found that her husband had committed suicide a few years earlier. His mother was an attractive person, and our visit was very pleasant. She was preparing fried chicken for dinner and much to her embarrassment, she overcooked the chicken. We laughed about it, and we enjoyed the dinner. Afterwards Cathy and I dated and enjoyed a good relationship for a few months until she met and married a retired military employee who provided her with far more financial security than I could. However, only three weeks after the wedding, I came home one evening and found that Cathy had left a letter on my door. In it she expressed disappointment that her husband had an injured back and was unable to provide adequate sex. I called her, and, after a friendly discussion, we agreed not to try to continue our relationship.

Unala

Another student, named Robert, who was a friend of Johnny's, also invited me to meet his mother, Unala, whose husband had also committed suicide only a short time earlier. Unala and I dated about two years (1957-1959), during which we had the closest family relationship that I ever had. I thoroughly enjoyed that relationship, and

if I was ever in love with a woman it was with Unala. It was to Unala and Robert that I wrote diary letters during my first tour of Europe in 1958 and with whom I left my '56 Thunderbird car. Shortly thereafter, Unala decided that we should be married. There was no discussion on the subject, but during a romantic evening she went to the dressing room and emerged with a beautiful wedding dress. I was absolutely shocked and embarrassed. I remember having what I called a cold spell. My diplomacy failed me, and I made a calm but early exit. We did not see each other for two weeks. Unala was a dental technician for my dentist with whom I had a prearranged appointment. I kept the appointment, greeted her cordially and she seated me for service. The dentist gave me two heavy doses of anesthesia and I passed out. When I recovered Unala was standing over me bathing my face with a cold cloth. We both shed tears, and the doctor excused himself for a few minutes and then resumed the treatment. We resumed our dating for a short time. During the spring of 1960, while I was back at the University of Florida undertaking my doctoral studies, Unala met and married an Italian American and moved to California. She took with her all of the dairy letters that I had written. I did not hear from her again until twenty years later when she divorced and moved back to Orlando. Only then did she finally give me the letters from Europe, my diary.

I loved those junior high school kids and I enjoyed teaching art and world geography. Within a few months, I knew that I had finally found a profession in which I would be happy. I liked the energy of those teenage kids. I took great delight in their creative abilities. I also found that my colleagues supported me in my work and as friends to a far greater extent than what I had experienced in the advertising field. Some of my colleagues from those years and I are still in contact, Some of those students still exchange Christmas cards and notes with me.

In the spring of 1958, Orlando began a population growth that, within only a few years, would change the entire city. It was the year in which two new high schools would open. Charles Terry, my Principal, invited me to accompany him in his move to Boone High

School. I made the change with him, not only because I liked him as an administrator, but because I felt that in three years I had built a good art program at the junior high level. I needed the challenge of doing the same thing at the high school. Fortunately, that was a rewarding move for me. I was starting a new program, still dating Unala and having success each semester with my student teachers. Also, I received an invitation to go to Europe that summer. So it was a beautiful time for me.

Europe 1958

Jim, the University of Florida professor with whom I worked and with whom I escorted the students to New York, had made regular trips, often with students, to Europe each year since 1948. He had a contract with Brownell Tours in Birmingham to escort a group of thirty-four members on a tour of Europe. He convinced Brownell that for him to escort that many he would need an assistant. Brownell agreed, and Jim asked me to go with him. It was a great trip, which the following year, began my own assignments to take tour groups to Europe for Brownell Tours.

I was, at this time, dating and deeply involved with Unala and her son, Robert. I had also recently bought a 1956 Ford Thunderbird red-and-white convertible that I left in her care for the summer. I hardly remember my trip from Orlando to New York because I was emotionally disturbed; disturbed about leaving Unala all summer, uncertain about the care of my car, and greatly concerned about my ambivalent feelings for Unala. I knew that she wanted us to be married, and I knew that I could not subject myself to that. I later found myself missing her greatly. I found myself thinking, often in tears, as I encountered such beauty on this tour, how great it would be to have her sharing the experience. I wrote her each day and asked her to keep the letters as a diary from which I could later extract notes as my description of the tour. This would later become quite a

difficult issue between the two of us. The message that I sent from New York read in part:

"My heart was so empty last night as I flew away from the two of you. Someday I will give in and let emotions find fulfillment in the warmth that comes with having someone like you. One of the benefits of travel is that we see ourselves and our life in a perspective much like looking at a painting from a distance. The details, the mire, the pettiness and the joys fall into place to form a whole picture from which we may try to escape, change or accept. In my view the painting must grow, I must make changes. If you had not seen me off last night I would probably now be resentful, lonely and cold. Thanks to you, I left with a wonderful feeling of belonging and worth. Love you both."

Jim and I met our tour members in New York for a briefing prior to our departure aboard the Greek ship The Queen Frederica. The group of thirty-four was simply too large, and keeping track of their sixty-eight pieces of luggage was a frightful task. The tour members were roughly evenly divided between an older group and the college age group. My two assignments were to help with all luggage transfers, count bags, and to cater to the college age group.

This was an exhausting trip to twelve countries in six weeks. It was one that opened new horizons for me, and it gave me first-hand information and experiences that I could relay to my students that fall! The maps, in the language of the country, which I collected from each country, along with my many slides, certainly gave me teaching materials that greatly interested the students. We sailed from New York to Barcelona, Spain, for a brief tour and on to Genoa, Italy, where we disembarked and began our bus tour through Europe.

The Queen Frederica was a good ship, smooth sailing, and with adequate cabin spaces. Of course, we were traveling tourist class with four to a cabin. I roomed with Jim and two male students from Miami. I quickly learned that if I dressed appropriately I could spend time in the first class areas, so I conveyed this to our members. One night some of the college students accompanied me to the first-class

lounge for dancing until the lounge closed at 11:00 p.m. We then went to a lower-level to dance to a different kind of music until it closed at 1:00 a.m., and on then to the lowest level, where we joined Greeks in all-night partying.

One afternoon when I was exploring the ship, I came upon a Greek monk sitting in an open doorway at the side of the ship near the water level. It was very quiet there, so I just sat, as he was sitting, with my feet hanging over the side. Neither of us said anything. We just enjoyed the silence as we watched the dolphins and fish and meditated. My mind soon wandered back to Orlando and to Unala. So I continued my explorations.

One tradition on the Frederica was an evening party and Miss Frederica contest. We encouraged one of my students, named Dee Dee, to enter the contest. She was a tall blonde, and she was quite a sight as she towered over the shorter, mostly Greek, contestants. She was a hit. She won the title. She and I were then invited to the officers' party. As that party progressed, she and I decided that we had better make a courteous exit because the officers were getting a bit too amorous with her.

We were met by our European courier in Genoa and began the land portion of the tour by bus. We traveled along the Mediterranean coast to Rapallo, to Grosseto, and to Naples. The area between Genoa and Rapallo was absolutely beautiful. I remember now the dark green vegetation and the multicolored flowers of the bougainvillea against the azure sea and blue sky. At one point, I was in tears, and Jim thought something was wrong. I explained that it was simply the beauty and my thought of sharing this with Unala that disturbed me. No words can describe how that beautiful setting moved me, and I swore that I would see it again.

Rapallo is a lovely town situated on a beautiful concave beach. However, Jim advised me to take a buggy ride instead of walking the short distance to Portofino. A lady on the tour accompanied me, and en route I was able to express to her some of my emotional responses to my experiences. It was good to talk about the experiences, and how I was feeling about Unala. All of this talk abruptly ended when

we rounded a hilltop curve where we could view the port town of Portofino because it was beautiful; red roofs and white yachts against the azure blue of the water. What a visual feast!'

The next day, between Rapallo and Grosseto, we made a rest stop in a small coastal town. The unisex toilet was a small outdoor facility for only one person at a time. We lined up and as the first, then second and third person exited, they were each laughing too hard to speak. The toilet had only a hole in the floor with a foot print impressed on each side. The water tank was above head and when one pulled the chain it flooded the entire floor! Jim laughingly remarked, "Welcome to Europe!"

As we entered Naples we encountered a long funeral procession of horse-drawn carriages and the hearse, followed by a long line of automobiles. Men on the carriages wore black suits with high-topped hats. We followed this procession ever so slowly down into the waterfront, where our hotel was located. Naples is certainly a city of contrasts. The waterfront hotels and the beaches were impressive, but the horse drawn buggies for tourists made the sidewalk café service undesirable. I found that we could walk safely only along the waterfront. The area back of the hotel was a poverty area and unsafe.

We made a trip across to Capri for a beautiful boat ride into the Blue Grotto and a chairlift to the upper point of the island. We went to the entrance to the Blue Grotto, where we transferred to a much smaller boat to enter. The water level in the grotto rises and falls with the tides so that the entrance is closed at high tide. As sun shines into the entrance it reflects onto the cave top, and a swimmer's body glows as if it is effervescent.

We then drove to Rome, where we toured all of the regular tourist sites. I was very impressed, above all else, with the Vatican. Of course, I had never before seen a cathedral or such an array of great art. It was as if my art history classes were finally becoming a reality. The massive size, the frescos and the sculptures were, as my students said, "Awesome."

Jim and I had one evening in a family home with his friends from

World War II. The couple spoke English, but they invited a young lady to have dinner with us who did not speak English. The home and the dinner were equally impressive, though I had no idea what I was eating! At the end of the evening the couple suggested that I escort the lady to her home a short taxi ride away. That was one awkward ride, to say the least. But it was a memorable evening.

Then it was on to Florence. What a beautiful city! It is the kind of city that invites one to walk, explore and relax in a friendly café or at sidewalk tables. We checked into the very contemporary Hotel Mediterraneo. My room was quite spacious with an oversized bathroom. However, the shower did not have a curtain or any enclosure. Shower water wet the entire bathroom. One had to leave articles in the bedroom while taking a shower. The hotel was centrally located so that we could walk to many of the sites and museums. On one such a walk, Jim was rushing me to see a lot of art: his favorite Baroque and Rococo. I noticed that one museum was currently showing works by Kandinsky, which he bypassed. I rebelled after we had finished viewing the impressive Michelangelo sculptures. I sat on the curb and asked Jim to leave me so that I could enjoy the Kandinsky show.

The Kandinsky works were like some form of recuperation from the excessive sweetness of the Rococo. I really enjoyed his works and the leisurely walk to the hotel. It is amazing how such small events are so long remembered. However, one cannot but be impressed by the rich history of this city, its magnificent architecture and the great artists, merchants and philosophers who contributed so much to Western Civilization.

From Florence, we drove via the Passo della Collina to Bologna for lunch and continued, via Ferrara, across the great Po River to Padua and to Venice. Of course, Piazza San Marco and the Doges Palace, with its massive flocks of pigeons and people, would impress anyone. The activities of people, the gondoliers, the busy narrow walking spaces, and, I must mention Harry's Bar filled with Americans, contribute to the cultural energy of this city. I even met a professor from the University of Florida enjoying the activities in Harry's Bar.

I did get a few hours on Lido Beach, which gave me respite from the pace we were keeping on the tour. The Murrano Glass studios and shop were very impressive, and I still treasure the item that I purchased there.

I am finding that each city is a jewel well worth longer stays or returns. I suppose that the short visit in each is adequate for an initial tour to the very unfamiliar sites. However, I find that Italy is such a very romantic country that I just want to linger there. Ah, the food! I have loved every meal. From Venice, I wrote to Unala:

"Unala, I do feel better after having received your letter. I am very aware that you love me. I feel guilty, or at least a little mean, at my inability to understand my own ambiguous feelings about us. It seems that I love you in spite of myself because I find it so wonderful that you love me. I realize that during my last week at home, which meant a lot to you, I was tense, rushed and distant. However, I warned you earlier that our relationship was likely to be that way. I am a very lonely person because of my inability to be close to anyone in a romantic and lasting way. I guess that art is my escape. I do all that I can to make everyone love me and to harm no one. I do not dwell on dislikes or hate, yet I am afraid to really love anyone. I often cry about this and I recognize events that brought me to this state. I have loved with all my heart and I have been too often used in return. These pains callus the conscience and shade subsequent responses to love. My overwhelming drive for education and accomplishments has taken precedence over amorous commitment even when I had truly loving relationships. I find it very difficult to change those priorities. You and Robert now play an important part in my life and I am trying to figure this all out in my mind. I send my love and a 'good night, Robert' from Venice."

The morning drive from Venice along the coastal region of the

Gulf of Trieste across the Piave River, via Monfalcone shipyards, introduced me to open vistas in contrast to the city tours. Trieste is picturesquely situated on the eastern edge of the Gulf of Trieste and is one of the most important of Italian seaports. Lunch on the plaza overlooking the gulf was a pleasant event and I am well aware that leaving here means departing Italy as well. After lunch, we headed to the Italian and Austrian border crossing to Klagenfurt, Austria, via Bad Villach on the River Drau, and the two elegant resort towns of Valden and Portachach on the Worther Lake. This was only an overnight stop en route to Vienna.

This drive to Vienna certainly introduced us to the beautiful mountains, rivers and lakes so readily associated with Austria. We drove from Klagenfurt to Vienna, with lunch in Bruck-on the-Mur via St. Veit, noted for its ancient strongholds and ruins, Neumarkt, Leoban, and the Sammering Pass to Vienna. This was an exciting, visually beautiful, day long drive leaving all of us rather exhausted!

However, the following morning we were off on a tour of the city and an afternoon drive to the Wiennerwald (Vienna Woods). The following day was at leisure. However, we left Vienna at 3:00 p.m. Thus, Vienna remains an enigmatic music center that I barely experienced. We drove to Salzburg along the Danube River with an overnight stop in Linz.

After the overnight stop in Linz, we drove along the beautiful Traun Lake via Wolfgangsee and the famous resort town of St. Wolfgang to Salzburg. The afternoon tour of Salzburg included a trip through a salt mine, a memorable event. We took a chair lift to the mine entrance near the top of a mountain where we were dressed in white suits, saw several exhibits of the salt mining, and boarded a rail line astraddle wood logs for a breath-taking ride to the lower exit.

Next we were en route to a city that I have anticipated: Munich, Germany. We traveled on the Autobahn past the famous dream castle of Ludwig II, through magnificent Alpine land, up the Irschenberg, the highest point of the Autobahn, descending to the famous Mangfall Viaduct that spans the 200 foot deep Mangfall valley. This was a beautiful trip.

Munich (Munchen) exceeded my expectations. I found it to be a sensuous city in a way that is quite a different sensuality than that of Italian cities. It is a city of great beer gardens and fun-loving people. The hospitality and energy was apparent from the first encounter. However, it is also a city of great art, and sunset music in the parks. I remember the wedding cake look of the great building named the Rathaus. The second evening in the Rathaus, I met an American Airman who was celebrating his last night in Europe before returning home. He later took three of us on a midnight tour of three great jazz bars. What a great treat. Amazingly, I came to realize what an exciting city Munich is in only a two-night visit. Fortunately, I was able to revisit Munich again on a later tour. Now, on to Zurich, Switzerland.

Upon leaving Munich, we drove via Landsberg with its Kaufbeuren fortress, where Hitler had been imprisoned in 1923, to Bad Schachen on the shores of Lake Constance (Bodensee) for lunch. Thence we traveled via Meersberg, across Lake Constance by ferry to Konstans-Staad, and via Winterthur to Zurich. The one day in Zurich was spent on a trip to the beautiful city of Lucerne. There, of course, we visited the watch factories and took a chairlift to the top of a glacier for lunch. I remember the silence up there as well as the sound of air through the wing feathers of the swiftly diving birds. It was a memorable day.

After two nights in Zurich, we motored on to Baden-Baden, Germany. We stopped along the way to see the Rhine Waterfall as it plunges in three giant leaps from a height of eighty feet from the 370 foot wide Rhine River above. Then we drove via Bergen, through the Black Forest, to Triberg for lunch. Afterwards, we drove through more of the Black Forest via Freudenstadt to the health springs resort town of Baden-Baden.

I remember Baden-Baden for the evening sunset, music in the park, the great beer steins, and gay couples making love in the park just out of public sight. One of our tour members, fourteen year-old Tommy, asked me, after the evening music, to play miniature golf with him. To my surprise, we played until one o'clock a.m. He was

traveling with his parents, and I was nervous about bringing him in so late. The following morning I was again surprised that they had not even been concerned. Later during the tour I learned that Tommy was gay as was his older brother. Thus I remember Baden-Baden.

From Baden-Baden we drove to Wiesbaden with a tour of the university town of Heidelberg and lunch at the famous Red Ox Inn. That was a really a most enjoyable lunch, and I was impressed with the hilltop view of the city, which seemed to flow down through the valley below us. The afternoon trip took us by Darmstadt to the famous spa city of Wiesbaden for only one overnight stop.

The following morning we drove from Wiesbaden to Assmannshausen, where we boarded a small ship to cruise the Rhine River to Bonn. That Rhine River cruise was a great experience as we viewed the passing German landscape and the many castles along the way. The hospitality of the other passengers and crew, as well as the beer and lunch, left fond memories of the journey. In Bonn, we disembarked and rejoined our bus for the fast Autobahn drive to Cologne, arriving there just in time for a great tour of the Cologne Cathedral. Of all the cathedrals and churches I have seen, I am still most impressed with the Cologne Cathedral. It is especially beautiful at night with its lighted copper roof.

Believe-it-or-not, the following morning we drove on to Brussels, Belgium, via Aachen and Liege. This is about midway the length of the tour. Some of the older participants were now feeling tired and, indeed, I was tired of counting bags. The process of collecting all passports for so many border crossings and hotels had been quite a chore. Some of the younger members were a bit irritated at not finding the night life that they expected Finally, I was beginning to enjoy the tour and the tour members with less thoughts of Unala. In Brussels, I found some private time during which I decided that, upon my return to Orlando, I must find a way to end the romance with her. It was, I thought, necessary for my own sanity, progress in my career, and to be utterly fair to her.

We arrived in Brussels about 1:00 p.m. on July 13, just in time for an afternoon tour of the inner city and the World Fair. I really

don't remember much about the city except that it was the year of the 1958 World Fair with its giant silver architectural structure in the form of an atom and the overhead cable rides to various sections of the fairgrounds. For this trip, at least, the fair took precedence over Brussels' fine museums.

The following morning we drove via Antwerp, Belgium, and The Hague, where we had lunch, to arrive in Amsterdam, Holland, about four-thirty in the afternoon. The next day, we had a short tour of Amsterdam, including the famous Rijksmuseum followed by "the Grand Holland Motor Tour" to The Hague, Scheveningen, Leiden, Haarlem, Volendam and the Isle of Marken. I had an empathic experience in the Rijksmuseum that I have remembered since. As I entered one of the galleries I came face-to-face upon a Vemeer landscape painting that simply grabbed my attention and, for several seconds, nothing else existed. I had never been so engrossed in any art as I was with that little view of the city! I have often related this experience to students in teaching them to "experience" art. Yes, I remember the dikes and windmills; of course we had to visit the diamond factory, and several tour members had to purchase wooden shoes. But, I remember the little Vemeer.

It was now time for us to leave our now familiar bus and driver, who had brought us from Genoa, through Europe to Holland, helping me count those seventy bags at each overnight stop. We took the train from Amsterdam's Central Station to Hamburg, Germany, and Grossenbrode Kai, where we boarded the ferry via Gedser to Copenhagen, Denmark. We arrived there just before noon, after a night of partying and beer drinking. It seemed to have been one fabulous party.

The next morning was free for rest, late sleep, recuperation! After lunch we had a sightseeing tour of Copenhagen by motor coach and a harbor tour by boat, including the famous Mermaid sculpture. The following morning we went by bus to North Zealand, Elsinore Castle and the Danish Riviera. While the Kronborg Castle in Elsinor was impressive, and I expected to see Hamlet there any minute, I really liked the waterfront Dutch Renaissance Frederiksborg Castle most.

The few Danes with whom I had contact were absolutely delightful people; hospitable, generous and sensuous. Nightlife was great, liberal, and with a thriving gay district. Unfortunately, time did not permit me to indulge here. But, I promised myself that I would return.

The next night, after dinner, we transferred to the rail station for the overnight trip to Stockholm, Sweden. This was my introduction to railway sleeper compartments, where four people occupy one compartment (room). These occupants may not all be with my group but may be from any place, speaking any number of languages. I learned quickly that the term "sleeper" did not necessarily mean that one actually slept.

We arrived in Stockholm at 11:35 a.m. for lunch, followed by a bus ride along rivers, forests and villages to our hotel. During the tour in Sweden, we visited the municipal building with its huge dining hall seating 800 guests beneath its barrel vaulted ceiling covered in gold mosaics. We also visited the Milles Gardens, the former home of Carl Milles, a famous sculptor who lived for about twenty-five years in Kansas and did some sculptures for Cranbrook Academy in Ohio. I like his sculpture.

On the morning of our departure from Stockholm, the boys took our bags to the rail terminal before I had time to check the count. Two bags were missing when we arrived in Oslo. Naturally, they belonged to the group's biggest complainers. I called back to the hotel without results, then to the police without results, and to the American Embassy, where I got results. They found the bags and shipped them to us in Paris. In the meantime, those two women drove me nuts; no toothbrush, no sleeping gowns, etc.

A young woman from Miami, who was on this tour, had driven all of us up the wall. So, today when she came down with menstrual pains, she got little sympathy. I learned that she had terrible personal problems trying to handle being raised an Orthodox Jew against which she was rebelling. She simply demanded too much attention, while being very caustic. I recorded my problems with her and sent them to the tour company headquarters for the record. I offered to

help her leave the tour and fly home. She refused to do so. So, as badly as I wanted to tell her to go to hell, I just told her that I was finished with her.

One college student who came on the tour with his girl friend had now come to the point of leaving her, and she was miserable. In my fatherly advice to the boy, I told him that he simply could not dump her or mistreat her on my tour. I told him that he would have to help me to make her happy until we landed in New York. This he did. Oh, God! I learned a lot on this trip.

The train from Stockholm to Oslo was enjoyable, swift and through some beautiful country. In Oslo, Norway, I saw the movie Windjammer. It was a beautiful wide-screen cinemascope production in English with Norwegian subtitles. The film follows a training cruise of a Norwegian sailing ship on a trip from Norway to the Caribbean, to America, and home. The movie begins in black and white, on a small screen, picturing a small sailing vessel on the horizon. As the vessel comes very close to the front of the screen above the viewer, the whole screen opens up in full color to everyone's surprise, providing an enjoyable venture with these young recruits.

We also visited the museum of ancient Viking ships that housed many of the tools, utensils, clothing, knives and sailing instruments from that era. Later, we visited the city hall with special notice of the contemporary frescoes. We then toured along the water front through hill country to an Olympic ski jump. During my last night in Oslo, I walked through the park and about the royal palace grounds at 12:30 a.m. It was still quite light, and people were still strolling about: lovers on the benches and children playing. I do not think I have ever seen such beautiful blond hair as I saw in Oslo! Beautiful people!

I was now feeling much more resolved to end my romance with Unala and I felt good about the decision. I also found that I was now enjoying the experience without constantly having her in mind. I felt, in short, relieved!

It was now July 23 and we had a two-night trip by ferry to Newcastle, England. We passed some very lovely scenery as we sailed out of the fjord from Oslo to open sea. The water was smooth,

and everyone enjoyed a good dinner. However, on the following day, the water was rough and only about twelve of our thirty-one members could come to lunch. Our tour leader, Jim, was ill, as was Tommy's father, our medical doctor. The doctor and I were sitting together in the upper lounge area attempting to converse and ignore the rough sea. Suddenly, he appeared to turn a rather green color and the corners of his mouth drew down. He gave up and went below to join his wife who was already ill. I avoided getting sick by staying out in the open deck as much as possible. At times I would look out to sea only to be looking directly into a wave standing higher than the ship! Crossing those waves does crazy things to whatever is inside one. I even played a little shuffleboard, but I could not control where the puck was going on the shifting deck. The lady from Miami, who had given us so much trouble, was having menstrual pains, needed help to get from the hotel to the ship, and became seasick. Needles to say, she got little sympathy. I did have the ship's doctor attend to her.

We arrived in Newcastle in beautiful weather and boarded our train to London. Everyone seemed to revive rather well. Our train was an uncomfortable coal-burning train that rode as smoothly as a wagon and made the train trip to London little better than the ship ride. Newcastle and the scenery to London were gray from the coal dust. Due to the dust, the strain and tension, I developed another sinus attack for a rough first night in London.

We did the general tour of London including the Tower of London (the Crown Jewels) and Buckingham Palace. They had closed the Lancaster House due to the crisis in the Middle East. We saw the changing of the guards at Buckingham Palace, which I found to be impressive. During our stay in London, I watched on television as Queen Elizabeth dubbed her son, Prince Charles, Prince of Wales. One evening I went to a play (*The Party*), starring Charles Loughton. It was not a very impressive or exciting play, but when Loughton made his entrance his immediate rapport with the audience made it all worthwhile. I did not understand how an actor could demand such contact with persons in the audience, but Loughton could certainly

make it seem as if I were the only person there. I also saw and enjoyed Vivian Leigh in *Duel of Angels.*

Thankfully, Unala sent my tuxedo to me. Customs opened it and resealed it with a lead seal. For Jim and me, this was our evening away from the group. Jim and I dressed in the formal attire and went to the railway station about 3:00 p.m. for the trip to Sussex and on to Glyneborne for the opera and dinner. It was strange to see so many people formally dressed boarding a train. They served tea en route, but I found the ride too unstable to drink tea. When we arrived in Sussex we transferred to a bus for a short ride out to the beautiful Glyneborne estate for the opera. We ordered dinner before the opera began and ate during intermission. One could eat either in the dining room or at a lakeside picnic area. We first saw a short operetta titled *Secrets of Suzanne,* whose secret was that she smoked. That was followed by dinner, a stroll among the swans at the lake, a little turn at croquet and then the opera *Ariadne Auf Noxus.* After the opera, we rushed aboard the bus and then took the train back to London. We rushed to the hotel, changed clothes, packed the tux and delivered it to the post office for its return to America. I got to bed about 2:15 a.m., and I had to be up early the next morning. But, the experience was certainly worth it for I loved Glyneborne and the opera.

We went to Windsor Castle, which I thought was very beautiful. Princess Ann was in residence, so they did not permit us inside the gardens. We did go through the State Apartments where the Queen's staff works and where she entertains when she is in residence there. The dining table that seats 150, as well as other furniture, was beautiful. We then toured Hampton Court Palace with its extensive and beautiful gardens.

Luck came my way. The bags that we left in Stockholm, arrived at our hotel in London. It pleased me that the two old gals stopped complaining.

From London, we took a dirty train to the coast, transferred to a ferry across to France and another train to Paris. The French train was cleaner than the one in England, and the railway was smoother. But my God! They made up for all of it by being so very

uncomfortable The seats were hard board, straight-backed and too narrow. We felt tired and irritable by the time we arrived in Paris. Then we found our hotel to be totally unsatisfactory. The old hotel could not handle the entire group, so I took several of our members to another hotel. The original hotel did not offer any transportation for us. In the second hotel, our rooms were old, the food was not good, and service was simply non-existent. Of course, this all dampened our mood for Paris.

We toured the city generally, visiting the Louvre, the Arch of Triumph and the Eiffel Tower. All of this was exciting, but the scale of the Louvre and its vast collection just overwhelmed me. The trip to the Palace of Versailles was wonderful. That must have been a really grand place in its heyday. One night about fifteen of us went to dinner "in the trees," one of Jim's favorites, and now mine also. We went by subway out to a suburb of Paris, where we walked about one mile uphill. We then climbed steps up to the levels of our various eating places in a huge chestnut tree. We had a good steak dinner with lots of wine, good music and some dancing beneath the tree. The view of Paris was magnificent.

We visited Montmare, and I found it to be rather dead. I doubt that another great artist will ever come from this tourist joint. Then about twenty of us went to the Follies with great expectations. I had a $5 ticket, but when I saw what it was I quickly sold it to someone who wanted to see the show. Then I paid seventy-five cents to stand and see as much as I cared to see. The performance was colorful and loud. They spiced it up with a bit of nudity to keep the audience and to sell drinks. Anyway, I left early.

Jim and I took time away from the group to see a show of impressionist art and other modern art. It was refreshing and educational

Our hotel was in Montparnarse, about one-half block from the Church of The Virgin. The area abounds with not so virtuous ladies, some beautiful ones at that. From our hotel all during the evening we could hear their silly giggles and coarse laughter. As we went to or from the hotel, these women followed alongside and whispered sweet

remarks or followed just back of us as they made crude, suggestive noises. Oh, well!

I was up at 5:00 a.m. on August 3rd, the day of our departure from Paris to Madrid, to push those darn slow French porters into action. They finally got our bags to the bus five minutes after the train was to leave. Some of our girls were just coming in at 5:30 a.m. from a night on the town, and we had to leave at 7:00 a.m. Anyway, getting out of Paris during the first days of August was an adventure. It was the beginning of a national holiday, when everyone who can leaves the city. We left the hotel at exactly 7:00 a.m. When we arrived at the railway station it seemed that every Frenchman in Paris was there to take the same train out of town. We crushed through the mob of people and baggage and settled in our compartments by 8:15. Passengers filled the passageways. We were to have lunch in the dining car, so at noon some of us started the journey through ten cars to the dining car. We climbed over, around and through the people and baggage, ate, and made our way back to our compartment by 4:00 p.m.. Only nine of our members made it to the dining car, and the food was not worth the effort.

When we arrived in Irun at the Spanish border, we had to leave the French train, pass through the station and customs to a Spanish train that operates on a narrower gage track. The little station was hot, dry and dirty and smelled terribly. We had a little food there and then boarded the more comfortable sleeper train to Madrid.

I found Madrid to be a very nice city with very wide streets and green parks. The architecture is an interesting combination of Moorish, Spanish, Roman and European designs, making it of great interest to me.

We had a general tour of Madrid and spent hours in the wonderful Prado Art Museum, where I especially enjoyed the El Greco paintings. We made a day-long trip out to Toledo. That city is unbelievable! It rises right out of an arid, almost dessert rock on a narrow river. It is a city of some 43,000 people located in a broad expanse of wheat fields. The stucco or stone houses with their tile roofs are often the same brownish red color of the earth around them. We had a great

view of the city from the hillside where El Greco painted his famous View of Toledo.

En route from Madrid to Toledo, we could see for many miles over the rolling or level brown fields dotted with ancient looking olive trees and stark white houses. Often we could see small patches of green gardens irrigated by water drawn from wells by donkeys going in circles attended by an old man or a little boy. We saw wheat being threshed by hand and by pulling a flat sled over the wheat placed on dry, packed earth. The wheat and chaff were then separated by repeatedly tossing the wheat into the air. The chaff was then baled for animal feed. We saw many women washing clothes by hand at community wells, wash places and in streams. They laid the clothes on the earth to dry.

After a morning tour and lunch in the cool basement of a very fine hotel, I succumbed to the heat and had to lie on a couch until our departure at 4:30 p.m. I did get to see the Cathedral of Toledo. I made the return trip to Madrid reclining on one of the seats. The hot weather was difficult for many of us, and many of us suffered from diarrhea. We were unable to drink the water or milk or eat eggs, ice cream or unpeeled fruit. Several of the members had been very sick, and I had mild cramps twice.

Brownell Tours, with whom I was on assignment, had another smaller tour group, #922, directed by a Mrs. Buday, coming into Madrid. Mrs. Buday hurt her back by lifting a bag and had to go to the American hospital in Madrid. Brownell called from Birmingham, Alabama, to ask me to take her tour on through Spain and to meet our tour, #902, in Gibraltar. Brownell asked me to escort both tour groups aboard ship and to the New York dispersal. Jim wanted to stay in Europe a couple of weeks longer. This was a big responsibility for me as well as an opportunity if I handled it properly. Mrs. Buday was a lovely person, and I wanted to help her as well. So I agreed to do this.

I then wrote to Unala: "My dear Unala and Robert, I have enjoyed your letters. I am on a different schedule now and it is unlikely that I will get others. Nor will I have time to write during the remainder

of the trip. I will arrive at the Orlando airport at 10:57 p.m. August 19. I hope you will meet me there."

After Mrs. Buday was hospitalized in Madrid, I took charge of her tour of 27 college-age girls and two boys. The changeover gave me a couple of additional days in Madrid that I enjoyed. After dinner on the evening before we were to leave early the following morning, a 28th girl arrived to rejoin the tour unexpectedly, accompanied by her parents and a brother. She had requested to leave the tour in Paris for a visit with her parents and brother and rejoin us in Gibraltar. This was on a signed contract and my tour members were well aware of it. Nonetheless, here she was and our train and hotel reservations throughout Spain did not include her. In Spain, it was very difficult for us to even change reservations for me, a male, instead of Mrs. Buday; a female. Our confrontation in the lobby was very nasty with the brother even threatening me. Even if I could have gotten her onto the train, I could not have guaranteed room reservations anywhere, and Spanish morality forbids even thinking of her sharing even a compartment with me. Once I had made that point clear to the mother, tempers subsided. After a brief family discussion, they again threatened to call my tour agency and have me fired and left the hotel, after which the tour group applauded. I loved this group of kids.

The following morning, we took the sleeper train to Granada through some very hot, dry farm and ranch lands. Occasionally, the train had to stop for sheep to cross the tracks. We were in Granada for two nights, during which time we toured the city and the famously beautiful Alhambra. Gypsy dancers entertained us there. From our hotel, we could see the city as well as the Gypsy caves and huts. Even during the afternoon siesta we could hear the Gypsy singing. The stark white color of buildings in the strong sunlight impressed me.

By taking this new tour group, I missed a scheduled bull fight in Malaga at Spain's annual festival. I tried to call Jim in Malaga to arrange a trip for me to see a bull fight. I learned that the telephone company will not take person to person calls. The hotel just left me hanging on the line while they never looked for Jim!

We left Granada early in the morning for the bus trip to Cadiz.

We were to lunch at this coastal town and then continue to Gibraltar. Midmorning, the driver stopped at the forks of the road. We were in the middle of desolate countryside. He tried to ask me, in Spanish, something about directions. One girl in the group had Spanish in college, but she could not understand him. From the map, I concluded that we had come to a spot where we could either go on to Cadiz for lunch or take a short cut and miss lunch to arrive earlier in Gibraltar. We had a brief discussion and decided to go on to Cadiz. Upon arrival in Cadiz we drove around to see the salt being extracted from salt water and to see some of the lovely seaside resort. We arrived at the hotel at 11:30, only to find that they would not serve us until 12:30. That explained something of what the driver was trying to tell us. I had some very disgruntled girls to appease. The group requested that we leave and find something en route. So, I paid the hotel and left. In about an hour of driving, in the middle of the barren countryside, the driver stopped at a metal- roofed shed beside the road, where he indicated we could have lunch! They were serving what appeared to be ham sandwiches, but we were afraid to eat that. Instead, we had watermelon, cactus pears, cokes and beer. As we arrived in Gibraltar the driver again made an unexpected stop in a very poor area and left the bus for a brief visit into one of the houses. We concluded that it was to speak to a girlfriend. Then, amid a lot of laughter and kidding by my group, he drove us to the hotel. There we relaxed and enjoyed a huge dinner. The girl whose family gave me a hard time in Madrid rejoined the group in Gibraltar, where she apologized to me for the misunderstanding and the family behavior.

The following day I went aboard the Italian ship Christoforo Columbo with my combined two groups of fifty-nine members! On this trip I received the red carpet treatment. When we arrived in New York one boy had only enough money to call home so I loaned (gave?) him a little. One girl was afraid to leave me in New York, so I had to escort her to her hotel to make family contacts. I made my connections for the flight to Orlando.

Isaac Perry Kelly aboard the Christoforo Columbo 1968

This was an exhausting trip to twelve countries in six weeks. It was one that opened new horizons for me. It gave me first-hand information and experiences that I could relay to my students that fall. The maps, in the language of the country, which I collected from each country along with my many slides, certainly gave me teaching materials that greatly interested the students. I am certain that I learned more geography and art history on this tour than I would have all summer in university studies. Also, I was anxious to share the experiences with my students! Unala and Robert met me at the airport with my Thunderbird in good condition.

Another Purge

The military purge of homosexuals during my Air Force service, which I described earlier, was unfortunately being repeated in civilian life during the mid fifties. A Florida senator, who I shall call John, from the small town of Palatka was creating quite a following by ranting about the communist threat. He convinced the Florida senate to fund a program through which he would investigate communist sympathizers among university professors. One of his suspects was Dr. Carlton, a political adversary of Senator John, at the University of Florida. John suspected that Carlton's annual summer sojourns to Europe were to make communist contacts. In fact, Carlton was a highly respected professor of political science who made the annual trips to gather information supporting his teaching and to upgrade his lecture content.

However, while John could not find evidence of Carlton's interest in or sympathy for communism, he did discover evidence that Carlton was gay! Like a wildfire, the investigation suddenly shifted to an investigation of Carlton's gay life, his contacts, and eventually to all those "queer professors." Carlton had many friends in the gay community, but he was discreet and well respected for his informative and arresting lectures. Efforts to ruin this fine professor were discontinued because of Carlton's professional stature and the

university support. John then convinced the Florida legislature to fund his new cause through a $75,000 appropriation. The "Committee" soon amassed a great list of reportedly gay professors and students. The Committee had legal authority to summons any individual to secret locations for inquisitions, to acquire names and information on any contacts and friends of those so interviewed, and to pursue searches into the private and public life of each of them.

My friend, Professor Jim, was summoned in the fall of 1958 after our return from Europe, to a private home for an early morning interview by the committee. The result of that interview was the end of a favorite humanities professor, a devastating end of a career, and a demoralized man. He soon found a position at the University of Texas in Houston where he remained until retirement. Jim was only one of many professors who underwent this experience. In seeking faculty replacements, the University learned the extent of the damage because some of the candidates refused to come to the Florida university system because of the atmosphere of intimidation and fear. The dean of the school of philosophy, who was not gay, resigned, stating that he "could not teach, or pursue philosophical discourse, in a community under such tension." He then moved to North Carolina. John's influence had demoralizing effects throughout the Florida university system. At this point, one might ask if I felt threatened by my contact with Jim. Yes, of course! However, Jim suffered the consequences of refusing to give names of his gay friends, and I had no other connections with the University of Florida at that time.

The Committee began to squirm under public opposition, its ineffectiveness, and a lack of funding. So, John turned his attention to gays in public schools. Some school systems, under such pressure and to forego suspicion, implemented policies against teachers of the same gender sharing a residence. By this time, I was teaching in Boone High School in Orlando. and no longer sharing a home with my former classmate. While I was not personally involved either at the university or in the public school setting, I did feel the pressure and empathy with friends and colleagues who were caught up in the travesty. I still respond emotionally to the name of that senator with

disgust bordering on hate. The Florida legislature sensed the political backlash of the Committee and discontinued the funding. The second purge had ended. The fear remained.

The High School Experience

I returned from Europe in August of 1958 and began my first semester of teaching at Boone High School in Orlando, Florida. I taught art and world geography again I had a short time to get ready for that semester. I quickly saw that the former teacher had a great interest in painting. She had given little thought to a full range of activities and media. I organized classes into five levels. Art 1 was open to any student who had not had classes in high school art. Art 2 was open to students in grades 10-12 who had one class in art. Art 3 was open to students in grades 11-12 who had previous art instruction at the high school level. Art 4 was an honors course for senior students who were serious about art as a further study or as a career. Art 5 was open to any student who wanted to apply art abilities to school art projects such as posters, murals, etc. The art 5 class turned out to be a difficult task of providing leads to projects. It was also an adventure that resulted in some outstanding art for the school. One of the projects resulted in a series of six murals, four feet by twelve feet, on an Indian theme, framed and mounted in the Auditorium. Several years later a magazine in California carried an article that described these murals. Even later, I received a call from someone at a school in California requesting information on those murals.

Within this curriculum structure the students reviewed the material that I thought we should study during the year and then organized the content according to their interests. Afterwards, we had to make only one change in "their" schedule during the year. This art program and this approach worked very well and my enrollment increased greatly.

I approached my World Geography class in much the same way. I discussed with my students the different approaches to the study of

geography. I explained that they would benefit from my preparation if we pursued the themes of cultural geography. I then showed them the themes that I thought were important for their understanding of the world and its people. They accepted my proposal with a few changes and then scheduled those themes throughout the year. I then correlated this plan with the other teacher of geography, and we had a most successful plan for the study of geography. I had rented a house on Jackson Street where I lived alone.

As it had been for each semester of my teaching, I received another student teacher from the University of Florida. She was a very good student from Miami. I quickly learned that she was a friend of the girl on my tour who gave me such a difficult time! It was she who told me sources of the girl's problems and behavior. Fortunately, I learned this before I relayed any tales from the tour.

I really did enjoy teaching at the high school. I loved those energetic, creative and adventurous students and have continued to have contacts with some of them. The principal and the faculty were totally supportive. I served as head of the Arts and Humanities and did some team teaching. The school had an enrollment of about 2100 students, which allowed us to offer a broad range of programs, but it was small enough for us to know most of the students. I began to paint again, and I continued to take courses from the University of Florida that were taught in Orlando. I also began to see less of Unala, primarily because I became so involved in this new program and this school.

It was during this time that my brother Marvin began to have problems with his medication for a heart problem and with alcohol. He became quite destructive to himself and vindictive toward me. He had drastic mood swings, during which he would embrace me and tell me how much he loved me and within minutes he would then curse me as an "educated son of a bitch!" I began to get calls at school to go get him or to attend to him. Often, he would actually carry a large knife with which he threatened me because he had come to believe that Carl and I were conspiring against him to get his property and business. Once when he was on alcohol and medication, he lay in

bed holding that knife and would not eat. I arranged to have him committed to a good clinic, but he refused to go unless the priest told him to do so. I called the church and spoke to a priest who promised to meet us at the hospital. Carl and I got Marvin into the ambulance and he was quiet until he realized that the ambulance was taking him past the general hospital where he expected to go. He quickly guessed that we were taking him to the detoxification hospital, and he was very difficult for the rest of the trip. He was given a shot at the hospital and then put to bed, where he went to sleep. When he was again awake the priest did visit him. When his doctor came in, Marvin was quick to assume that he was a psychiatrist and refused to talk with him, calling him a "head shrink" and a "quack." His treatment there did help him, but I then knew and told him that Orlando was too small for the two of us and that I would probably go somewhere else to live.

Marvin suffered greatly from the anxiety of being gay. He became increasingly estranged from our relatives in Orlando, and he would not go home for visits since he knew how the family felt toward his relationship with Carl. I felt the effects of being caught between him and the family members and struggling to face my own sexuality. I also became increasingly distant from my aunts and cousins, whom I greatly loved, because my friends more frequently were coming from the gay community. I, like Marvin, could not stand the pain of the homophobia among our family. I felt sorry for Marvin because he had to live with the knowledge that the family knew he was gay. Yet he had to live also with the pain of not being able to discuss it with them. It must be very difficult for a straight person to understand how painful and demeaning the gay person feels in certain social relationships. One could not discuss gayness much less being gay. In public, people either whispered about the subject of homosexuality or made it the content of crude jokes. Yet it seems almost impossible for the gay person or the straight person to open the dialogue on the subject due to the taboos associated with it. It was this frustration that was driving me to pursue sexual activities with women, which Marvin had never done.

Phil

A student named Phil transferred in from another school and requested to enroll in my homeroom and an art class. I had taught Phil in junior high school but he moved away, and I barely remembered him as a cute little Greek American with thick black hair. Well, Phil was now anything but "cute" for he had developed into a very handsome young man. He was very popular with the other students and a charmer with the girls. He was dating Cheryl, who was probably the most beautiful girl in the school. Within weeks we had developed a good rapport and friendship that would last until his death some thirty years later.

It was early in November when he enrolled in my school, and the weather was often cold at night. I noticed that Phil was frequently unable to stay awake in class and that his clothes were not clean. I asked him to see me after school, at which time we discussed his problem. He was sleeping under the shrubs around the school and would awake at the sounds of routine patrols during the night. As each patrol came by, he would quickly go into the adjacent orange grove and then move back to the warmer locations near the school. His father had left when Phil was twelve, and he was having a difficult time with his mother. On his birthday in November, I asked him and a couple of his friends to my house for dinner. I bought steaks and prepared a great dinner, but Phil never came and never called. The following day in class, I acted as if nothing had happened, and I did not make any personal comments to him. After school he came by to tell me that he was not able to get a ride from his girl friend's home some three miles out of Orlando. I invited him to come again that Friday evening.

When he came in the door he had his books, a quilt, and some few clothes. He never left. The following Monday, I talked with the principal about this and he supported the idea of me giving Phil a home. Soon other teachers quietly contributed to purchases of clothing for him. He had been with me about two weeks when I persuaded him to go to an opera with me. I gave him the story of the opera, played the music for him, and dressed him in a tuxedo for the

occasion. He enjoyed the opera and being so dressed. However, the real reward was in his being seen there by other students and by him seeing classmates there, much to his surprise. This obviously made a change in the way in which the students perceived him. His daily dress improved, his demeanor changed, and his dating opportunities greatly improved. He continued to date Cheryl. I don't think Phil ever paid for entry fees or food at student functions or at clubs because the girls would pay for him.

One night his mother, who had obviously been drinking heavily, called me about 2:00 a.m. and wanted me to come over to her house. I did not use her name, but when I finished the brief conversation Phil turned to me and asked, "That was mother, was it not?" He was very angry. He had mild stomach ulcers, and from his bed I could hear him, even in his sleep, reacting to the pains. This made me more upset about her call.

My aunt once asked me to stay at her house while she was out of town for a weekend. I told Phil where I would be. I was awakened about 1:00 a.m. Sunday morning by Phil tapping on my bedroom window. As I opened the door I asked, "Why are you here?" To this he replied, "I took Cheryl home, and I did not want to stay the night without you."

Phil remained with me for another year, until I left Orlando. He graduated in 1961, and I paid for his tuition for two years at the community college. He then went into the Air Force, where he became a helicopter pilot in the Vietnam War. He later married three times and had two lovely children. We remained friends until his death from leukemia in 1994. His son is still a friend who visits me, and he, as well as his mother, knows of, and accepts, my sexual orientation.

Experiences with Other Students

The students asked me to serve as sponsor of the Junior Civitan Club that was the most active club in the school. I volunteered to

do this, but resigned after the first year. The first big project that the club undertook was selling Claxton fruit cakes for Christmas. We organized the procurement, sales and delivery of over 2400 pounds of cake in one month. I never wanted another Claxton fruit cake. In this process, one favorite student procrastinated in turning in the money from his sales. I finally had to have a conference with him and his mother in their home. It so happened that his priest visited the home at the same time. There was no more trouble about that money.

However, after the sales were over I had some of the money in a file cabinet in my office that I would deliver to the school vault at the end of the day. During the time I was out of the room for less than ten minutes, someone stole the money. I expressed my dismay and disappointment to each class, but especially to the class that was in session when someone removed the money. Phil, and two other boys in that class, immediately became my suspects. I could not imagine Phil taking the money. He and I discussed the matter during the evening, and he was aware of how this break of trust pained me. The following morning as we were leaving for school, I glanced into the letter box beside the door, which, to my surprise, contained money! Phil expressed surprise and suggested that perhaps whoever took the money regretted it and wanted it returned without being known. I later learned that indeed Phil, and the other two boys, had taken the money and that Phil put the money in my letter box! I never reported the incident to the school principal.

Sandy, one of the trio, was later taken out of the school by his parents, and sent to a nearby military school. He soon left that school and came to my house where he stayed four days. His mother and father were divorced. His mother insisted that he return to the military school, so I drove him back to the school. That was a dreadfully ugly place, and I sympathized with Sandy's attitude. In a few days he called me. He was depressed and threatened suicide if he could not leave that place. After conferring with his parents, they agreed to me going for him. I brought him to my house for a few days, enrolled him in my high school again, and persuaded him to return to the home of his mother.

John, the third member of the trio, and Phil were friends who sometimes spent weekends together either at my house or at a downtown hotel, where John lived with his father who managed the hotel. John was very homophobic and sometimes would permit himself to be picked up for the purpose of sex and then demand all of the money the person had. When I learned of this, I discussed it with Phil, who assured me that he had never done that and that John had seldom done it. This began the end of John's relationship with Phil and me.

The Junior Civitan Club was as much a fraternity as a club. During the initiation ceremony, which we held beside a secluded lake, the initiates undressed and were blindfolded for part of the activities. They then dressed and were instructed to hide in the wooded area. If they were caught by the members, they would be paddled. They were instructed to report to a specific safe area after one hour of hiding. After the hour, one student named Charles did not return. He had become disoriented in the palmetto swamp and each time he heard us looking for him, he would hide. I walked into the area calling to him to come out safely. When I came upon him, it was almost dark, and he was standing in an attack position holding a large tree root and frozen in fear. We helped him into the jeep where he fainted. We attended to him, and he soon recovered his composure. At the same time I almost lost mine. After this incident, Charles became a close friend of mine at a time when he could have become just the opposite. We still correspond and visit occasionally.

Another incident with this club involved the son of our county sheriff. A hurricane had left many trees downed, and people were in need of help in clearing the debris. One Friday afternoon the club organized into work crews and went out on Saturday morning to earn money for the club. It was hot, and each crew had bottled water. In one crew, a student passed a bottle to the sheriff's son, who drank before realizing someone had placed urine in the bottle. Of course, he drank very little of it, and it did not hurt him, but he was angry. I was both furious and afraid of having him report this to the school or perhaps worse to his father. He did neither.

In the spring semester, the club was to have its membership party to which they invited prospective members. We had the official meeting on a lake owned by one of the students. After the meeting, some food and a little swimming, I went home. The boys then rolled a barrel of beer from the bushes and really had a party. Two of them came to sober up at my house. On Monday, I resigned from this sponsorship with the excuse that I was far too busy to continue this.

Daytona Beach, as well as other beaches, was within easy access to us, and it was not unusual for any of us to spend a weekend on the beach. Charles once asked me to go with him to the beach for the weekend. Charles was a rather mature, tall, Norwegian, blond senior, who was a black belt karate student. We remained friends and it has been painful for me to see what happened to that boy during and since the Vietnam War. He received a wound in the scrotum and his back. He continues on morphine and marijuana to overcome the pain. This was the most personal experience that I had with the losses of that war. Phil did serve as a helicopter pilot but was not physically harmed. He did return with psychological problems. Both were tragic losses of optimism, productivity, and beautiful persons.

I remember particularly two girls from this school. Karen was a lovely, energetic and personable young lady, who came rushing by my desk each morning to say good morning with a kiss to my check. The other students loved it. I reflect on that action knowing that today her actions would be very dangerous, for me, at least.

The other girl, Lois, asked to see me after school near the end of the spring semester. She laid several pieces of jewelry on my desk and asked if I knew where she could pawn them or if I would loan her money on that jewelry. Of course, my first question was about the purpose of this. She confided that one of the teachers, her neighbor, had given her a ride to and from school each day and now, at the end of the semester, had asked for payment. I instructed her to keep the jewelry and to see me the following morning. I then went to the principal, who promised to handle my problem with utmost confidentiality. When I then told him the story, I thought he would

explode. However, he instructed me to tell the girl that she was not to pay the teacher anything and that she need not worry about repercussions. When I relayed this to her she burst into tears of joy. I loved that school, my colleagues, my teaching experiences and the students.

A Change of Course

In January, 1959, while still teaching at Boone High School, I enrolled in a course being taught each Tuesday evening in Orlando by Dr. Ballard Simons, a professor from the University of Florida. A few times when the professor could not come to Orlando he called me to teach the class. He often encouraged me to go back to school for my doctorate. I had no intention of doing that nor did I think that I was capable of doing doctoral work. After class one evening, he took me aside to remind me that classes for the spring semester would be starting in two weeks and that I should prepare to return. I was shocked at his persistence. I was not prepared to leave Orlando. I asked him to review my scholastic records the following day (Wednesday), to confer with other professors there who knew me, and then to call me if he really thought that I was capable of doing doctoral work. He agreed to do this. Much to my relief, I did not hear from him on Wednesday or Thursday. However, just before school was dismissed on Thursday, I received a call to the office to take a long distance call. I knew that it had to be Ballard, and I went down the hall repeating to myself, "No. no, no!" When I took the phone, he began in his boisterous loud voice saying, "Look, Perry, I have made arrangements for your dorm room. You will be working in my office, and you are to report for registration on Saturday morning. Now I made arrangements with the registrar to handle your registration since others registered this week. You go ahead and take care of this and report to my office Monday morning, O.K.?" I almost fainted and merely replied "Yes, Sir!" I then turned to the principal and asked "Do you know what I just did?" to which he simply replied "Yes." I remember Charles Terry,

the principal, fondly as the finest administrator with whom I have ever worked and as a true humanitarian. He sent someone to cover my class and we discussed my departure. He had already discussed it with Dr. Simons. I felt trapped!

I hurriedly located a retired art teacher to take my classes and introduced her to my students on Friday as I also said farewell to them. I followed Ballard's instructions and arrived at his office early Monday morning almost in shock. I was afraid, entrapped and depressed. In the evenings I would cry when I had time to reflect on leaving my students, my high school colleagues, my house, and especially Phil who had to return to live with his mother!

Oh my God, why again has my life become stagnant? Why again must I seek new directions and adventures? Why can't I find love and contentment? I rationalized that I was happy living with Phil even though I knew that soon he would find a wife, and again I would be alone. Rationally, I knew that this opportunity was right for me. Again I had no choice.

CHAPTER EIGHT
THE DOCTORAL STUDY

At the University of Florida during that 1960 spring semester my work with Ballard went well, I acquired new friends, and began to feel that I had done the right thing in coming back. Unfortunately, my roommate was the crudest person I have known. He would enter the room already in the process of taking off all of his clothes. He would not shower, but would only bathe in the sink. I complained to the housing office, and they found me a much better private room in a suite. A Chinese student replaced me. When he complained, the housing office moved the crude guy off campus.

I enrolled in my first course in statistics. I was very much afraid of the math component of that course. It was like trying to learn a new language. The very old professor, who had written the text book, often lost those of us who were weak in math. One lady in the class asked him if we were in competition with each other for grades because we were from such diverse disciplines. He quietly looked out the window and slowly replied "Well, hell, yes. The grass competes with the weeds, which compete with the bushes, which compete with the trees for the sunlight!" Upon hearing this, she began to cry and left the room! I struggled through the class knowing that I had to have at least a grade of "B," but very sure that I could not make that. The morning of the final exam a friend gave me a tiny pill to make me calm. I took the exam and was the first to complete it. I handed it in and wondered how he could have made it so easy. I did

not pass that exam, since I was on valium! I later explained this to the professor, who laughed and suggested that I repeat the course during the summer taught by a professor from the psychology department. I did that and passed the course. I learned not to trust friends with pills!

Each of us in the doctoral program had to go through a series of screenings during that first semester. At least one of these was designed to weed out those who were not likely to complete the program. Screenings could weed out those who were not really wanted in the program as well as those who could not take the psychological stress. One very elegant student, customarily excessively dressed, knitted during class. After the shock of a screening interview, she returned to class without jewelry and without the knitting! She also began to take copious notes. One student, who traditionally dressed in coat and tie and appeared to be in complete control, came out of his interview in a daze. His tie was off side, and he sat on the curb until his wife came for him. She took him to the hospital. I knew that I would face that committee screening in my second semester!

Dr. Johns, who I knew socially from my earlier stay at the University, directed the studies in school administration and taught a course in which I was enrolled. I had come to the University of Florida to study art education with the view to becoming a supervisor of art. I quickly learned that art educators were regarded with disdain by artists in the department of art and that in the School of Education I would be pursuing a program in school administration.

Dr. Johns asked me out for coffee. He sipped his coffee after we were seated. Then, without looking at me, he asked "Perry, why don't you get the hell out of here?" I felt faint in the silence that followed and concluded that with that remark from him I would indeed be gone. The brief silent moment seemed like an eternity. Then he explained that he knew me, he knew my art, and he knew that my objectives were more in art and art education. He observed that I should not waste my time in school administration but should concentrate my talents and energy on my art. I assured him that I appreciated his views and his candid remarks and that I would give

this serious consideration. I went back to Ballad's office and relayed this to him whereupon he stormed out of the office, went down the hall screaming at Dr. Johns with me in pursuit to calm him. I headed him off and told him that I indeed would be moving to another school within the next few weeks.

Professor Dale Summers, in the department of art, was my mentor and friend who befriended me during my earlier studies at the University of Florida. He and his wife even gave me a room in their home for two weeks before and after I went to do my student teaching. He and I discussed my alternatives, and he provided me with information on art education programs at other universities. I looked at the highly respected art education program at Florida State University and the program at Peabody College in Nashville, Tennessee.

My visit with professors at Florida State, who I knew and considered to be friends, left me with an uneasy and negative feeling about that program. I sensed an unfavorable political climate that I needed to avoid.

I then visited Peabody College, where I was offered a teaching assistantship and where I was warmly received by Dr. Gus Freundlich, head of the department of art. Peabody had accepted and publicized the creative dissertation component of the art education doctoral program proposed by Gus. This creative program appealed to me. So, I made plans to enter Peabody College in the fall semester 1960.

I wrote to the housing office at Peabody late in July to inquire about some work to help support me during my study there. I knew that it was late and that they should have all positions filled by that time. However, I knew that sometimes all positions were not filled even when schools start. Perhaps I would have a chance at a job. I cited this in my letter to the housing office. I got the job, as the director later told me, "Because that letter conveyed a maturity and knowledge of functions of that office that appealed" to her. Thus, I arrived at Peabody College with a teaching assistantship and a job as "Dorm Daddy" to 120 male students. Joan, a classmate, was "Dorm Mama" to a like number of girls in the nearby girls' dorm.

Perhaps the story of my stay at Peabody could be described in two stories. One might be about my studies but a second could easily be written about the experiences with managing the dormitory and advising those students. I soon learned that among the one hundred twenty undergraduate and graduate students in the dormitory, twenty-seven of them were gay. Some were discreetly so, while others were obviously so. It was quite amazing to see to what extent some of the gays decorated their rooms. There were the usual crude remarks among the other students but they maintained an atmosphere of general tolerance. There was only one incident during my stay relative to this issue that caused a disturbance or called for disciplinary action. One freshman student started a rumor that I was gay and that I had approached him for sex! He was a good student, a pleasant advisee, and a member of a group who often were the source of minor disturbances throughout the dorm involving such things as firecrackers, water hoses, etc. One of my duties was to enforce decorum among students in the dorm. I only learned about the problem when I became aware that for some reason I was being shunned by some of my former close student friends. Then, a music student, one of my best friends, came to me and asked, "Perry, are you aware that Tom has circulated the story that you propositioned him?" Not only did I not know about this, I was shocked. I immediately consulted with the head of my department and when the President of the College came to his office the next morning I was waiting for him. He had not heard about this but was very appreciative of having it brought directly to his office. After a conference with his deans and with each of us, during which he found no evidence of truth in the accusation, he expelled the student. It took weeks for us to regain the student cohesiveness which this had disrupted in the dorm. The President's action had a calming effect on the group of students who had been giving us the most difficulty. My friends rather quickly assured me of their support throughout this incident. Some of these friends, including the music student, are still in contact with me.

I remember very well one young student who came to me for freshman advising. He was unable to talk with me because of his

stuttering. He was a tall lean guy from eastern Tennessee who could play a guitar very well, and I had heard him sing without stuttering. I advised him to report to the speech clinic, which had a very fine staff and services for the students, to register for therapy and then to return to me for advisement. He did as I had instructed and made great progress in his therapy. He later invited me to his home, where I learned that when he was in high school on a fishing trip with his father and brother, his brother had fallen from the boat and drowned. The student had not spoken to anyone for two years. He did graduate and later served in the Army, received his Master of Fine Arts degree from the University of Georgia, married and taught art for me at Western Carolina University. I have always been glad that I faced the problem with that young man, and we remained friends until his death in 2012.

One of our doctoral students was from Iraq. While he was in the dormitory, he wore his traditional garb but dressed in white shirt, tie and a suit for classes. Consequently, he never had the suit cleaned and the odor was very strong! He also had the habit of perching on the side of the bath tub and bathing with a cloth as he splashed water out onto the floor. I never learned why he would not get into the shower or into the tub.

We had several students from Laos and Cambodia. I remember that four of these students arrived late on Friday, and someone took them to a hotel for the weekend instead of bringing them to me. When I met them on Monday morning they were as confused about this as I. The only English food they knew, which I suspect they knew from French, was ham sandwich. Consequently, they had eaten ham sandwiches all weekend. Meat, certainly pork, was almost taboo in their diet. It was my duty to orient them to the cafeteria and to the different foods. They never wanted any more ham. One of these students had studied as a civil engineer in Laos but was sent to Peabody to study zoology. The textbook was far too complicated for him. In working with him, I labored over translation of terms which I hardly knew in English. He became so nervous that he became sick and had to return to Laos. Of course, he viewed this as failure. He

feared and dreaded facing his government and friends back in Laos. I was quite upset by his departure.

I had one problem with the Laotian students involving their inexperience with using the toilet. They were not familiar with the toilet seat or flush mechanism. They were using the toilet by perching on the seat where their shoes left dirt, sand or grit that led to complaints from other students. They also did not know to flush the toilet. It became my duty to correct this situation.

One young American student who lived across the hall from me surprised me with his lack of general knowledge of his own anatomy. Surprisingly, he was majoring in physical education and since has earned a doctorate in that discipline. Sam had returned from a date about midnight. I heard him go to his room and soon heard him moaning in pain. I went across to his room to see if he needed help. I found him lying on the floor with his heels up the wall as he held his scrotum and writhed in pain! I recognized the problem and helped him to the shower. Neither of us ever mentioned the incident.

There were so many unique situations with life in the dormitory that Joan, the dorm mama, and I have often wished we had kept a journal. She had similar incidents with her female students, and we would often share these over dinner. For instance, she had a young student from Saudi Arabia whose room on the second floor faced the men's dorm. She was very fond of fruit and flowers that she kept in the windows. She continually neglected to close the window blinds when she changed clothes or undressed! About bedtime each night our dorm seemed to shift weight in that direction as the men moved to that side of the building. Joan admonished her to close the blinds. Her reply was, "Why? I do nothing wrong in my room!" Joan was successful in convincing her by having her look at the men's dorm one night as she was preparing to dress for bed. This student also had not used forks, knives and spoons. She ate with her hands until Joan instructed her otherwise!

Joan and I held similar jobs at Peabody College. We were classmates and we became lifelong friends. During our stay at Peabody we dated and were very close. She was from Montgomery,

and our earlier education and environment gave us a great deal in common. We shared very similar viewpoints on education and art. Near the end of our last semester when we were about to graduate, we attended a conference in Birmingham where she had a job interview at the University of Alabama. En route home I asked how the interview went and if they offered her a job. I was driving and she turned to me as she replied. "The interview was good, I was offered a job. But, I told them that I would have to think about it." Later, when I was employed in North Carolina I recommended her for a teaching position at the University of North Carolina at Greensboro. She received the appointment and served there until her retirement. We remain close friends.

Joan and I, along with about eighteen others, came to Peabody primarily because the School had advertised the creative doctoral program in art education. In this program the student could satisfy the dissertation research through a creative studio project. Things went very well for us until Brian, a fellow student, presented his thesis topic to his committee members. He proposed a thesis in painting. Two of his committee members avowed that they would never accept painting as a thesis. All of us then huddled with Gus Freundlich, our department head, then with our dean. The President then called a meeting of the involved faculty to discuss the issue. Subsequently, the School would not accept the creative studio dissertation. The major reason seemed to be that "None of us know how to evaluate the process or the product." They would not listen to our plea to bring in experts in the specific art disciplines. Brian left Peabody immediately. The three or four of us who were near the dissertation stage changed our topics from creative research/exhibitions to traditional research and written theses. Others left the program, and Gus, left Peabody. I later did a dissertation titled Art Education in North Carolina. Joan did her dissertation on the relations between structure in art collage and structure in learning.

During my stay at Peabody I majored in art education and ceramics. I was very happy there and with my progress. I loved the ceramics and spent many long nights in the ceramics studio. During

this time I had two memorable problems. One was the shock of having to take another course in statistics. For this course, I secured the help of a classmate math major. I think I really passed the course by helping the professor to draw a three-dimensional brick pattern on the board and by promising that I would never have use for this stuff Well, to my surprise, while doing my dissertation I used quite a bit of it. I had no problem with it in this practical application.

A second incident involved my ceramics instructor. At the end of the fall semester, when our work was displayed, I had quite a large production, and the professor used several of my items to illustrate positive points in his critique. So I went home for Christmas feeling very good. But, when I returned and saw my grade of "D" for the course I was shocked! I had a conference with Gus, the department head, who stated that he could not understand what had happened to the professor nor could he change the grade. He suggested that I bring the body of work to his office for a review. I did so, and he agreed that I did not deserve that low grade. So, he advised me to do a research paper on the topic of form in ceramics. This I did and received a grade of "A" for the course. I never spoke to that professor again, so I never had any clarification from him. Years later I had an occasion to meet his ceramics professor from the University of Michigan. When I told him under whom I had studied ceramics, he exclaimed, "Hell, I taught him, and he was not worth a damn in ceramics! I never knew he was teaching ceramics because he majored in jewelry."

In all of my contacts with so many professors, only a few made lasting impressions on me and altered my life. I learned the pain of dishonesty from that professor, but Gus Freundlich was the most considerate, humane, yet thorough professor I have known. His classes were tough, but his concern for his students as human beings was genuine. In my years of teaching, I have tried to avoid putting students in uncomfortable situations. I have tried to emulate Gus as my mentor. Professors Dale Summers and Dr. Johns at the University of Florida were the same kind of persons. Dale became a long-time friend and Dr. Johns had the strength and courage to be honest in

his advice to me, thereby sending me where I belonged. Oh, how I appreciate those professors.

Europe 1962

In the summer of 1962, Brownell Tours invited me to conduct another tour to Europe. I knew that I would be facing my final and exhausting doctoral exam in the fall, but I felt that I had studied for it until I just had to get away from it. Gus remarked that he had never heard of a student touring prior to one of these exams. After my lengthy description of the 1958 tour of Europe, I shall try to be a little less descriptive here.

I met the group of college-age students in New York aboard the Queen Mary. I learned that tour directors were assigned to "available space." Because the ship was so full, I had been assigned a private stateroom on the Restaurant Deck. This was the top deck; the room was plush with full windows instead of portholes, and a service boy was standing by. Being in these first- class accommodations was wonderful, but I did not have any formal wear with me for the two formal dinners. The group with whom I was assigned a table for meals was diverse and very pleasant. It included one man from Australia with whom I became friends and spent a couple of nights in the bars, all night. On the night when we had the formal dinner I opted to have dinner in my room, but the guests at my table insisted that I come to dinner in my suit. It so happened that others also wore suits, and I felt comfortable. It seems that the Australian had just inherited a lot of money, and he was willing to spend it for fun!

In the evenings I danced in the first class lounge, and then went below for late night dancing with my tour members. Tommy, who had been with me on my tour in 1958, again joined me for this tour. I found the entire group of students to be very pleasant, energetic and ready for night life but much uninformed about the arts or geography. We sailed from New York to Southampton, England, on the HMS Queen Mary. The trip was delightful. This ship was large and luxurious. I

was amazed when I approached the ship in harbor in New York as it towered above the dock buildings. The food was absolutely fantastic. The Queen Mary made the ships Queen Frederica and Christoforo Colombo that we used in 1958, appear to be small boats.

We arrived in Southampton on the third day of July, where we met our Italian courier for the trip by train to London. The courier was a young lady with red hair, unshaven armpits and sleeveless blouses. Her body odor was so strong that none of us could sit beside her on the bus! I wired this to Brownell, and I reported this to the agency upon our arrival in Rome. They replaced her with another young person for the remainder of the tour.

After the tour of London we took the train and ferry across to The Hague in Holland (The Netherlands). This tour included Amsterdam, Volendam, Haarlem, Leiden, and the Isle of Marken. I remember that our Dutch guide was a very handsome man who excited the women on my tour. However, within the first day of touring, even they realized that he was gay! He was a very good guide and a gentleman throughout the tour of Holland. He was able to direct the students to some very good night spots for dancing. He also came to my room one evening, where we discussed being gay in Holland. He revealed that he was very much afraid of being exposed. I assured him that he was safe in talking with me and that my students already realized that he was gay. Some of the girls expressed disappointment because he was so handsome.

We then took the train from The Hague to Brussels, Belgium, where I was able to revisit the sight of the 1958 World Fair. The Atonium was still impressive as an architectural feature. but the fairgrounds reminded me of the void I had experienced upon visiting an unused air base. Of course, the excitement was gone. but memories were still strong.

From Brussels, we again took a train to Luxembourg, where we had lunch and a brief tour before meeting our continental bus and driver, who would be with us for the remainder of the trip. Then we continued by Grevenmacher, Wasserbillig, Trier, along the Moselle Valley to Bernkastel, via Kirchberg to Bacharach, then along the

Rhine river via Bingen and Mainz to the famous spa of Wiesbaden. This was a beautiful drive, and the students were in good spirits but tired when we arrive in Weisbaden for one night. We relaxed there and took advantage of the spa.

On July 9 we went from Wiesbaden along the river Main via Darmstadt to Heidelberg. There we had a most memorable lunch at the Red Ox Inn and toured the city, just as we did in 1958. I recall the view of Heidelberg from a hillside castle view because it was a beautiful vista of the red tile roofs along the winding river. We also visited the University of Heidelberg whose famous old buildings certainly needed a lot of repair. After lunch, we drove on the autobahn via Stuttgart and Augsburg to Munchen. The beer gardens and the architecture in Munchen were as impressive as on my previous trip, but the one night there did not allow enough time. We had a morning tour of the city and lunch before driving on to Innsbruck, Austria.

En route to Innsbruck we drove via Starnberg Lake to Murnau then off the autobahn via Bad Kohlgrub to Oberammergau, where we attended the famous Oberammergau Passion Play. For me, this play was too long, and I was not interested in the content. We then went via Oberammergau to Garmisch-Partenkirchen. This city is located at the foot of Mt. Zugspitz, the highest peak in Germany. Then we went via Mittenwald, Scharnitz, Seefeld and Zirl into Innsbruck for one night only.

We departed Innsbruck the following morning for the trip through Matrel and Steinach to the Brenner Pass. This pass into Italy goes through the magnificent Dolomite Mountains, along the coast of Dobiaco Lake and Misurina Lake to Cortina D'Ampezzo. There we had lunch before we drove on to Venice, Italy.

I often think how unfortunate it was that this group of college students had only two nights in Venice. However, during that short time, they did have a good tour, and they did a lot of the night life. For me, the visit was memorable for two reasons: we had a great visit to the Murana glass factory, and I revisited the Venetia Biennale. The manager of the Murana glass factory gave me a beautiful

contemporary bowl. We also had a great time at Harry's Bar, where Americans customarily gathered.

Upon leaving Venice we continued our Italian tour via Mestre, Padua and Bologna to Florence. I remember well that as we approached Florence one student asked me "Tell me, why we are going to Florence? What will we see there?" That question confirmed how ill prepared the students were for this trip. They knew little geography or the great arts of the cities they were visiting. After my polite and lengthy reply to the question, they had only one further question, "Do they also have good disco?" The Hotel Mediterraneo where we were staying, as we did in 1958, was new, modern and nice. It was also very convenient for walking in the city.

During the afternoon in Florence, several of the students had taken a bus to a city plaza. During dinner that evening I had a call from the police asking if a certain person was on my tour and if I would please ask to see her passport. Obviously, she panicked when she could not find it. While she was on the bus a young man lifted her passport from her purse. Fortunately, he was observed by an out-of-uniform police officer, who arrested him after he got off the bus.

Florence was, as I remembered it, a very enjoyable city. A few of the students and I went to a central plaza after dinner, where a few young men invited them to go dancing. Since they would not go without me, I climbed on the back of one of the five motor scooters and away we went into the unknown! They actually took us to a nice restaurant and dance pavilion. Later they brought us safely back to our hotel. It was a fun evening in Florence.

From Florence we went by train to Rome. This trip was only about four hours long, and we arrived there for lunch. We had three days in Rome with all of the usual tours and sites. One of my tour members certainly made a hit in Italy. I had cautioned the tour members not to become involved with hotel employees. However, this one member met one of the desk clerks who asked her out for the evening. The following morning she had little to say about it. When we were apart from the group, she related that it had been a fun evening among movie directors, actors, etc. For her it was a waste, since it turned out

that the entire group was gay. She did agree to go out the following evening with another guy from that party. He introduced her to a straight man with whom she developed immediate rapport, and he came to see her off as we left Rome by bus. When we arrive in Siena she called him. When we arrived in Rapallo she called him. When we arrived in Nice, France, she told me that she just had to return to Rome to see him. We had a father-daughter private talk and, after calling the Brownell agent in Rome, I made arrangements for her to return to Rome and rejoin us later in Paris. When she arrived back home in Texas, she flew back to Rome!

From Rome we traveled to Siena for an overnight stay and morning tour. We then continued to Pisa, where we had a city tour including the Leaning Tower of Pisa. Then we passed through La Spezia and the Bracco Pass to Rapallo. After one night in Rapallo we drove along that beautiful coast via Genoa to San Remo for lunch, and along the French Riviera via Monaco to Nice, France. A young lady on my tour and I went sailing during our morning stay in Nice. We were both from Florida and each assumed that the other was experienced at boating. As we saw the coast disappearing, we both had to confess that neither of us had ever sailed a boat before. We began to have visions of Africa on the horizon. With practice and a mild wind, we soon learned how to bring the boat about and back to shore. I do not think that either of us divulged that story to anyone on the tour.

The Italian coast and Rapallo were as beautiful as I had remembered it from the first trip in 1958. The scenery there, as well as that along the Amalfi Drive at Naples, is remembered as the most romantically beautiful places I have seen.

From Nice, France, we went to Aix-en-Provence for an overnight stop, then along the Rhone River to Valence for lunch and on to Geneva, Switzerland. Then we went to Lucerne and on to Basel, where we transferred to the train for the trip to Paris. We had three days in Paris and Versailles before we departed St. Lazare Station aboard the Boat Train to Cherbourg. In Cherbourg we boarded the HMS Queen Elizabeth and sailed to New York.

I never in my wildest dreams thought that I might one day sail aboard the Queen Elizabeth (QE-1). On a later tour, I also sailed on the luxurious QE-2. The QE-1 was one luxurious ship. It had rich tapestries, fabric (silk) wall covering, fabulous woodwork, impeccable service and great food. I remember lying awake at night listening to the soft creaking sounds of timber stress as the ship reacted to the waves. Like the HMS Queen Mary, this ship also towered above the docks in New York. Locating our luggage that had been unloaded on the dock was quite a hassle.

Obviously, this was a fast paced tour of Europe that I would not want to repeat. The trip had exhausted us by the time we arrived in New York. The tour had been a success with no problems. I was glad to arrive with the group back into New York and to have them depart safely to their respective homes. After assisting them with luggage and transportation, I flew back to Orlando. Then I had time to realize that I had only a short time to return to Peabody College and face those exams.

Return to Peabody College

In the fall of 1962 I returned to Peabody College in Nashville, Tennessee, for the last year of my doctoral studies. I also continued to teach art appreciation and to administer the men's dormitory. Joan and I spent a lot of time preparing for exams.

One classmate, who was about forty-three years old, was advised against entering the program at that age. He had been teaching at a nearby college, where he was passed over for promotion to department head when the job was given to an available coach. Joan and I advised him that he was there for the wrong reason. As we approached the exams he had a mild heart attack but recovered rapidly and insisted on taking the exams. For the written part of the exam he received slides of Roman ruins and sculptures to identify and to describe. I am certain that he was given that impossible task to weed him out of the program. It did just that.

I have no idea what my topics were. I only know that I wrote for seven hours and many pages of legal-pad paper. It was an exhausting exam. I received notice about one week later that I had done well on that part of the exam. I scheduled the oral part, which could be up to eight hours long, conducted by my committee chair and my department head with four other committee members. I entered the room for the exam prepared with a small note pad and a new pencil. I took a seat at a desk facing the committee members sitting in chairs. I felt at ease as the questions began. Later one member asked what books I had read during the last year. As I began to name them I could sense the tension invading my body, and I tried to remain calm. I named the fifth book. Then one of the professors interrupted to ask "Do you agree or disagree with the major thesis of *The Lonely Crowd* that you included in your reading?" I tried so hard to recall that book, but I focused on its color and panicked! At that point I heard the pencil in my hand crack in half. I really did go blind and could not see even one of the members. I quickly recalled the content of the book and answered the question in a trance. I stated that "I disagree with the thesis that Western Civilization has reached a peak and is now moving for a decline, which was one of the major themes of the book." Then I heard my committee chair say "Thank you Mr. Kelly. That will be all." With that my vision returned. I thanked them, picked up my two pencil halves and the pad and left the room. Joan was waiting to have lunch with me, but I went right past her until she called to me. I do not have any idea how long I was in the meeting, but it was over long before lunch. That added to my apprehension about passing it in the short time. I soon received notice that I had done well and should proceed with finishing my course work and turn my attention to my research topic for the dissertation. Ever since that examination the thought of it makes me tense and nervous, but having gone through it prepared me to face other situations in administrative positions. I was never afraid to face anyone after that, and it was good training in being prepared with content and composure before meetings.

After that event the rest of the year seemed anticlimactic. I

completed my courses. I wanted to research the role of intuition in forming ceramic art objects because I experienced a reciprocal relationship between the clay and my hands in working the wheel-thrown pieces. I quickly realized that intuition was far too elusive a topic. I left Peabody without having a dissertation topic.

In my last semester during the spring of 1963 I mailed out one hundred twenty job inquiries with my resume. Early in May I had only one positive response. That was from the College of Guam, where they wanted me to establish a program in ceramics. They did not mention art education. I made further inquiries of them about the College and its programs. I received an offer of the job, and I later received a telegram encouraging me to accept it. While I had romantic ideas about going to the South Pacific, I hesitated to accept the job because I was afraid to go that far from the mainstream of art education in America. Finally, on Thursday, since I still had no other offers, I decided to go to Guam. I prepared to post the telegram on Friday. Thursday night I had a call from Tony Swider, the art education supervisor in Raleigh, North Carolina. He asked if I would accept his position since he was resigning to move to Alabama. I flew to Raleigh the next day, had my interview and accepted their offer of the position! Then I flew back to Peabody and wired the College of Guam that I would not be coming there.

In June 1963 I loaded hundreds of pieces of my pottery and my other possession into a rental trailer and moved to Raleigh, North Carolina, probably the second most important move in my life. Joan moved to Pennsylvania and later to North Carolina. This graduate study had been an exhausting experience. I am still amazed that I had the audacity to leave a good job in Orlando and to undertake this move. In many ways my life was still oriented to Orlando, and I missed friends there. The traumatic experiences of the doctoral program still make me tense when I think of them, and I can hardly bear describing the exams to anyone. I was in debt and I was greatly relieved to have a job.

CHAPTER NINE
RALEIGH, NORTH CAROLINA

I now had a position in the North Carolina Department of Public Instruction in Raleigh. I had the title of Supervisor of Art Education. Upon arrival there in early June 1963, I checked into a hotel and reported in to my office. Someone from the staff, along with a Realtor, tried to help me find a place to live. I quickly learned that housing there was very scarce. Through some informal source I learned that a person had recently been murdered and that his former apartment would be available when it was released by the police. We went to see the owners who advised us that it would be about two weeks before it would be available. However, she referred me to a lady where I could get a room for the two weeks. I remember her remark in reference to the c individual, "She is cream of the crop in the social elite in Raleigh, and if she likes you, you will have it made!" Well, I did meet her, had a good rapport with her and moved into a room in her big house filled with antiques. She lived only one block from my office, just off the capital square. Each piece of the Victorian furniture seemed to have never been moved over the many years. My bed was very large and comfortable, but I had difficulty adjusting to its position in the room away from all four walls. When she talked with me, it was always in the living room as we both sat on very uncomfortable strait-backed chairs. She always sat up straight with both feet on the floor and her hands in her lap. Within one day I

learned that her house was a novelty of antiquity and that the social scene had long since passed her by.

After a couple of days there I took some time for a trip to Florida with Chuck Ray, my former roommate. I drove by Atlanta, Georgia, to get him. We both then agreed to dispose of all reminders of time and just go where we pleased, when we pleased. We drove to Jacksonville, Florida, to visit one of our female classmates. It turned out that her father was one of my clients when I was in advertising some ten years earlier. So they invited us to stay with them for a few days. After three days of enjoying their hospitality we drove the short distance to Jacksonville Beach, where we went swimming, and then drove along the coast to Daytona. From there we drove west to Silver Springs, where we took a cold freshwater swim. We felt quite exhausted when we arrived at the home of Betty, a friend in Winter Park. We spent one night there before visiting my brother Marvin in Orlando for a few days. The remainder of our trip included a stop in Ocala, a drive to Atlanta where I left Chuck, and my return to Raleigh. That was one of the most enjoyable and relaxed trips of my life.

Shortly after my return to Raleigh the apartment became available, and I moved into it. The family who owned the apartment building and lived next to me turned out to be quite an experience. It consisted of an eccentric elderly man, his even more eccentric wife and their fourteen-year-old grandson. The grandson's mother was a mental case living nearby. I learned that the grandson was a very mature and intelligent young person. I also learned from him that he had a brief experience with the man who was murdered. The death was the result of his bringing a male stranger home from the nearby bus station one night. They never found the murderer. The grandfather had the habit of sitting around the house in his underwear while the grandmother habitually wore her black slip while she was in the house and the basic black dress every time she went out of the house. The grandson made remarks about these habits. He confided in me that he had no young friends because he had no place to entertain them. His grandparents kept him close to themselves. Nonetheless, he was a very good student who later was quite successful.

Incidentally, the grandson was gay. Within a year, I was able to locate an apartment in a new complex and moved from this central location.

In 1963, Raleigh, North Carolina, the state capital, was still a village without bars or the sale of alcohol other than beer and wine. Several of the State politicians wore traditional white straw hats of Southern gentry. A different church occupied each of the four corners of the State capital square located in the center of Raleigh. That was prime real estate. I remember how I resented paying the monthly parking fee to the Methodist Church that owned the parking lot adjacent to my office building. The social structure consisted of a rather rigid perception of political insiders and others, as well as personal connections. During my five years there I never adjusted to that structure and, while I acquired many friends throughout the State, I had only three close friends in the city of Raleigh.

Fortunately, I met and dated a wonderful colleague by the name of Macil whose job was in Business Education. We were very close, and we did discuss marriage. One evening we went to see a house that became available in a desirable section of Raleigh. The house was of modern design sitting off the street beside a creek. I thought it was a lovely and romantic place. However, I remember her chilling remark as we left the house. She said "If you think I would live in that house you are crazy!" Obviously, she wanted a more ostentatious and traditional house. That ended any and all of my interests in further romance or marriage. Macil later married an older retired medical doctor who had a large house with white columns in Fayetteville. We remained close friends.

My cousin Myrtle in Florida had a female friend in Raleigh who I met and visited a few times. She was especially fond of having me accompany her to church on Sunday. She attended the Episcopal Church, the older more conservative of the two opposite each other on the capital square. During one of the Sunday morning readings in church, I listened intently and decided that I was being a hypocrite by even being in the church since I did not believe in any of it. Over

dinner we discussed this and, while we remained friends, I never went with her to church again.

I had a conference with my immediate supervisor soon after reporting to my new job where I inquired about my duties. I had done some research on duties of supervision in art education, but most of it related to local school systems. I found nothing on the duties of the statewide position. The former supervisor of art education had been conducting workshops for teachers throughout the State, and I was not certain that this was the route that I should follow. Nile Hunt, my supervisor, told me that since the position had only been created two years earlier they had never defined the duties. He said, "You will have to go out there and find out what the schools need from you." Subsequently, within one year, I had visited each of the 172 educational units in the State of North Carolina! From these visits I learned that we were requiring teachers in grades one through eight to teach art, a subject that very few of them were prepared to teach. I learned further that the traditional route to becoming a school administrator was through the athletic programs. Administrative positions traditionally went to men who had absolutely minimum familiarity with the arts. I decided that the research that I was already doing should make for a good dissertation. Considering these findings I concluded that I could never educate all of the administrators, nor could I possibly teach all of the teachers what they needed to teach art to children. I began to revisit each of the 172 units where I would discuss art education values with superintendents and administrators, and I conducted system-wide demonstration workshops in the teaching of art. These workshops involved teachers and administrators in enjoyable activities of art media and philosophy. At the same time, I began an art education newsletter, printed on pink paper to get attention, in which I called attention to the values and rewards of art education programs, as well as information on necessary supplies and facilities for art education. I also wrote on annual reports from the principals where a school did not have and art teacher, a reminder of this deficiency in their programs. While this notation had no legal or

enforcement value, it did prick the consciousness of administrators and made them think about it.

The State Superintendent held weekly, Monday-morning meetings with the staff. As I listened to his discussions, I noticed that he never mentioned art in his references to school subjects. So, I moved my chair to the end of the table opposite him and began the practice of raising my hand as he finished references to disciplines and say, "And art!" Within weeks, he would end these references with a finger pointed at me and repeat "And art!" It was all in fun, but it got the point across to all of the staff that art was one of the essential disciplines.

I presented a dissertation proposal to my committee at Peabody in which I would research the status of art education in North Carolina schools. This, I proposed would include assessment of the qualifications of the teachers to teach art as required of them. The committee accepted the proposal and I began the research. As a chapter draft was completed I would mail it to Peabody for review, and I went to the campus with the material several times. Finally, in the spring of 1965 I took the final copy to Peabody and had my committee review. I thought the review would concentrate on the content of my dissertation, but one professor kept trying to get me involved in a discussion of aesthetics by asking my opinion first of a new church a few blocks away, then a Jewish student center which he referred to as a synagogue, and the major building on campus. I had rather negative responses to all three buildings and explained why. Finally, Gus Freundlich, my department head, came to my rescue by asking me to comment on a painting that was hanging in the room and to describe what I would do to improve that painting. At first I thought he was out of his mind or at least turning against me. I took time to peruse the painting and then declared, "This abstract, non-objective work is complete and, while I may not like it, the painting would have to be accepted as a finished product since all elements appear to be working together to achieve a cohesive unity. Furthermore, the artist had signed the painting indicating that the work was complete." With that Gus thanked me and the committee

dismissed me. I later learned that he had done this to "save my neck" from the tricky tactics of the other professor. The committee accepted my dissertation. A couple of days later the Dean, who was to sign my dissertation and verify my preparation for graduation, asked me to come to his office for the dissertation. When I arrived in his office I noticed that he had the College catalogue lying open on his desk beside my records and the dissertation. I sensed that something must be wrong. He explained that the rules clearly state that "One can transfer in from another institution only twenty-four hours of credit." I had transferred in seventy-two hours from the University of Florida! I sat down, and I think he must have enjoyed my bewilderment for a moment. Then he stated that I had transferred in under another dean, who had indeed signed for me to do so, and that he was now going to sign my dissertation. He signed it, I thanked him profusely, and I quickly left with my copy. My step-mother and my sister, Mary Trease, came to my graduation.

One can hardly imagine how happy I was to have completed this degree. I was the first person in any of the "Kelly Family" to have a doctorate, and I was happy to have my step-mother and my sister attend my graduation. I was now free to pursue a career to which I was devoted. And, psychologically, I needed to end the five years of insecurity and the loneliness associated with being submerged in work and writing. I was forty years old and beginning a new career in a new geographic location some distance from any of my family, and I was no longer in any mutually dependent relationship with my brother Marvin. All of this gave me great impetus to put all of my energies into my work in North Carolina.

My dissertation did serve my agenda in North Carolina. It was used by two different state study committees appointed by the Governor. It received statewide attention and was cited in two legislative studies to verify the weaknesses in the State's art education program. It also received national attention as a model for similar studies in other states.

In 1963, North Carolina still had segregated schools. Not only were there Caucasian and African American schools, there were

segregated Indian schools as well. When I held workshops, the participants often were racially selected. In my travel over the State, this racial separation and disparity became a problem for me. These situations were painful to me and made me determined to do whatever I could to alleviate this social injustice.

In one system in the eastern part of the state, to which I was invited to hold workshops with all of the teachers, I was asked to hold three sessions: one for whites, one for blacks and one for Indians. I refused to do so but agreed to hold one in the afternoon and one in the evening. When I arrived for the two workshops, they had assigned whites and blacks to the afternoon session and Indians to an evening session. Even then, the races sat separately during my lecture. So, I divided the participants by grade levels for the creative experiences with art materials, where they would be required to work together. They did this without incident and with observed positive interaction.

I was later scheduled to do a workshop in a school system in the western part of the state. I noticed, as I was preparing for the workshop, that none of the African American teachers were present and that their one school was the only school not represented among the participants. I quietly called the supervisor aside and assured her that I would not hold this meeting without some of them being present. She quickly called the school and got seven of them to attend, on about a thirty-minute notice. They later thanked me for letting them participate because, had I not had the supervisor call the school, they would not have known about the workshop. That was really painful for me. It was so very difficult for me to concentrate on my presentation without really expressing how the situation was affecting me. But, I had to maintain my professional demeanor.

In a visit to two separate schools that sat back to back, separated only by a low fence but facing different streets, one African American teacher asked me privately if I would speak to the Superintendent about an issue for her. I promised to do so. It seemed that in the white school each teacher had a metal name plate on the door. She had this information and wanted the same for her school. I went to

see the Superintendent immediately afterwards and called this to his attention. They got their name plates. I was absolutely amazed at the simplicity of the request, which was symbolic of a far greater disparity.

I organized and directed tours for art teachers to major museums in New York, Washington and Philadelphia. The participants were selected without regard to race. On one trip, a white teacher from a small rural town refused to be photographed with the group because it was integrated and that would "be an embarrassment to my husband who is a lawyer." On another trip with four of the State's only five local art supervisors, one participant was an African American male. One white female refused to walk on the sidewalk in New York with that member of the tour. I photographed the group together and later published it in the newsletter to art teachers.

The art teachers in the Raleigh City Schools asked me to meet with them, and I invited them to meet at my apartment. During the discussion about our next meeting, a Jewish woman stated that she would like for us to meet at her house, but she could not have the integrated group because her neighbors would not like that. I, a gentile, asked her what she thought my neighbors were going to think or say when they saw a Jewish woman leaving my apartment. To this she replied "I get the message. Come to my house for the next group meeting". I didn't bother to tell her that my neighbors were Jews.

In my official duties, I attended the conferences and professional meetings of various educational organizations. The teachers had two segregated statewide professional organizations composed of departments according to disciplines, such as math teachers, art teachers, etc. The State at that time had only about two hundred art teachers who had loosely organized themselves as departments in those two teacher organizations. However, some of the art teachers were unhappy with the segregation and with the very limited funds available from the parent organizations for professional meetings and programs. These art teachers had organized a third integrated group outside the two professional organizations. This was done under the leadership of Dr. Wellington Gray, who was Dean of the School of

Art at East Carolina University and a close ally of mine. I called a meeting of the officers of each of these three groups, during which we organized the North Carolina Art Education Association (NC-AEA) and planned a statewide conference to be held at the University of North Carolina at Greensboro. This was the first integrated organization of teachers, and it became the first "discipline" department to become independent of the parent organizations.

In planning the first conference, we were told that we could hold this integrated meeting at UNCG but that we could not have any integrated social events such as a dance or cocktail party on the campus. I convinced the commercial art suppliers to host an evening social, dance and cocktails in a motel. This conference was a beautiful experience. The group organized, adopted a constitution which Wellington and I had written, and elected officers with minor racial problems. By the end of the evening dance at least one white male was seen dancing with a black female. The NC-AEA grew into a very large organization as the schools acquired an increasing number of art teachers. Between 1963 and 1968 when I left Raleigh, there were many and drastic changes along these lines. I take pride in being a constructive part of that movement.

In 1967 my brother Marvin died in Orlando. I flew there for the funeral, and I was the only member of his immediate family to do so. Aunt Dora, Aunt Beaulah, Myrtle, many of Carl's relatives and many friends did attend the funeral. He was then buried in the family plot of the Isbell family, alongside the space for Carl. That was the first time I had attended a funeral service in the Catholic Church. One of the attendants was a former high school student of mine who worked at the funeral home. He was very comforting to me, and he wrote to me for years afterwards through which he kept me informed of his career and family changes. Of course, I felt a great loss and a sense of relief for Marvin because he had suffered through years of physical and mental pain. He died painfully aware of the isolation from the family, which he needed. In his will, he left everything to Carl, much to the consternation of some family members. My sister Louise forever resented that. Twenty years later she and I would have

a lengthy discussion about Marvin being gay and it being only right that Carl would inherit whatever they had together.

During my stay in Raleigh I was professionally involved in so many things that I can only touch on the highlights here. For me, it was a period of extensive development. I was active on the State level as well as the national level. I worked with Paul Welliver in Mississippi in developing an art curriculum for statewide educational television, with the city of Chicago in developing televised art instruction, with the National Center for School and College Television (Bloomington, Indiana), and with North Carolina Public Television for the same curriculum. I was active in and served on the board of directors for the North Carolina Art Society, which supported the North Carolina Museum of Art. Besides serving in almost every official capacity with the NC-AEA, my responsibilities involved me in local and national levels of Scholastic Art Awards, the American Red Cross International Art Exchange, the National Art Education Association, the Associated Artists of North Carolina, the American Craftsman's Council, the National Council on The Arts in Education, etc. Through all of these activities I met wonderful people who helped to bolster my confidence, to extend my expertise, and to make my professional and personal life rewarding. These professional activities, the travel and duties of my job left no time for my creative art work, but I did have a few exhibits of my graduate works. It was five years of personal growth and happiness.

In my visits to schools, community colleges, colleges and universities, I came to know all of the programs of art instruction in North Carolina as well as most of the people involved. In 1966, Western Carolina approached me about moving to that university, as they did again in 1967 and in 1968. East Carolina University twice asked me about going to the art department in that university, and I taught two summer sessions at Appalachian State University. Finally, in the summer of 1968, Newton Turner, the Vice Chancellor at Western Carolina University, called me for some assistance in developing the art program there. I went to WCU to confer with him, only to find that he wanted to offer me the position of Head of the

Department of Art at WCU! He stated that he knew what my salary was in Raleigh and that he was prepared to double that salary if I accepted the position. That promise closed the issue. I returned to Raleigh and resigned effective September 1 and moved to Cullowhee, North Carolina. Upon my departure, the staff gave me the following poem:

Before I met Kelly,

I'd have no part of Modern art,

I simply couldn't stand it.

I like it now, but I vow,

I'll never understand it!

As I reflect on the Raleigh experience, I realize that social interaction depended greatly on political and social cliques, that my friends were elsewhere over the state, and that I was so busy and so engrossed professionally that romance, aside from Macil, had played a very minor role for me there. I left Raleigh anticipating new professional development and a new social setting.

CHAPTER TEN
CULLOWHEE, NORTH CAROLINA

To reach Cullowhee in 1968 I left the four-lane highway at the top of Balsam, just west of Waynesville. I drove the circuitous, two-lane, mountainous road about ten miles to the village of Sylva. Then I drove south about seven miles on a road that followed the Tuckaseegee River to Cullowhee. The name "Cullowhee" translates from the Cherokee language to "the valley of lilies." Indeed, there was little here other than the beautiful valley and the small college that had begun in 1889 as a rural elementary school. The school then grew into a high school, a normal college and a teachers' college. In 1967, it became Western Carolina University, one of sixteen campuses of the University of North Carolina. The administration was in the process of establishing and staffing the various schools and departments of a university. The enrollment was about twelve hundred students, and it was experiencing rapid growth. I entered the campus drive between the Baptist Church and the campus steam plant. The older part of the campus was on the hilltop, near the original location, with newer buildings being erected further down the hillside. This new construction was edging into adjacent pastureland and hayfields. Other than the one paved road from Sylva, other roads were still unpaved.

Housing was very limited in the Cullowhee area when I arrived in the summer of 1968. I stayed in the home of one of my professors

and his wife, Ted and Mim Matus, for about three months until housing became available. I occupied their son's room while he was away attending the University of North Carolina at Chapel Hill. Ted's house was an old two-story frame house, just off the WCU campus. The son's room was in the renovated attic. Since the house was heated with only a small wood-burning stove in the living room, it was quite cold in the attic.

Dr. Newton Turner, assistant to the President, hired me during my initial interview before I had met the dean of my college. Dr. Turner instructed me to "develop the finest art education program available in North Carolina." During the weeks between that interview and my return to the campus, President Reid had retired, and Dr. Alex Pow had arrived as the new President. Dr. Pow was displeased that Dr. Turner had hired a head of the art department without consulting him. He had wanted to bring in an artist with him from Alabama. Upon my arrival, I reported to Dean Eller, who expressed his concern that he had not been permitted to interview me before Dr. Turner hired me. He then strongly suggested to me that he wanted the department to emphasize the crafts, which were indigenous to the area. He told me that Dr. Pow was unhappy also, because he wanted the department to emphasize the "fine arts" of painting and sculpture. At this point, I was quite angry at the whole situation. I explained to Dr. Eller that I knew that each of these three concerns was important. I asked him to convey to the President this message: "I was hired to develop an outstanding comprehensive art department. For me such a department has to encompass the four major components of studio arts, art history, crafts, and art education. I was going to do just that. I do not want to be a party to dissensions about the importance of any one of them." I never heard about that issue again, and these three administrators became my closest associates on the WCU campus.

Dean Eller escorted me "up the hill" to the Joyner building, where he was moving the art department, and into the room that was to be my office. Students and faculty built the Joyner building in 1925 on a base that was far from square and adjusted or compensated for the mistake by making one wall thicker at the corner to square

it up. I remember this initial visit so well because my office was a neglected corner room with large windows through which ivy and trumpet vines had grown half way across the room. Layers of paint were hanging from the walls in great sheets, exposing the various colors they had been painted over the years. Student organizations were currently using the building, and it was in disrepair. However, it was a spacious and attractive old building with a large wooden staircase from the front door to the second floor. The large windows admitted adequate light for art instruction, and it served the needs of the art department well at the time. This would be the home of the first Art Department at Western Carolina University.

The art faculty consisted of six professors organized as part of the Department of Industrial Arts and Home Economics, headed by Dr. Rodney Leftwich. While Dr. Leftwich was an industrial arts administrator, he had done his doctoral study in crafts and had written a book on the crafts of the Cherokee Indians. His wife, Janie, was also teaching art appreciation in the department. I was the seventh faculty member, and I immediately hired Joan Byrd, as the eighth, to teach ceramics. In the next eight years, until my resignation as head of the department, we built that department to a faculty of eleven members. We had over two hundred amd forty art majors in studio arts and art education in the BA, BFA and MA degree programs. I had good rapport with the faculty, and I found friends throughout the University such as I had never known in Raleigh. The late sixties and the decade of the seventies were exciting and creative times. Students took a cavalier attitude toward tradition and toward careers, and enrollment in the arts grew rapidly. I was deeply involved in planning a new art building that we occupied in 1970. It was an exciting time for me.

Before I came to Cullowhee, friends told me that I would find a community of gay people here. I had names of twenty-seven professors and students who were gay, including some of my own faculty. I made contact with most of them and cultivated a few of them as friends. It was in this environment and among these friends that I gave up, in my own mind and in practice, on being heterosexual

177

or even bisexual. I acknowledged to myself that I was indeed gay. To this day, I have been unable to discuss this with any family members, except my cousin Myrtle. It has been so painful to accept and more painful to face probable rejection from my family. Being gay in the university environment was never a problem professionally. Being a single person, and in some cases being gay, did preclude my being invited into a few homes for some social activities.

Warren

I met Warren in the fall of my second year at the University. I was wearing beads when we met in the hallway, and he remarked "I wish I had some pretty beads." The following day I again met him and placed a long pair of beads on his neck. I still remember that he was wearing a long-sleeved white shirt that complemented the blond hair and blue eyes. At that moment his eyes were wide open in surprise. He wore those beads almost continuously the remainder of the semester. While I was on a business trip to New York in January I asked him to housesit for me. I returned on Friday and he indicated that he wanted to stay there over the weekend. After that weekend together, we maintained a monogamous relationship for six years. We remained close friends as he moved through two graduate school programs, in Tennessee and Wisconsin, and various teaching jobs, until his death by heart attack in 1989. I believe that this was the first time, since my relationship with Tommy, in Hawaii, that I had really been in love. I have not been in a relationship since. I was devoted to that young man, and I have not felt such a deeply emotional and reciprocal relationship with anyone since. Warren, like me, never had another lasting relationship in his life. His father told me that he had been aware that Warren was gay since the seventh grade. His mother did not know about it until a few years before his death. They accepted me into the family, and we remained good friends until their deaths.

A few months after Warren's death, I visited his parents, and

I remember so well that I was sitting between them in the living room when the subject of his "life style" came up for discussion. Subsequently, his mother asked me "What did we do wrong with Warren?" Since I knew that Warren's brother was straight, I asked in return "What did you do right for his brother? Did you take him to a prostitute? Did you tell him how to have sex?" Then I explained that she had done nothing wrong. Indeed, she had done so much right because she had loved Warren all of his life, and he knew that. Not once did his parents ask me questions about my life style or about our relationship. They simply accepted it and appreciated me for loving Warren. His brother had totally rejected Warren after Warren told him that he was gay. The emotional impact of that rejection haunted Warren until his death. He had a weak heart, was depressed, and ended his life with alcohol.

The first of the following two poems was written in response to an experience I had one rainy evening while I waited in my car for Warren to join me for dinner. The second poem was written in response to the many pleasant hours we spent together.

SHADOWS
Perry Kelly

Rain on the windshield
Casting shadows
Beneath the street light,
As I wait.

Hastily and wet,
He enters my space.
And rain casts shadows,
Across his face.

Rain on the windshield,
Casting shadows

On two smiles,
In silent repose.

His warmth
Enters my space,
And rain casts shadows
On our embrace.

SILENCE
Perry Kelly

We have made our way
Through autumn color,
To the forested hilltop.
Without conversation,
We rest.

Birds chirp and flutter.
Wind, like spirits,
Drifts through the leaves.
Our silence awakens us,
To each other.

We linger there in silence
Until one speaks
With deep emotions,
And philosophical thoughts
Of each other.

Again silence invades,
Words no longer divide us.
Together we lie amid the splendor,
Contemplating our space, we rest,
With each other.

Other Students

The rewarding relationships and bonding that I have experienced with students throughout my teaching career have been, as it is for most teachers, one of the greatest pleasures of my life. By establishing a good rapport with students, they are free to explore and learn. Such rapport also established channels through which I understood the students, as the following antidotes demonstrate.

I met a student named Jim on the stairwell one day and remarked that he looked disturbed or depressed. He replied that he was depressed and needed to talk to someone. Thinking that he was having trouble in one of his art classes, I invited him into my office to talk. When I looked at him from across my desk his eyes were full of tears. He began to talk about personal relationships on the campus and how he could not seem to make friends here. I quickly realized the point of reference from which he was speaking. I let him talk through his problems without mentioning that he was gay. Jim did not talk about his real problem of being rejected by his roommate, for whom he had deep emotions. I surmised these facts from his circuitous conversation. I advised him how to handle his emotions, how to concentrate his attention on his art, and to give his relationships a little more time. He later moved away from this roommate. He told me that I had saved him from leaving college and going home. Jim and I thereby established a lasting professional friendship. After graduation he was teaching art in a high school in Atlanta when he and I finally spoke of our being gay. He was a smart, energetic, and ambitious young man. Each time I had contact with him I insisted that he get started in a graduate program, and I finally persuaded him to enter Georgia State University, where he finished his MFA degree. I then hired him to administer a federal grant program that I had in Polk County, North Carolina, schools. He handled the three-year program very well and submitted the most meticulous, well written, reports that I ever received. Afterwards, I persuaded him to enter a doctoral program in art education at Florida State University. He completed that program and has since held prestigious university positions while

being openly gay. I felt that I had made a contribution to Jim much as another professor had done for me some years earlier.

At one time, Marlon, a graduate student in geology, transferred from Canada and was unable to find an apartment. A mutual friend asked me to let him occupy a spare bedroom at my house, which he did for several months. Sometime later, when Marlon was dating the daughter of a man in the university administration, he spoke to the father about marriage to his daughter. The father told him that he did not want his daughter to marry a gay person. He had heard that I was gay and had assumed that since the student lived in my house, the student was also gay. The daughter knew better. And, although they did not marry, she remains a friend of mine. Marlon very angrily clarified our relationship in heated language. While the parents have always been very cordial to me, the incident distanced us forever. Marlon soon met and married another lovely girl, and I served as best man at his wedding.

Lars and Mary were two of my favorite students who became lifelong friends. They had been together since seventh grade and came to Cullowhee as a married couple. Both of them enjoyed partying with gay students and faculty, and they really knew how to invigorate a party. Lars' parents' home was in a well established, rather wealthy community. However, unbeknownst to his parents, he found his recreation across town, where he was introduced to all the sleaze a military city had to offer; from country clubs to the sleaziest night clubs! I thoroughly enjoyed them. They once took me to shop at Victoria's Secret just to see my reaction. Another time they took me on a tour of about four awful clubs; topless, strip, and make-out. We are still friends.

Western Carolina did not have a dress code in 1968. However, females were expected to wear skirts, and the dress for men, due to the influence of fraternities, was white shirts and khaki trousers. One female student named Carla came to a pottery class wearing jeans and was sent to my office to discuss the "code." Of course, she was absolutely right in refusing to wear a skirt as she straddled the potter's wheel! With my approval (encouragement) she skipped other

administrative levels and went to the Chancellor for permission. She not only got permission to wear pants but prompted the removal of such dress code. I was proud of her.

Students in my fiber arts classes were highly motivated and energetic and about equally divided in gender. Instruction was oriented toward the individual in an informal working setting. Two lovely females, who were obviously engrossed in social and Greek issues, became a nuisance to me and the class with their chatter and lack of focus. After repeated cautioning, I had to intercede by taking each out of the studio for individual counsel. One of them revealed that the other was a close friend who was "driving me nuts!" She cried, and elaborated on the social relationship. We discussed ways of distancing herself from the friend, and I ordered them into separate work spaces in the studio. By the end of the semester they were distant friends, and I continued a long friendship with both.

Weaving on a loom requires concentration. Much of the work requires counting carefully. On one occasion an older student repeatedly made mistakes in her counting until I asked her privately to discuss her problem. Her surprising opening remark was "My family is driving me crazy!" She spoke of problems with a son and stress with her husband. My advice was to forget about the weaving class for a few days to settle issues at home. She left for several days, during which I became increasingly concerned. She returned a very changed woman. She confided to me briefly how she had made changes. Thereafter she progressed quite well.

Another older female student had enrolled in the fiber arts class as an art major seeking a master's degree at the same time her son was majoring in art as a freshman. She also had trouble concentrating on her weaving, and it became apparent that she was struggling through some of her other classes. I learned during a counseling session that she had a degree in nursing, her husband was a medical doctor, and that she was enrolled in art primarily to encourage her son to study art against the wishes of his father. I advised her that she was in school entirely for the wrong reason. She completed the semester

and withdrew from the university. I learned later that her son was relieved. He later graduated and established his own pottery studio.

Teaching at the university level necessitates the same strategies as teaching at any other level. Always, concern for human growth super cedes course requirements. Art experiences are indeed integrating experiences for anyone.

The years of the sixties and seventies were exciting times. It appeared to be a period of liberal attitudes, rather relaxed interrelationships between students and faculty, and two decades of growing enrollment. It was a period when students were less concerned with careers and more interested in programs of study that they would enjoy.

Faculty

In my administrative position, I had the pleasant responsibility of hiring faculty. I had the terrible responsibility of firing them as well. I became very upset the first time I had to give a professor notice that we would discontinue his contract and service with the University. That meant that the University would not give him tenure at the end of his probationary period. I became so disturbed that I could not sleep well for two weeks. He was married to his second wife with whom he had a number of children, and I liked him and his family. I finally called him to my office and told him that he would not be granted tenure. He remarked, "But you can't do that. I already have tenure." I was certain that it was not true, and I could see trouble developing. I assured him that if he could prove to me that he did have tenure, then I not only would continue his contract but I would apologize as well. After he left my office he called union headquarters in Washington. As a result, the Dean and I had to meet with three representatives of that union to review the record of the professor. We told the members that he had never been granted tenure. Furthermore, he was on three-year probation for being drunk and causing a disturbance at a student party. Upon learning this, the union representatives simply folded

their papers and excused themselves. I then had a short conference with the professor to clarify his status and departure schedule.

I later hired a professor in art history who came to us highly recommended. At the time he was living and painting in Italy. When he arrived for the job, he was accompanied by his Italian male mate and a large dog; both understood only Italian. He was a very fine teacher and a most likable person. However, his friend from the city of Florence, Italy, who did not speak English, could not adjust to the isolation in Cullowhee. He began to drink and became an embarrassment to the professor. I attempted to understand them and to help the professor through that difficult time. I thereby learned many things about the professor's background that would have prevented my hiring him had I known such before bringing him to Cullowhee. Subsequently I had to deny him tenure on the faculty, and that was painful. The Dean once asked me if I thought the professor was gay. My reply was "I assume so."

An artist from Poland who had married an American and lived in North Carolina was recommended to me as a fine painter and teacher. From among other qualified applicants, we chose him. I had a Polish friend translate his credentials for me. His record was impressive. He was a good painter and an adequate teacher. He was also a womanizer who could not keep his hands off the female models or students. I advised him that the University would not give him a contract for the following year. Thereupon, he filed a case against me for being biased against Poles. The Dean, my faculty, and I had to undergo another hearing. Not only was I a close friend with two other Polish faculty members, I also had another Polish member on the art faculty. In the committee's meeting with the art faculty in reference to this matter, they asked if they ever heard me tell Polish jokes. To this, my faculty remarked, "Dr. Kelly cannot even tell jokes! He is lousy at remembering jokes!" The issue was closed. However, the professor quickly found a job teaching in Texas, in a girls' school! He lasted there only about six months. In his application for the next job, surprisingly, he gave me as a reference. Of course, I refused.

One other case will suffice to illustrate some of the trivia and

stress associated with university administration. I had a professor in painting whose wife had a degree in art history. We were close friends. I had hired her on a temporary basis to teach one course in art history while we were adjusting the faculty and hiring a new person. The new position was for a design instructor to develop a graphic design major. The wife applied for the job. We dutifully considered her application and concluded that her preparation did not qualify her for that position. She in turn filed a case against me for being biased against women. The first person I hired upon coming to Cullowhee was a woman, and we employed other female professors from time to time. We had another hearing, and the committee dismissed the case.

Sometimes, I had to deal with faculty as artists, who could be quite temperamental. One professor enjoyed holding critiques of student work by sitting in a large chair and berating the art of each student to the point of bringing the student to tears. He never gained tenure. Another professor had a fetish about female breasts. He repeatedly spoke to the drawing class with excessive references to the model's breasts. I pointed out to him that some of his students did not share his interest in breasts. I also told him that he should be aware as well of the gay and lesbian students in his class, who responded negatively to his remarks. He had never thought about it. At the end of the year, his contract was not renewed.

One female professor and one male professor shared a room for alternate classes. One day, the female drew a black line through the middle of the room by which she proclaimed one side for herself and the other for the male teacher. I had the line removed and told the faculty that the room was available for the use of any one of us. This altered the physical nature of this problem, but it did not heal the hostility between the two professors. Fortunately, she soon found a job elsewhere.

Another of my most highly respected professors dashed into my office one Friday afternoon, closed my door and began to curse, berate and threaten me for no apparent reason. I had no idea why he was angry when he came in nor after he left. I leaned back in my

chair and let him rave for a few minutes as he paced in front of my desk. Then I interrupted him with instructions to leave my office immediately and to return when he was calm. I promptly consulted my Dean, who then spoke with the Chancellor. The Chancellor and the Dean advised me to fire him before Monday morning. I could not do that without knowing more about the causes. I waited until Tuesday to call him to my office. I handed him a statement to read that I had prepared late Friday. I had the secretary type and witness this paper in which I detailed the event and the gist of our conversation. The professor exclaimed "I don't remember saying any of that!" He signed the paper, and I placed him on probation for three years. Ironically, he has retired from the University, and we remained good friends until his death. We never discussed the issue, nor do I know why he was so angry at me.

Such issues and incidents contributed to the excitement of the times, even though they required unbelievable patience and diplomacy. None of these incidents are cited here to demean the faculty. Quite the opposite is true. We had a faculty of accomplished artists, generally great teachers, and congenial friends. We developed a comprehensive art department, gained statewide recognition, participated in visits to public schools, extended class offerings through this end of the state, and hosted conferences having national recognition.

Student enrollment had grown to 240 majors with an art faculty of eleven by 1978. They were: Perry Kelly (Department head, Art Education and Fiber Arts), Betty Watson (Art History), Ray Menze (Art Education), Ted Matus (Metals and Jewelry), David Nichols (Glass Blowing and Drawing), Jack Lewis (Sculpture and Design), Lee Budahl (Drawing Calligraphy and Art Appreciation), Melissa Murray (Drawing and Painting), William Lidh (Drawing, Design and Printmaking), Joan Byrd (Ceramics and Design), Duane Oliver (Art History and Art Appreciation), and Janie Leftwish (Art Appreciation). This was a youthful, energetic faculty who maintained respect for and friendship with each other. I really enjoyed my association with each

of them, and I greatly appreciated the expertise that each contributed to the success of our program.

I will cite a few of our accomplishments here. I had a federal grant, and a team of local educators involved in it, to establish art and music teachers in all of the schools in the eight westernmost counties. This project was called the Smoky Mountain Cultural Arts Development Association (SMCADA), and it proved to be the most successful grant program I ever administered.

In 1969, we hosted a conference titled "Confrontation with the Arts," with regionally and nationally recognized participants, as a means to focus attention of school administrators and educators on the values of arts education. This was followed by a workshop that I led called "Don't Stifle Creativity," in which educators were asked to nurture creativity in child behavior, learning and expression.

I had organized and conducted tours for groups of art teachers and art supervisors to art centers in New York, Philadelphia and Washington D. C. before I came to Cullowhee. In 1968, I conducted such a tour, sponsored by the North Carolina Arts Council. In 1970, I again organized and conducted a similar tour for award-winning art teachers, sponsored by the North Carolina State Art Society.

One contribution that I think made an impact on art education was my service as a committee member on a program for Evaluation of Art Teacher Programs in North Carolina Universities. Earlier, I had made a study of the art education programs in all sixteen of the universities, after which some of them were denied certification for their art education programs. Of course, I used this study while on this committee. Our recommendations strengthened the programs for preparing arts educators.

I wrote a brief letter to the Chancellor of Western Carolina University in which I decried the visual appearance of the campus. I explained that a university located in such a beautiful environment deserved far more "garden like" landscaping. The Chancellor agreed and appointed me chair of a committee to propose changes. We contracted two landscape architects and three architects to visit the campus, to meet in a public forum, and to recommend desirable

changes. They drew rather elaborate plans for a centralized campus, a lake on campus and removal of the public highway from the campus. Their first recommendation was for a "year round grounds crew" or "landscape team." This recommendation was implemented within the next budget, along with funds for extensive planting of trees, shrubs, and flowers. One need only to view the campus today to assess how successful was our impact.

The North Carolina Art Museum curator asked me to assist in development of a special educational Gallery for the Blind. This gallery gained national attention as "a first." Meantime, I met a young man, Mack, who was blind but wanted to learn pottery. So, Joan Byrd, our lead ceramics professor, and I created a space for the student in the ceramics studio, where blind students might work along with other students, and developed a course in Art Appreciation for the Blind. This was a most gratifying adventure for me. Mack later opened his own studio and sales shop in Virginia.

Meditation and Yoga were very popular during the seventies, and I often questioned how such practices related to art. Soon it occurred to me that the very processes of creating art are forms of meditation. Getting students engrossed in the art or creative process involves them in meditation, self examination, and relationships. Ray Menze, one of our professors, had done his dissertation on the topic of "Gestalt Psychology, Phenomenology, and Aesthetic Perception."

This research furthered my interest in art as meditation. In response, we hosted a symposium during a joint conference of the Virginia Art Education Association and the North Carolina Art Education Association to which I had just been elected President. The presenters at this conference were: Dr. Herbert Burgart, Dean of the School of Art at Virginia Commonwealth University; Dr. Perry Kelly, Chair Department of Art at Western Carolina University; Dr Ray Menze, professor of art at Western Carolina University; Dr. James Wise, professor of philosophy at Norfolk State College. The monograph from this symposium was published and widely distributed.

One criterion for annual positive evaluations of faculty during

my tenure at Western Carolina University was a record of service to the community and the region, along with on-campus duties, student advisement, and administrative work. This idea of service to the community, which the regional university serves, motivated many of us to participate in professional activities for long hours outside of the normal teaching schedule. As part of my service, the activities I describe here included workshops in the schools.

In 1976, a group of professors who were involved in the arts and literature, including me, assembled to discuss the status of the arts in our area of the state and the role of the university in nurturing the arts in the region. As a result, we formed the Jackson County Arts Council and obtained its designation as the Designated County Partner with the North Carolina Arts Council, a state agency from which we received annual matched funding for arts programs. I drafted the By-Laws, and the organization was chartered in North Carolina in 1978. The Jackson County Arts Council, a totally volunteer organization, continues to provide programs in the arts annually for every age group. And, I continue to be involved with its administration.

The Scholastic Art Awards program of local and national competitions in the art of children was one of my favorite activities. I served as president of the Greensboro, North Carolina, chapter and served as juror several times in state and national competitions. These experiences prompted me to get involved in the American Red Cross International Exchange of Children's Art. This art exchange program, between American and foreign students, was not successful due to the lack of art supplies available to our foreign exchange schools.

In 1970, I was elected President of the Associated Artists of North Carolina, which I had helped to organize during my stay in Raleigh. In 1977, I served as an evaluator for review of North Carolina's National Teacher Exam (NTE). I was also elected to presidency of the North Carolina Art Education Association (NCAEA), which I organized in 1964. I was appointed, in 1983, to the Board of Directors for the John C. Campbell Folk School in Brasstown, North Carolina, and served as Chair of Distant Gifts during the Folk School's National Capital

Improvement fund drive. After my retirement from Western Carolina University in 1990,, I became Interim Administrative Director 1990-1991. In 1981, I was elected President of the Associated Artists of North Carolina. I received the award "Art Educator of the Year" from the North Carolina Art Education Association and the Southeastern Division of the National Art Education Association, presented at the national conference that year.

The demands of administration, teaching and other duties began to affect, my health and I wanted to return to full time-teaching. I consulted with the Dean, who told me that I should feel completely free to relinquish the position and return to full time teaching. I considered the various aspects of the matter, including financial concerns, for a week. Then I asked to be relieved of my administrative duties. The faculty began the process of selecting a new department head, and I began teaching full-time in the fall semester of 1976. I continued to teach Art Education, Art Appreciation, Fiber Arts, and Drawing as well as student advising. The university deducted my administrative supplementary salary but then gave me a merit raise equivalent to that administrative sum. The Dean did this, as he said, "for the good job you have done in a most trying position."

At that time I belonged to and was active in about seventeen professional organizations at the local, state, national and international levels. I also began to devote more time to my own art production and exhibiting in fiber arts and photography. I was now able to devote more time to those professional activities as well as to my teaching. I also continued to travel extensively.

The University was by now offering instruction in glass blowing in a new facility designed for those classes taught by David Nichols. David, Joan Byrd and I organize a national exhibition of blown glass, which brought national recognition to our programs. We also organized a National Fibers Exhibition in our efforts to promote the fine crafts as part of our arts curriculum. Both of these shows created extensive attention as well as financial support for those programs.

I received an invitation in 1983 to teach a summer session at The University of North Carolina at Chapel Hill. The professor who

normally taught art education there took leave to travel. In making my preparations, I spoke with him three times but received little concrete information. So, I arrived for classes prepared to meet students enrolled in art education. In the first class of thirty-two students only two were art education majors. Of the others, only one was an art major. I learned from the students that the class was a simple crafts class that they took for easy credit. I dismissed the class and went to consult the head of the department. He was unaware of the content of the course. During our conversation, to my surprise, he asked me to define "art education" and to describe what I thought those students should have to satisfy a need in their general education program. I then suggested that the course should be an art appreciation class in which student would learn terms, concepts, media and history of art. He then asked me to make it such, overnight no less! I worked all afternoon and into the night to prepare new materials for the following day. It was most successful with the students, and the other professors in the art department welcomed the change. When I returned there to teach the same course in 1984, I found students lined up in the hall. I accepted thirty of them and hastily recruited another art educator to teach a second group. The experience was enlightening and rewarding for me. I finished that summer with a renewed confidence in my teaching but some negative ideas about that famous institution. When the professor returned that fall, he found that the department had terminated the "art education" program. I have not seen or spoken to him since.

I received an honor from the North Carolina art educators in 1985, when they named me "Art Educator of The Year." I had served for five years as the Art Supervisor for North Carolina schools; I had organized the North Carolina Art Education Association (NCAEA), in which I had held almost every office. And, I had chaired several state conferences. Therefore, I knew many of the art teachers in our public schools and colleges. I was very proud to receive this honor. I received additional recognition when they presented the award at the National Conference. They did that before many of my friends from Florida, where I had served as president of their art

education organization as well. In 2012 the NCAEA presented me with their Lifetime Achievement Award during the state conference in Asheville, North Carolina.

Back to Europe in 1970

In 1970, I signed on with Brownell Tours, to escort my third trip to Europe. The participants in this tour were about nineteen to twenty-three years of age. Upon meeting them in New York, I felt that I had a good rapport with this group. We seemed to maintain that rapport throughout the trip. We sailed from New York to Southampton aboard the Queen Elizabeth II (QE2). This tour would be similar to the first two, except in reverse order.

I quickly began to compare this ship to the older Queen Elizabeth on which I had made an earlier voyage. The QE1 was a ship of detailed craftsmanship, fine woods, luxurious fabrics and a total atmosphere of elegance. The QE2 was a far more stable ship, having the same high standards of craftsmanship in stainless steel, glass and Plexiglas in contemporary design. I sensed a need for the older woods and fabrics. However, the service and the foods were comparable. It was a great trip on this new ship.

We disembarked at Southampton and took the boat train into London. We toured the city and went to Stratford-on-Avon for a production of *Hamlet*. We also saw the play *Hair*, which I thoroughly enjoyed. I again took great delight in the "changing of the guard" at Buckingham, just as I had twice before. Sharing the enthusiasm of my young group added to the excitement as we experienced so many sights that they were seeing for the first time. One of the rewards of conducting tours is sharing the excitement of experiencing the new and unfamiliar. Sharing the thrill of seeing for the first time such monuments as Westminster Abbey, or a great cathedral, or a first-rate play such as *Hamlet* enriches the repeated experience for me.

The group then went by boat train to Harwich. From there we had an overnight ship to Hook of Holland. We boarded the steamer

at about ten o'clock at night on July 4, and I think that nearly all of us stayed up all night to enjoy the beer, the boat ride and the camaraderie. We arrived at Hook of Holland early in the morning and boarded a bus for a tour. Several of the participants slept through the tour, and I admit that I also had to keep active to stay alert. The tour of Holland included the fabulous Rijksmuseum, Mauritzhaus Art Museum, and the international Court of Justice as well as a general tour of Amsterdam.

We went by private bus from Amsterdam to arrive in Brussels, Belgium, about noon, where we had lunch and a general afternoon tour of Brussels. I reminisced about my first visit and the great World's Fair, and I was anxious about seeing the old fairgrounds. I visited the site, where only the Atonium stood as an unforgettable icon. Other sites included the Stock Exchange, the Grand Palace, the Royal Art Gallery and Notre Dame du Sablon.

On July 8, we drove to Aachen, Germany, for lunch, and continued on to Bad Codesberg, Germany. En route, we stopped at the American Military Cemetery of World War II, which was an emotional experience for me. I always find it difficult to view such memorials without feeling a great sense of loss and anger at our inability to avoid such tragic conflicts.

In the afternoon we visited Cologne, Germany, for a tour of the Cologne Cathedral with its copper green roofs and its juxtaposition to the contemporary train terminal. It was here that I realized how little background information my tour members brought to this tour of Europe. It became obvious that few of them had adequate information about art, architecture or geography to fully appreciate what they would be seeing on this tour. These participants, however, did have keen interests in evening activities and discos. I prepared materials for briefings on each city we were to visit, and I gave a brief talk en route to each city. This served to orient them to the city and to the significance of the sights we were to visit.

We continued on to Wiesbaden via Andernach and Coblence after an overnight stop in Bad Codesberg. From Coblence, we went by Rhine Steamer to Assmannshausen, where we returned to the bus.

From there we continued the trip to Wiesbaden for one overnight stay. From there, we drove to Heidelberg for lunch at the famous Red Ox Inn and a brief visit to Heidelberg University. Afterwards, we continued on to Baden Baden for a one-night stay.

The following day, we drove via Schlossberg and the Black Forest to have lunch at Titisee. After lunch, we continued via Hufingen and Zollhaus to Schaffhausen for a view of the beautiful Rhine Falls that plunges some eighty feet. Then we went to Zurich, Switzerland, for a brief stop and on to Lucerne. Switzerland. We arrived at Lucerne about seven o'clock that evening, and we certainly were ready for a break in the travel.

While we were in Lucerne, we drove along the Lake of Lucerne via Alpnachstad, Sarnen and the Brunig Pass to Grindelwald. After lunch there we had a wonderfully quiet ride in a chair lift to Grindelwald. First, a peak above a glacier. I remember the green of the grass in contrast to the glacier white, the quiet at the peak and the swishing sound of large birds gliding past. The view over the snow to the distant mountain tops was magnificent. The following day was one of rest, individual sightseeing or shopping. In the evening, we had an enjoyable fondue dinner that was accompanied by an evening of folk singing and dancing.

On July 14, we traveled from Lucerne to Oberammergau, Germany, with lunch in Bad Schachen. For some unexplained reason, the German border guards detained us for quite a long time at the border crossing from Switzerland to Germany. We had scheduled a visit to the castles of Hohonschwangau and Neuschwanstein, but we arrive there just as the gates to the grounds were closing. I had, for a long time, been anticipating a first visit to the castle Neuschwanstein. Having to continue on without this visit was most disturbing. I still have not fulfilled that desire.

We spent our one day in Oberammergau at the Passion Play, a dramatic production, centering on the crucifixion of Jesus, which the local people present every tenth year. I knew of it as a very fine production. However, I slipped away after only an hour of that

performance. I do not have the religious attitude for attending that lengthy drama. I could not focus on it for a full day.

The following day, we drove on to Salzberg, Austria, where we had an afternoon tour including Mozart's House and Hellbrun Castle noted for its amusing water play and the mechanical theater. After one night in Salzberg and a morning of leisure, we drove on to Innsbruck, Germany, where we stayed only one night. Early the morning of July 18, we drove on to Venice, Italy, through the Austrian Tyrol and the Brenner Pass. This route gave us a wonderful view of the valley Pustoria and the gigantic peaks of the Dolomite Mountains. We had lunch in Cortina d'Ampezzo, Italy, (4025 foot elevation) at a lovely hotel overlooking a lake and the peaks. We arrived in Venice, Italy, about six o'clock that evening for an exciting gondola ride to the hotel.

We were in Venice during the annual Feast of the Redeemer and the Grand Regatta. After one night and a morning tour, we boarded the bus again for the trip to Florence, Italy,. The tour of Florence included the Medici Chapels, the Cathedral of Florence, the Pitti Palace, the Uffizi Gallery and Santa Croce. Florence is a grand a city. The art, architecture and the ease of getting around the city make it a most desirable place. In the afternoon of July 21, we drove from Florence to Rome, arriving there about six o'clock. The tours included the Vatican Museum, the Sistine Chapel and the Basilica of St. Peter. I had a much more leisurely and less crowded viewing of the Sistine Chapel which I continue to hold in awe. The tours also included the Capitoline Hill, the Coliseum and the Church of S. Peter in Chains containing the famous Michelangelo sculpture of Moses. For me, this Moses is far more appealing than is his Vatican sculpture of Mary holding Jesus.

Our tour continued from Rome to Sienna and Pisa on to Rapallo which I consider, along with Portofino, to be one of the most romantic places I have seen. We then drove to Cannes, France, where we had a much needed day of rest.

We left our bus and driver in Cannes and went by train into Paris, France. My tour members and I were very excited about being

in Paris, and I think that the city was all that we expected. The two full days and nights in Paris were packed with activities for us. This included a tour to Versailles and dinner in Montmartre. We boarded the Queen Elizabeth II in Le Harve on July 31 for the return voyage to New York. The second trip aboard this luxurious ship was as great a pleasure as was the first one. However, the return trip by any means is likely to be anticlimactic. The excitement of European travel fades into memories as one anticipates the New York arrival and thoughts turn to home. This was a fast-paced tour suitable only for young people. It was a memorable experience for me, and I remember many of the members fondly. I returned to Cullowhee and resumed my university duties.

My Sister's Death

By 1989 my mother, father and two older brothers had died. Only three of my mother's children were now alive; Louise, Clifton and me. Surprisingly, the idea of being the oldest member of my family was a psychological issue with which I had to deal. Upon my first visit home after my father's death, I was seated at the dinner table in what was customarily Daddy's seat. I simply could not sit there, and moved as graciously as possible to a side chair, proffering the seat to my brother-in-law, who lived in the house at the time. Having my siblings defer to me as an honor made me uncomfortable. It took years for me to deal with this personal issue.

I was most comfortable in my relationship with my sister. We often talked and, as she raised three children and went through three marriages, we had some personal discussions. Her first husband, the father of the three children, was always dominated by his mother. It was a difficult relationship for Louise, and they divorced after the children were near maturity. She once asked my advice about a problem she was having with Jack, her second husband, and then she told Jack what I had advised. They were divorced, and she later married an older man with whom I had a good relationship. They

continued to live in the small town of Cuthbert, Georgia, where everyone seemed to know every person in town. The three of us were having dinner one evening when she revealed that her husband's nephew was gay. The husband asked me how he should relate to the young man. I entered the discussion by asking, "Did you love your nephew five years ago? Do you love him now?" He answered both questions affirmatively. The conversation that followed revealed that the issue was really how to accept and relate to the gay nephew in that small town. I advised that he continue to love the nephew, to let him know it, and to help him into a secure life in a larger city. Louise never revealed why she felt comfortable asking me to discuss this issue. Nor did either of them ask me any personal questions. Anyone who was as closeted as I, can understand my relief when the conversation shifted.

I was so relieved that Louise seemed to be happier in this marriage than I had ever known her to be. However life was short for her husband, and she had a difficult time after his death.

She later developed cancer, and, in 1988, just before Christmas, I visited at her bedside when she asked me, "Perry, I am dying aren't I?" Believe me, it shocked me! Her health had deteriorated to the point where death was imminent, and I wanted to be comforting to her. My reply was, "Not yet, Louise, not yet." She only smiled and drifted to sleep. In all the years since, I have regretted not being honest with her. She then lived a short time and died in 1989. A second shock for me came when, upon my arrival for the funeral, I was escorted to the funeral home and viewed her body. She was like a complete skeleton over which someone had stretched her skin. That view of my sister in such a state really upset me. The funeral services were somewhat anticlimactic.

Life in the Seventies

From my observations and experiences, the seventies were vastly different from the nineties! Our enrollment grew rapidly during the

seventies, we recruited a good faculty, and student-faculty relationships were great. With minor exceptions, conflicts were minimal. Students exercised great freedom in their personal lives and in their choices of courses of study! They seemed unconcerned about preparing for a career! Life during those years was one hedonistic period!

I had decided, or accepted, without a doubt now, that I was indeed gay and I felt at ease with myself except around my family members. I no longer even attempted to "date" a female except for social or dancing occasions. None the less, I maintained a cordial but professional relationship with my faculty and colleagues. Being gay in that setting was never an issue. After Warren's death, I was not very interested in anyone else.

As we moved into the 1980's, the mood of the time seemed to change rather rapidly. National and local events brought a schism between faculty members and students. Career courses of study became more important, so enrollment in the arts leveled off. I assume one might call this a swing toward the more conservative decade of the nineties.

The Orient 1977

I first met "Orientals" while I was serving in the Air Force in Hawaii. My immediate superior at Hickam Air Force Base was a Korean civilian with whom I developed a friendship. Then, as I spent more time among local residents, I acquired many friends among the Oriental population. However, this trip with the Consortium for International Education in 1977 was my first travel west of Hawaii and my introduction to the Orient.

I learned of the Consortium for International Education (CIE) in 1959 while I was teaching in Orlando. Jean Marcus, a CIE representative, was at that time a nun in a Florida convent when she introduced me to study and travel with that organization. I contacted her in 1977 and found that she was no longer in the convent, but indeed was then Vice President of the organization's American office.

She also had married a Jew, had a young step-son and had moved to California. Jean was a most remarkable person of whom I was very fond. She told me of the proposed tour of four weeks to the Orient, and I arranged to go with the group. The tour was a fast-paced introduction to six countries: Korea, Japan, Taiwan, Hong Kong, The Philippines, and Thailand.

We assembled at the international airport in Los Angeles. As I waited for the members to arrive, a young man in the group approached me and introduced himself as Steve from Michigan. He said that someone told him to meet me because we would like each other. He then stated that he had met his roommate for the trip and asked if we could travel together. I had not yet met my roommate, but I did know that he was a retired military person. I immediately agreed to room with Steve. That turned out to be a most fortunate decision for both of us.

We flew Korean air lines directly to Seoul, Korea, where we found the security to be very tight. We were instructed to lower our window blinds as we landed, and we then deplaned into a section of the terminal that had all of the windows painted. After a brief stop in the terminal, we boarded another Korean plane for the flight to Tokyo, Japan.

Our itinerary stated that upon arrival in Tokyo we would "check into the hotel Urashima -- twin bedded rooms for everyone." However, there were six of us assigned to a sitting room and one bedroom furnished with six futons! The floors were covered with traditional tatami mats with cushions around a low table in the first room. After an evening of sake and conversation among the six of us, Steve and I took our futons into the sitting room to sleep. Early the following morning we were awakened at 4:30 by police whistles and commands during Tai Chi exercises in front of the police station across the street from our bedroom. So our first full day in Tokyo began very early. Breakfast at the hotel was a second surprise for us. When we went into the dining room, we faced some twenty feet of breakfast foods including American types of cereals, Japanese foods, rice and raw eggs that the Japanese broke onto the hot rice. Afterwards,

we toured around the Imperial Palace, the Diet Building, the Meiji Shrine and the Kannon temple. The following day, we visited Sony Company and Canon Company with the afternoon free for individual sightseeing or shopping. I do not think that I was prepared for the crowded conditions or the traffic of Tokyo. I did enjoy the bustling night life of the Ginza, the Broadway of Tokyo. I found it most disconcerting that addresses or even hotel names could be the same in different prefectures. When we took taxis, we had to show the driver a card from the hotel so that the address and prefecture were clear to the driver.

On June 29, we took a bus to Kamakura, where we visited the Daibutsu, or "Great Buddha", a magnificent 13th century sculpture some thirty-nine feet tall and ninety-two feet in circumference. The sheer size of this bronze sculpture in its garden setting is very impressive. The graceful, meditative pose is effective. I went to the back side and entered so that I could see the structure. To my surprise, I was able to observe the welding whereby the large molded pieces were assembled. I remember that sculpture with the same kind of awe that I remember Michelangelo's David, but with completely different emotions.

From Kamakura we drove to the Fuji National Park and to our hotel Hakone Kogen within sight of Mount Fuji. The Hakone Kogen hotel was a Japanese style hotel located in gardens and having at its first floor center a large glazed public bath. For our use, the bath had been scheduled for females and then for males. Interestingly, Steve and I stood on our balcony and watched others bathing near the semi-transparent glass. Later in the evening, we invited tour members to our room for drinks and to see that view where we had earlier observed them. He and I decided to use the bath after midnight when it was empty, and we bathed opposite the windows. First we sat on small stools using buckets of water and soap for bathing and then soaked in the very hot water. Our only thin towel was about twelve inches by twenty-four inches. So, we dried as best we could, put on our comfortable robes and went for a walk in the gardens to dry. Others in our group availed themselves of the famous Japanese

massages. That was a most romantic place. The following day we drove up toward Mount Fuji. However, the fog moved in and we spent the day driving without seeing any views of the mountain as beautiful as those from our hotel.

On the first day of July, we went by bus from Hakone to Atami. We then took the very fast bullet train to Kyoto. I was thoroughly impressed with that train. It came into the station at a rapid speed but stopped so precisely that I stepped directly through the door of my assigned car. As it left the station, it accelerated quickly but so smoothly that one had to look at passing scenes to realize the speed.

I found Kyoto to be a much more orderly city than Tokyo because I understood the grid system on which the city was designed. I felt a greater freedom to walk about the city. We visited the Hein Shrine, the Sanjusangendo Hall with its 1,001 Kannon figures and the Kinkakuji Temple or the lovely "Golden Pavilion." In the evening some of us went to a tea ceremony. As I stood in line to purchase a ticket, the manager approached, retrieved my ticket, and asked me to sit on the stage to participate in the tea service. As I sat on the stage waiting for the ceremony to begin, two of my colleagues from Cullowhee entered to observe the tea ceremony. They were most surprised, since they did not know that I was in Japan. They took pictures of me and sent them back home before I arrived home. They jokingly expressed their displeasure at having to pay to see me being served tea. I enjoyed Kyoto and would like to return there for an extended stay.

In the afternoon of July 3 we flew to Taipei, Taiwan. Some of the memorable things about Taipei were the massive crowds on the streets after dark, the pathetic animal enclosures at the zoo and the decorative Taipei Grand Hotel. The most impressive item was the National Palace Museum with its huge collection of first-rate art from China. I had mixed emotions about that hoard of great art being housed on this island away from the people of China. I have since come to realize the danger it would have faced in China during the Cultural Revolution, and I am happy that it was in Taipei. I would

like to return to Taipei only to spend extensive time in that great museum.

Steve's father was a veterinarian, and Steve had recently enrolled in Michigan State University to follow in the same profession. We earlier agreed that I would accompany him to the various zoos, and he would in turn accompany me to the art museums. We were both disturbed by the confinement of animals in Taipei and impressed by the art museum there.

We took a bus around the island through Taroko Gorge and across Tienhsiang Foot Bridge for lunch in a pagoda site. The gorge had some narrow roads winding along the river beneath overhanging cliffs. The bus was too long to make it around some of the curves or turns without backing up a couple of times. We visited a marble quarry during this trip to see the process of marble carving. This tour along the rice fields and the river gorge was a very exciting diversion from the city of Taipei.

From Taiwan, on July 6, we flew to Hong Kong. The descent into Hong Kong for the first time visitor is quite a surprise because the landing strip is in the bay between towering buildings on both sides. The gleaming white buildings of the central city are a jewel-like cluster set in the blue ocean. As the plane nears the landing strip, these buildings flash past as though the plane is landing in the city. In Hong Kong, we toured the Kowloon's newly constructed center for refugees from China and the New Territories overlooking mainland China. We also took a tram ride up to Victoria Peak for a panoramic view of the city, visited a beach area and had dinner in the Floating Restaurant at Aberdeen. Steve and I then joined a smaller number of the participants for a trip to Bangkok, Thailand.

I was only in Bangkok on Saturday, Sunday and Monday morning, but I came to love the city and the people I met there. We visited several temples, the Emerald Buddha, Wat Arun and the famous floating market with a short cruise up the Chao Phya River. We visited a small Thai village to witness a demonstration of monkshood ordination, Thai dancing, boxing, folk dancing and elephants at work. We also visited Wat Trimitr with its 5 1/2 ton gold sculpture of

Buddha, Wat Po with its Reclining Buddha and the royal palace. We also enjoyed a classical Thai dance after our evening dinner of typical Thai foods.

When we arrived in our Bangkok hotel room, the "room boy" or attendant on our hallway asked me to go out for the evening. I rejected the offer. Steve went to visit a friend of his father during the next evening, and he urged me to go out with the attendant. So, I changed my mind. After dinner the attendant came for me, and we went by taxi some distance to a small house made into a bar and club. The first room was a well-lighted dining area. The second room had less light and contained a small dancing area. The third room containing the bar was very dark. As we entered that room many hands began immediately to feel all of my body! I grabbed for my passport and moved, along with my host, to the bar. We bought drinks and returned through the "feeling section" to the dance area. That was quite an experience. My host introduced me to a couple of Thai women who spoke English and who had been in the United States. We danced a while, and I enjoyed the conversations. A group of about eight German sailors came into the dance area, spoke English, and joined us for a few hours. Then in the early morning hours my host, who happened to be gay, escorted me back to my hotel, where Steve waited to hear of the excursion. As we departed the hotel the following morning the hotel staff lined up to say farewell, and my emotions were indeed at high pitch. I went to the airport, boarded the plane and was in flight before I could speak even to Steve. I remember that he finally turned to me and quietly questioned "You liked Bangkok?" It was all too much for one weekend, and it was such a sensuous experience that I could not help but like it! We returned to Hong Kong to rejoin the group for the flight to Manila.

We arrived in Manila on the morning of July 13. The temperature was unbearably hot and the moisture of the atmosphere made it seem like a sauna. Though the hotel was air conditioned, even the bed sheets seemed damp. Pollution and auto exhaust fumes were unbelievable. I took a taxi for a few blocks in the congested traffic. The taxi was not air conditioned, the windows were open and the

fumes forced me to cover my nose and mouth with a handkerchief. I have never had a desire to return to the Philippines.

The Manila tour included St. Augustin Church, Fort Santiago, the American Battles Monuments Cemetery, the Nayong Pilipino, and a fiesta dinner. The Nayong Pilipino exhibit, located near the Manila International Airport is a 15 hectare miniature of the Philippines. It includes a Mindanao Village, Muslim minarets, Mayon volcano, simulated rice terraces, tribal rituals and folk dances. It serves as an introduction to the Philippines.

On our free day, several of us opted to go on a tour to Corregidor that included my first ride by hydrofoil boat. This tour was an historic pilgrimage to the isle of eternal memory of General Douglas McArthur, and it included a trip to the Pacific War Memorial. The boat ride gave us some relief from the heat and oppressive humidity. Otherwise, it was a very uncomfortable trip.

On July 16 we flew from Manila via Hong Kong to Seoul, Korea. We were not required to lower the window shades this time as we approached the landing strip in Korea. However, the dingy airport did have the windows painted. We could see that the landing strip was heavily guarded. Signs were posted even in our hotel windows that photography in certain directions was not permitted. These security precautions caused us to be a little apprehensive about being in Seoul, but the city did turn out to be interesting.

During the stay in Seoul we visited Kyoungbok Palace of the Ying Dynasty, the National Museum, Namsan Park and the Bukak skyway. We had two days in which we could tour alone or go shopping. I enjoyed the shops beneath the streets at the intersections. A few of our members took a trip to Panmunjom Demilitarized Zone, but Steve and I chose to remain in Seoul. In the evening the Korean Ministry entertained the whole group at dinner. The President of the University, who just happened to also own the hotel in which we stayed, presented us with a book and a recording of music that he composed.

We went to the airport in the early morning of July 21 for our flight to Honolulu. There we found our luggage piled high in the

middle of the terminal! That was a mess as we each tried to find our own luggage. We finally secured the luggage, went through customs and flew to Honolulu.

We arrived in Hawaii about ten o'clock in the morning, and I left the tour to visit friends there. Friends who met me at the airport took me to the beaches for the remainder of the day. After we arrived home about five o'clock, I was sitting on the floor when, amid the conversation, I went to sleep and I slept there through the night. After a few days in Hawaii, I flew home to North Carolina to end a most memorable tour to the Orient.

Steve and I had established a good friendship and departed with promises to visit each other. Later that year, he and his family visited me, and I visited them in Michigan. Later Steve and I visited Chicago and New York together. He later, at the age of twenty-two, earned his doctorate degree at Michigan State University, married, served as a veterinarian in Alaska, and became a missionary. He was a remarkable companion.

Denmark 1980: The Folk School Study

In 1980, I was very actively engaged in the activities of the John C. Campbell Folk School located in Brasstown, North Carolina. I was a member of the Board of Directors of the School that maintained an exchange program with the Folk Schools in Denmark. As part of that exchange program, a group of us went to Denmark to study the Folk Schools that served as inspiration and models for the Campbell Folk School. We were hosted by the Danish Gymnastics and Youth Organization (DDGU or Danske Gymnastik og Ungdomsforeninger) and in family homes throughout the journey. We had scheduled the trip for January, just after I had spent a Christmas vacation in Hawaii, and the weather in Denmark was bitterly cold.

There were about eighty-seven folk schools throughout Denmark. All of the schools had similar purposes and basic curricula, but each had its curricular emphasis. For instance, there was an art school,

a slaughterhouse school, a gymnastics school and one philosophy school. The name of the philosophy school was Ry, which we were totally unable to pronounce. Students in these schools must be eighteen or older. All of the schools had a common origin in the teachings of a nineteenth century philosopher and preacher named Grundtvig. The common purposes were to provide universal education for citizens of Denmark, to develop moral character, to develop a common sense of pride in being a Danish citizen, and to love life. Anyone who knows a Dane is acutely aware of the success of these schools in reaching the stated goals, especially that of Danish pride. I was able to visit a craft centered residential school for elder blind persons, an art school, a weaving school, a labor union school, a philosophy school, and a slaughterhouse school. The Danish Folk Schools operate as private schools but receive about eighty percent of the support from the government. There are no textbooks, no exams and no grades.

I had lunch with a young student in the Ry philosophy school, who told me that before entering the school he had been on drugs and was wasting his life. He had returned from military service unprepared for civilian life and unable to find work. He soon succumbed to drugs and a "useless life without purpose." His purposes in coming to Ry were to find himself, to find purpose in life, and to understand why he was unable to find gainful employment. He stated that he was no longer a user of drugs and had a clearer view of self worth. I accompanied him to class in which the professor held a brief discussion and sent the students outside for thirty minutes. They were instructed to locate a desirable personal spot from which they could observe a scene that interested them. Upon their return to the classroom, each told what he or she had seen. One student reportedly saw nothing. Another saw beyond himself and the scenery to the universe. One saw only the green of the distant forest beneath the blue sky. A few questions directed attention to the value of these uniquely personal observations, the universality of the process, and the infinite abilities of the mind to see beyond the immediate and the physical self.

In contrast to the Ry School, students at other schools had more career-oriented goals. In the slaughterhouse school, I had lunch with

a student who took great pride in telling me that she was in training for employment at the task of cleaning hog intestines for sausage making. I well remember how she looked forward to having a job and to making it on her own!

During our visit to the art school, our group was placed on a raised platform before the art students. After brief introductory remarks by each of us, we responded to questions from the students. Students repeatedly asked questions about racial conditions in America. One student had shore leave in a Texas port city and stated that he never wanted to return to America! Another had a brief visit to New York. Finally, I asked the students to look around the student audience and to identify one person who did not have blond hair and blue eyes. There were none, so I pointed out that I had observed a large community of Turkish and Eskimo residents and heard complaints of isolation and unemployment. I then asked why they were not in the school. There was general applause to this observation and the subject did not come up again.

In each school the day begins with a morning song before breakfast. Other meals and functions begin with singing from the DDGU common song book. Indeed, the theater production that I attended began with food and singing, and the evening ended the same way. Each school places some different emphasis on the selections of songs. For instance, the labor union school emphasized songs having a march tempo for the purpose of arousing emotions and creating unity of objectives. I found the singing to be a most delightful part of my visit. During a church service the choir sang beautifully from the loft, but I heard a beautiful voice behind me. It was the voice of a twelve-year-old boy that made a lasting impression on me. Several of us sitting in that area of the church commented on that beautiful voice.

My visits to the folk schools ended at Frederikshavn, near the north end of Denmark. I boarded a train south to Alborg and Arhus. As I entered the train I selected a compartment occupied by only two men who seemed to be asleep against the window. As I entered the compartment the tall blond man quickly took my bag and threw

it into the overhead rack. I thanked him and he exclaimed "You are an American!" With that he hugged me and woke the other guy. The blond individual was a carpenter and the Eskimo was a fisherman. They were on their way to Alborg to collect unemployment pay. He invited me to stop with him in Alborg, where he could show me some of the rougher side of Denmark. This would be an area where I alone would last no more than five minutes unless he was there to protect me. In the next town an elderly lady entered the compartment, took a seat opposite me, and began to crochet. I asked the first man to tell her that I also could do that and that I was a weaver. Neither of them seemed to believe me until I showed them photographs of my work. He explained that she was making booties for her grandchild, an act of love and devotion that he stressed as being "a real Dane." When he left the train in Alborg he made me promise to see that she disembarked at the right station. That was a most pleasant encounter.

The family home visits endeared me to the Danes. My first host family, Aase and Arne Sand, son Jakob and daughter Agnethe, lived in Taestrup near Kobenhavn. Arne, a Harbormeister in Kobenhavn, invited me to accompany him to work. We arrived at his office in the seaport area before daylight. When he had made coffee, he offered me a drink of schnapps. He then took me to a land point near the harbor entrance, where I could observe a "real Danish Viking taking her bath in the icy water." We entered a tiny shed near the water in which a harbor guard was on duty beside a small heater. After introductions, he again poured generous drinks of schnapps and beer. We sat for about an hour, but she never came, and they explained that she did not come every day. We then toured more of his command area, I watched him direct a ship to its docking site and we had lunch with more schnapps and beer. In the afternoon we toured a museum of World War II underground activities and equipment. We arrived back home well after dark.

Another host family, Helga and Kai Hansen, with their three young sons, proved that having different languages need not be a barrier to friendships. Helga taught English in the school, and Kai

taught music. Neither of the boys spoke English, and I did not speak Danish. I sensed tenseness between us as we began the first dinner together. After some general conversation, I secretly folded a paper plane, which I abruptly sailed in between the boys. They looked in astonishment to their parents, who were laughing uproariously. We then began to play until their bedtime. Another amusing language problem arose between us near our own bedtime. The three of us were having drinks about midnight around a small table in the living room. I turned to Kai and asked "Shall we go to bed?" He obviously misunderstood, and when Helga translated that I thought it time for us to go to bed, we had a great laugh.

Borge and Inger Worm, in Greve Strand, invited me to have New Year's Eve in their home. They served the food on low tables in the small living room, and we crowded in around it. As guests moved in and out of the room, one lady made her way over to sit beside me. She asked if I was married, and, upon my negative answer, she showed me her hand and stated that she also was single. She then flirted with me to the amusement of others until I guessed that she was our host and indeed the wife of the man across the table from me. At midnight, we went upstairs, where they served a large ring cake and champagne as we watched the fireworks over the village. A small female doll on top of the cake wore only a few colorful feathers. It was presented to me as a memento amid much laughter at her nudity. It was at least a different and an interesting New Year's Eve for me.

I visited about fourteen schools during this visit to Denmark and stayed in homes of several families. Each has its own story, and each left me with lasting impressions of the Danes. I have shown my photographs in three exhibitions in Denmark. I later hosted two Danish gymnastic groups in my home, and I promoted their performances in this area. Each brought delightful personalities into my life for which I am grateful. I know that visits in family homes may be the most difficult way to tour a country. It is indeed the best way to come to know people of different cultures.

Guatemala and Honduras 1981

In 1981, a friend and I toured Guatemala and part of Honduras. My friend, Lynn Gault, and I drove to Miami, Florida, and flew to Guatemala City. There we rented a small car and began our tour by driving to Copan, Honduras. We crossed the mountain border on a terribly rocky unpaved road. The weather was dry, and the road was deep in dry powdered dust. The guards were asleep in hammocks when we arrived at the border. We checked in with the Guatemala guard, who stamped our passport and directed us to the next tiny hut and the very simple gate. The Honduran guard then left his card game long enough to stamp the passports and to take his fee. He then directed us to a person lying in a hammock, the agricultural inspector, who sprayed a chemical on all four tires and the mat under the driver's feet. He also demanded a fee. We returned on Sunday and had to send someone for the guards, who then charged higher fees "because it is Sunday!"

En route a bus loaded with black people passed us. They were singing and playing drums, and along the way they stopped to pick berries and fruit to eat. Late that night they woke everyone in the village of Copan with drums and singing. I got out of bed, dressed and went out to see them. They were using drugs, as I was told, and presented quite a show.

We stayed in the best "hotel" in Copan. Yet it was primarily a bar, small dining area and a few rooms without doors. I have no idea what we ate, but I did wash it down with rather good beer. The sounds of that tropical night are unforgettable. The following morning we drove through banana fields to the Aztec ruins at Copan. The heat was unbearable, so I moved from shade tree to shade tree while photographing the monuments.

We began the trek back from Copan along that rough road about mid afternoon. Only this time the rain began. In the tropical rain, we stopped at a small store to buy gas. I was driving, and Lynn ran into the store to pay the attendant. As he returned to the car, a native forced his way into the back seat. Lynn's wife taught Spanish, and

Lynn knew a little of the language. He learned that the man only wanted a ride some short distance. As we drove in the rain I could barely see past the front of the car, and the dust turned to deep mud. In one precarious section of the road, between high banks on either side, I suddenly found that I was staring directly into the face of several cows The brakes held, and the tires gripped the mud enough to stop the car. The cows passed, and we continued the drive. When we reached the first paved road in Guatemala, the passenger indicated that he wanted to leave us there, and he thanked us profusely.

Early on Monday we flew to Tikal. The airline ticketing agent told us to be at the airport very early. We arrived only minutes after the early morning flight had left for Tikal. We showed our tickets and argued with the clerk that we had arrived two hours early for the published departure time. He told us to catch the next plane to Lake Flores and then they would take us on to Tikal. Seats on that plane were not reserved, and everyone simply pushed their way to the plane. We then realized why the ticketing agent told us to arrive so early. Once everyone was seated, we had a comfortable flight to Lake Flores. When everyone deplaned, including the pilot and flight attendant, I reminded the flight attendant that we had tickets to Tikal. She replied that we should come with her to lunch, and then we would continue to Tikal. The airport at Lake Flores was a tin shed only. We had a beer with a little something to eat. The pilot then flew the two of us on to Tikal, where he circled around before landing, so that we could see those beautiful ruins from the air.

We checked in at the "main house," located our thatch-roofed cabin, and toured one temple site. We then ate a very light meal, talked with other tourists, and went to bed. The only lights in this tropical setting were powered by a generator that they turned off without warning at 10:00 p.m. Two people at least found themselves unprepared in the jungle darkness. They made their way to their cabins guided by calls of friends. One person from France brought a hammock that he had difficulty finding. The Frenchman told us the story of his hitch-hiking across Canada and northern United States, down through California and Guatemala. The following day we

explored the ruins and flew back to Guatemala City in time for late dinner that night. Three days later, Indian rebels invaded Tikal and destroyed some of the artifacts in the simple museum there.

The following day we drove to Antigua. One section of this main highway was under repair, and we were directed to travel along a mountainous detour over some very rough roads. As we came to the northern end of the unpaved section, two men stopped us. One spoke English and asked where we were going. We replied "to Antigua." He then began negotiations to be our guide for the day. He seemed well informed and the final fee was only five dollars for the whole day. He accompanied us to Antigua and directed me to "my village" of San Antonio Aguacaliente. There he introduced me to some of the finest of Guatemalan hand-woven fabrics. I bought several items and returned to Antigua for the night at a nice hotel. I greatly appreciated his assistance. Later, I was able to bring one of the weavers to the John C. Campbell Folk School, in North Carolina, where she taught traditional back strap weaving.

The next day we drove to Chichicastenango for the weekend market. That was indeed an experience worth the trip to Guatemala. I made many photographs, ate unfamiliar foods, and talked to a few English-speaking Indians. I also observed the candle-light religious activities on the steps and down the nave of the local church. It was all very colorful and a photographer's dream. En route to Chichicastenango, we came upon an American who had hitch-hiked from California. He was in an isolated mountainous region, and we gave him a ride. Only minutes after he joined us we came into a very heavy hail storm, and he repeatedly expressed his gratitude for the ride through that storm.

We had planned to continue on to Huehuetenango, but hotel officials in Chichicastenango cautioned against that due to rebel disturbances there. So we turned back to Solola and a boat ride across Lake Atitlan to Santiago Atitlan. Santiago had only a few days earlier been the scene of rebel fighting. So the natives received us cautiously, and they discouraged photography. The people there forbade us to

take pictures of them. The following day we returned to Guatemala City along the west coastal route and flew home the following day.

China 1984: The First Time

My earliest perceptions of China were rooted in childhood stories based on the quaint customs, famine, exotic foods and exotic dress of distant peoples. I developed later perceptions through romantic stories of an empire overthrown by Sun Yat-sen. Then I heard news stories of the exploits of Chiang Kai-shek, and the word "Generalissimo" became a part of my vocabulary. After 1950, China became, in my mind, a country whose corrupt government I learned to fear. The term "Communism" became synonymous with that fear. Westerners had limited access to China by 1980's, and we began to replace our fears with curiosity. Our news stories about China whetted my appetite for less biased information. I wanted a personal experience with China as people instead of politics and ideology. The opportunity came in May 1984, when I joined a tour group with Great China Tours in San Francisco. Great China Tours recruited members of this tour group from Chinese Americans throughout the Country. I recruited Lynn Gault, a Caucasian friend to accompany me on the tour. We were surprised to find ourselves the only two Caucasians on the tour when we assembled in San Francisco. Being in this minority position had its rewards and only a few minor problems having to do with group dynamics and language rather than ethnicity. Some members spoke Cantonese, others spoke Mandarin and some of them did not speak English, which Lynn and I used exclusively. The tour guides gave instructions and information in the three languages. The guide would often tell a joke in Mandarin, then in Cantonese and finally in English. By the time he told it in English, we had already enjoyed the laughter and the translated jokes seemed anticlimactic. The rewards of our minority position came in the experience itself, the rich exchange of ideas with Chinese Americans, and the extant source of information on Chinese customs. The guides worked very

hard and successfully to develop a cohesiveness of this group during the twenty-one days.

This tour included visits to cities near the east coast of China, which were open to tourists at the time. We flew China Airlines from San Francisco to Shanghai, Beijing, Xian and Nanjing. We went by train from Nanjing to Wuxi and by boat from Wuxi to Souzhou. We again boarded the train for the trip from Souzhou to Shanghai and to Hangzhou. We flew China Airlines from Hangzhou to Guilin and to Guangzhou. We exited the country from Guangzhou to Hong Kong by train.

We arrived in Shanghai after the trans-Pacific flight about seven o'clock in the evening of May 17. We boarded another plane after a customs check for the flight to Beijing and arrived at our hotel in Beijing about midnight. The China Airlines plane was crowded with an over abundance of bags and packages, but it was a comfortable flight with good service. The Beijing air terminal was spacious, a little dirty and under construction. Waiting rooms and sales shops were very dull. Upon entering the main terminal visitors are faced with a very large poem by Mao. The hotel was new, a little gaudy in decor, and craftsmanship exemplary of rushed construction.

The Tiananmen Square, covering some 98 square acres, is an impressive sight. Its sheer size and the masses of people there are difficult to imagine. It is flanked by the impressively large, colonnaded Great Hall and the contemporary tomb of Mao Zedong. We were ushered to a designated square area and then to the next as we waited our turn to view Mao. When we approached the entry, we were first lined up four abreast. Then we separated into two lines to move through on either side of the body in its crystal case. Smoking and speaking were forbidden throughout. The tomb was heavily guarded, and any speech was met with a stern rebuke. The experience was rather disturbing. When one enters the Great Hall of the People's Assembly the very cavernous size is amazing. It is a little like going into a cathedral, except that one's attention is drawn to the stage and speakers' area instead of the upward ceiling of a cathedral. We had a wonderful view of some very fine art and crafts when we

visited representative suites adjacent to the Great Hall. Each suite was decorated with the finest art from the province represented.

The Temple of Heaven, for some reason, calls to my mind the Pantheon. Both are impressively large, hollow and beautiful. Each, for me, represents an historic era or a skeletal remnant of once grand functions. For one to appreciate the intricate details of the Temple of Heaven, it is necessary to think of it in the Oriental concept of time and massive human labor.

I climbed Coal Hill north of the Forbidden City, now called The Peoples Palace Museum. From there, I could have a good view of that area of Beijing and the layout of the Palace as well as the adjacent lake and park. The cityscape was one of tall construction cranes, as the city was rapidly erecting high-rise apartments and tourist hotels. The apartments were badly needed to get people into decent housing. The hotels were needed for the influx of business people and tourists. I was very cognizant of the absence of motorized vehicles. There was mass movement of bicycles and hand carts, on which the masses seemed to move everything. There was no heavy equipment on street construction or at building sites. Rocks for paving were hauled in old trucks to the site, broken and sized by hand, placed and packed by hand. Building scaffolding was constructed of bamboo poles tied together. The Palace Museum, while being architecturally a great monument, was picturesque as well as depressing. Many of the artifacts on exhibit were archeological, and I remembered the great works of art I had seen at the museum in Taipei. My brief tour through the Palace Museum made me want to study the buildings and the art at far greater depth. It also made me want to return to Taipei and to the fine Chinese art stored there.

We had a rough bus ride of about two and one half hours to visit the Great Wall. Much of the road was unpaved and followed a dry rocky valley. Once we were on the Wall, we quickly forgot about the rough ride. The Wall is indeed a great sight. I walked a long way over some steep inclines to get photographs void of people. The Great Wall was a popular sight for Chinese as well as foreign tourists.

En route back to Beijing we visited the Ming Tombs. Of the

thirteen tombs, only one, the Ting Ling (10th), was open. The stone gate and the stone animal sculptures along the entry road (Spirit Road) were most memorable for me.

I realized, after this first introduction to China, that my romantic views of China were now being smashed by the stark reality of regular people struggling for the same basic needs that all of us seek. I realized also that I was a victim of biased or limited news in America. I had been apprehensive about my experience in the police state and my own security. I asked our Chinese guide during the first day if I could go for a walk and take photographs. He assured me that I was free to go about Beijing as I pleased if I spoke Chinese, so that I could find my way back. I then walked a few blocks, with the top of our hotel always in view, and took photographs. My sense of security was thus bolstered, and my questions about "the American view of China" began to concern me.

I asked many questions about life and social conditions in China without getting into any discussions of politics. Our national guide, who would accompany us throughout the country, was twenty-six years old and still lived at home with his parents. He was studying English at an institute, and he enjoyed playing soccer and reading English as well as his job of touring the country. He said that if he married, his wife would, by custom and by necessity of housing, come to live with his parents. He would then apply through his work unit at the tourist service for an apartment that he might expect to get in about two years. Another man told me that he and his wife had an application number behind 3400 on the waiting list in Shanghai. Housing was allocated on the basis of needs compared to others in the work unit. A bachelor could apply for an apartment but would be unlikely to get one. An unmarried couple or a gay couple was not permitted to apply for an apartment. Abortion was available free for married couples and available at cost for unmarried women. However, the unwed pregnant woman would be ostracized by the family and her work unit to the extent that she would have to move. It then would be very difficult for her to find housing or work.

The tour group members seemed to enjoy the Chinese food.

I loved it! However, we were unable to accustom ourselves to the Chinese breakfast foods. We did occasionally have an "American breakfast" of eggs, toast, a kind of Canadian bacon, tasteless oatmeal, and the worst coffee I ever tasted. We learned to eat Chinese breakfast foods after only a couple of the American breakfasts.

On May 21, we visited the Imperial Summer Palace (popularly noted for its Marble Boat), where we walked through about one and one-fourth miles of corridors and rooms on different levels, up the hillside. We had lunch in a pavilion overlooking the lake in this beautiful and romantic setting. I had read of a hotel near Beijing designed by I. M. Pei. Lynn and I inquired about it and learned that it was near the Summer Palace area. So en route back to Beijing, we visited the Fragrant Hill Hotel, a modern spacious hotel in a large wooded setting. I loved that hotel, but it was not well occupied because it was not convenient for business people coming to Beijing.

Back in Beijing, we went to a zoo to see a panda. We stopped at the Friendship Shop en route to the hotel. Friendship Shops were government operated stores for tourists, where they accept Master Card and Visa. I bought a rug to be shipped home and handed the attendant my card. He explained that he could not take the card and that I would have to get money from the bank for him. Conveniently the "bank" was a desk on the second floor of the store, where I presented my card and asked for the amount to pay for the rug. The clerk explained that he could only give me a portion of that amount but that I could get the rest of it at another bank. The "other bank" turned out to be the next desk some few yards away! I secured the money and returned to pay for the rug. When I arrived home, the rug was waiting for me in Atlanta.

In the evening, I walked a few blocks to the Great Wall Hotel to see the lobby with its huge glass-rod chandeliers and 15 foot by 45 foot silk embroidery on netting. The silk work was of very expensive, double-faced embroidery. Another nearby hotel had a giant waterfall in the lobby. So my introduction to China had been both a surprise and a delight. Beijing was a city in physical transition. It seemed to be a city under siege by cranes, engineers and construction crews. There

was an expressed urgency about getting people out of the hovels into high rise apartments as well as about making preparations for business people and tourists. Roads, sewers, water lines, bike routes, power lines and buildings all seemed to be under construction. All of it was going on without one bulldozer or one back hoe in sight!.

On May 22, we flew from Beijing to Xian. We spent the afternoon sightseeing and shopping in center Xian, where we had dinner of pepper hot foods. Afterwards, we had a forty- minute drive north of Xian to a rural village and to our Guest House. Several young Chinese opened a "bar and disco" for us, and we danced for awhile. The disco was very sparse, with music from a tape player and a bar of about four bottles and a few beers. I did try my first Maitai here and found it to be totally undesirable. In the morning, three of our members requested a Western breakfast and found that they could not eat it. The coffee was soupy thick!

The following day, we went to see the terra cotta warrior and horse figures of the Emperor Qin tomb. We then returned by the hot springs excavations and the Ban Po Museum. This was an ancient village excavation with good educational displays of life in the village some 6,000 years ago. These displays included information on the transition from a matriarchal to a patriarchal society and from family to clan order with inter-clan wars.

On May 24, we toured downtown Xian, the Wild Goose Pagoda, the Forest of Tablets, a cloisonné factory, and a ceramics factory. We then went to the Xian Foreign Language Normal School, where we visited English classes for more than two hours, and toured the print shop. The school was a three-story building in need of cleaning and repair. Sand and trash in classrooms and hallways had been swept into the corners and left there. The language lab in the basement was sparsely furnished with a video tape facility and a few listening devices only. The administrator and students were very proud of the school's print shop. It contained some 50,000 lead Chinese fonts and a couple of old presses, which were hand-fed, one page at a time. Our discussions with students were most rewarding. I remember that one question asked of us was "Why do all Americans believe in God"? Of

course, several of our members were American Chinese Buddhists. Students asked if I would consider returning to the school to teach English. I explained, to their surprise, that if I did, then we first would have to clean and paint the classroom. One has to remember that Xian is on the eastern edge of the desert, where dust and sand are problems for everyone. Xian was for me an undesirable city, and I remember well the dinner that was so hot with peppers that I thought I would die after only one bite!

We flew from Xian to Nanjing, May 25, on a four-engine prop plane. I found it rather disconcerting that upon departure from each city we had to go through customs check. In Nanjing, we had a city tour and visited the former palace gardens, the museum of Sun Yat-sen, the Drum Tower, and the Yangtze River Bridge. This one-mile long bridge, built in 1958, spans the river for automobile and train traffic. The bridge is an impressive construction decorated with large Communist-era sculptures. The museum of Sun Yat-sen is located in a forest and hills area. It is accessed by climbing hundreds of steps over a series of levels. Our hotel, Ding Shan Fan Dian, was quite nice, and the food was great. The hotel Jing Ling, which we visited, had a revolving dome restaurant for a view of the city and a very good martini. Silk ties were available in the hotel shops, for $2 each. In the evening, we attended a concert along with about 10,000 other people. Party officials occupied front seats and tables, where they were served tea. The concert included six violins, drums and various other Chinese instruments with singers. They played and sang several recognizable Western tunes, such as Old Man River, and Susanna in equally heavy bass over a very loud system. All of the music seemed to have a similar kind of polka beat and a mix of tonal and atonal melodies. There was a rousing ovation to the Communist song.

On May 27, the train to Wuxi was clean, comfortable and enjoyable. Wuxi, noted for its fine silk culture and manufacture, was a small town with the second highest population density of any city in China. We were introduced to the silk industry, from the silk farms and mulberry bushes to the spinning machines and the weaving rooms. Thus, we were able to see the process from the cocoons to

woven cloth. The Wuxi silks were of a very high grade and yardage was available at very low prices.

Our hotel in Wuxi, located in nice gardens near the lake, was quite enjoyable. The lake on which it was located had some very beautiful scenery. In the evening, the hotel provided us with folk dance and music with a very fine baritone singer. From the hotel, we took a boat across the lake to island parks and then visited a jade factory and a clay figurine factory.

On May 29, the boat ride along the Great Canal from Wuxi to Suzhou was rewarding and pleasant. For any photographer, there were great views of barges, people and ever-changing scenery. Some of the barges actually formed long trains, snaking their way through the active canal traffic.

In Suzhou, we visited silk tapestry and silk embroidery factories, where we saw workers making the double faced, or double sided, embroidery with unbelievable skill. Later, we visited a sandalwood fan factory, a bonsai garden, and a factory for mahogany furniture and screen manufacture. Otherwise, I found the city of Suzhou to be of little interest.

We took a late afternoon train through beautiful farms and forests to Shanghai. I doubt that a Westerner could ever be prepared for the masses of people on the streets of Shanghai! A brief visit to the street market near the hotel was a frightening experience. The Hotel Shanghai was a twenty-four story hotel, only one-year-old, and it was quite nice. It was designed and built for the tourist trade and it was operated very efficiently. The nearby Shanghai Art Museum offered extensive exhibits of art as well as some fantastic views of the city streets. The current exhibit was one of calligraphy by children of all ages. For anyone not aware of the artistry in calligraphy this could be a boring exhibition. I wondered how an exhibit of handwriting by American children might compare to the skills exhibited here. The food in Shanghai was the best that we had on this trip. It was spicy and often seasoned with hot peppers. But none was as hot as the food in Xian!

One afternoon, we took a boat ride on the Wangpo River out to the Yangtze River. Later in the evening, we attended a gymnastic

show. The following morning, we visited a workers' residence area to see a kindergarten, a couple of resident apartments, and medical facilities. The kindergarten consisted of clean floors and mats for resting without chairs or desks. There was an abundance of child art taught by the teachers. The headmistress said that occasionally an art and music teacher came to give demonstrations and that the best ones are those from America. The child performances in music and dance were very impressive as well as enjoyable.

Medical facilities were described as containing unit or local area clinics, local or "grass roots" hospitals, area hospitals, and the major city or province hospital. We visited the #2 local hospital that, by our standards, was ill-equipped and dirty. I had chipped a tooth while eating in Xian and contemplated seeing a dentist. After this visit to a dental office, I was certain I would have to contend with the broken tooth until I arrived home!

The apartment that I visited was occupied by a widowed retiree in her late fifties. She was a most gracious host. The apartment contained only two rooms. A toilet, a small kitchen, and a bath room equipped only with a 24-inch wooden wash tub for each apartment, were located in the hallway between apartments. These were shared with two other families. She spoke of these other users of the facilities, as one might of an extended family. She knew of their needs, routines, and use of the facilities just as they did hers. She spoke candidly of her family, her husband's death, and of her current income. She remarked that she now had enough money and time to occasionally see a movie or travel to visit in nearby towns. That visit was indeed a rewarding experience for me.

This visit was followed by a huge two-hour lunch (banquet) at the nearby Jingan Guest House operated by the tourist service. The food was served with abundant wine, beer, and brandy as well as a sampling of Maitai. The appetizer was an eight-dish spectacle. This was followed by dishes of shrimp, pork, beef, fish, Peking duck, vegetables, fruit and baked Alaska. This meal prepared us well for the afternoon three-hour train ride through the picturesque

countryside to Hangzhou, where we enjoyed another late dinner of Peking duck.

June 2, 1984, was my fifty-ninth birthday. When the group assembled that morning, to my surprise, they sang happy birthday to me. During the day, I thought often about the improbability that I could be celebrating this birthday in China, and I marveled at the events that made this possible. During the day, we enjoyed a boat ride on West Lake, a walk in the park, and a climb to the top of Six Harmonies Pagoda. We then visited a large bonsai and a garden of orchids. Kirt bought wine and Lynn bought bourbon for the cocktails and dinner celebration. Afterwards, we danced to live music in the ballroom until ten o'clock.

Hangzhou was a beautiful, calm city with just over one million residents. The lakes were occupied by canoe crews, small pleasure boats, fishing boats and tourist boats. Strolling pedestrians, bicyclists and joggers occupied the lakeside. Hangzhou is also the home of Oolong, tea and we had a morning visit to a tea commune. The commune included large areas of cultivated acres of tea bushes, a woodlands, kindergarten through middle grades schools, and a hospital. The commune workers were divided into cadres and units of tea farmers and other specialized workers according to their duties. One tea bush can live about 300 years. On the tea farms, they are usually cut to the ground after 29 years, and they are replaced after ninety years. The tender tea leaves are picked, dried in the sun and packaged for green tea preferred by Chinese. The black tea is derived from a process whereby it is heated, fermented, dried and rolled in one day.

After lunch in Hangzhou, we flew by prop-jet plane to Guilin. This two-and-one-half hour flight would have been thirty-six hours by train. Since the planes were not air conditioned during loading, we were very hot during the boarding process. The plane was crowded, my seat was broken and another seat was wet from earlier use. The arrival in picturesque Guilin made us forget these inadequacies. We arrived in time for dinner and an evening walk.

In the morning of July 4, we went to a central city hilltop park for a magnificent view of the city and the hills for which this area is

famous. After a lunch of spicy hot frog and vegetables, we toured a large cave and a teachers college, where Chiang Kai-shek taught in the 1920's. This school of some 3,000 students, like others we have seen, was badly in need of cleaning and repair.

The following day, we went on a day long boat ride up the beautiful Li River. The schist mountain peaks rising above the river created ever-changing views. Life along the river was primitive to picturesque; fishermen, villages, bamboo and banana trees. The fishermen stgood on floats made of several bamboo poles tied together. Some of the fishermen used trained pelicans to dive for fish. Each pelican was tethered with a color that prevented the pelican from swallowing the larger fish, which the fisherman retrieved when the pelican returned to the float. When we reached our destination, we disembarked and boarded a bus for the return trip to Guilin. That was a mistake! The road was under construction and being "paved" with broken stones, crushed and laid by hand. The filler of dirt was packed by hand. The river trip was one that tourists to China should not miss. In the evening the local guide, Han Wei Ping, invited me and one couple to go to another hotel for dancing, even though dancing, at that time was forbidden by the national government. He introduced me to a couple of women with whom I could dance. We drank lots of beer, tried to dance to some strange off beat-music, and went home with pleasant memories of Guilin.

On June 6, we enjoyed a memorable flight as we left Guilin and flew over those schist mountains out over the flat lands to Guangzhou (formerly Canton). In Guangzhou, we visited a beautiful orchid garden and an anthropological museum from which we had a great view of the city. We stayed in the White Swan Hotel that had an immense lobby and shopping area. It had a three-story rock waterfall in the courtyard. The White Swan was the most impressive hotel I saw throughout this trip to China.

Our departure on June 7, from Guangzhou to Hong Kong, was by train. I shall long remember two facets of that trip. Upon our arrival at the rail terminal, we had to line up outside a fenced area until we were admitted through a gate. The national and local guide had to

leave us there. As our guides left us at the fence gate, Han Wei Ping whispered to me, "Perry, unless you return to China, we will never see each other again." I could only reply, "Wei, someday you will be able to travel in America. Goodbye, my friend." We then went downstairs through a lower tunnel for customs and back up to the loading platform, which was unbelievably dirty. The car to which we were assigned was clean and comfortable. Other cars occupied by local citizens were crowded and filthy. When we arrived in Hong Kong, the rush from the train up narrow stairs to the baggage area was a nightmare. I never wanted to see that train terminal again, but I did see it once more, in 1988.

Peru and Bolivia 1985

In the summer of 1985, I joined a group of eighteen people from various American cities for a textile tour of Peru. We were to research and buy native hand-woven fabrics. We named ourselves "The Textile Group" or "El Groupo Textile." The group assembled in the airport at Miami, Florida. We flew to Panama, where we changed airlines because the American plane could not enter Peru. In Lima, we stayed in a hotel facing the main plaza and government building. We planned to travel through much of Peru into La Paz, Bolivia, and then fly back to Lima to this same hotel.

Lima is an exciting and beautiful city. Our hotel was good, the food was great, and the hospitality was unsurpassed. I loved the music. However, I was not prepared for the impact that the poverty would have on me, nor was I prepared for the lack of safety in the city of Lima. Police with rifles seemed to be everywhere. Yet the street alongside the hotel was crowded with money changers and illegal drug money being laundered rapidly. Our host advised us that none of us would be safe on the street alone and that we should not wear any jewelry outside the hotel. One evening, I ventured to walk alone to window shop the two blocks from a dinner party to my hotel. Within the first block, I noticed two men were obviously following me. I cut

across the street to pass a police officer. To my surprise, he stopped me, and asked in English if I had a watch. It was obvious to me that he did this on purpose, because at that point the two men disappeared into a narrow store front. I quickly crossed the plaza to the hotel.

In Lima we visited the Yuri family tapestry workshop and show room and the Los Alamos textile exhibit room. We also visited the Silvania Prints Workshop where pima cotton fabrics were printed with Peruvian folkloric designs. On the city tour we visited the Yoshito family Amano Museum that houses a vast collection of textiles and we toured the Gold Museum. We drove through one of the poverty areas to reach the home of a lady who had a fine textile collection. It seemed that her home had been in a lovely forested area, but it was then an isolated fenced oasis amid the shanty housing of recent arrivals from the countryside. I spoke to and made photographs of some of the children. I returned to the hotel in a depressed mood. I felt such pity for these native people.

I was quite excited about flying to Cuzco the following day. En route, we were reminded that the elevation in Cuzco was 11,000 feet and that we should move slowly, very slowly while we adjusted. I checked into the Hotel Royal Inca and proceeded to carry my light luggage up two flights of stairs. I was able to climb only the first flight of stairs before I had to sit down and take a pill that hotel desk clerk rushed to me. It relieved the pain almost immediately, as I slowly moved to my room. A young lady on the tour rushed up to the third floor and began crying in pain. During the remainder of the trip, the even greater elevations did not bother me.

Cuzco is a beautiful city! The air was very clear and the bright sun made the red tile roofs shimmer. It is no wonder that the Incas favored this area. It was a far safer city than Lima, and I loved walks amid the beautiful old buildings. We visited the ruins of Kencko, Tampumachay, Puca Pucara and Sacsayhuaman while we were in Cuzco. We then visited Chincheros village to see native weavers and to collect woven items. On Sunday, we attended market day at Pisac. I found that to be a very colorful sight, and I excitedly took many

photographs. En route to Pisac, we visited the Ollantaytambo Fortress with its unbelievable stone work.

On Monday, we traveled by train to Machu Picchu, the "Lost City of the Incas," where we would spend one night in the "cozy" Machu Picchu Inn. Because Cuzco is located in a valley, the train had to switch back and forth up six inclines to reach the peak. This afforded us various views of the city. The city site of Machu Picchu is breathtaking. The city must have been a splendid sight. Early the next morning, I joined a few others to climb to the peak of Minor Picchu along a most precarious path. The views up and at the top are splendid, but they certainly are not for one who is afraid of heights. One young lady became frightened about half the way up to the peak. She sat down and made her way back down without again standing. I made my way to the peak and, to my surprise, I discovered several high school students there for sunbathing and picnicking! Upon my return to the base, the guide told me that I was the oldest person to go to the peak in recent memory. I loved it up there.

We were scheduled to depart Machu Picchu on the three o'clock train. However, the army had commandeered that train to transport visiting Japanese dignitaries. We waited for the six o'clock train, and we were soon joined by the larger crowd scheduled for the six o'clock departure. My group moved aboard quickly, but the train left several people at the station, where they had to stay until the following morning arrival.

On Wednesday, July 24, we were scheduled to depart by train for Puno on Lake Titicaca. Upon our eight o'clock arrival, by bus, at the train station, we learned that the "trains are on strike!" We sat in the bus until eleven o'clock listening to various reports about the ending of the strike. The group then voted, over my objections, to take a bus to Puno. I objected because I was sure that would be a rough ride. The pavement ended when we were only a few miles out of the city, and the road and ride seemed to become less comfortable each mile thereafter. We stopped in a small village for "lunch." The restaurant was one room, about ten feet square, containing four tables. It had open doors and no screens. I asked for the toilet and the owner directed me out the

rear door. As I passed through a corner of the court, I saw an elderly woman washing dishes in a pan of dark water. Then, as I entered the tiny toilet, I faced a toilet bowl filled several inches above the seat! I quickly returned to advise the group against eating anything there. We did buy oranges, bananas and bottled beer, and boarded the bus. Late that afternoon, the driver stopped at a tiny village gas station for gasoline. He was told that delivery drivers were on strike. They would not sell us any because they had to keep the remainder for local users. The driver went to the police who shrugged and suggested that the next village may have more. We arrived at the second village about dark and there were no gas stations. A police officer directed us to a house that served as a village grocery store, where they sometimes had gasoline in five gallon cans! The lady there sold us two cans, but had to charge extra for it because of "the strike!"

We made our way across the "Altaplano" to La Raya at 16,000 feet elevation. The Altiplano is a vast desolate grassland overlooked by snow capped peaks. It was especially beautiful in the moonlight. About eight o'clock that night, the rear wheel come off the bus. After a long wait, our driver caught a ride on a passing truck and left to get help. After we sat there a few hours, we realized that we would be there all night. We unpacked the many rugs, ponchos, etc., that we had purchased and wrapped ourselves against the cold. The temperature fell to twenty-six degrees Fahrenheit. I volunteered to stand guard at the door, partly because I was unable to sleep. About ten o'clock the next morning we saw a small motorcycle in the distance. It was our driver and a "mechanic." We had to leave the bus and lie in the tall grass and sunshine while they fixed the bus. The tourist office in Cuzco thought we were in Puno, and those in Puno did not expect us because of the train strike. In late afternoon, we arrived in Puno, where the hotel staff quickly arranged for our lodging in two separate small hotels. That was one memorable trip!

I had wanted to see Lake Titicaca since I first heard about it in my sixth grade geography class. I stood on the shore and marveled at the beauty of the lake and the clear sky above it. I remembered the sixth grade teacher and wished that I could tell her how she sparked

this interest, which at last was a reality. We boarded a small boat with a noisy, smoking motor in the middle. An Inca native and his young son operated the boat. We toured through some of the floating reed islands out to the open lake. The operator sat on the side of the boat, opened a small note book and began to make notes. One of our members sat beside him, introduced herself and inquired about his notes. He told her that he spoke the native Quechua language and Spanish. He was trying to learn English. As he heard English words he would write them into the little book. He then translated that to his native language! About mid-morning we arrived at the island of Tiquille, where we were to have lunch and tour the village. We docked on the leeward side of the island beside a rather large rock. The small dock was on the other side of the island, but it was much too windy for us to disembark there. I became aware of the altitude after I had climbed only a few yards. The village was at the top of the island at well over 1200 feet. We slowly made our way along rocky paths as we gazed at the snow-capped peaks over in Bolivia, spoke to a few natives, and made photographs. It was Sunday, market day as well as a day of religious festivities on the island. I enjoyed both of these very much as I bought various woven items and took many photographs. They cooked our lunch in a tiny dark room and served it on a flat rock outside. It consisted of a thin soup followed by delicious fried fish from the lake. They also served beer, cokes and fresh fruit. They served the food in enameled metal bowls and plates. Later, we made our way down the incline to the other side of the island, where the boat now waited beside the dock for the return trip to Puno.

The following morning, we departed Puno for the trip to La Paz, Bolivia. As we drove across the flat grasslands, we repeatedly saw sheep being herded by a lone woman and a single dog. Often, she would be sitting on the ground while she spun wool into yarns for weaving. That seemed to be a desolate and lonely life. We had traveled only a short distance before we were met by a bus from La Paz. It had been dispatched by the agency there to locate us. There ensued a heated discussion about which bus should now take us on to La Paz. We expressed confidence in our driver and the bus

to get us to La Paz and continued the journey, followed by the bus from La Paz. En route, we stopped for a tour of the Tiahuanaco and Desaquadero. When we reached the boarder of Bolivia, we met many money changers. I changed twenty dollars and, to my surprise, received millions of Bolivian lira currency. The following morning, my breakfast cost well over fifty thousand liras!

The highway descends into La Paz, Bolivia, at an elevation of 13,000 feet. It follows a circuitous route that gave us great views of that city. We arrived near sundown and checked into the hotel Plaza which was very beautiful, clean and comfortable. We had a message to call a lady who had been anxiously awaiting our arrival. She was a professor at the university there who had a marvelous collection of hand-woven fabrics, and she wanted to show them to us. We were very tired and dirty, but we rushed to her lovely home. She served refreshments and spent about two hours showing us the collection. Many of the items in her collection were historically valuable. Her information was invaluable to this textile group. We then took a brief tour of an alley of native shops and weird religious and voodoo paraphernalia before going to the hotel for the night.

On July 28, we experienced beautiful views as we flew back to Lima. Upon our arrival there, we found the city under complete curfew. It was the day of inauguration for President Alan Garcia. We found that dignitaries had occupied our hotel, and it was not available to us. We then went to a lovely hotel in the Miraflores district. Since many of us had left luggage in the original hotel Bolivar, we secured passes and the bus to take us there. Armed guards stopped us at every intersection. Absolutely no traffic and no people were on the streets. Guards stopped us within two blocks from the hotel and denied us access to the hotel. They finally let four of us off to walk to the hotel entrance. There armed guards stopped us, took our luggage tickets and had the luggage brought to the entrance for us to carry to the bus. That was an eerie and disturbing experience. Back in the hotel in Miraflores, we watched the inauguration with awe. They filmed the entire ceremony in the presidential palace with a cross between the camera and the dignitaries. The anxiety was greatest when the then

President Garcia descended the outside steps to receive the pledges of the military. Each branch of the military in turn was to present the President with a pledge of support and a token item presented on a colorful pillow. I have never experienced such mass tension and silence. We were told that even a firecracker could be a very serious disaster at that moment. There was a mass sigh of relief when the army accepted Garcia as President. After the last branch of military made the presentation, the public made great cheers locally and over the television.

We went to the Lima airport Monday morning, July 29, for the return trip via Panama to Miami. Upon our arrival at the airport we learned that Panama no longer permitted Peru access to the Panamanian airport. We then waited and waited until officials made arrangements to fly us to Jamaica, where we could transfer to our American plane to Miami. So, we had a brief visit to Jamaica!

The city of Miami never looked as good to me as when we flew in over the gleaming white, green and blue scene. The trip had been exhausting but educational.

Montana 1987

By 1987 I had attended conferences or visited art museums in almost every major city in the United States. I had flown to most of these cities. Therefore, I had only aerial views of the landscapes. Except for one drive to New York City, I had never driven the highways outside the Southeast until my sister, Trease, and her husband, Gene, invited me to drive with them to Montana. The avowed purpose of the trip was to visit their son in Great Falls, Montana. I welcomed the opportunity, and since we had plenty of time, we plotted a circuitous route.

We drove from North Carolina to Fredricksburg, Virginia, to see the National Military Park. Then we drove to Washington, DC, primarily to the National Gallery of Art to see Andrew Wyeth's Helga paintings. We then drove to Corning, New York, to see the Corning glass works and the glass museum. From there, we went

to Buffalo, New York, and to Niagara Falls, crossed the border into Canada, and drove west back into the United States to Grand Rapids, Michigan. We anticipated that we would go by ferry from Grand Rapids to Milwaukee, Wisconsin. There was a long wait for a ferry, so I persuaded Trease and Gene to drive to Chicago to see a special exhibit at the Chicago Art Museum. This exhibit was of sixteenth century Turkish art from the World of Sultan Sulyman The Great. It was well worth the drive via Chicago.

Our journey continued via Dells, Wisconsin, and Reedsburg, Wisconsin, where we stopped to see the Norman Rockwell Museum, to Monticello, Minnesota. From there, we drove around Minneapolis to Great Falls, Montana. The last part of this drive across North Dakota and Montana was long, monotonous, and exhausting.

We visited my nephew, Steve, and his family, during which we took a trip to Yellowstone National Park, with one night in Jackson Hole, Wyoming. We returned through South Dakota, Iowa, Missouri and Tennessee. We did stop to see the Badlands and to buy some Black Hills gold jewelry. The trip was about 6,000 miles.

I anticipated the great expanse of North Dakota and Montana but underestimated the flat terrain, the distant vistas, and the monotony of driving with such unchanging views. Great Falls had the C. Russell Museum and the Paris Center for Contemporary Art with a fine national exhibit of clay works and an exhibit of paintings by Brian Holtzinger. Great Falls also had strange gusts of wind that disturbed me. For a time, the wind would be absolutely still. Then, without warning, a strong gust of wind would rip through the trees and windows. I found this to be most disconcerting, and I was eager to leave Great Falls. Yellowstone National Park and the great Tetons were delightful sources of photographs. I excitedly photographed animals and the snow-capped peaks.

This trip with my sister was a great pleasure and in some ways a bonding experience. Trease and Gene were deeply religious couple who abstain from any alcohol. I am absolutely the opposite. I am antagonistic toward organized religion, and I like wine at meals as well as a late afternoon drink. I knew that I could not enjoy the trip

if I could not be myself. I did have wine with my meals and tried to participate in their prayers at each meal, even though I did not like to do so. I was very tense by the time we reached Great Falls. I remember that during one particularly lengthy dinner the subjects of evolution and homosexuality came into the conversation. I remember well the derisive language that my nephew voiced on both subjects and how my attempt at reasoning brought abject rebuke. Steve had been my favorite nephew until that moment when he indirectly and unknowingly rejected my viewpoints, thus me, in such strong language. I asked to change the subject, which we did. However, this event caused me to realize how vastly different our philosophies had become and that I had to discuss this with Trease. We did have an opportunity for such a discussion soon after we left Great Falls. I sat beside Trease as she drove, and I became increasingly distressed or depressed. I did not want to return home leaving such distance between us. I explained that I knew the sources of her beliefs and fears and that I respected her views and life style. I further explained that I believed she was not cognizant of my philosophy or life style and that I needed her to know and to respect my viewpoints. After some lengthy discussion driving along that rain soaked highway she turned to me and said "Perry, we were raised in the same family, were we not"? With that we laughed and ended the philosophical exchange. I am certain that I was much more relaxed for the remainder of the trip, and I sense that we became closer friends than we were before. I have not seen Steve since.

This cross-country trip to Montana is memorable in that it helped me to visualize the great geographic distances of my native country and the rich variety of its topography and its people. It is memorable as well for helping me narrow the philosophical distance with one of my sisters.

China 1988: The Second Time

I was fortunate enough to travel to China a second time in 1988 for

more extensive visits inland and a cruise up the Yangtze and the Danning rivers. This time my travel companion was John Wade, a colleague at Western Carolina University. We went with a group of Chinese Americans, as I had done before, on a tour organized by Great China Tours in San Francisco. John and I were the only Caucasians in the group of eighteen. We flew from Asheville on May 10 via Atlanta to San Francisco, where we met the group and boarded a plane of the CAAC (Civil Aviation Authority of China) airlines to Shanghai. We deplaned in Shanghai, went through customs, boarded a second plane and flew on to Beijing. We arrived there about eleven o'clock at night after a tiring twelve hour flight.

On May 14, we made a trip to the Great Wall, where we found an unbelievable mass of tourists. It was then that I realized that 1988 had been designated "The Year of Tourism in China" and that we would likely be a part of this influx wherever we went. I walked along the Wall for a few miles to take photographs away from the people. En route back to Beijing we toured the Ming Tombs. The following day we toured Tiananmen Square and the Peoples Palace Museum, now called the National Palace Museum. We ended the day with a good Peking duck dinner.

On May 16, we flew from Beijing to Xian. Because of the influx of tourists, we flew on a military plane, which first had to go to Shanghai before taking us to Xian. In Shanghai, we had to get off the plane, go through the terminal, and go back onto the same plane. Before the plane could depart, passengers had to move toward the rear of the plane "to balance the load." We arrived in Xian in time for lunch and a tour of the great White Swan temple. The following day we toured the Qinshiguangdi excavations to see the now famous clay horses and soldier figures. Afterwards, we visited a pottery factory, where they were making miniature copies of the clay figures, and we visited a zoo to see a brown panda. In the evening, a few of us visited the Xian Foreign Language School. It was the same dirty place as before, but the students were delightful. I found Xian to be far more developed than it was on my last trip. There were many more automobiles and trucks with more pollution added to the traditional

desert sand and trash. Of course, a chance to see the clay figures at Qinshihuangdi is worth anyone's visit to Xian.

On May 18, we traveled by train from Xian to Luoyang. We had to get out of bed early that morning and rush to the railway station to do this trip. We arrived at and went through the terminal before going through an underpass to board the train. We were going through the underpass just as the mass of people arriving on the train was rushing into the terminal in the opposite direction. We had to make our way single-file along the wall of the underpass and up the steep steps to the train. Fortunately, our baggage had already been delivered to the train. Once we were on the platform, making our way along the train to our assigned car, we had to be very careful of where we stepped because of the trash and feces. We were assigned to different compartments aboard the train. I was assigned alone to a compartment of Chinese travelers. Three of them smoked, and I had to spend my time outside the compartment. However, one of them spoke English and did not smoke. He was a Chinese civil engineer, and he told me that his wife was a medical doctor in Xian. This gentleman made the trip very pleasant for me. The landscape along the route from Xian to Luoyang is one of farms, terracing, small villages, and some cave dwellings, and I was glad to get this countryside view for photographs.

On May 19, we took a bus trip out of Luoyang to Longmen (dragon) Grotto to see the many Buddhist sculptures there. This trip also included a visit to White Horse Pagoda and Temple. This was the season for the beautiful peony blossoms, and we saw many of them. After dinner that evening we went by train from Luoyang to Zhengzhou. This was only a three-hour trip.

In Zhengzhou, we made a second bus trip to sites out of the city. We left the hotel early in the morning for a trip along narrow paved roads to Shaolin Temple. En route, we came upon a wreck that tied up the traffic for hours. Finally, a Chinese American from our bus walked to the wreck site, spoke Chinese to men around the wreck, and directed them to physically move the two trucks to the side of the road. Afterwards, we were able to continue the trip. The

Shaolin temple visit was pleasant and photographic, but the area of the Thousand Pagodas was even more so. These pagodas, part of the Shaolin complex, were great examples of Indian influence and the source of many photographs for me. In one residential section of the Temple where young monks lived, I photographed a clothes line of Jockey underwear!

We were scheduled to fly from Zhenghou to Wuhan on May 21. However, we found that the airport was closed for repairs for one year! So, we spent the day touring Zhenghou and took a train in the evening for the overnight trip to Wuhan. I appreciated this extra day in Zenghou because we saw the Henan Provincial Museum, a magnificent view of the Yellow River, and excavated house sites over 5,000 years old. The Henan Provincial Museum had a good display of anthropological objects: pottery, bronzes, architecture, photographs and "contemporary traditional paintings." We arrived at Wuhan at 5:20 in the morning. Of course, the rooms were not available. We did have one suite for our luggage and for use of the bathroom. Then we went out to see the sunrise over the Yantze River until breakfast was ready at 8:00 a.m.

Wuhan was an interesting city and a good experience for me. The hotel Qing Chuan was a modern hotel on the Yantze with docking facilities for large cruise boats. It was constructed beside a traditional Buddhist temple. The juxtaposition of the two buildings was a fortunate association of architectural features. The bridge crossing the Yangtze River was located only one block from the hotel, and the Yellow Crane Pagoda was near the far end of the bridge in view of the hotel. This pagoda was restored in 1985, and it was a beautiful example of that period of architecture. During the day in Wuhan we toured the Hubei Provincial Museum, which contained beautiful and intricate bronzes and large chime bells. Then we went to a pavilion overlooking the Yangtze River, a modern bridge and the city of Wuhan. We also visited the 1911 revolutionary headquarters building of Sun Yat-sen. Most memorable of the sites in Wuhan was the Friendship Park home for retired persons. It was here that I heard men doing impromptu singing of Peking opera from an outdoor stage,

and I saw a rather geometric sculpture of an aged lute player and his younger friend. The guide related the story of these two friends for whose friendship the park was named.

The following morning we boarded the ship Jingling for the Yangtze River cruise. The ship had a crew of one hundred but only twelve of us plus two students from Wuhan University and our two guides were aboard for the three-day cruise up the Yangtze. The ship was a very good vessel, the hospitality was great and the food was delicious. After dinner we were invited to the "bar" for a drink and dancing. The bar turned out to be nothing more than a few bottles of Maitai and several bottles of beer along with a tape player. The curtains were drawn because dancing was prohibited in China at that time. We did dance with a few of the crew members for an enjoyable evening. I remember that the girls were most reluctant to dance, so we men danced together most of the evening

Late the next afternoon we stopped at the village of Shashi for a brief tour and a visit to a good anthropological museum in which items were well displayed on white cloth in a clean, well-lighted environment. The museum had a mummy displayed beneath the floor with viewing through glass raised about two feet high. The mummy had the stomach and intestines displayed beside the figure! We returned to the ship after dinner.

I had never seen locks that raise and lower ships navigating a river, so my journey through the locks was exciting. We passed through the most impressive three gorges at Xiangxi and Zigui to arrive at Wushan in the late afternoon. The following morning, we disembarked about 7:30 for a trip through Wushan to a dock and then for a full day cruise on the Danning River. The boat for this cruise was much smaller, and the cruise afforded us opportunities for unusual photographs, pleasant walks on pebbled beaches, and a good lunch overlooking the river and mountain peaks. Some of the peaks in the "Lesser Three Gorges" rose to over 3,000 feet overhead. They were indeed spectacular. The Danning River was of the swift-flowing white- water type so that the journey upriver took hours, while the trip downstream was very quick. Both trips afforded us some exciting

moments over rapids. The village of Wushan made one think time had stopped at about 1930. This is a cliffside village overlooking the Yangtze River at the confluence of the Danning River. The few streets were paved only a short distance to the edge of the village, and we saw no cars or trucks. The "dock," approached only by a rough dirt road, was nothing more than natural rock. We returned to the ship about 3:30, had dinner, danced a while, and enjoyed a lengthy conversation with the two Wuhan University students. We then went to bed early as we continued the Yangtze journey.

Early on the morning of May 27, we arrived at Wanxian, where we spent about three hours visiting a free market and a silk-weaving factory. Looms in the silk factory were old models but were working well. They used low-profile looms for plain weaves and standard old Jacquard looms for pattern weaves. The woven patterns were dated and unattractive to westerners. We had lunch aboard the ship and later stopped to explore Shibaozhai temple. From the top of this temple we had wonderful views of the terraced hillside farms as well as the town.

On May 28, we arrived at the city of Chongqing situated at the confluence of the Yangtze and the Jialing rivers, where we would leave the ship. In Chongqing, we visited a good Municipal Museum and a hotel built in the traditional Chinese temple architectural style. The museum had one wing devoted to natural sciences and one wing for art.

We then visited Loquat Hill Park, developed by a wealthy salt merchant, which had beautiful, well tended, gardens. Our next experience was a visit to Painters Park, a residential studio communes for painters. The artists living in this park are selected for the quality of their work and their need for development. They live in apartments adjacent to the individual studios and exhibition galleries. In the studios that I visited, the artists were doing woodcut prints in contemporary international styles, and some artists were painting copies of Western art. It was interesting to talk to the artists and to gain some understanding of their interest in Western art. One artist in particular was doing a fine job of copying the works

of impressionist artists. She was proud of her accomplishments and proud to have them displayed in a main gallery. She expressed great pleasure in knowing that I could recognize the work of these Western artists whose work she had copied. For some of these Chinese artists, it was their first attempts at using oil paint or acrylic paint which are so familiar to Westerners.

On the day of our departure from Chongqing, our lunch was a fiasco. The restaurant had run out of food! We waited while the manager conferred with our guide and the Hong Kong office of the restaurant owner. We were then given ham and egg sandwiches with a coke to go. We were anxious about being late to the airport, but upon our arrival there we discovered that we faced another wait. When the call came for us to board the plane, this mass of people rushed for the doors. Upon exiting the doors, we found five planes lined up, and there were no instructions as to which plane we should board. Our guide yelled at us to go to the far right. Then, before we reached that plane, she yelled for us to go left to the fourth plane! At the fourth plane, the attendant did not know if the plane was going to our destination of Chengdu, but the flight attendant at the door ushered us aboard. We then sat there for fifteen minutes in sweltering heat without air conditioning before departure. Forty-five minutes later we landed in Chengdu.

We made a bus trip out of Chengdu to Guanxian to see an irrigation system at work and to visit a Taoist temple park. This irrigation system directed the adjusted amount of water to the various irrigated farms over long distances, and it directed cut logs on their journey to the mill. The Taoist temple park was beautiful and the view of the river from its upper balconies was memorable.

In Chengdu, we visited a deer park in which they raise male deer for their antlers. These antlers, which the deer shed annually, are used in traditional medicines. We then went to an embroidery shop, where they were doing exquisite double-sided stitchery, and to an art gallery sales shop. This shop had very fine paintings with prices in the range of $5,000.

On May 31, we made an early morning flight to Kunming. Again,

there were five planes lined up outside the terminal as we joined the many people pushing their way through the opened door. We had learned that the airplane number was printed on the ticket instead of the flight number with which we were accustomed, and we quickly identified our plane. It was a Boeing 737, and our flight to Kunming was very pleasant.

Kunming is a beautiful city on the north shore of Lake Dianchi near the north end of the Burma Road of World War II fame. It is located in the mountainous area at the foot of Tibet near the border with Vietnam. It is the home of Yunnan University, a Minority Institute, an art school, a teachers' college and at least three fine art museums. It also has recently developed a theme park of Minority Nationalities on the shore of Lake Dianchi. Yunnan Province, in which Kunming is located, boasts of having about twenty-six minority nationalities or ethnic cultures. It also boasts, rightfully so, of its spicy culinary products.

Upon our arrival in Kunming, we went to the Yuantong Temple and to the Yunnan Provincial Museum that houses a fine collection of art by Minority Nationalities people. After lunch at the Green Lake Hotel, we drove along Lake Dianchi to Western Hills. There, we climbed up a rugged Cliffside passage to the Dragon Gate overlooking the lake and the city. That evening, we had a "banquet" consisting of thirteen courses. The food was delicious.

Yunnan University had an exchange program with Western Carolina University, and I knew that one of our professors was in residence there at the time. So John and I asked the University for a guide to show us the campus and to escort us to visit our professor colleague, much to his surprise!

On June 1, we drove sixty miles to Stone Forest which is a spectacular forest of tall rock formations rising out of a plains region. These beautiful rock formations are also home to one of the Minority Nationalities.

On my birthday, June 2, we flew from Kunming to Guangzhou, where we went immediately to CAAC and CITS (China International Tourist Service) to book our train to Hong Kong. It was still mid

morning when we went to the Sun Yat-sen Memorial Hall. Then we had lunch at the CITS restaurant before checking into the Garden Hotel about 2:15 p.m.

Afterwards we toured the Temple Museum of anthropology and one last temple. The "birthday dinner" that evening extended over a long time while we drank toast after toast in celebration of my birthday and our times together on this trip.

On June 3, we boarded a very nice, air-conditioned train to Hong Kong. The arrival in Hong Kong was the craziest scramble that I have seen. Passengers rushing off the train had to crowd together up a narrow flight of stairs, through customs, and into the terminal lobby for bags. The bags came up an elevator on carts and the people made a mad dash to claim them. We then took a taxi to the Holiday Inn and did some shopping. The following day, we flew from Hong Kong to Vancouver, Canada, and then to San Francisco, where John and I rented a car to drive through San Francisco to Napa Valley and back over the Golden Gate bridge. As we were returning to the hotel, in anticipation of an evening in San Francisco, both of us became very sleepy. That was all we saw of San Francisco!

This second trip to China was tiring but exceedingly rewarding. It also whetted my appetite to see more of that great country. In 1992, I would return for an even longer tour to China.

Brazil 1989

In 1989, I was a member of the International Society for Education through Art (INSEA). It was through the INSEA newsletter that I learned of a conference planned for August 14-18 in Sao Paulo, Brazil. For a long time I had wanted to visit Brazil, and I jumped at the opportunity to attend this conference. As I thought about the theme of the conference, I decided that I should prepare a lecture as well. I then wrote to Mrs. Barbosa, the conference coordinator, sent her a proposal and offered to give the lecture. She invited me to do

so and arranged for my housing, meals and transportation while I was there.

On August 12, I flew from Asheville via Atlanta and Miami to Rio de Janeiro. Leaving this country alone is for me a very great challenge. I found it to be a frightening experience when I flew to France alone. The fright was even worse as I flew out of Miami to Brazil! I arrived in Rio and took a bus into town. The bus driver told me, in his language, when I came to my stop He indicated that I would find my hotel only one block off the beach front where he had stopped. It was raining rather hard as I carried my bag to the hotel. I knew, when I saw the hotel, that there must be a mistake because of the condition of the hotel. The concierge told me in English that I had reservations at the hotel facing the ocean and instructed a bellhop to take my bag and me to that hotel. Again, I walked that distance of one block in the rain. The ocean-front hotel was far superior. The hotel staff there was most apologetic. They also spoke English very well as they instructed me about security. I learned that even the beach front and those beautiful mosaic walks were unsafe. They cautioned me not to wear jewelry or take my camera outside the hotel alone. So I went on a group tour of the city and had dinner in the hotel. The next morning was Sunday, the weather was beautiful, and I did go for a long walk along two beaches and through that part of the city, where I made a lot of photographs.

On Sunday afternoon I flew to Sao Paulo, where someone from Sao Paulo University met me and drove me to a University hotel. I learned during my first hours in Sao Paulo that security was a problem even greater than in Rio. None of us attending the conference left the hotel except in groups. Yet, one person had her purse taken within ten feet of the hotel entrance as she waited for a group to assemble.

The conference was well organized with some very outstanding speakers of international renown. A university language student translated my speech very well. The audience responded well to my talk, and about a dozen guests spoke with me afterwards. That was a rewarding experience for me.

Mrs, Barbosa arranged for us to have a city tour as well as a visit

to a tent school. The tent school was located in one of the many very poor sections of the city. She also took us to a museum of avant garde art, a contemporary exposition hall, and to an evening reception at a sculpture museum. The sculpture exhibition impressed me with the sculpture and the flow of champagne. The poverty and the disparity between the wealthy and the poor people appalled me, just as it had done in Peru.

I flew to Brasilia for two nights after the conference ended. I arrived at the airport and found it to be almost empty of people. I went to the taxi area, but there were no cars there. I approached a couple standing nearby and asked about transportation. They were Americans, who had called a hotel for transportation, and we were able to ride into town together. The young driver left the couple at their hotel and then took me on a tour of the city without charge! He then delivered me to my hotel with instructions on how to best see the city at night. I found the city of Brasilia to be much more secure than Sao Paulo. The front door of my hotel had no less than six armed guards, as well as hotel attendants. As I walked the beautiful wide streets, I was very aware of armed guards on every corner. Brasilia was a relief from Rio and Sao Paulo. The city certainly lived up to my expectations. I was well aware of the story of the city, its modern architecture and some of its sculpture. The experiences with these features were more beautiful than I could have anticipated.

On Sunday morning I flew to Rio and to Miami. I shall always remember the exhilarating sight of the white buildings and beaches against the blue water as we came into Miami. I was so happy to see that scene and to sense the security of being home again. Brazil is a great country, and I wish to return there again on a general group tour or for home visits.

Hawaii 1990

Although I lived in Hawaii for almost four years, 1947 to 1950, I had visited only the islands of Oahu and Hawaii. In 1990, I decided to

see some of the other islands and to visit friends on Oahu and Kauai. Colonel George White in Oahu and Robert Sanders in Kauai had been my friends since 1949. I planned my tour of the islands to spend some time with them. I had visited with George before, and he had been my guest in North Carolina many times. I flew from Asheville on November 20 to Los Angeles and to Honolulu, rented a car, and drove through Honolulu to George's home in Hawaii Kai. I spent three days with George, during which time we drove and visited friends about the island of Oahu.

I flew to Kauai on November 24, picked up another car, and drove to the Coco Palms hotel. In the evening, I visited with Bob and other friends. The following morning, I drove along the south coast to Waimea, then followed the road at the edge of Waimea canyon to Kalalua Lookout. The canyon and canyon walls are impressive, and I was surprised to find such desert-like conditions so near such great amounts of water. The Kalalua Lookout gives one a magnificent view of great cliffs, covered with green vegetation, and rising almost straight up from the blue Pacific Ocean. It is here that the annual rainfall is greatest in the world. I felt a sense of being very small and a kind of insecurity when I realized that I was standing on this tiny island point looking northwest into the vast Pacific. I also saw a double rainbow, one above the other, from this vantage point. I thought, as I turned to leave, how unfortunate it was that I had no one with whom I could share that beautiful moment.

I flew from Kauai back to Honolulu and then to Kahului Airport, Maui, where I had a car waiting. I then drove along the coast toward Hana, and returned to Kaupakulua Road for the drive up toward Haleakala. The rains came before I was half-way up to Haleakala so I returned to Kahului and crossed the island to the Royal Lahaina Hotel in Lahaina. This was one of several large modern hotels amid an equal number of golf courses. These were luxurious and uncrowded resorts.

The following day, I flew from the West Maui Kapalua Airport to Hilo, Hawaii, where I rented a car. As our flight approached Hawaii along the eastern coast to Hilo, the view of this volcanic island was

magnificent. I was surprised to see so many waterfalls cascading into the ocean. I had not been to Hilo since 1949, just after a part of it had been destroyed by a great tide of water resulting from an earthquake near Alaska. At that time, Hilo was a village with a small airport. Now it was a much larger city. However, my interest was not in Hilo but in the drive to Kalapana Black Sands beach and the Kiluea volcano. These two spots, along with the village of Kona, were very romantic memories for me because I had such very enjoyable times there in the late 1940's. Alas, the Kalapana Black Sands beach and the road to it had been overrun by lava from recent eruptions. I drove to the edge of the lava, reminisced about the black sand, and continued my drive to Kiluea. The roads through the sugar cane, then the tropical growth, and to the volcano rim, seemed as if nothing had changed in those forty years. After a few hours exploring the volcano area, I drove on through the black desert area, which I remembered so well, toward Kona. In Kona the familiarity ended. When I last saw Kona, it was a small fishing village with thatched roof cottages and one motel. Now it was a much larger town, which had maintained much of the fishing village character, except for the few large hotels and golf courses. I loved it now as I had in 1949. I flew back to Honolulu late in the afternoon of November 20, retrieved my car and drove to George's home in Hawaii Kai.

After a few more days of sightseeing around the island of Oahu and evenings with friends, I flew back home to North Carolina. I still remember Hawaii as the singularly most romantic place I have ever been. This trip was, however, a distressingly lonely one. George's health prevented his travel, and seeing the sights alone provoked a sad nostalgia rather than romantic exuberance. Even though Honolulu has grown to an impossible size with unbearable traffic problems, and all of my friends have moved to the windward side of the island, I always want to "return to Hawaii."

INTO RETIREMENT

Here, I suppose, one would expect more information on my professional experiences and accomplishment during the three decades in Cullowhee. One might assume, after reading all of the travel notes, that travel was my major accomplishment. Far from it.

As mentioned earlier, I had already had a major role in founding the Florida Art Teachers Association, writing the statement of philosophy for the State Guide for Art Programs in Florida Schools, serving as treasurer and then president of the Florida Art Teachers Association, hosting state, and Southeastern regional conferences of art education associations, before coming to North Carolina.

In my position with the North Carolina Department of Public Instruction, I had established, through my thesis research, the groundwork for making arts education available in all public schools of North Carolina, participated in state, regional, and national Scholastic Art Awards Competitions as well as the international Red Cross Student Art Exchange programs, participated in writing the State Guide to Art on Public Television for the State of Mississippi, participated in writing the Art Curriculum Guide for the city of Chicago, and administered several federal grants to establish art education programs in various North Carolina school districts. One such grant was one encompassing the eight western counties of North Carolina titled The Smoky Mountain Cultural Arts Development Association (SMCADA). Through this grant we placed art and music

teachers in each school on the promise that after three years the positions would be funded by the local school districts. This project was a complete success. I organized the racially integrated North Carolina Art Education Association (NCAEA), served as host to three state conventions, served as president of the NCAEA, and in 1985 I received "Art Educator of the Year" award as well as being nominated to receive the Southeastern Art Educator of the Year Award. I also participated in planning the art and design program, emphasizing photography, at Randolph Technical College.

At Western Carolina University, I served as the founding Department Head and professor of art as the department grew to an enrollment of 240 art majors with thirteen faculty members. I often presented public and in-school lectures on art topics as a regional representative of the North Carolina Museum of Art. I served as a Director of the John C. Campbell Folk School for several years and as interim director for eighteen months, served on visiting teams to evaluate schools and colleges for the Southern Association of Schools and Colleges, and taught off-campus in service evening classes as far away as Charlotte. I also served on the board of the North Carolina Art Society, as president of the Associated Artists of North Carolina, and co-founder of the North Carolina Watercolor Society in which I served as president.

On campus, besides teaching, counseling, and administrative duties, I served on committees to establish the Mountain Heritage Center, the Mountain Heritage Day Festival, the campus plans for a centralized campus as well as a full time landscape and gardening staff. I also participated in planning and moving to the new Belk Building art facilities. I developed the state's first on-campus glass-blowing program and facilities, developed a program "Art for the Blind" in conjunction with the North Carolina Art Museum, developed a program in which I taught fiber arts (weaving and structures) and hosted a national exhibit of works by fiber artists. I organized and hosted conferences bringing national authorities in Art Education to explore "Confrontation with the Arts" and "Creativity and Meditation." After my tour of the Folk Schools of Denmark,

I arranged for Danish gymnastics teams to perform twice in two years at the John C. Campbell Folk School and at Western Carolina University. This exchange resulted in an exhibition of my photographs in three Danish galleries. And, I continued to jury school art as well as exhibitions of local adult art, and to give public lectures on various art topics.

I had found in Cullowhee and Western Carolina University a comfortable livelihood, a creative and accepting environment, and work that I enjoyed. After arriving in Cullowhee, even after all of my travel, I never considered moving elsewhere. I enjoyed the challenges and rewards of administrative work as well as teaching university students. When I reflect upon my years of teaching in public schools and universities, it seems that I entered both at the "right" time. Discipline was never a problem for me, students enjoyed being involved in the creative process, students freely elected to major in the arts, and student-faculty relationships were casual. I had taught art education, drawing, art appreciation, and fiber arts as well as world geography! All were my favorite subjects. I had learned much from my colleagues, and I enjoyed the camaraderie. I had learned to accept being gay, to realize that aging increasingly renders sex of less importance than camaraderie and friendship.

In 1990, at the age of sixty-five, I was beginning to feel the strain, not of teaching, but of keeping abreast of advances in art and art education. I also began to lose interest in the departmental functions and directions of growth. So, I concluded that it was time for me to make another change in my life. It was time for me to retire! I did so on May 31, 1990.

Subsequently, the Board of Trustees of Western Carolina University, upon recommendations from the department of art, the dean, vice chancellor and chancellor, conferred upon me the title Professor Emeritus of Art. This meant nothing to my bank account but a lot to my ego and attitude.

Aside from the expected congratulations, there were two notes from former students that certainly were rewarding. Lars and Mary (1974) wrote "Perry, you will never know all of the times Lars and I

have talked about you. We both learned so much from your friendshipyou have always been my mentor. I often ask myself 'How would Perry handle this?' Then guide my actions that way." Jim, then assistant dean in the College of Art at Ohio State University, wrote "You played a significant role in shaping my view of art education and art when I was a student at Western Carolina, your impact on my career has been considerable." Other former students and two colleagues from 1955-59 also wrote congratulatory notes of which I am proud.

<div align="center">

ANNOUNCING
THE RETIREMENT OF
Dr. Perry Kelly
As Professor Emeritus
Western Carolina University, Cullowhee, North Carolina
Effective May 31, 1990

</div>

Thirty-five years in education in Orlando, Florida; University of Florida; Peabody College; NC Department of Public Instruction; Appalachian State University; UNC Chapel Hill; and Western Carolina University; former president of the Florida and North Carolina Art Education Associations; exhibiting artist in clay, fibers, and photography with exhibits in Denmark and China. He will continue to live in Cullowhee, North Carolina and to travel.

Obviously, there are several concerns facing anyone transitioning to retirement. I guess the first question that occurred to me was the question of finances. One meeting with our personnel officer made it clear that I would be financially safe. A second concern is that of being separated from one's peers and colleagues. After some consideration I decided that this was not an issue since I would remain in Cullowhee. A major issue was a concern about keeping busy and

keeping healthy. I have always been somewhat of a "workaholic," and I was a bit afraid of leisure time. I rationalized that I would spend more time in my gardens, create more art, do more traveling, continue to serve as president of the Jackson County Arts Council, etc. I even bought several video tapes of operas that I wanted to watch, but I have never viewed them! With that much activity available to me the issue was not one to concern me. So, I came to view retirement as a positive change in life, much like changing jobs, instead of an end to anything.

I quickly learned that the physical demands of pottery and fiber arts were already beyond my abilities. So, I turned to photography, collages and painting as my art forms and gardening as my physical outlet and hobby.

Another thing that I learned soon after retirement: the department of art seemed to have relegated me to the irrelevant. Not once has anyone in the department of art requested my input on any subject. In fact, one event left me very angry toward the department head, who, at that time, was the most selfish and crass person I had ever known. The secretary called me one morning and invited me to bring three of my recent works of art to be entered in the current faculty show. When I arrived in her office and explained to her what the paintings were, the department head yelled at me from his adjacent office, "This show is for current faculty only!" One can imagine how this made me and the secretary feel. I said not one word, but took my paintings away. I have never spoken to him since.

The second issue one faces upon retirement: colleagues who for years have enjoyed social events at my house and at my expense soon seem to forget to include me in their social circles. I don't take this personally, because other retirees have made the same observation.

The dean consulted me on the issues of hiring an interim department head and on hiring the director of our new fine art museum without informing the department. I met the director in the dean's office, as I did two other candidates, sat in on the candidates' presentations to faculty, and advised the dean on my choice. When he had made the same choice, he found that the candidate's

expectations for salary were beyond the budgeted salary. I then wrote a letter, which he took to the chancellor, to explain why this candidate was so very worth his requested salary, and the university hired him. I have maintained a good relationship with other parts of the university.

The Folk School

I had served on the board of directors of the John C. Campbell Folk School in Brasstown, North Carolina, for several years when, in November 1990, we had to dismiss the current director. I was asked by the board of directors to serve as interim director of the school. I accepted the challenge and began the seventy-mile commute each weekend.

The Folk School, located in Brasstown, North Carolina, is a school based on the Danish Folk Schools, for the study of folk art, crafts, music, dance and cultures of Appalachia. Classes are offered for weekend, week, and two week residences in any of these subjects taught by experienced professionals. There are no textbooks or exams. Instruction is based on individual learning through personal experiences and sharing of ideas and information. Social interaction is encouraged so that the school is a place of enjoyable learning.

I arrived on the campus at the worst time of the year. There were no winter classes, and no one had planned the spring/summer classes: therefore, the catalogue was overdue, roofs were leaking, water pipes were breaking, an unfinished large dining hall had to be completed, the School had an excess in personnel with ill defined duties, finances were in the negative and, of course, morale was low. Also, the entire water system was about to be condemned by the health department! The president of the board and two directors gave me courage and backing to take any action that I thought necessary, with board approval, to save the School. Their salary offer was more than my university pay had been. Otherwise, I think my stay there would have been very short.

I perceived that I did have respect of, and a good rapport with, most of the staff. I quickly learned that I had to make some tough personnel decisions, that I had to get control of finances, that the physical plant had to be secured, that my job included acting as contractor for construction of the dining hall, and that diplomacy was paramount. I learned that one or maybe two staff members were negotiating with the former director to follow him to his new position, therefore owing no loyalty to the School. I also learned that one staff member's salary was from a federal grant about to expire without adequate accounting, evaluation or reporting.

The physical plant caretaker was a young local man with whom I immediately established good rapport. He was a really good man to have on board and gave the School service beyond what I could have expected. The School registrar would not help with registration or greeting of incoming students on Sunday afternoon for religious reasons. Handling that situation did indeed demand diplomacy and arrangements of staff assignments that prompted her voluntary departure. We established as priority number one the development of the spring and summer courses and publishing the catalogue. The former program director, as expected, left to accompany the former director, and the director of the federal grant resigned on the day I was to give her written notice of dismissal. Then, morale improved, and progress was obvious. We did get the catalogue out, the leaks stopped, and the water supply repaired to meet health standards. In April we were ready for classes!

Supervision of the dining hall construction was almost a full time job in itself. I could hardly believe how many times each day that I had to go to the construction site and how many decisions I had to make. I noticed, as we were installing the interior walls of wormy chestnut board, that after only about twelve feet on installation the boards were getting out of plumb, I dismissed the carpenter and located a very young local carpenter, who would take the job only if he would be permitted to remove what had been done. I agreed to this, and he installed the walls to perfection. He then did the window

and door framing and the stairwell with the same meticulous detail. I was so proud of that young man, his integrity and his abilities.

I continued as interim director of the School for eighteen months, when finances were again in the black, and we hired Jan Davidson as director. Jan had been folklorist at the Mountain Heritage Center at Western Carolina University, thus a colleague of mine, and I recommended him highly for the position. He continues in that position, and the School is doing extremely well under his direction. I take pride in what I accomplished in that difficult situation for it was indeed a challenge that I had not anticipated in retirement. Oh, it was wonderful to be back in Cullowhee full time!

After this challenge another one arose. I had been serving on the board of the Jackson County Arts Council as well as the Jackson County Visual Arts Association for a few years and now held the office of vice president in the Council. In the Council's April 1997 meeting, the president announced that he was resigning as of that date. I had to step into a position for which I believed I was unprepared. We were facing the end of our fiscal year with annual reports due by July, including the annual report to the North Carolina Arts Council. I learned a lot in those three months. I then held the office of president for eight years, until I resigned in 2005 and accepted the office of Council treasurer. I was later named "President Emeritus" and, at the age of eighty-five, relinquished all duties on that board. I was also serving as treasurer of the Visual Arts Association and the Bridges to Community multicultural association. I continue to be active in the Friendship Force International which promotes international and national exchanges of people to promote international friendship, education and peace. And, of course, I continue to travel!

My Art Work

As an undergraduate at the University of Florida, I majored in painting and design. The works that I created there have features

which evidence the influence of the German Bauhaus concepts because most of my major professors had been influenced by art teachers who fled the Nazi oppression in the thirties and forties. One can readily see this emphasis in the geometric forms and compositions. At the time, Cubism and Alexander Calder mobile sculptures were very popular art forms, while some professors were engaging us in non-objective, abstract, Expressionism. Only in graduate school did I finally paint a six-foot by six-foot abstraction to my satisfaction. That painting was based on my emotional responses to the Berlin Wall. I have included photographs of a few examples of my paintings.

One of my professors was Fletcher Martin, an ex-Navy boxer and a New York painter who towered over the students and mumbled comments quietly to each student. He regularly emphasized his preference for the Expressionist techniques. Once we had an assignment to be done over the weekend. I hurriedly sought some content and settled on a magnolia blossom available at the time. I spent all weekend rendering that flower realistically. I was the only student who presented a realistic work in the Monday class. Fortunately, Martin expressed his pleasure with it and made only few suggestions for changing it to a more expressive form. After I made those minor changes, the painting was greatly improved.

Another professor observed that my work illustrated a dependency on Cubist geometry and sharp edges. He suggested that I go to the local bar for a beer before the next class! I found that it would take several beers to break my preferences for flat surfaces and sharp forms. So he suggested that I try smoking a pipe over the weekend. I bought a neat, little , smooth edged pipe and tried to smoke it. In the Monday class, he exclaimed, "Why didn't you buy a large, roughly carved pipe?" I replied, "That would not be related to my nature." He got his message across to me and to the other students. Friends tell me that I am still a neat freak!

Perry Kelly

Appalachian Stream (Oil 18x24w)

Cultural Confrontation (Oil and Collage 36"x 48")

Portrait of Harry (Oil 18"x24")

Spatial Figures (Oil 35'x48")

In my graduate study, I majored in art education. In preparation for teaching art one has to acquire skills in a wide variety of art media. Therefore, my art experiences included, besides painting, drawing, and printmaking, experiences with various craft media. In the craft classes, I was introduced to ceramics, which I enjoyed most of all.

In my doctoral program I selected ceramics as my major studio program. That turned out to be a most fortunate selection. I finished that studio program with over a hundred quality items.

Constructed stoneware.

32" high stoneware.

Wheel turned and hand built items in stoneware.

While I was in the doctoral program at Peabody College of Education in Nashville, Tennessee, I chose to take one class in weaving. During that class we were introduced to the Arrowmont School of Crafts at Gatlinburg, Tennessee. I later did post graduate study in weaving and fiber arts at Arrowmont. While I was teaching at Western Carolina University, the department of art instituted a program in fiber arts which I taught. I also hosted an international fibers exhibition at Western Carolina University. I also joined a tour group to study and collect hand woven fabrics from Peru and Bolivia. Photographs of examples of my fiber works are shown here.

Wall hanging 3'x9' nylon boat rope with wool and cotton.

Kimono, rice paste resist on rayon dyed dark blue/teal.

Russia 1992: The First Time

Early in 1992, I learned that the Friendship Force International, headquartered in Atlanta, was organizing a group of about two hundred members to be the first Americans to march in the May Day Parade in Moscow. The Friendship Force is noted for its international exchange of citizens through home stays. This appealed to me greatly, and I quickly registered to participate in this trip to Moscow, even though I did not know one word of Russian.

The group assembled at Dulles Airport in Virginia on April 27

for the flight to Frankfurt, Germany, and to Berlin, arriving there before lunch on April 28. Then, on April 29, we left Berlin by train to Warsaw, Poland, and to Moscow, Russia. We arrived in Moscow in the evening of April 30, where we were met by Friendship Force members and our host families.

The flight to Berlin aboard Lufthansa Airline was comfortable, and the overnight stay in Berlin was exciting. I looked forward to the train ride because I would be able to see more of the countryside. However, the train ride turned out to be worse than I could have imagined. The compartments on the train had two upper and two lower bunks, and they were clean and comfortable. However, the train carried no water. The toilets opened directly to the tracks below, and they were filthy. Each of us had our own bottles of water and food for the trip, but for two days we simply could not use the filthy toilet. I arrived in Moscow and met my host family about 7:00 p.m. We went directly to their apartment, where I immediately used the bath and the toilet!

When we assembled in Dulles I met, among others, a young man named Kirk, who was a theater major at a prestigious American University, and a young couple, Ammie and Marcus, from Ohio. The four of us seemed to have a good rapport, so we agreed to share a compartment on the train. Marcus was a photographer. As we became better acquainted during the trip, our relationships became so strained that we barely spoke to each other by the time we reached Moscow. Marcus and Ammie were not married, and it became obvious that their relationship was shaky. He was generally a generous person with limited interests. Ammie was the most selfish and hardened person I had ever met. We attributed these personality traits to her family life and to her job as a prison guard. But, they also made it difficult for the three of us to tolerate her on this trip. Kirk and I agreed that we certainly would not accompany this couple on the return trip. It turned out that Dr. Ainsley, a retired professor formerly at Western Carolina University, and his wife were on the same tour. I had known Dr. Ainsley as Dean of the School of Education. Kirk

and I arranged to travel with them on the return train trip. They were very pleasant.

The train trip did have two memorable features. The countryside in Poland was in full bloom, and the farms were freshly tilled. The dark rich soil with the contrasting flowers was beautiful. The second memorable event was the change of train wheels at the Russian border. The train was raised by jacks. The wheels and axles were removed and rolled back down the track. Then other wheels of a different width were installed.

My host family in Moscow consisted of Alexsander Gorohov, his wife, Vera, son, Mikhail, daughter, Natasha, and Alexsander's mother. They lived in a sixth-floor walk-up apartment. The entry level was dark, and the elevator area smelled of garbage. Glass at the front entrance was broken, and the light at the elevator was not lighted. So my first impression based on these exterior features made me uneasy. The interior of the apartment was quite different. It was well furnished and clean. It was a small apartment, typical of the type built hurriedly by the Communist government in the 1960's. It consisted of a kitchen and dining area about eight by ten feet, a living room area, a toilet with a separate bath, two bedrooms and a narrow hallway. The parents occupied one bedroom while the daughter and grandmother occupied the other. Mikhail usually slept in the living room, but while I was there he slept in the parent's bedroom. There was a cloak closet and area for removing the shoes just inside the apartment doorway. The one apartment door was sturdily constructed with double doors secured with three locks. There were no laundry facilities. Laundry was done in the bathtub by the women. I soon learned that this apartment and the security door were rather typical of Moscow apartments for workers. Alexsander spoke very little English. Mikhail spoke a little more than the father did, but others did not speak any English. All of our conversations involved our dictionaries. Difficulty with the languages did not prevent conversation, it only slowed it considerably. The hospitality of this family more than compensated for the inconveniences. Alexsander came to my bedside early in the morning of May 1, and awakened

me with the phrase, "Perry, stand up!" To my surprise I immediately stood up! We laughed uproariously when we realized that he meant to say "get up."

The large group of Americans assembled about mid-morning on May 1, a few blocks across the Moscow River from Gorky Park. We were loosely organized so that we would join the parade after the first band and officials passed our point. This was Russia's first "civilian" rather than Military May Day parade, and we were the first Americans to march in the annual May Day Parade. Each of us carried an American flag. We joined in the parade as it moved across the Moscow River to the entrance of Gorky Park, where we listened to speeches. Then we went into Gorky Park for ice cream, long walks, and a boat ride for a wonderful view of Moscow and Moscow University. That May Day passed without incident, and it was a memorable event for me.

We spent the remainder of the week seeing and photographing the sites in Moscow with one delightful trip to Zogorsk. The Kremlin and the church architecture made enticing subjects for any photographer. They were especially attractive to me. It was on these sightseeing trips that I met Andrey Evsukov, a fifteen year old nephew of my host. Each day he, and often his mother, Galina, would either come for me or meet us at some designated spot and serve as interpreter. One evening Galina invited several of us to her home for dinner. I established a rather close friendship with Andrey and his parents. During one of our visits I asked Andrey if he would like to study in America after he finished high school. He gave me a rather weak answer of "perhaps." In 1992, I invited Andrey to come to America for study. He came to live with me and to attend Western Carolina University. I have described his stay with me in other chapters.

The American group bade farewell to our hosts at the Moscow railway on May 6, and we departed by train for Warsaw. This return trip was on a similar train, but we were by then prepared for the inadequacies. We had one night in Warsaw, but we did arrive there in time for a late afternoon tour. This was just enough to whet my appetite to see much more of that beautiful city. We arrived in Berlin

on May 8 for two days of sightseeing. The visual disparity between East and West Berlin was so very apparent. The monumental architecture served as attractive material for photographs. By this time, of course, the Berlin Wall was little more than small sections remaining for historical and tourist purposes.

We departed Berlin on Lufthansa Airlines on May 10, and arrived home the same day. Later, I would return with Andrey for Christmas in Moscow and Saint Petersburg.

China 1992: The Third Time

In September of 1992, I went to China for the third time. Lynn Gault, a friend who went with me on my first China trip, accompanied me on this lengthy journey across the Gobi desert ending with me doing a two-week lectureship at Yunnan University in Kunming, Yunnan, China. I once again went with Great China Tours of San Francisco and again most of the members of my group were Chinese Americans. We flew on China Airlines from San Francisco to Shanghai and to Beijing.

First, a brief overview of the tour: The first city on our tour, the city of Urumqi (Uli Mu Chi) is located at the northwestern end of China's Gobi desert. It is also at the western end of the Great Wall. The tour then went by plane from Urumqi farther west to Kashgar (Kashi), the western most city in China near the famous Khyber Pass and the border of Tajikistan, with a return flight to Urumqi the next day. From Urumqi, we went east by bus into the great Gobi desert to Turpan. Turpan, an important city on the ancient silk route, is located in an oasis in the Turpan Basin, some 505 feet below sea level. The area is famous for its grape vineyards and grape products. We then traveled east to Dunhuang which is famous for its Magao Caves containing some of the oldest (336 AD) and priceless Buddhist art. Then we undertook an all day bus ride south across the great Qaidam Basin and the salt lake to Golmud (Gur Mood). The lake at Golmud is about eighty-four percent salt. The road across the lake is made of

hardened salt. From Golmud, we drove northeast to Qinghai Lake, a second salt lake, having far less concentration of salt than Golmud but noted for its navy installations and its fish. The tour then went east to the city of Xining, located on the eastern edge of the Gobi desert. This is rich farm land at the western end of Inner Mongolia. Upon leaving Xining, we had a short train ride to Lanzhou. This city is located on the upper end of the Yellow river. It is one of the oases of the silk route. This rich farm land is populated by Chinese, Mongols, Tibetans, Uighurs, and Hui peoples. It is also noted for its reservoir on the Yellow river and the Bingling Caves containing famous Buddhist sculptures. The tour ended in Lanzhou. I flew to Kunming to serve two weeks as a visiting lecturer at Yunnan University, after which I flew to Hong Kong and San Francisco.

Now, the details: We arrived in Shanghai late afternoon on Monday, September 7, after a twelve-hour flight. The temperature was 90F degrees. We deplaned, went through a glass- enclosed hot terminal, down a crowded escalator to go through passport check, then back up an escalator to a waiting room that was not air conditioned. We waited there while they serviced the plane for the flight to Beijing. Then we boarded the plane, which was not air conditioned until we were air-borne. We arrived in Beijing after only a one-hour flight. We were soon at the very nice hotel Jing Lun and, since I had a bad headache, I went to bed by 10:45 p.m.

All of us had been to Beijing before, so we spent only one day there. During that day we visited the Dajue Temple or the Great Bell Temple and Museum. The temple grounds cover over 30,000 square meters. Its main attraction is a huge sand-cast bell dating from 1733. Pictures in the museum illustrate the sand-casting process. This trip took us along major new boulevards, which, to my surprise, were crowded with cars, trucks and busses, and far fewer bicycles than I had seen previously. Much of the ancient housing had given way to new high-rise apartments and commercial buildings. The highway to the airport was under construction, hopefully to serve the Olympic Games traffic in the year 2000. Several years prior, Mao had decreed that Chinese must reforest the land. He is quoted as saying that one

million people of China must plant one million trees. Believe me, I think they did it. There were many, many more green trees in the city and on the highways. I was impressed by the progress, which was so apparent in rapidly developing China.

After this brief visit to Beijing, we flew west across China to Urumqi (pronounced Ulumuchi). Most of the flight over the desert was at an altitude from which we could see the terrain. These views presented three new experiences for me. First, I was impressed by the great distance within China as well as the vast space of the Gobi. Second, I had not expected to see snow-capped mountains along the desert edge. Third, I was enthralled by the aerial view of the sculptured sand dunes and shadows. I could hardly wait to see the sand dunes from a closer vantage point. That was a great flight, and the views should have given me some idea of what lay ahead during the return trip across the desert by bus.

Upon our arrival in Urumqi, we deplaned onto a bus from which we joined passengers from three other planes entering the one double door into the terminal. This horde was then funneled through one single door into the baggage claim area. This was mass confusion in a totally inadequate airport! While we were waiting for our bags, we observed several Russian merchants who had come to Urumqi to buy bales of clothing (about 3'x3'x6' in size) for transport to Russia. We departed the airport from the glass-enclosed area to the outside, through a large crowd of people waiting for incoming passengers. It was a great relief to be aboard the bus. En route to the hotel, we stopped at a rather "local" restaurant for lunch. The condition of this restaurant and its unsavory food was a bad introduction to Urumqi. Nothing in the restaurant was clean, and the service was as bad as the food. However, our hotel, The Holiday Inn, was a very nice hotel, so I soon forgot about the distasteful lunch.

Urumqi is one of the most interesting cities in China, and it certainly deserves to be seen by many more Westerners who wish to know China. It is located at the edge of the Gobi Desert within sight of lovely snow-capped mountains separating the desert from the Junggar basin. It is within a short distance of Mongolia and

Russia. It is the center city of the Uygur peoples. During this first stop in Urumqi, we toured Heavenly Lake, which is about 31 miles out of Urumqi in the snow-capped mountains. This is a lovely, clear lake supplied by melting snow, and it is a popular visitor's center frequented by local people as well as by outsiders. The boat ride around this lake and the lunch in a quaint lakeside restaurant was most enjoyable. However, the drive to and from the lake was over very rough roads through a heavily polluted industrial area of coal-burning cement and brick factories and oil-processing plants. The route also goes through some desolate grazing areas, where one may see camels, horses, mountain goats and sheep. During our stay in Urumqi, the region had early September rain, and snow fell on the mountains. This was a sure signal for the herdsmen to begin the trek to lower grounds for the winter.

The next morning, we drove to the high pastures to see waterfalls and to have lunch in a felt yurk of the Kazhak herdsmen families. The yurk had lovely hand-woven carpets on the floor, the walls and ceiling. We sat on the carpets and had lunch on low tables. The herdsmen had indeed started their drives to lower pastures for winter grazing. En route to the high pastures, our bus trip was interrupted five times by herds of sheep and horsemen making the drive to lower pastures. It is quite a sensation to be in a bus while large numbers of sheep surround it, like water flowing around an object. The whole trip was a photographer's dream.

During the late afternoon, we walked through the market and then flew to Kashgar (Kashi) near the Tajikistan border for the weekend. Since Kashi is a border town, one might expect different nationalities there and a busy commerce. Since it is also rather isolated between the desert and the mountains bordering Tajikistan at the western most end of China, one might expect less-than-first-class accommodations. It is a city of industrious craftsmen, who line the streets and make everything from bread to shoes and copper kettles. The Kashi area produces an abundance of vegetables as well as meat animals. Its local inhabitants are mostly Uygur peoples who practice Muslim religion. We visited two of the mosques. Both of them were in need

of repairs. One interesting feature was a cemetery in which each of the graves was covered with a handmade clay enclosure standing about two-feet high. These are used to expedite the edict of placing the body in the earth within twenty-four hours after the death occurs. We were invited into two Uygur homes. One had an enclosed well of fresh water brought to the city from far off mountain streams through underground tunnels. We would later see more such wells around the edge of the desert and marvel at this engineering feat of transporting the melting snows to the populated areas.

The most memorable event at Kashi was the visit to the Sunday farmers' market. This market is open daily, but Sunday is the day when farmers bring produce to market. Here one can buy farm produce, silk cloth, and handmade furniture or a fur hat from Russia. I had been to markets in Guatemala and Peru as well as to several in eastern China. However, this market at Kashi was a far larger market with unbelievable numbers of people. There was standing room only amid trucks, horses, sheep, as well as piles of produce, vegetables and fresh meat hanging in unprotected exposure. I made my way through all of this to a wall, which I mounted and from which I photographed the scene. Truckers made their way slowly through the mass with repeated beeps of the horn. At one gate, the truckers were attempting to enter a restricted unloading area while the throng of people amassed around it to gain entrance as well. Guards literally had to block their passage. This was a worthwhile experience, which I do not care to repeat.

Sunday afternoon we drove to East Lake through farms of cotton, corn and rice. Then we visited a typical early Uygur village with its narrow alleyways and stucco structures. This village scene was very impoverished and littered with human and animal feces. It was not a pleasant way to end a visit at Kashi, but it was a very realistic one. I had come to admire the Uygur people and found them to be very photogenic. I felt depressed to find any of them living in these conditions. Afterwards, we had dinner and took a plane to Urumuqi, arriving at our hotel about midnight.

The following morning, September 14, we boarded our bus and

drove east to Turpan, or Turfan, an oasis city famous for its white grapes and raisins. It is the grape center of China. Many of the streets were beneath lattice-supported grape vines laden with very large clusters of white grapes. The population of Turpan is about 200,000, of which 80 percent are Uygurs and only seven percent are Chinese Hans. It is a city of Muslims and Chinese Buddhists. The arts and architecture reflect this Uygur influence, making it a rather unique city. It is an oasis with water supplied from the snow-capped mountains through a system of wells and underground passages. An irrigation system provides water from the river to the rich soil in the vineyards and the fields of cotton and corn. The Turpan basin is about 505 feet below sea level.

We visited Jiaohe, an ancient Uygur city that, much earlier, had been sacked by Mongolians. We were not allowed to photograph within these acres of abandoned home-sites or in the adjacent Buddhist monastery. We did photograph a nearby mosque that had been renovated in 1983. We ended the day with dinner and a Uygur music and dance performance.

On September 15, we drove to Flaming Mountain to visit the Bezikelik Grottoes, which house ancient frescoes on clay walls and ceilings. The Cliffside caves are located high above a small river that meanders through rough, arid terrain. Fortunately, these frescoes are now under guard. Many of them are open to day-light only as tourists are ushered through. In the afternoon, we drove to Sugong Tower, an attractive mosque that has a tall tower made of adobe brick. After dinner, we drove about thirty miles to the railway station, where we waited in the Foreign Visitors Room for the 9:30 train to Dunhuang. This was a thirteen-hour train ride on mostly single-line tracks. This railway is built to the geographic advantage of the desert terrain rather than into the various towns along the route. Therefore, the stations are often miles outside of the town, as it is in Dunhuang.

Like other towns along this Silk Route that we were following, Dunhuang is an oasis in the Gobi desert. It is the site of a good folk museum as well as an attractively restored temple. When it was cooler in the late afternoon, we drove to Moon Lake, a small crescent-

shaped lake amid towering sand dunes. Moon Lake is considered to be a sacred lake because, in its 2,000- year history, the shifting sand dunes have never endangered the lake. There, we mounted camels and rode out into the sand dunes. So I did get a close-up view of those beautifully wind-sculpted shapes with their dark shadows cast by the bright desert sun. They are indeed impressive.

At Dunhuang, we also drove out to Yangguan Pass at the western end of the Great Wall. This pass commands a view of the surrounding territory with a great view of an oasis. From this desolate end of the Wall, one can understand that it need go no farther. Horsemen crossing the desert here could have been seen well in advance. They then could have been met with force.

Dunhuang is noted in the world of art for its Magao Grottoes. These caves contain some of the world's most important Buddhist murals and sculpture. The central carved stone figure of Buddha is thirty-five meters (115 feet) high. It sits inside one of the caves, where one can view it on three floor levels.

Our last visit in Dunhuang was to a carpet factory, where a weaver, working by hand on upright looms, works one year to create about thirty inches of carpeting. The silk rugs are woven at 400 lines per inch. The worker receives about fifty to sixty dollars per month.

Upon our departure from Dunhuang on Saturday, September 19, our guide gave each of us a metal enameled bowl and a set of chop sticks. He told us "You will have need for these today and tomorrow." Only a few hours south of Dunhuang the road became rough, winding and unpaved as we went from grasslands to more desolate desert terrain. The bus stopped in the middle of this rough landscape for us to relieve ourselves. Men were instructed to go to gullies on the left side of the bus while women were told to go to similar gullies on the right side! Everyone took this in good humor. This exercise would be repeated that afternoon and twice the following day. Then, as we continued through herds of grazing camels, at noon we came down into the village of Yiqa, where we stopped for lunch. The guide had asked a truck driver to deliver a message to this tiny restaurant that we would be arriving for lunch. They had prepared some vegetables

for us in the dirtiest quarters in which I had ever eaten. That is where we used our bowl and chop sticks as well as some canned food that our guide had stored on the bus. Afterwards we continued the decline to Great Salt Lake with its fifty-mile long bridge of salt. The water in the lake is 94 percent salt. The road is created by layering salt, instead of earth, across the lake. It was one rough ride as we continued the decline to the town of Golmud. I arrived with a terrible headache and neck pain from the rough ride. The city of Golmud was begun in 1954, and at this time had some 150,000 residents. The major activities there were associated with salt production, reportedly enough salt to supply the world!

Sunday, September 20, we departed Golmud to cross still rougher desert terrain. As we ascended to the upper grass lands we saw many more camels, yaks and sheep. After I had taken too many pain killers with coffee from generous associates, I slept some on the bus and felt better when we stopped for lunch. Lunch in the village of Dulan was in an even smaller cafe than the one in Yiqa. At the doorway to the cafe was a stand on which a pan of water and a cloth had been placed for patrons to wash! The water was dark in color, so we each decided to forego the wash. We used our metal bowls and chop sticks for the second time. However, the food that they served was better prepared and tastier than what had sufficed for lunch the previous day. By then we had reached a paved road on which we would continue the climb to Caka. We arrived in Caka at 6:00 p.m. The hotel was only four months old, but it appeared to be much older, and part of it was still under construction. It was located on a salt flat adjacent to the salt factory. It was not ready for visitors because it had no heat or hot water.

On Monday, September 21, we drove from Caka around the south end of Qinghai Lake. This lake is also salt water, noted for its fish, and the home of a large naval research facility. Much of the base was then used for tourists and recreation. We had lunch of fish in a pleasant lakeside restaurant. I found the fish flesh to be too soft and to have far too many bones in it. This was then further ruined by a visit to the toilet, that was nothing more than a long slit in the

enclosed rock floor over a stream that ran to the lake! The smell was unbelievable. So much for the fried lake fish! After lunch, we drove east to Sun and Moon Pass at 12,500 feet elevation. At the peak of the pass, the view behind us to the west was one of rugged grass-lands while that to the east ahead of us was verdant farm-lands under dark rain clouds! That contrasting view was certainly memorable. As one might expect, most of us felt some discomfort with the rapid change in elevation, but the eastward view made us soon forget. We saw a Tibetan funeral site at the top of the pass. This was a raised platform, constructed of natural wood, upon which the body had been placed, the idea being that eagles would consume the flesh and thus give flight to the spirit.

The views between Sun and Moon Pass and Xining, through the green trees and rich farm lands, gave us great relief from those of the desert. I certainly was glad to see the change and to arrive at the really first-class Hotel Qinghai in Xining.

The following morning, we ate an American breakfast of oiled (fried) eggs, bread, jam, fruit and muddy coffee. We then toured the Taer Lamasery, about nineteen miles out of Xining. This very large lamasery (monastery) enclosed behind stucco walls had very interesting architectural features. Roof lines and entrance woodwork are typical temple features. These were set against white stucco walls having half-timber upper structures interspersed with an interesting design feature. This element was made of small sticks that had been stacked in large triangles within the wall structure. The ends of the brown sticks gave a pleasant texture relief to the white stucco. The lamasery encompasses a temple, a very interesting museum, living quarters, work quarters, and a farm. All of it was in need of repair, which, we observed, was in progress. It is located at the edge of a small village of unpaved roads.

In the afternoon, we visited the cleanest market that I had seen in China. We also visited a department store and a very good museum of Minority Nationalities. This museum houses archeological items, well displayed, that indicate human life was existent as early as

30,000 years ago. Other artifacts indicate human culture here at least as early as 1500 BC.

Dinner that evening was served in the Mongolian manner. Each of us had an individual flame beneath very hot water. Thin sliced meats (camel foot and lamb), vegetables and noodles were placed in the center of the table. Each person then used chop sticks to lift the food into the hot water, where it quickly cooked. As the dinner progressed the water became a well- flavored soup that one eats as the last course. The Mongolian tea was served in small bowls filled with fruit and a large sugar cube. It was the best tea I have ever had.

On September 23, we departed Xining by rail for the four-hour ride to Lanzhou. This railway line follows the Yellow River for spectacular views of rich farm-lands, dark green vegetables and fruit trees, and towering mountains. Lanzhou is an interesting city that one might divide into the clear atmosphere of the east and the polluted industrial west. It is populated by a dynamic mix of Chinese Hans, Mongols, Tibetans, Uyghurs and Hui peoples. The Jincheng Hotel in which we stayed comprised two nineteen-story buildings with large dining facilities and shops. It was a very busy first class hotel. I requested that we change our itinerary from a trip to White Pagoda Mountain to a tour of the Provincial Museum. This is a large museum with a fine anthropological collection well-displayed with English titles. It is the home of the famous Flying Horse bronze and a valuable collection of pottery from the Gansu Province.

Activities of the following day included a bus trip through spectacular hills of terraced farms and a boat ride on a large reservoir to the Bingling Caves. The Bingling Caves were once high above the valley in cliffsides. When the reservoir was established the valley was flooded so that the caves now seem much lower. The front of the caves is occupied by a very large Buddha figure carved into the cliff stone. The caves contain very ancient stone carvings created by reclusive Buddhist monks. The caves are connected by wooden stairways. The lake sides were mountains of varying coloration and shapes. Many of them had small farms irrigated from the reservoir

and often clusters of houses along the banks or up on the hill-tops. The trip offered many opportunities for photographers.

On September 25, we went to White Pagoda Mountain for a panoramic view of the Yellow River and the steel bridge built in 1910 to replace a wooden pontoon bridge. The new bridge is named for Sun Yat-zen. After a rewarding tour of a painting exhibit and sales gallery as well as some last minute shopping, we drove fifty miles to the Lanzhou airport. There, I saw off the tour members on their departure flights. The guide then escorted me to a small hotel across the street from the terminal. I spent the night there alone waiting for a flight to Kunming. Since no one there spoke English, the guide made arrangements for my room and meals. He then instructed me to go for dinner and breakfast by taking me to the restaurant and introducing me to the waitress. After the guide left I fell into a keen sense of being alone. Dinner and breakfast were strange experiences because I was the only Caucasian in the large dining room. The meals consisted of several generous plates of foods. It was far more than I could eat, and I was psychologically uncomfortable. I slept intermittently and suffered with sinus congestion.

After breakfast the morning of September 26, I went to the airport, watched a line form. and moved in with my ticket. When I reached my seat, I spoke in Chinese to the lady next to me. She immediately recognized me as an American and greeted me in English. She introduced herself as a translator for a petro-chemical company and then asked me to go into the airport with her for something to clear my head! The flight would be delayed due to fog. She bought a pill and hot tea for me. As we sat in the terminal, I finished my tea, and a man told her that I needed more tea, whereupon he went for some. There was no hot tea (I know, "no hot tea in China?") so he brought me a cold drink. Another man quickly admonished me (in Chinese) not to drink cold liquids with a cold. Then he took my drink and went for hot water. By the time I returned to the plane, I felt that it must be filled with Chinese friends. During my flight through Xian to Kunming, I was very much at ease. Six University professors met me at the Kunming airport.

Kunming

The Kunming visit was an experience in the finest Chinese traditions of hospitality and excellent food. From the moment I arrived until my departure I was treated like an honored guest with constant companionship as well as an over abundance of food. I presented lectures on Western art, on my life as an American, on my art, and on the fiber works of my students. I gave these lectures in Yunnan University, in the Yunnan Art School and in the Yunnan Weaving School. The most difficult lecture I gave was on the subject of Modern Western art. It was most difficult because the interpreter had difficulty with concepts or meanings of terms. I also joined students in evening sessions as we practiced pronunciation of English words and sentences. That in itself was a rewarding exercise for me. I had dinner twice with students in the student cafeteria, and the students invited me to a class party. At this party the students asked me to read a poem in English, which a student then read in Chinese. The "party" consisted of a performance by students, our poetry reading, brief group singing, and food followed by general ballroom dancing. It was most enjoyable.

During this visit to Yunnan University in Kunming, I learned of the Minority Nationalities of the region. I visited the Minority Nationalities Research Center, the Minority Nationalities University and Museum as well as the Minorities Village under construction on Lake Dianchi. In all of China, there are about 86 different ethnic or nationality peoples. Twenty-two of those are located in Yunnan Province. My interest in these Minority Nationalities prompted me to propose a tour group to Yunnan University to study these minorities. This proposal was accepted by the Department of Chinese Literature and Languages. I returned to Cullowhee, where I presented the proposal to Western Carolina University. It was accepted as a summer course in the Division of Continuing Education. However, the course did not generate enough interest to make the trip. That has not diminished my interest in the subject.

Perhaps it would be of interest here to describe the Department

of Chinese Literature and Languages. It was they who invited and hosted me during my stay. The "Department" is roughly equivalent to the organization of the American School within our universities. It was established in 1951. In 1994, it had an enrollment of 500 regular students and 2700 night students. Study is offered in seven areas: Classical Chinese Literature, Contemporary Chinese Literature, Theory, Foreign Literature, Composition, Journalism, and Linguistics. The Department also administered three research offices: Minority Folk Art, Southeast Asia Culture, and Anti-Japan Literature.

In each class, the students greeted the professor by standing and applauding until they were thanked and asked to be seated. I can tell you that is a great way to greet a professor. It is a sign of appreciation, and it puts everyone at ease for the class activities.

Professor Haoru Zhao was my host in Kunming. One morning he told me that we would go to the Kunming Textile Industry Academy and that I should bring photographs of my weaving. To my astonishment, while we were there, the entire school assembled for me to show slides and talk about my weaving. This was an impromptu lecture with an interpreter. It went well and we then had a great lunch with the faculty. On another day, Professor Zhao took me to The Yunnan Art School. At the entrance gate, he asked me to pose before a large poster of calligraphy. Afterwards, I asked him to read it to me. To my surprise the poster announced my visit and invited students and faculty to my lecture at 2:00 p.m. I showed slides of my work and that of my students and talked about my university. It was well received and, again, it was followed by a grand lunch. During a lecture that I gave for the University community, some questions from students were significant of mention here. One student, upon seeing slides of my university as well as some of my home and my car, asked "Are you rich?" Immediately another asked "How much money do you make?" These are questions I had never been asked before. I explained that an annual salary of, say $40,000 seems like a lot of money. However, I explained, with numbers written on the board, that my taxes, costs of cars, houses, foods and medical care leave us with little of that. And, no, I am not rich! Another student

asked "What do you think of your government selling military planes to Taiwan?" To this I responded that I was a guest in his country as an artist and academician and that it would be inappropriate for me to speak to this political issue. This answer brought quick applause from administrative leaders and thus the students. A third question that I remember vividly was, "What kinds of work do Black People do in your country?" To this I replied that his question spoke eloquently about his lack of knowledge of my country. I then explained that African Americans, like any American, did whatever work they chose to and were prepared to do. I mentioned personal acquaintances with African American professors, lawyers, doctors and teachers.

Thursday and Friday, October 1 and 2, are traditional holidays in China, and I was fortunate to be there for the occasion. It is the national holiday in celebration of the October 1 empowerment of the Communist Party. They celebrate it much as we do the Fourth of July. However, little mention is now made of the source of the celebration. They now called it simply a National Holiday. I had to ask three times before someone explained the nature of the holiday. During the day, we went shopping in a very busy central Kunming, where we had lunch of Overbridge Rice Noodles. These are special noodles served with thinly sliced meat and vegetables that each diner cooks in the individual bowl of hot water. That lunch was special indeed. We shopped first in stores and shops before going into the open market, which was very crowded. However, one could find almost anything to buy in the open market. In the evening the city is lighted much as we do at Christmas. At the end of the evening, we boarded an extremely crowded bus. Yet, when I entered the door, a young man stood and insisted that I take his seat. I saw this courtesy extended repeatedly while I was in Kunming. It made me feel honored for my age but as well for being a foreign visitor.

On Friday, October 2, Zhao arrived promptly at eight, along with his wife, his son, friends Mr. Wu and Mr. Wu Wei, and a driver for us to go on a holiday trip. I could only understand that we were going to see some of the countryside of Yunnan. However, the trip turned out to be about eighty miles over two mountain passes and through three

villages. We had lunch in a village teeming with market celebrants, a visit to a fishing lake and finally a visit to a very large park. The park contained a Buddhist Temple, a Taoist Temple and a Confucian Temple and their gardens. We finally had dinner en route and arrived back home about 9:30 p.m. This was a very tiring trip in an old university van over rough roads. The driver must have learned to drive in warfare because he was good at dodging holes, bicycles and animals. He actually was a very good driver. As I lay in bed that night I reflected on the trip and marveled at how much they had shown me in one day. It was very educational, and the companionship was most enjoyable.

I knew a Chinese student in Cullowhee named Li Hong. Her mother, Mrs. Lu Ying, who was a school teacher in Kunming, invited me to dinner with Li Hong's husband, Wang Bing, and her brother, Li Yang. Li Yang came for me in a taxi. The apartment was very small, but they had prepared a delicious dinner with lots of wine and beer. After a most pleasant exchange of gifts, a delicious dinner, and taking a lot of photographs during the evening, Li Yang escorted me back to my hotel. Wang Bing later came to Cullowhee to join his wife in school at Western Carolina University.

The most memorable dinner of any trip to China was one on October 8, in the beautiful Kunming Hotel. Haoru Zhao, his wife, Jiang, and son, Nan, came for me about 8:30 a.m. Haoru told me that we were going to see a packaging exhibit. When we arrived at the Kunming Hotel, we were greeted by a gentleman who I later learned was being honored for his administration of a packaging manufacturing plant. We went into the spacious dining room, where we were seated at a large round table at the edge of the stage. Guests on the stage included the man being honored, the mayor of Kunming and the head of the Yunnan Communist Party. After we were seated, these three came to our table to meet me amid all the cameras and lights. They returned to the stage for a presentation, during which I was introduced as their American guest. I was the only Caucasian in this elaborate banquet for over 250 guests. The

dinner was thirteen courses, each dish was a work of art, and the service was impeccable.

My interpreter, who accompanied me almost every day and to almost every place, was a young student by the name of Yang Jing. She was small, delicate and an adorable person. She majored in English, and her command of English was very good. I learned that she adored her grandfather, who lived a long distance from Kunming. She said that my nature reminded her of him, and she bestowed upon me the affection she held for him. She always held my arm as we crossed a street or even stepped off a curb. Often, she would hold my hand as we walked. I met her fiancée whose name was Fu Zhi Shang. He worked in the student union building, and he was equally a charming person. Both of them were good students whom I came to admire very much. The night before my departure, Chinese friends came to my room to present me little gifts and to say good-bye. One student who had heard my lecture and saw a picture of my sister Florence sent a package to my hotel. It was a handmade blouse which was exactly Florence's size. Fu came with a beautiful handmade card and with a message that Jing simply could not bear to come say good-bye. It was very difficult to leave Kunming without saying good-bye to her. We have corresponded since. She and Fu are now married.

At the airport the following morning I had to pay a departure tax of about twelve dollars. I handed the clerk my passport and the money in Chinese currency. She would not accept the currency because it was real Chinese Yuan instead of visitor's certificates! I then had to go next door to change it for visitor's certificates. There, the clerk would not accept the Yuan from a visitor, but demanded American dollars instead. By the time I was cleared to board the plane I was more than ready to bid farewell to China. I flew via Hong Kong, to San Francisco, where I changed planes and flew directly to Atlanta. The experience in China left me with many wonderful memories, but also with a warm place in my heart for that beautiful country and its people. My heart is so empty when I think of my friends there and how difficult it is to keep in touch with them.

My Stepmother's Death

My stepmother, Mary Ruth Kelly, had spent her life as a devoted wife to my father and as a mother to the children. She had never remarried after Daddy's death and continued to live in the family home, which she shared with my sister Florence and her husband, Tommy. As her health began to decline, it became evident that she would increasingly rely on Florence for support and care. Ruth did spend time with her other daughters, Mary Trease and Margaret. Seeing your mother or beloved stepmother slowly decline in health and memory prompts extensive introspection. The experience prompted me to arrange more time with her and to inquire about her early life, of which I knew so little. She spoke freely in response to my questioning, often with emotions, until the conversation approached her pregnancy and the birth of Mary Trease. Only in her last year did she mentally revert, as is so often done, to remembering only those stressful events of life and less of more current events. Her post high school pregnancy prompted a traumatic confrontation with her parents. She finally told me that her mother beat her with a "yard broom" made of tree branches. It seems that her father interceded but then joined the mother in rejecting their daughter. After she had been so good to all of the children, and so kind to other people, it was difficult for me to understand how anyone could be so cruel to this woman. This made me love her all the more and prompted me to love Mary Trease even more as well.

By the year 2002, Ruth's health had deteriorated to the point that she required constant care. In November, at the age of ninety-three, she developed cancer. Doctors advised that her heart would not survive an operation. We could only attend her and wait for her death on December 2. All of the children were at her side as she peacefully drew her last breath. I tried desperately, at her death and at her funeral, to practice all I knew about Buddhist detachment and existentialist relativity. In the end, I gave way to my weaker emotions as did the other family members. Losing her was simply overwhelming.

A couple of days after the funeral, all of the children, and several of the in-laws, gathered in the home to witness the reading of the will of my father and of my stepmother. We gathered around the dining table, and again they proffered me the seat at the head of the table and asked me to read the wills. I first reviewed Daddy's will. Then I began to read Ruth's will when, much to my surprise, I discovered that she had named me and Ross as co-administrators of the estate! After a moment of complete silence, I said, "I do not have to do this. But, I will undertake this task only if I have the support of every member present." To this they all agreed and then agreed to have me and Ross carry out the wishes expressed in the will. My first order was that in-laws would not participate in the discussions and that Ross's mate, Carol Adams, would serve as secretary. Our first inquiry was about the financial status and, to our astonishment, Florence produced a statement from the credit card company indicating that Ruth owed about $13,000! Obviously, this was an embarrassment for Florence, and everyone agreed that we must clear that immediately. With little further discussion we dispersed.

Ross and I then secured Ruth's accounts and proceeded to execute the dictates of the will. This task occupied us for more than a year, and the tension was almost more than I could bear. Some problems did arise as expected, and relationships were strained. We all came to realize that our brother and sister relationships would never be the same. The unity of this family had passed to separate families. I feel strongly that, in Ruth's demise, I lost an anchor and family. Face it, I am alone! Bitterness between some of the siblings remains today. The relief was tremendous for both of us when we wrote the final checks to disperse the account. However, it made me realize that someday someone would be facing the same task as they settle my own estate. Since then I have been attempting to catalogue, order, and file whatever I can in preparation for that event!

The loss of my stepmother, even though I knew it was coming, was indeed a traumatic event because she, more than anyone, expressed pride in my accomplishments and had offered me encouragement all of my life. She was also the hub of the family, and I now saw the

spindles of the wheel digress in distant spaces with me floating, as a lose spoke, alone, very alone.

George

Colonel George White and I met in 1949 while I was in Hawaii. But, only later, while I lived in Cullowhee, did he come to have a part in my life. He had been on duty as an aid to General McArthur in Tokyo and came to Hawaii after retirement for graduate studies in Oriental Art History at the University of Hawaii, where I was also enrolled. I remembered George as one who was very slow in action, certainly not in wit or intellect. We often took the same bus to the university, and as I rushed to class, George took time to "rest" on the steps to the art department and, to watch the passing parade of students. I still have never seen George do anything hurriedly. He was a member of the social group that included Tommy and me.

During the ensuing years, as I made my way to North Carolina, George had retired and moved to Hawaii from Dallas, Texas. He had established himself as an annual vacationer at the Pisgah View Ranch in Candler, North Carolina. He had come to know the Ranch during his undergraduate studies at the University of North Carolina - Chapel Hill. During one of my trips back to Hawaii, we reestablished contact and our friendship. He then began to include visits with me during his stays at the Ranch in North Carolina. I really looked forward to his visits each year, and I visited him a couple of times in Hawaii. As we approached each of these visits, I would prepare to slow down, to anticipate fresh news from Hawaii, and to view photographs of his latest orchid or hybridized hibiscus. He also began to bring along exquisite jewelry and rare stones stashed in a simple old brown paper bag in his carryon luggage. He would stop in San Francisco for a visit with his jewelry designer and to swap a few stones. Then he would visit fine jewelry shops in North Carolina, always carrying that brown paper bag, because, as he said, "No one would ever think that anything valuable might be in that bag."

After his graduate studies in Hawaii, George had turned his attention to orchid culture. His expertise had become recognized internationally and was for some time a consultant at the Great Smoky Mountains National Park to reestablish our native wild orchid. He was quite excited to later find those orchids growing in the forest on my property.

I last visited George in Hawaii after his health prevented him coming to North Carolina. I made the trip alone. After a couple of days in his home I took time to visit the islands of Kauai and Hawaii. These islands offered glorious sights just as I had remembered them, but the experiences were muted by thoughts of my friend George sitting alone at home. I knew how much he would have enjoyed sharing these sites with me. Also, having no one with whom I could share the beauty rendered me into moods of loneliness. I was glad to get back to share the experiences with George. George's health continued to decline, and he died soon after my visit.

Andrey

I first met Andrey Evsukov in 1992, during my first trip to Moscow, Russia. I was a guest of his uncle, who spoke very little English. He depended on Andrey and his mother, Galina, to escort me and to interpret for me. When I arrived in the Moscow rail station, I was met first by Andrey. I remember first seeing this small and frail teenager of fifteen as his wide blue eyes and white smile greeted me at the train window. I also remember that he had the most beautiful, very full and curly, blond hair that I had ever seen. His very light colored-skin was and is absolutely smooth as silk, and his voice was of a deep mature Russian resonance. Of course, I looked forward to seeing him the following days as we made the social and official obligations. By the second day Andrey was already feeling the strain of keeping his schedules, attending classes, and escorting me. And, incidentally, I knew him well enough to know that he absolutely was not gay. At the same time, his family was housing another of our

tour members, and we often traveled about the city together, making it even more difficult for interpreters. By the third or fourth day, I noticed that Andrey was being very curt with his mother and not very attentive to his duties with us. I then began to see him as a very spoiled and selfish only child. I think the term "brat" could easily have been used to describe him. However, I did appreciate his help. Near the end of the visit, I asked him if he would be interested in coming to America to study after he finished high school. His reply was a rather neutral "maybe." En route to the railway station for our departure Andrey took me aside and asked if I would do him a favor when I arrived home. He wanted a large American flag to go over his bed. I had a very large American flag, which I boxed and sent to him immediately upon my return home. That flag still hangs over his bed in Moscow.

Andrey graduated from an eleven-year Moscow high school in June. While Bob Branden, a mutual friend who speaks Russian adequately, was visiting Andrey's family in July 1993, they placed a courtesy call to me. During the conversation, I learned that Andrey was unemployed, was facing a very likely call to military duty, and that he was getting into trouble on the streets and with the local police. I then instructed Bob to ask Andrey if he would like to come to my home for his twelfth year of high school. Andrey was hesitant in his answer, so I asked his parents if they wanted him to come here. The mother answered affirmatively and the father stated "he will go." I then spoke to Andrey for him to verify that he would come.

In August 1993 Andrey arrived in Atlanta, where I met him to transport him to Cullowhee. Without a doubt, this location in the rural mountain environment was a cultural shock for this kid from the huge, metropolitan Moscow. His use of English was fair, and his year in high school was a period of cultural, social, and educational orientation. His education in math, science, geography and history was superior to that of the American students. His knowledge and skills in computers was far superior to that of even his computer teachers.

This was a year in which I also had to be reoriented. I had been

retired since 1990 and had completed more than a year as director of The John C. Campbell Folk School. By 1993, I had settled into a rather relaxed retirement. After Andrey arrived I had to assume the roles of "fatherhood," advisor and chauffeur. I awoke each morning in time to prepare breakfast for us, wake him, and drive him to school before eight o'clock. My day then had to be arranged to meet him after school and often take him to swim practice. This routine certainly changed my life, but it gave me purpose and companionship. We both realized and discussed what a great chance we took on assuming that we could be compatible. Fortunately, we were very compatible, but I had to be very patient with this selfish teenager as I waited for him to mature.

Andrey had been with me for about three months when my friend, George White, came to visit. George was then in his mid eighties, extremely slow of movement, and having kidney problems. Amazingly, Andrey was immediately jealous of my attention to George, and he was, as teenagers tend to be, very impatient. He and I took George to Bradenton, Florida, to arrange for an assisted-living apartment for George. From the beginning, the two of them were miserably at odds. This, of course, made the trip very difficult for me. I managed to attend to the two of them in different ways, and I welcomed the return to Cullowhee. I had known George for about forty-five years, and he felt free to speak with me about Andrey "the brat" and admonished me to send him home at the end of the year.

Andrey enrolled in an English class at Western Carolina University during the spring semester and did rather well in it. However, he did very little studying for the class. I then realized that he had charmed his way through the Russian high school and had not studied any for his classes at our local high school, where he elected a non-diploma program. He was arrogant about his capabilities and about Russia and was unable to acquire friends at the high school here. I finally had to chastise him about this arrogance. I advised him that he must not continue to compare everything here to the "bigger and better" things in Moscow. Through considerable talk, news programs, and news from Russia, he came to realize himself that life in America

compares favorably with that in Moscow. He became much more realistic about the comparisons.

He returned home to Moscow in May 1994. Upon my invitation, he returned to Cullowhee that August to enroll in Western Carolina University as a full-time student, majoring in computer science. He completed his third year and graduated in June 1998. My four years with him were wonderful years. We proved to be extremely compatible.

It seemed that each time Andrey went home to Moscow he returned "in love" with a new girl friend. During one such trip, he met and "fell in love with" Anastasia Ryzhanushkina who later came to North Carolina, where they were married. She is a beautiful and intelligent young lady. They moved to Raleigh, North Carolina, bought their home, two cars and a cat! This guy who had lived all his formative years in a third-floor apartment in Moscow, now has an interest in his yards and even won "Yard of the Month" in his neighborhood. I could hardly believe it. They are adapted to the American life and they both stated repeatedly that they would never return to Moscow!

He has matured into a considerate and interesting young man, a highly talented computer programmer and a good friend. It has been my great pleasure to have had Andrey living with me, and I have thoroughly enjoyed my visits to Moscow with him. I introduced him to life in America, gave him an opportunity and motivation for a college education, and saved him from Russian military duty and possibly from police arrest. I know that his parents are extremely grateful. Thus, I have been able to help another young person as others have done for me. We continue to be good friends.

Russia 1992: In Winter

In December 1992, Andrey was going home to Moscow for Christmas. He and his family invited me to accompany him for the three weeks of Christmas holidays. While I was happy to be going to Moscow

with Andrey, I was apprehensive about the winter cold and about the three weeks as a guest in the smal0l apartment. We flew from Atlanta to Moscow with only a brief stop in New York. Andrey's parents brought two small cars to meet us at the air port. We arrived there just before noon on December 16, just after a heavy snow had turned the landscape into a beautiful scene of white. The drive into Moscow was three hours of mud, slush and unbelievably chaotic traffic. Our driver handled it exceedingly well as he stopped occasionally to pour anti icing liquid on the windshield. The highway, which appeared to have no marked lanes, became at times three to five lanes depending on how many trucks or busses were in the vicinity or how many holes drivers had to maneuver. We arrived at the apartment house, where we carried our heavy luggage and boxes up to the fifth floor.

The apartment building was typical of those built in the first decades after World War II. The building was of a simple box shape, almost a block long, with apartments arranged vertically off a flight of stairs. Just inside Andrey's apartment, there was a cloak and shoe closet, where we took off our shoes and donned slippers. There was a small combination kitchen and dining room, measuring about eight feet by ten feet. It contained a table on which the meals were prepared and served. Andrey's mother, Galena, assigned me a chair between the table and the refrigerator, where I could sit comfortably out of the way of kitchen movements. Adjacent to the kitchen was a small room containing the bath tub and sink. Next to that was an equally small room containing the toilet. Andrey's room, which I occupied, was about eight feet by twelve feet, furnished to resemble a one-person dormitory room. Beyond that was the living room, which opened onto a balcony. In summer the balcony served as a garden spot, but it now served as additional freezer space! Frozen foods were actually stored there. The only other room was the parents' bedroom.

Andrey's grandmother came to dinner with us this first night. She was typical of the American vision of the Russian grandmother. She was rather large in stature, heavily clothed against the cold, and she wore the typical head scarf. However, I soon forgot these preconceived images when she invited me to have vodka with her.

I quickly explained that I could not drink vodka in the traditional Russian manner and instead would have to sip it. She found this to be quite amusing and proceeded to empty her small glass of vodka in one gulp! She also proved to be a good dancer and a singer of Old Russian folk songs. I enjoyed her company.

Food was very scarce in Russia at this time. Our breakfast usually consisted of vodka, coffee, cooked cereal, bread and occasionally a piece of sausage. Lunch was almost always vodka, cabbage soup or sausage with barley. Dinner was usually of a similar soup with small amounts of meat, cheese, bread and, yes, vodka. When we were invited to other homes for dinner the fare was quite extensive but always contained lots of vodka and wine. I went with Galina, Andrey's mother, shopping for groceries. She noted that a store some two blocks away would have bread on Thursday. So we would tread through the snow hoping that it really would be there. Then we went to three stores for chicken. The first store showed us a chunk of ice containing random pieces of chicken. The clerk took it out of the case, threw it on the floor, and placed a large chunk of it on the scales. Galina refused to buy it with so much ice. The clerk only shrugged! The second store performed the same ritual. The third store had less ice and Galina bought a few pieces of chicken. The next day my lunch soup had one small drumstick in it. Occasionally, Andrey's father, Sasha, would bring home a few pieces of sausages or cheese from the Kremlin where he worked. Clerks or museum attendants would often ask me, "Do Americans know how difficult it is for us?" My reply always was, "Yes, we lived through such a depression in the 1930's." It was a time of deep depression in Russia and I experienced this first had.

Our rather flexible routine was to have morning coffee and cereal, tour for a few hours, return home for two o'clock lunch, tour again and return home for late dinner. Andrey had been rejected by his current girlfriend and was behaving miserably. I told him to make reservations for me to fly home. But, on Friday morning Galina informed me that she and I would go to St. Petersburg by train that evening. Of course, my first thought was about how I could take that

colder temperature. The train trip was an eight-hour ride: midnight to 8:00 a.m. Upon arrival in St. Petersburg, we went to an inexpensive hotel, checked in and ate a little food that Galina had packed for us. By nine o'clock I was having my first lesson on walking on ice. We spent the day and the next trudging over ice to see the beautiful sights and the Hermitage Museum, where we were the only visitors that day. By the time we arrived back in Moscow on Sunday morning, Andrey had become much more civil. The next week went very well for each of us. This was an eventful, educational and enjoyable trip with lots of Christmas and New Year parties. The three- week visit was educational and, the time seemed to go quickly. Andrey and I returned to Cullowhee.

Russian River Cruise 1996

Andrey's mother, Galina, had toured St. Petersburg with me during my tour to Russia in 1992. She knew the city very well and had made that a memorable trip for me. Since then I had wanted desperately to see that beautiful city in the summer. So, I scheduled a cruise from St. Petersburg to Moscow aboard the Russian ship Krasin for June 28 to July 13. I flew from Atlanta to Orlando, then via Frankfurt, Germany, to St. Petersburg, where I met a guide and transferred to the ship.

The stop in Frankfurt was memorable because of the austere design of the airport terminal. It is the most inhospitable building that I have ever experienced. Its Bau Haus design and construction of glistening steel and glass make it, for me, a very hostile and inhumane place. The experience of this architecture made the decorative city of St. Petersburg a welcome sight.

Upon arrival in St. Petersburg we were met by Russian tour guides. Soon, there were about fifty of us being ushered to the one waiting bus. After much delay amid confused chatter among the guides and driver, all of us, along with our entire load of luggage, were packed aboard this single bus for the trip through St. Petersburg to the ship Krasin. That was a most unpleasant introduction to the

tour, but I was too tired to be disturbed by any of it. That first evening dinner aboard the ship was a great disappointment: a couple of fish cakes and mashed potatoes. Later, the daily breakfast proved to be the best of the meals: oatmeal, cheese, sausages, very good breads and coffee. While my single room aboard the ship was small, it was adequate. My small bathroom/toilet had one unique feature. The faucet on the sink was made to be lifted off and used as a shower after the toilet was closed off with a shower curtain. It actually worked quite well, and it was an efficient use of space.

I enjoyed three days of tours in and around St. Petersburg seeing many of the same sights that I had seen in winter with Galina under quite different weather conditions. The city and the great Hermitage were as beautiful as I had remembered them except now I had to stand in long lines to enter the major tourist places. Two new sights for me on this trip were the trips to Pushkin for a tour of Catherine's Palace and the trip to Peterhof or Petrodvorets, the palace of Peter The Great with its vast gardens and many cascading fountains. We attended an evening ballet performance by the Kirov Ballet at the Hermitage Theater. The dance was very good, but I could hardly resist comparing the theater with the beautiful Kirov Theater where Galina and I had seen a performance.

On the third day of July, we sailed from St. Petersburg up the Svir River, across Lake Ladoga with a four-hour tour of the city of Svir Stroy. On July the fourth, we arrived at Kizhi Island on Lake Onega. Kizhi Island, for me, was the highlight of the entire cruise. It was a beautiful day, the island was covered in brightly colored wildflowers, and the architectural restorations museum was a delight. Earlier, I had read about the Kizhi Island restoration project, which is partially funded by the United Nations, and I was anxious to see it. Currently, the restorations consist of a chapel, a cathedral, two homes, a wind mill and a shop, all constructed of wood in earlier styles. The chapel and the cathedral had onion-dome cupolas covered with wood shingles, which resembled fish scales and which seemed to be different colors as the sunlight changed on them. The pleasure

of walking in silence amid the waist-high flowers as I photographed the buildings will be remembered for a long time.

We then sailed up the Svir into White Lake for a stop at the city of Goritsy, then into Lake Rybinsk for a tour of the city of Irma. En route, we had ascended through several locks, sometimes on water above adjacent homes and villages, and descended into the Volga River on which we cruised to a most memorable and picturesque stop at the city of Yaroslav. On July the eighth and ninth, we sailed on the Volga for tours of Kostroma and Uglich before arriving in Moscow on the tenth of July. Tours in these various towns were pleasant and educational, but as tourist often say, "soon one cathedral looks much like another cathedral!"

We arrived at Moscow about 2:00 p.m. on the tenth of July, where Andrey's parents, Galina and Alexsander (Sasha), met me. They live on the southeast side of Moscow, and the docks are on the northwest side. They did not have a car, so had to pay a friend to drive us across Moscow, which he did at unbelievable speeds, darting in and out between cars and trucks. In Moscow, a four-lane highway more often than not seems to accommodate six lanes of traffic. Believe me; I was happy to be deposited in front of the apartment. That evening, Andrey's grandmother, Marie, came to have dinner with us around the tiny kitchen table. The food was meager, but jovial friends and the vodka rendered that fact unimportant. The temperature in Moscow at that time was 100F degrees, the apartments were not air conditioned, and there was no cross ventilation. The living room door to the balcony was unscreened and had to be kept covered with sheer curtains against mosquitoes. I suffered and missed the comfort of the ship.

On Thursday, July 11, the family and I went to the Pushkin Museum in the morning, had little eats on the street, and went across Moscow to the new World War II Memorial. The Memorial consists of a huge plaza containing great stretches of fountain pools, a holocaust monument, and expansive steps leading up to one very tall monolith. Back of the sculptured monolith is located a curvilinear building with ground level columns and a windowless upper level, all in white. Back

of this geometric structure is located a large cylindrical and domed building, which one enters through a massive color glass doorway. The domed structure contains the names of patriots who died in World War II engraved on the cylindrical wall, an eternal flame and a stature. The upper level of the building houses an immense collection of memorabilia as well as six expansive dioramas depicting war scenes in various cities. This is a very impressive memorial.

After this tour, we returned to the heat on the streets for the bus rides across Moscow to the apartment building. Upon arrival there, and the climb to the fifth floor, we quickly tried to refresh ourselves before walking about twenty minutes to a friend's apartment for dinner. I went that distance prayerfully hoping for a cooler apartment upon our arrival. No such luck awaited us. We enjoyed a most impressive Russian dinner with the family, while everyone wiped sweat and fanned with anything available. I was later told that this was the hottest weather on record for over one hundred years. Before I went to sleep that night, I told Andrey that I had to return to the ship the following morning to join my group. On Friday morning, the parents escorted me via subway and bus back to the ship. As soon as they departed, I showered and went to sleep. The family, including Andrey and several friends, came that evening to have champagne and vodka with me. They each brought small gifts, but Galina and Sasha brought me a beautiful quilt for my queen-size bed. The parents accompanied me to the airport the following morning after which I flew to New York and to Atlanta. Andrey would return to my home in August to continue his studies at Western Carolina University.

Russia and Siberia: 1997

In June 1997, the Friendship Force International celebrated its 20th anniversary. One of the special programs was a tour to Russia, Siberia, and "around the world" by traversing the length of Russia. This tour included a home stay and a tour of Moscow, a home stay

in Irkutsk, and brief visits to Lake Baikal, Maksimikha, Ulan Ude, and Khabarovsk. It also included an over-night journey aboard the Siberian Express railway going from Ulan Ude, around the south end of Lake Baikal, to Irkutsk.

On June 29th, we took a Delta Airline flight to Kennedy Airport in New York, and transferred to the Russian Aeroflot airline overnight to Moscow. We followed the coast of eastern North America, where we saw many icebergs in the Atlantic off the coast of Labrador. The solstice sun shone throughout the night. We passed over Helsinki and St. Petersburg before landing in Moscow.

In Moscow, we were met by members of the Friendship Force Moscow chapter, who drove us about 60 miles to the Hotel Moskva in the heart of Moscow. En route, we encountered a huge traffic jam, due to returning vacationers, which continued until we were entering the heart of Moscow. However, the highway had been greatly upgraded, well-paved and lane-marked. Along Leningrad highway, we noted a couple of McDonalds, and we were told that Russia is now developing a number of Bistro shops, fast food, serving Russian food. Leningrad highway becomes Tverskaya Street (formerly Gorky Street) as it enters Moscow. It is the "Fifth Avenue" of Moscow.

The hotel was conveniently located with views of the Red Square and the Kremlin just across the street. It is a large, sterile facility built earlier under Communism for the purpose of facilitating large numbers of Russian tourists to the city. It is currently being upgraded, as is most of Moscow, in preparation for the 850th anniversary (September 1197). There is construction and renovation underway everywhere, twenty-four hours per day. The hotel had no air conditioning, and the staccato sound of jack hammers and flashing welders' torches through open windows was disturbing. So what? I slept well!

To my surprise, Andrey's parents, who are members of the Friendship Force, met us at the hotel bearing a large bouquet of flowers and a supply of rubbles for me to spend. It was so good to see them again, and I arranged to have some time in their apartment.

During the first afternoon, our group toured along the Moscow River, Red Square, Novodevichy Monastery, Lenin Hills, St George's

Chapel and the sight of the Cathedral of Christ the Savior, now being rebuilt after being destroyed by Stalin in 1937.

The following day we had a walking tour through the Kremlin, then to the Cathedral of the Assumption with its many beautiful frescos, the Archangel Michael Cathedral, the Cathedral of the Deposition, and finally the Cathedral of the Patriarchs. It was noted that Red Square is populated by so many pigeons that falcons are kept there to keep a status quo. Too many cathedrals for me! In the afternoon, we were refreshed by a visit to the famous Pushkin Museum with its many French Impressionist paintings and treasures from Egypt.

Andrey met me at the Pushkin, we walked to the hotel, and then went to his apartment for dinner. Late that evening, he and a friend (Anthony) escorted me back to the hotel. Even for Andrey it was not safe to return from downtown alone late at night. The weather in Moscow was hot and humid. I was delighted to learn that Andrey, at last, has a fan in the apartment. It provided some relief from the heat during the dinner. The next morning Andrey, Galina, Alexsander and Antony came to see me off to Siberia.

To Siberia

On the second of July, 1997, we flew from the domestic Sheremetyevo Airport, located across the airfield from the International Airport in Moscow, to Irkutsk, Siberia. We were met by another group of Friendship Force members and transferred to private homes. Our flight passed over Nizhny-Novgorod, Kazan, and Novosibirsk, arriving in Irkutsk about 10:30 p.m. with the sun just setting at that latitude.

At the Airport, I was introduced to my host family, Alexsander (Sasha) Portyaksky, his wife, Marina Levinson, and daughter Inna. We went by car to their home in the suburbs. Alexsander was a Professor of Physics at Irkutsk University, and Marina worked for an international marketing company. This was a Jewish family.

Alexsander's parents retired and live in Israel where his mother teaches English in a Russian school. Interestingly, I learned later that when they arrived in Israel, they were surprised to learn that they were unable to understand or to speak the Israeli Hebrew language. The family was accompanied to the airport by a good friend, Vladimir Leviant, another professor of physics. I would spend a lot of very enjoyable time with Vladimir and his wife.

The drive to their apartment was an interesting experience. The four of us were cramped into a small car, along with my baggage. As we drove to the apartment, the streets became progressively worse as the pot holes became more frequent and larger. We drove through some water in pot holes wider than the car. Upon reaching the doorway and stairs to the apartment, Sasha had to hold a cigarette lighter for us to see our way up two flights.

The second floor apartment had only a small living/dining room, an adjacent cooking area, a bath and one bedroom. Unbelievably, they gave me the bed and bedroom while they slept on the very depressed opened couch. There were only two small, white, square stools for us to sit on. The kitchen, which they had just refurbished, did have a microwave, refrigerator, stove and a portable washing machine. They did have a small television. Food was sparse, with a cucumber-cheese-sausage dish at every meal, along with the ever-present vodka. The friendly atmosphere and charm of my hosts made all of these inconveniences seem unimportant. During my visit, the daughter slept in the nearby apartment of her grandmother. There were windows on only one side of the apartment and, because of mosquitoes, the windows, except for one twelve-inch window in the bedroom and in the dining area, were not open, and netting covered those. However, I slept well, being disturbed by mosquitoes only twice. My host and hostess were well educated, spoke English well and were good conversationalists. They were very eager to show us their city of Irkutsk and Lake Baikal. Food is scarce. The economic conditions here are much worse than in Moscow.

Customarily, the Friendship Force participants are taken on tours during the day and return to the host families for evening and the

night hosting. So the group met at the Angara Hotel the first morning for a city tour. Irkutsk (founded in 1661) is located on the southwest of Lake Baikal on the Angara River. It has about 730,000 inhabitants with an average age of 31 years. About 26 percent of the population is students. I learned, via the internet before I left home, that Irkutsk has an international gay club, and that the city is gay friendly. However, I chose not to pursue this further.

The oldest building in the city is the Church of Our Savior built in 1706. It has frescoes on the exterior. The Church of the Epiphany stands nearby and is now open. There is also a Polish Catholic Church created by the many Poles who were exiled to Siberia, and one Protestant Church. Other religions are now being tolerated but opposed by the Orthodox Church, which no longer wields the power that it did in pre-communist days. These churches were closed during the Communist era. Some were destroyed while others were used as museums or storage facilities. The two main streets in Irkutsk are still named Karl Marx Street and Lenin Street because it costs too much to have them renamed. We visited one area of log cabins that are of historical significance, thus preserved much as those in America on the National Registry of Historical Places. These are made of local lumber from the Larch trees that take on a soft gray color and last a very long time.

Before the Revolution, there were 40 churches in Irkutsk. Those were subsequently reduced to only one. Now there are only five open. Most structures in Irkutsk, as elsewhere in Siberia, are of unpainted wood that takes on a lovely gray tone with age, including the wood shingle roofs. One of the most interesting features of Siberian houses is the window treatment. The windows are normally small glass areas surrounded by intricately carved wood decoration. Even the wood shutters, which serve to keep the cold out in winter, are often beautifully carved and painted.

In the afternoon we visited the Decembrist House, where noblemen were exiled for trying to bring about democratic reforms in Russia. Some of the wives followed them into exile bringing some measure of culture with them to remote central Siberia. In the

Princess Volkansky reception room, we were treated to music by Glinka piano music and operatic singing, along with champagne! That evening, my host family invited Vladimir to have dinner with us in their home. Strangely, two physicists and this artist had no shortage of conversation that evening.

Traditionally, the host families will plan programs for us on weekends or holidays. Well it is then the Fourth of July, and we were treated to a "July 4th Holliday" outing. I, and my host family, Vladimir, American guests Bill and Emma Batson, and Batson's charming host couple, Irina and Dmetri Neudachin, drove first to an open-air village Ethnological Museum of early Siberian architecture. This museum reminded me of the similar one on the isle of Kishi near St. Petersburg, in that it contained very interesting wood buildings with wood shingles and domes covered in shingles shaped to fit. Bill Batson is an architect from Kentucky, and we enjoyed discussions of the forms, techniques and aesthetics of these buildings. The Ethnological Museum contained an Evenki native teepee, a water run grist mill, a Cossack village, an old Ilimsk church built in 1667, an Ilimsk fortress watchtower of the Savior (1667) with a chapel above the gate, and a school house for 15 students. All houses open to the west. Traditionally, inside the house, the husband faces west, the wife east. Buryat yurts in the museum have eight sides and face south. Even in hot summer weather these houses remain comfortably cool. We were served a small drink of Buryat vodka made from milk. The museum also contained the house/yurt of the shaman (medicine man) of Shamanism practiced by the Buryats.

Then we went to Lake Baikal for a boat ride with an onboard picnic consisting of raw and smoked Omul fish. The taste of the raw Omul was not bad, but the texture of raw flesh made eating it very difficult for me. Vodka helped! I did enjoy the cooked Omul. After lunch we left the boat for a stroll along the rocky coast and the end of a railroad. Vladimir explained that in winter the track went on across the frozen lake. That day it was hot and the flying insects were bothersome. Batsons' hosts were quite young and a beautiful, stylish couple. Irina is a dermatologist who wore extremely revealing

(sexy?) clothing, beautifully stylish, which she made. Her Fourth of July dress was a very short skirt bearing the stars and stripes of the American flag. Yes, I remember! Her husband, Dmetri is a Karate teacher.

In the afternoon, the Levinsons took me to visit Marina's parents who were staying in the dacha (pronounced da cha, not da sha), a short distance outside of Irkutsk. We approached the dacha on a narrow dirt road, pulled up to the gate, and were met with generous hugs by both her parents. I had no idea what a dacha was like until now. For some reason, I had assumed it to be a spacious summer home for the rich. This one, and all those near it in this country setting, was quite small, reminiscent of a mountain cabin in the United States. The small house was surrounded by a vegetable garden at the rear of which stood the outdoor toilet and the single water spigot. I learned that some of these were rented during the summer, and they offered some relief from the summer heat. In Siberia?! This dacha with its garden, like so many others across the landscape, was only about fifty feet long in either direction, and it served two functions: a place to escape the city heat and a place to grow food for the winter. Marina's father was a retired photographer who did not speak English. Immediately upon my arrival he insisted that I remove my shoes and experience the cool grass in his garden and to have a generous shot of vodka. However, upon seeing my camera, we had an immediate rapport. He examined my camera, went inside and got one of his, and challenged me to photograph three picturesque buckets of water sitting in his garden. Without language we indicated the best angles, the best light, and how to frame for the best picture. We really had fun with that experience. Later, he called to me to come across the garden. I asked Marina what he wanted, and she replied, "He wants to show you his squash and to get a photo of you there." When I came to his side, he indicated that I should put my bare foot beside the squash, whereupon he took several photographs of my foot. I treasure those shots! In late afternoon we had "late lunch" of cooked Omul and fresh vegetables from their garden.

In the evening my hosts and I had dinner with Dimetri and his

wife, Irina. It was very good food with lots of vodka and champagne. I had taken several small American flags and one larger one (3'x4') with me and displayed them at this evening meal. My host family took the large one home and hung it above the couch in the living room, much to the delight of the young daughter. So, our "Fourth" in Siberia, Russia was indeed a memorable event!

The next day, July 5, was a day for my host family and friends to show me how they live and "Our Irkutsk"; a tour of the city, its parks, antique shops, and a museum of art with its Coca Cola umbrellas on the terrace.

In the evening, I went to Vladimir's residence, a small house across the river but not far from downtown. In my mind, this physics professor deserved better. When we arrived, Vladimir was quick to call my attention to the new wooden fence across the front of the place, which he had recently built. Once inside the gate, we entered a courtyard, where the ground was covered with boards long since covered with sand and weeds. To my left, was a tool shed and banyo (sauna), straight ahead, the garden leading to the outhouse, and to my right, the very dilapidated residence. Vladimir's wife was a demur young lady with very attractive features. Her reticence to converse was due to her inadequacy in English. She soon forgot that and joined in the chatter in Russian. This was, to me, very poor housing for the Siberian winters, and Vladimir showed me where he was calking and repairing windows for the long winter. However, the main room walls were filled with books, They had adequate furniture as well as a microwave, radio, television, and music. Soon we were joined by two charming young couples who would spend the evening with us.

After a very good dinner with vodka and merriment, Vladimir invited all of us to join him in the banyo. He had discretely been stoking the fire all evening. I had no idea what a banyo was. In less time that it took to cross the courtyard to the banyo, we were in the nude! So, here were three male college professors, one auto mechanic and four young women nude together enjoying a sauna! Vladimir threw a bit more water on the red coals, and proceeded to "switch" each of us with wet birch branches. This felt especially

good on the bottoms of my feet. In earlier conversations, Vladimir had learned that I had some training in Swedish deep muscle massage and Japanese shiatsu. Evidently he had told this group. One young lady asked me if I could give her a massage. Upon my affirmative response she immediately stretched out on the bench before me and, of course, her husband. When I had completed the back head-to-toe massage she flipped over for the front massage. Everyone was in uncontrollable laughter, and I was on the spot. But I had to finish the job to everyone's delight. Then, each of us exited the banyo, where we were drenched with a bucket of cold water. Then, we dressed, drank more vodka, and enjoyed more conversation. Then I departed for my host home.

I spent the next day with my host family viewing the city from a strategic hill top, visiting the riverfront park, and shopping in antique shops/art and crafts store at the corner of Marx and Lenin Streets. We also had a brief visit to the school of science at the University of Irkutsk, where Sasha and Vladimir taught physics. That visit was disappointing but educational. We drove to the front of the building, approached a large old wooden door, and knocked for entry. It was chained and padlocked. After a short time, the door was slowly opened and a disgruntled looking janitor peered out. Vladimir explained that he wanted to show an American guest a little of the school. With some argument, Vladimir pushed his way inside as I followed. The door then slammed shut, and the big lock was latched. We then went through some of the hallways and looked into a few classrooms, one of which was a small computer lab. The hallway floors and walls were badly in need of repair. Tiles were broken and grimy, paint was dirty and peeling, and we could smell the men's rest room, even as we entered the hallway. It was a poor environment for teaching and learning. Neither of the professors had been paid in the last six months! The very obvious improvements that I saw in Moscow had not reached Siberia.

A Friendship Force farewell was scheduled that evening at the Irkutsk School of Art. There, a youth jazz orchestra entertained us playing popular and old favorites: *In the Groove, Sunrise Serenade,*

Chattanooga Choo Choo, and Love Me Tender. These tunes were played very well. After the concert, we were treated to a dinner, good food and lots of vodka and other drinks. I met the director of the school, Vitaly A. Rizhakov. I proposed that we get the group to play in America but, of course, money was not available to do that. When I returned home, I tried to interest someone in funding that trip, but to no avail.

On July the seventh, we were up early for our boat trip across Lake Baikal. We were transported to the Irkutsk boat terminal on Lake Baikal just above the hydroelectric power dam. There we boarded the catamaran Barguzin for the ten-hour trip up the Angara River and across Lake Baikal. Due to weather conditions, this trip really took twelve hours instead.

There were over 120 passengers aboard, many of them youths headed for camps on the east side of the lake. The boat was very crowded with people, luggage and camping gear. Our stops included Listvyanka, Bukhta Peschanaya, Mala Morskaya, and Ol'khon. The lake and its shore lines were indeed beautiful. We docked at Ust Barguzin in late afternoon and boarded a bus for the 25-mile trip to our camp site, six miles south of the village of Maksimikha. In camp we were housed in one new, large, two-story, wooden cabin. The wood work was beautiful. The 26 of us shared the only two wash basins in one room. The toilets were unisex outhouses about one block away in the woods. There was no paper! Luckily, I always carry a roll that I shared with a couple of guys and Kristen, our youngest member. Meals were served in a large commons dining room. The food, cucumbers at every meal, was minimal but filling. Omul fish, directly from the lake, was served raw. My roommate, Steve, and I had a room upstairs overlooking the lake.

In the morning we began a four mile hike along the shore to Maksimikha. However, several members could not walk that far in the heat and the local guide arranged for a bus to take us on the eight-mile round trip. After we disembarked at the village, and the bus had departed, one lady slipped on gravel. Only a few minutes later, another turned her knee. Our local guide had a most difficult

time helping us to see the village and caring for the two who needed transportation back to camp. Our American guide escorted one group along the shore back to camp, and I escorted another group along the shorter road. That was one hot four-mile walk. The village was hardly worth it, but it was interesting to see the unique boats and cows, instead of people, lying on the beach. Cows also have the right of way on the roads!

That afternoon, we were treated to the Siberian banyo, or sauna, which I had seen in Irkutsk. This banyo was a room with a sunken pit of hot coals and rocks onto which the attendant splashed dippers of water. The resultant steam was intense. Since this was an American group, the attendant asked the ladies to use the banyo for the first hour and men the second hour. The women wore their bathing suits, but the men stripped as they entered the room. The women were splashed with cold water upon exiting the banyo, but the men, after a long steaming, birch switching, and a couple of vodkas, ran nude the short distance to dive into the lake.

That evening, we were treated to a picnic beside the lake with one long table laden with foods and drinks. Raw Omul fish were sliced and served with sliced cucumbers, bread and potatoes. Omul were also placed on stick skewers that were stuck in the sand near the bonfire for cooking. The cooked Omul were delicious. During the dinner, the 28 people drank 17 bottles of vodka and 3 bottles of champagne as we were entertained by Anatoly, the camp host/caretaker, the same guy who attended the banyo, who sang Katyusha and Moskovsky Vyecherom and led us in group singing. He was a native Buryat, forerunner of the American Indians, and practitioner of his native religion. He had a good baritone voice. Ending the evening, still daylight, with one Macarena and Bunny Hop, we helped each other to the cabin.

Early on the morning of July ninth, I walked along the lakeshore for some photographs and to explore more of the campgrounds. After lunch, we began a 130-mile bus ride on unpaved roads south to Ulan Ude (pronounced U lan U derr, the "e" has an "r" sound, meaning Red River in Buryat language). This turned out to be six hours of

slow, hot, dusty bumpy travel in a bus without cooling and hardly enough power to get us over the mountain range.

Along the way we stopped at Volyachinsk to view the hot springs and gardens. Dodging cows and many potholes we passed through the villages of Turka, Gremyachinsk, Kika, Nesterevo, and Zyryansk. To pacify the shamans, we stopped atop the mountain pass to rest for a few minutes and to dash a bit of vodka into the bushes in thanks for the safe trip before descending down to Ulan Ude.

Ulan Ude has some 400,000 inhabitants. It is located about 200 miles north of Mongolia and southeast of Lake Baikal. It is a major rail stop on the Siberian Railway. About 41 percent of the inhabitants are Buryat, 55 percent are Russian. The rest are a mixture and Mongolian. A very large bronze sculpture of the head of Lenin still dominates the town square between the opera house and the municipal building. It is being left there because "it is history' and because the impoverished city cannot afford to remove it! The opera house is a grand building facing the main square, but it is in need of repair. I noticed that the area around the opera house, especially the back side, was littered with broken bottles and trash. The city "does not have money to clean it up!"

We spent the night in the Hotel Baikal located on the city square. It was quite adequate, and the food was good. In the morning of July 10, we took a bus about 30 miles south along the Selenga River, passing the Ulan Ude Airport, to the Buddhist monastery. The yellow-roofed monastery, about forty years old, is actually a series of wooden buildings in a fenced compound at the head of the valley. About 80 lamas reside here. Each Lama lives in his private little house, and each has a young trainee under his tutelage. The school offices and services are in the large temple. Yellow is the sacred color, prayer wheels abound here, and there is a "prayer garden" where prayers are written on strips of cloth then tied to tree branches to blow in the wind. I had seen this practice outside of Irkutsk as well. (The prayer tree is indeed a trashy looking place.) These Buddhists maintain that only men can reach paradise and that women, as the source of evil,

must eventually be reincarnated as men to attain paradise. So we were told.

After lunch at the Geser Hotel, we visited the Buryat Open Air Museum of Ethnicity, where we were treated to a program of Cossack music and dance with a photographic session with the performers. In the evening at dinner ,the Buryat Ministry of Culture provided us with a program of Buryat songs, operatic singing, flute and piano music. The three television channels there were in Russian and Buryat languages. One of the programs was *Dynasty* in Russian.

After the dinner program we ordered the Selenga train (a segment of the Tran-Siberian Railway) for our overnight return to Irkutsk. The electric train was clean and comfortable with good toilets.

We arrived in Irkutsk about 6:00 a.m., where we were met by our host families. Sasha and Vladimir took me on a shopping tour with lunch at the apartment. Anatoly, director of the art school, invited about four of the host families, and their American guests, to a "covered dish" dinner at the art school. The food there, prepared in the homes, was the most that I had seen at any meal in Russia, and I dare say, the best as well. To our surprise, Anatoly played piano jazz very well. He played for some of us to dance, and I won a bottle of champagne for being the best dancer! It was a great farewell dinner party.

It seems that communications across Siberia (all of Russia?) is not always reliable. Our flight from Irkutsk to Kharbarovsk near the east coast of Eastern Siberia was scheduled for a 6:30 a.m. departure. At the airport, we were told that the flight was delayed due to fog in Kharbarovsk. So our hosts took us to different places for a little breakfast. My roommate, Steve, and I went with our hosts to have beer and snacks. Then we were told that the plane would depart at 10:30, so my host took me home for a little sleep. Finally, we did depart Irkutsk for Kharbarovsk, only to learn that there had been no bad weather in Kharbarovsk.

Kharbarovsk, founded in 1858, has about 660,000 inhabitants of which 80 percent are Russians, is located only about 30 miles north of the east-coast border of China. Our Intourist Hotel, located

on Karl Marx Street at the city square, was the best we have had in Russia. Television programs here included CNN, a sports channel, NHK (Japanese), and three Russian channels. The city is built on three geological ridges so that many of the streets remind me of San Francisco, California. So Steve and I went for a rather long walk to explore the area of the hotel. We were delighted to find, within sight of the hotel, a huge sports arena and complex, a lengthy riverside beach very much in use, and a great display of varied architecture. There is definitely an international presence in this city, since it is the eastern civil and commercial gateway to Siberia.

Our city tour on July thirteenth included Komsomolsk Square with its large sculpture commemorating the Bolsheviks, the small Assumption Cathedral, which has been rebuilt after it was destroyed by Stalin in the 1930's, the Territorial Library with its red and gray brick façade, and the Cathedral of the Nativity, the only one of the original 13 Orthodox churches in Kharbarovsk before the revolution.

Then our boat ride on the Amur River took us to the 1.5 mile long railroad bridge across the Amur River. Currently, vehicular traffic uses a tunnel under the river, but a highway bridge is being constructed along the railway bridge over the Amur. We then visited a large War Memorial that bears the names of 30,000 Kharbarovsk citizens who lost their lives in World War II. This is an impressive memorial.

We departed Khabarovsk for Anchorage, Alaska, and San Francisco at 4:15 p.m., after paying 127,000 rubles (about $23) in airport tax. Steve and I located two empty rows of seats where we were able to sleep and spend a few hours in conversation. Our flight took us over Komsomolsk, Nikolayevsk on the Amur, the Sea of Okhotsk, over spectacular views of the snow and ice, and the Bering Strait, to arrive in Anchorage about 4:00 a.m., still on Sunday, July 13, since we crossed the international dateline. After a couple of hours in Anchorage, we continued the flight to San Francisco, where the group dispersed, and I went to a hotel to rest overnight and to visit friends in San Jose.

The early morning flight from San Francisco to Atlanta and to Asheville was a beautiful experience as I observed, on this clear day, the changing landscape below. Arriving in Asheville, driving my car down the wide, smooth interstate highway were thrills to make anyone proud to be an American! It took me five days to overcome my "around the world" jet lag and to adjust to the time.

Summarizing: Conditions in Russia have changed since I was there about four years ago when they were in the depth of a depression. The markets then were almost bare, the huge farmers market in Moscow was almost out of business, meat cases often had only one block of cheese or one chunk of frozen chicken for sale, and there were long lines for bread wherever it was available. People really were struggling to survive, even in Moscow and St. Petersburg.

Conditions in Moscow and St. Petersburg have certainly changed. Moscow has a vast rebuilding program underway, churches are being repaired and rebuilt, shops in central Moscow are filled with very expensive products, farm produce is now available, and the American dollar is almost a common currency. However, this progress certainly has not reached most of the vast Siberia, where even university professors and public workers often go unpaid for months, and public facilities show signs of great deterioration. Subsequent communication with friends in Irkutsk indicates that conditions have improved slightly. This was indeed a very educational trip!

China 1998: A Medical Journey

Like (Leek) Jiang, from Beijing, and I became friends when he was a student at Western Carolina University. His wife came to join him after he graduated and was employed in Knoxville, Tennessee. Once, when I was exhibiting my photographs in Beijing, his father helped me to expedite the process. Like had mentioned several times, that he wanted me to accompany him to visit his family in Beijing. In the fall of 1998, when he and his wife Jan and their newborn baby were planning a trip so that the parents could meet the baby, he asked me

to accompany them. At the same time, Like's friend Taylor, a heart surgeon in Maryville, Tennessee, had been invited to perform a surgery demonstration in the heart hospital in Beijing. He would be accompanied by a medical staff member and friend, Michael.

All arrangements were made for Taylor, Michael and me to meet Like's family in Detroit, Michigan, for the flight to Beijing. Meantime, Like's father was rushed to the hospital, requiring Like and Jan to fly to Beijing earlier. Like's father died before their arrival with the new grandson.

Taylor, Michael and I met at the airport in Detroit on Wednesday, September 23rd, and flew directly to Beijing, uncertain of how Like was going to handle this trip or if he would be able to meet us in Beijing. The three of us seemed to be an unusual trio, a surgeon, a medic and an artist. Like and a friend, William Liao, who was general manager of a medical supply business, did meet us and took us to our Holiday Inn Hotel. Like and William accompanied us to dinner that evening and made arrangements for us to visit the Heart Hospital's chief surgeon the following morning.

Upon our arrival at the hospital on Thursday morning, we were escorted to an upper level, and, surprisingly, directly into the area where the surgeon was busily involved in an operation behind a glass petition. There were four other patients lying on gurneys lined up in the hallway as they awaited their operation. The surgeon looked up and nodded to us. Soon he turned the procedure over to an assisting surgeon and came to speak with us. He was an impressive person, a fatherly figure, with whom I was immediately at ease. He spoke with Taylor for a few minutes and then we were escorted to lunch with Taylor scheduled to do his demonstration the following morning.

Like and William gave us a great day touring, as they did each day we were in Beijing. We ended the day with drinks in William's apartment and dinner at a huge Mongolian restaurant. I counted 110 items on the service bar from which we took raw food to our table and cooked it in steaming hot water in the table center. Each person cooked in the one cooker and, as the meal progressed, the water became a very tasty soup.

Subsequent tours included the Palace Museum (formerly the Forbidden City), the Summer Palace, and the Great Wall. All of this was possible because William drove exceedingly well and fast. It was great to drive to the Great Wall, not only in the luxury of a car but on a new highway as well.

Like came to our hotel early Thursday morning to inform Taylor that the surgeon would not do surgery today because of an infection on his arm and that Taylor should plan to demonstrate his procedure on Monday morning. So we had a weekend of touring and visiting with friends in William's apartment. Again, we had dinner together and then went for a walk through Tiananmen Square. I started to say "stroll" but the square was far too crowded for a stroll. We were there during a national celebration, and the area was packed as, I think, only Chinese can pack into an area. I clung to Like as we made our way through the throng and back to our car. William demonstrated his expert driving skills, finding an illegal parking space and getting us out of those crowded streets back to our hotel.

Taylor received a message late Sunday evening canceling his appointment the following day. The surgeon would be going to Shanghai for a two-day national conference. However, he invited us to go to Shanghai, where he and Taylor might have some time together. William made arrangements for us to fly to Shanghai as guests of his company, Dongfang Huatong Medical Co., Ltd., and to have a young lady, Simone Ding, meet us in Shanghai and escort us during our stay. Simone was Business Director of Shanghai Z. H. Industry Development Co., Ltd. She was a very good-looking and charming young lady.

Upon arrival in Shanghai on Monday morning, we went to the conference site, spoke with the surgeon briefly, and since the conference was, of course, in Chinese, Taylor opted to accompany us on a tour of Shanghai. The conference site had a huge display of medical tools and equipment, so Taylor took time to walk us through it while making comments and giving explanations about many of the items. I found that to be quite enlightening.

Then, during our stay in Shanghai (Monday, Tuesday, and

Wednesday), Simone took the three of us on tours to the Shanghai Museum, which is greatly improved since I last saw this magnificent collection, the Magic Island Animal Paradise, which is a beautiful zoo in a park setting, another magnificent park of ancient architecture, and to Yuyuan Garden with its Ming Dynasty period architecture, furniture and gardens. Yuyuan Gardens was a private home and garden some 400 years ago; it is very well preserved, and it is listed in the national protected cultural relics by the State Council Government. This is a "must see" for anyone visiting Shanghai. Finally, we strolled along the famous Bund, primarily for a view of structures across the river.

On my earliest visit to Shanghai that area across the river from the Bund was shacks and rice paddies. It is now the location of a magnificent new art museum, a postmodern music hall, and a most spectacular tower called the Oriental Pearl Tower. The tower tour is certainly worth every minute of it. On the ground level is the Oriental Pearl Science Fantasy World. On the first level at about 300 feet is the Space City. Then at the 400-to-750 feet level is the Space Hotel. Just above the hotel is the circular viewing area from which one can see the city and the spectacular night lights along the river; much like Times Square at night. There is the great Revolving Restaurant at the 770 foot level, and finally the Space Module at 1150 feet. The communications tower extends far beyond that! (This footage is approximate. Measurements are in meters.)

I must bring in a side note here. As Simone escorted us through the day on Tuesday, both Michael and I noticed that she was making a play for Taylor! On Tuesday, they were holding hands while walking the tours. By late afternoon, the affection appeared to be mutual. We flew back to Beijing on Wednesday, leaving Simone in Shanghai. However, she took a later flight and spent Wednesday and Thursday with Taylor in Beijing. Taylor was recently divorced and was dating a nurse in Knoxville, Tennessee. On Friday, the second of October, he left Beijing and Simone. Taylor told me that all of this was too sudden and he was confused. He asked me, "What am I going to do, Perry?" To which I replied. "Do nothing until you are back in

your home environment. This may be serious, but it may be simply Simone's way to come to America. Do not say anything to the nurse in Knoxville until you are more certain that this is not just a foreign romantic interlude!" Soon after our return home Taylor did go back to Shanghai to visit Simone and her family. I have not heard from him since.

Interestingly, I did not get to meet Like's father because of his death; I did not meet his mother, who was in mourning, nor did I see Like's wife and baby. Like's marriage was an arranged affair and, as was customary in China, he spent most of the week with us; even the evenings were out without his wife. Nor did Taylor do any demonstration operations. There were no explanations for this but one must remember that Chinese go to great lengths to be hospitable and to "save face." as we westerners say. It may be that the chief surgeon just did not want to risk having Taylor do the demonstration, or it may be that "authorities" finally did not permit it, or that doing so would have favored the Dungfang Huatang Medical Company. We will never know. This trip was educational and enjoyable, but the three of us had too little in common to make our relationships very comfortable or our friendship very lasting.

Continuing in Cullowhee

I have included these travel notes in this manuscript because travel has been such an integral part of my development and education. These experiences have helped to shape who I am, what I believe, and my life style. You may notice that I have yet to describe later tours, listed on page four, to: China the fifth time, Russia the fifth time, Uzbekistan, Australia, New Zealand, Costa Rica, Panama, Chile, Argentina, and Mexico's Copper Canyon. Those tours were taken after I completed this manuscript. I plan to continue traveling.

My experiences while living in Cullowhee have been extremely rewarding. I came to love the mountains, the pace of life here, my associates and my gardens. I maintain a close and valued relationship

with the University and my colleagues. In 2012, the North Carolina Art Education Association, which I organized in 1964, presented me with their Lifetime Achievement Award, the Jackson County Arts Council named me President Emeritus and dedicated the new office to me. I completed a fourteen-foot mobile sculpture for the new Jackson County Library, and I donated eighty-six art objects to the Fine Art Museum at Western Carolina University. I now concentrate my time on volunteer work, my creative work in photography, tending my gardens, and travel. I have about thirty bonsai plants under cultivation with the oldest being about thirty-seven years of age. I remain ever an optimist! My journey continues past the eighty-eighth year.

CHAPTER TWELVE
EPILOGUE

It has been a long journey from the cosmos screen, and history has revealed pages of information prior to the cosmos experience. I suppose it is here that I should wrap it up by sharing some personal viewpoints. I know now that the greatest events in my life were being born into a dynamic family, the Air Force experience, pursuing my education, finding a career in education, and coming to North Carolina. Deaths of family members and friends were sobering experiences. Logic and emotions have been conflicting forces. Religion and reality are contradictory. Life is a finite process, and I see reality as only relative perceptions. Gender is a masculine/feminine scale of inherited and cultural characteristics. Youth and passion defy reason. And I am left to wonder about it all.

> "The Moving Finger writes; and, having writ,
> Moves on; nor all your Piety nor Wit
> Shall lure it back to cancel half a Line,
> Nor all your Tears wash out a Word of it."
> *(Rubaiyat of Omar Khayyam - Fitzgerald Version, pg. 31)*

Search for Meaning

Meaning and significance are perhaps illusions, as much as reality is perception, which we seek for our own mental health or upon which

317

we generate purpose and motivation. It is important for me that I seek these illusions for better understanding of the person I have become and for understanding those forces which directed me in this life. I believe those conditions before and during birth, as well as each event during this life, have propelled me into becoming what and who I am. Significantly, at my current age of eighty-eight, I am still in this continuum of becoming. I will not "conclude" anything. But, I can draw on some facets of my life that are significant conditioners. Perhaps the influences that I have had on the lives I have touched shall be my legacy.

Family

My mother's limited diet did not prepare her for the birth of seven children, two of whom did not survive, and others survived with health problems. We will never know if her health may have also contributed to the failing health of two of her children, Jay's impaired heart and early death, or Clifton's rheumatic heart condition. Her early death, of course, had a devastating effect on my life, as it did on the entire family.

The patriarchal structure of family relationships certainly established in me a social consciousness that has been difficult to overcome. The impact of inadequately educated family role models failed to establish the foundation that I needed. Having relatives react so negatively to my stepmother impressed in my consciousness a kind of bitterness that I have yet to conquer.

My parents, grandparents and other relatives always gave me the attention and love that I needed. I also recognize with gratitude the role that my brothers and sisters played in shaping a lifelong positive attitude about life. The give-and-take adjustments required in a large family, as well as the camaraderie, served me well. Many of my attitudes and ideas were shaped through our interrelationships. Cousins also contributed to my education and my concept of joy for living.

Had my family been more knowledgeable and less homophobic, then Marvin and I would have struggled less with our sexual conflicts.

Security

Had I not experienced the deprivation of the depression years, perhaps I would have been materially more secure as well as educationally better prepared. Opportunities denied me by poverty limited my progress and my perspective of expanding horizons. One might observe, however, that those same conditioners may have been the source of my motivation and stamina, as well as humility and empathy with other people. Such thoughts do not negate my abhorrence and fear of poverty. My whole life has been oriented toward work and saving that would elevate me above the travesty of poverty. Currently, the pleasure of a sumptuous dinner evokes memories of an earlier simple baked potato, a bowl of soup, or a single orange at Christmas time. The fear of poverty is indeed real. Pursuit of education was my way of dealing with that issue. Military service and the GI Bill provided the opportunity for me to overcome the poverty but not the fear of it.

My early years of education were indeed limited by poverty and the lack of educational opportunities. I had many well-prepared teachers who struggled with students from inadequately supportive homes and indifferent or uneducated parents. The inadequacy of my schools became so very apparent when I arrived in my freshman year of college, where I had to compete with students having far more advanced preparation. However, those same teachers laid the foundation for me to later pursue higher education. To them I am grateful.

Poverty promotes fear, intimidation, enslavement, and crime. I am deeply moved by visits to areas where I see poverty binding people, especially the young, to such conditions. I empathize deeply.

Influential Persons

I hope that I have conveyed in this writing my deep appreciation to the many individuals who offered guidance and even opened doors of opportunity for me. It is amazing how effectively one person, with perhaps one remark or one suggestion, may present passage to new directions or new horizons for a receptive mind. Mention of only a few of them here will suffice to illustrate the point. My brother, Jay, assisted me in my move to Orlando, while Marvin and Carl helped me to get established as an adult. Marvin gave guidance in the development of my attitudes and behaviors as I drifted into a gay community in Orlando. He taught me that being gay did not require flippant gestures or obvious display of the effeminate.

Ethel Bass recognized my art abilities, exposed me to the world of art, and protected me from apparent exposure to a less than desirable gay element. Bill Grannell from Brooklyn, New York introduced me to the symphony and theater while we were in the Air Force and Jim Wathen at the University of Florida introduced me to opera as well as a world of travel. Edward Roberts made it possible for me to return to the University of Hawaii. Professors who guided me through some eight years of college studies deserve my gratitude. Dale Summers did so much to help me to be more introspective and to deal with my nature through art while Dr. Johns was brash enough to direct me away from the University of Florida during my doctoral studies. John Mahony, Linda Mahony and their three children have offered friendship that has sustained me more than they realize, and they provided me with a much needed familial stability. I do appreciate the students who have kept in touch with me over the many years. To these and many, many more, I offer my thanks. And, I deeply appreciate the friendship of my long-time neighbors, Henry and Elizabeth Mainwaring, and their children. Great neighbors and friends!

Education

I see education as the major liberating force in my life. All of my activities have been centered on the educational values to be derived from each. Even writing this book has been an educational venture. It is my hope that the reader will benefit from the reading as I have from the writing.

This book will have served its purpose well if the ideas presented herein give one person reason for optimism, if a parent of one gay child accepts and supports that child, and if one gay person is saved from rejection, depression, or suicide. It is all about education.

The travels were essential to the development of my international perspective. They contributed to my understanding of international issues, and to my view of myself as a member of the international society. The travels were humanizing experiences.

Seeking Acceptance and Love

David Riesman, in his book *The Lonely Crowd*, describes people as "inner directed and outer directed." I am more of the outer directed type in that I have spent all these years in activities oriented toward the nurture of others, and the acquisition of acceptance and love. Teaching is an act of altruism. It is an act of giving to the development and education of another person. When I have been involved in guiding students through creative activities my energies are focused intensely on the individual's acquisition of information, total development, and self expression. When I return home or to my studio afterwards, I am unable to do my own creative work. My art has been created as inquiry and expression for the enlightenment and joy of the acts and for the learning and joy of others. My art has not fulfilled its role until it is shared with others. That sharing is a source of my being recognized and accepted. Of course, I have experienced deep love from family and lovers, and I have experienced recognition and acceptance of my art. However, I have experienced rejection of

my art as well as my person. I can tell you that both are painful. In my life, acceptance and love have been far more prevalent.

That has led to a sense of worthiness.

Sex was never a topic of discussion with my father beyond the obvious breeding of the farm animals. Sex was not a word to be used in polite company, and certainly not in company of the opposite gender. Sex, however, was surely a word bandied about among the brothers, cousins, and male friends. Early in life, we understood that the act, even the word, was some unhealthy concept. It took practice for me to recognize it as a basic, wonderful part of being human. Old age renders it far less a human force.

I firmly believe that sexual orientation, as well as other factors of one's psychic nature, are both inherited and culturally developed. I don't know what genetic traits I inherited, and I can only surmise certain cultural facts that directed my development. One might observe that my early years were oriented to relationships with a beloved but dominating grandfather, as well as with a father who offered discipline and love as the most stable element of my youth. Being the fifth of seven children, with two older brothers directing much of my learning, and five male cousins with whom I had a close relationship, certainly shaped my social attitudes. And, finally, the changing female parental relationships could have been major psychological influences. Perhaps these cultural factors contributed to my, as well as Marvin's, orientation. Having two straight brothers subjected to these same cultural factors with perhaps different genetic makeup speaks well for the inherited factors. Current genetic research is beginning to clarify this relationship between genetic and cultural influences.

Having participated in heterosexual and homosexual sex acts gave me a view of sexuality as a range of human affections and emotions. Being homosexual is not about the sex act. It is an orientation of emotional and psychological needs and responses, not unlike heterosexual needs and responses, to another person. Only the gender of affection is different. I have never understood why some non-gay persons can't recognize the fact that the emotional, physical,

psychological attraction for two gay persons is no different than their own. Only the physical is different. There are vast differences between the physical sex act and the psychic emotions that bond two persons. It is so fortunate that I have lived to see vast changes in public attitudes toward this topic. It is equally unfortunate that so much ignorance and intolerance still exists about any sex that does not conform to the cultural bias.

It is unfortunate too, that current discussions of gay marriage have melded the church-state entities in a society that espouses separation of the two. Marriage is first about state recognition of civil and legal rights and, second, about the church ritual of recognition. The church is a social organization that should have sanctions or objections to anyone who joins and submits to its rules. Marriage for the state is civic and legal issues of constitutional law and the civil rights of all citizens. I should have the right to acceptance of my relationships in the civil law. Simultaneously, being accepted or rejected in any religious organization should be the prerogative of the specific religion. The one should not be dictated to by the other.

Sexually, I first went through about five years of denying my orientation and about twenty more years of ambiguity and bisexuality. At about the age of forty-five (the late 1970's), I came to accept the fact that heterosexual intercourse left me with unpleasant emotions and often with undesirable involvement. At that time, I accepted the fact that I was absolutely gay. My sexual development took me through periods of fear, intimidation, sometimes degrading relations, and isolation, as well as great relationships of real love and sexual satisfaction. Physical sex, for me, has always been secondary to the emotional bonds between two people. I have never imposed sex on anyone of any age, and only persons who offer mutual affection attract me. My many heterosexual male friends offer me emotional stability, motivation and camaraderie.

If this story saves even one person from rejection, depression or suicide, the labor will have been worth doing. If one parent reads this and comes to accept a son's or daughter's homosexuality with love, the work will have been worth publishing. Hopefully, I can feel less

isolated when this issue is made public. Those family members or friends who cannot accept my homosexuality will have to deal with it as their own problem.

International Perspectives

I realized, in the first year of my teaching World Geography, that the standard textbook was very inadequate, and that my knowledge of world geography was far too limited. I returned to the University of Florida for summer classes in World Geography. In the second year of teaching Geography, I acquired additional textbooks to meet the needs of the various levels of student capabilities, and I changed the curriculum to thematic studies. I also began my international travel. Thus my teaching Geography became a focus on "Human Geography" instead of "Physical Geography," with student research and discussions replacing lectures. People who live in the confines of physical or ideological boundaries make the dynamics of geography. Through the studies of human geography and international travel, I came to see my own society, as well as myself, in unique ways.

On Religion

I sent my Soul through the Invisible,
Some letter of that After-life to spell;
And by and by my Soul return'd to me,
And answer'd "I Myself am Heav'n and Hell!"
(Rubaiyat of Omar Khayyam, Fitzgerald version pg. 80)

Ironically, my earliest years of religious influence set the stage for philosophical inquiry, which led to my agnosticism, and later to atheism! That process of exploring religions and religious institutions contributed to my current viewpoints on religion. Later experiences, education and exposure to other religions, relativity, Dadaism and Existentialism shaped my view of life. I accept as unknowable for me

the spiritual nature of humans, the source of humanity, and a view of the afterlife. I acknowledge that my moral and ethical values have their roots in the Christian religion. I do reject organized religious ritual as part of my life. I attempt to practice the Buddhist philosophy of self responsibility and stoicism. I do consider myself to be an atheist.

I believe sincerely in life that is always becoming, always evolving, and that my lifetime accomplishments have contributed to the richness of that process and to the lives of others. How, when, or why the natural events occurred that evolved to my existence interests me only intellectually. Where it evolves to from here or how our knowable existence ends are irrelevant. How our tiny earth and our minuscule existence came about is for me a fascinating subject for intellectual inquiry, not with religious mythology. How it will end is pure speculation. I perceive that human demise will be either so catastrophic or so evolutionary that humans may not, in either case, realize the event of their demise.

The evolving concepts of gods as forces to be dealt with, to monotheism, and to current modes of civil law provide humanity with a vast and exciting history. I anticipate that in the future we will come to see that religious practices that now divide us will evolve into recognition that their sameness can unite us.

Continuing

I have always been afraid of the dark. So, my abrupt departure from home in the middle of the night required untapped bravery. Coming to terms with homosexuality in a fundamentalist Baptist family, and final acceptance of my sexuality, says a lot about my abilities in social adjustments. Breaking away from Orlando and entering the Air Force at the age of twenty-one projected me like a rocket into an alien life, and it was one of the best choices I ever made. In the Air Force, I experienced camaraderie and acceptance such as I have never known elsewhere, and I discovered my independence as my

life took an opposite direction. How else would I have ever had the nerve to break away and enter college and to finally earn my third degree in art education?

Forgive me now as I cite a few achievements through which my life has influenced the lives of so many others. In teaching world geography, I opened avenues of cultural understanding for youngsters, thereby preparing them for their place in an international society. Through my own world travels, I became a more informed teacher of art, geography, and cultural awareness. In teaching art, I nurtured creative expression and independence in many, many children, youths and adults.

In 1957, I helped to organize the first Florida Art Education Association, and co-authored the statement of philosophy for the charter, which gave credence to the values of arts education. By openly refusing to participate in segregated professional activities, I contributed to the dissolution of segregation in the schools in Orlando and in North Carolina.

In North Carolina, I served as the first "State supervisor of Art Education" in the State Department of Education. It was here that I wrote my dissertation on "Art in the Public Schools of North Carolina." This study laid the groundwork for legislative action requiring certified arts educators in all public schools in North Carolina. While in that position I brought together three embryonic organizations of white, black, and integrated groups of art educators to form the integrated North Carolina Art Education Association. That was the first independent, integrated, organization of North Carolina teachers. I also held meetings, workshops and art demonstrations in each of the 149 educational units in the State, refusing to make such presentations for segregated participants. These workshops demonstrated the values of art education for all children and for society in general. I also received grant funds for, and supervised, several grant funded projects, which placed art teachers in each school of the funded educational districts. My dissertation also revealed the weaknesses in the university arts education programs that lead to curriculum changes throughout the university system.

I was director of the North Carolina chapter of Youth Art Month, and served as juror for the Southeastern District, and the National Competition in New York. I also served as juror for the International Red Cross' "International Exchange of Student Art" based in Atlanta. I served on the board of the North Carolina Museum of Art during a time when we purchased two paintings with a value of over $550,000. One of those was purchased over the phone to Paris. I was a member of the art museum's membership and support group called the North Carolina Art Society.

While at Western Carolina University, I directed the faculty in planning a comprehensive art department encompassing art history, art education, and fine arts and crafts. I also taught summer courses at the University of North Carolina–Chapel Hill, and at Appalachian State University. In the first ten years, we developed an art faculty of thirteen members with 250 undergraduate art majors. During that time, we planned and constructed a new building for the new arts programs. We laid the groundwork for what is now the School of the Arts and the Fine and Performing Arts Center and Museum. I chaired a committee that hired architects and landscape architects to propose campus landscaping and centralized commons that is now a realty. I was a member of a committee that started the WCU Mountain Heritage Day Festival, which has grown to a very large annual event, as well as the committee that organized the WCU Mountain Heritage Museum. I was one of six founding members of the Jackson County Arts Council, for which I wrote the by-laws, and I was a founding member of the Jackson County Visual Arts Association, which operates Gallery One in Sylva, North Carolina. I also helped to organize, and wrote the charter and by-laws for, Bridging Jackson Communities with the avowed objectives of promoting cultural intercourse and unity among our diverse citizens.

Throughout it all, I have given counsel to many, solace where it was needed, and constructive critique where guidance nourished growth. Meantime, perhaps that is enough for one lifetime, and I am pleased now to close the colorful Cosmos Screen for you. As the sun sets on my cosmos screen, I take an existentialist view of life as

only one's perception of a brief segment of time and events having no finite beginning or ending but simultaneously being a part of the continuum of existence. From some infinite source of minute cells I came into life and into some infinite cells I shall return, having obeyed my mother's admonishment to "always leave a place and people in better condition than you find them." I, in turn, admonish my reader to take a blossom from the cosmos in remembrance of what I have added to local, national, and international joy of others; thereby leaving this a better place than I found it and people better prepared for living a good life than when we met. Thus, this educator leaves the message that education leads to understanding of self and relationships as nothing else can and that knowing oneself better prepares one for living a worthy life. The less-educated person becomes the subject of others more fortunate. Set your own feet in the sands and shadows of your own screen and move forward with hope and optimism realizing that, from knowing of my experiences, you may know yourself more completely. May you live your life without fear or hunger, without boundaries of religious strictures, and without restrictive social injustice. In other words, may you receive from my journey, directions for your own energetic and rewarding life. Perceptions of my cosmos screen fade into memories as sunset fades the color of cosmos blossoms.

This story is continuing beyond me, far beyond the Cosmos Screen. My life has been a great and joyful experience. I am happy to have shared the story, and I hope it enriches the lives of others as have the acts of my living. From the screen of cosmos blossoms this barefoot boy in the sands of Alabama accomplished a lifetime of successes that can only be described as AMAZING!

Finis.